**Opposite
Eugène
Delacroix**,
*The 28th July
1830: Liberty
Leading the
People* (detail
of 64),
1830.
Oil on
canvas;
260×325 cm,
102¼×128 in.
Musée du
Louvre,
Paris

Introduction

In Paris in 1827–8, visitors to the Salon – the great annual
exhibition of contemporary art – found themselves confronted
by an astonishing picture. The *Death of Sardanapalus* (see 2),
by the 29-year-old Eugène Delacroix (1798–1863), delivered
a battering to the senses as violent as its subject was brutal.
Even today its irrational composition and exaggerated colour
throw the eye. Everything seems to be sliding or spinning out
of control, and the paint runs like blood. For the painter's
original audience, all the rules of art were cast asunder. So,
too, apparently, was the duty of moral instruction that such
monumental narrative pictures were supposed to deliver. At
the heart of Delacroix's vast canvas lay a moral vacuum, all
the more shocking for ignoring the message of the play by the
English poet Lord Byron from which he had taken his subject.
In Byron's story Sardanapalus is an ancient Assyrian ruler
whose only wish is the good of his subjects; unjustly defeated by
rebels, he steps nobly on to a funeral pyre, followed by his most
faithful concubine. Delacroix reversed all this, unleashing the
massacre of an entire harem while his king reclines unmoved.
The immediate response was shock, and a closing of ranks. In
an icy interview with the Minister of Fine Arts, Delacroix was
warned that he would have to paint very differently if he
expected any official commissions.

Sardanapalus is famous as the most outrageously 'Romantic'
picture ever painted. It appeared in a city whose cultural life
was riven by a 'battle of the styles' (1). On the one hand was
Neoclassicism, the dominant official style. Governed by rules
enforced by academic training and maintained by official
patronage, it was an art that strove to preserve values thought
to descend from ancient Greece and Rome. On the other
was Romanticism, the rebellious newcomer. Rather than a

systematic programme, it was an association of ideas that delivered unprecedented freedom of imagination and expression, and encouraged artists to appeal directly to the emotions of their audience. While Delacroix claimed these freedoms pictorially, his writer friend Victor Hugo did so for literature. His own Romantic manifesto appeared the same year, 1827, in a preface to his English historical drama *Cromwell*. It advocated a rich variety of expression and experience to reflect the complexity of the world and the

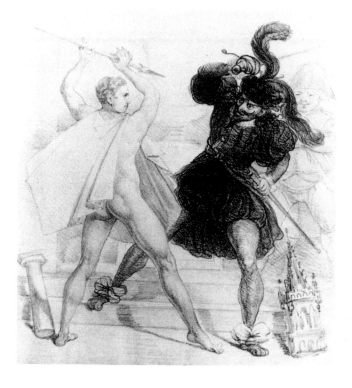

1
The Great Battle between the Romantic and the Classic at the Door to the Museum, 1827

self, rather than the cold formalism of classical drama, and recognized the value of the ugly or grotesque in engaging the senses, rather than beauty in winning only admiration. Now Delacroix's picture appeared as a pictorial equivalent, in which beauty, in the sensuous forms of the concubines, existed only to be destroyed. The emphasis on colour and texture, rather than outline, matched Hugo's rejection of classical dramatic structure. And the subject, though in its way Antique, was not

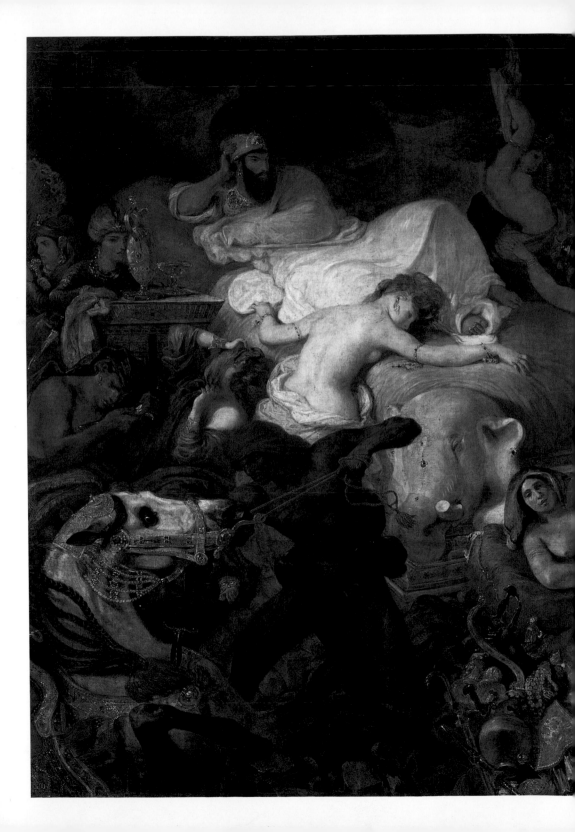

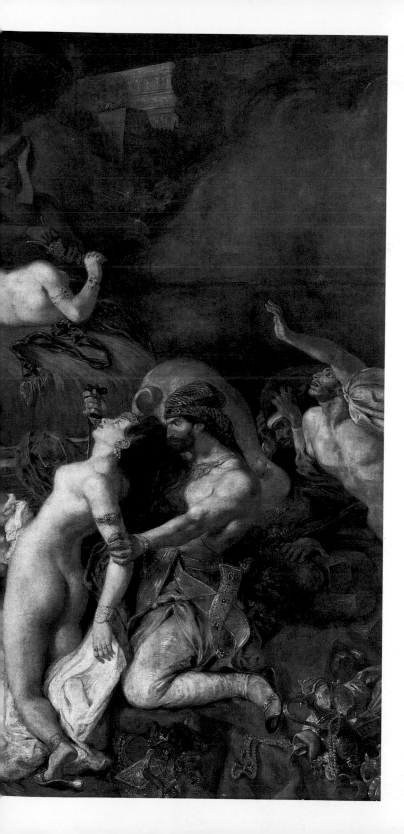

2
Eugène
Delacroix,
Death of
Sardanapalus,
1827.
Oil on
canvas;
392×496 cm,
154¼×192¼ in.
Musée du
Louvre, Paris

from the Greco-Roman world but from the East. All the essential ingredients of the new Romantic art – violence, rebellion, exoticism and bravura – were here incarnate.

For the French poet and critic Charles Baudelaire, 'Romanticism is precisely situated neither in choice of subjects nor in exact truth, but in a way of feeling.' He regarded Delacroix as the epitome of the Romantic artist. Delacroix himself seems to have disliked the label. Hugo, for his part, found the distinction irrelevant, declaring that the important differences were not between Romantic and classic but between good and bad, true and false. This was not to deny the ideas behind Romanticism but rather to acknowledge the loathing of being pinned down, which was fundamental to it. Romanticism was by its very nature provisional: it reacted against what lay around it, was constantly mutating, and was often defined by what it was not. It was a youthful movement, pitted against every manifestation of age and experience. As soon as it was recognized and proclaimed, and worst of all defined, its targets included itself; it was rejected as soon as it threatened to become established. While Romantics easily dismissed what they did not like or believe, they found it genuinely difficult to martial a coherent alternative programme. In 1829, in the first history of Romanticism, the critic F R de Toreinx described it as 'just that which cannot be defined'. Nevertheless, the search for a definition continues, not least because many of the greatest early nineteenth-century European artists – and writers and composers – were profoundly affected by it. J M W Turner (1775–1851), John Constable (1776–1837) and William Blake (1757–1827) in England; Francisco Goya (1746–1828) in Spain; Caspar David Friedrich (1774–1840) in Germany; Théodore Géricault (1791–1824) as well as Delacroix in France, cannot be understood in isolation from Romanticism.

When and where did this cultural movement originate? Although this account began in Paris in the 1820s, Romanticism's beginnings can be found earlier and elsewhere.

For much of the eighteenth century European cultural life had been dominated by an ideal of Enlightenment. It was believed that advances in knowledge, gained through objective, rational observation and experiment, would bring about sustained improvement in the human condition. They might even deliver perfection. The cult of reason reached far beyond the arts but found its perfect aesthetic expression in Neoclassicism and its values of logic, harmony and proportion. *Agrippina Landing at Brundisium with the Ashes of Germanicus* (3), painted in 1768 by Benjamin West (1738–1820) and depicting a subject from the Roman historian Tacitus, exemplifies these admirably in its frieze-like composition and the emotional restraint with which this scene of a widow's grief is treated. The Enlightenment was not without subversive aspects, for it advocated freedom and equality, and questioned many traditional beliefs, especially in the field of religion. But in the second half of the century it was increasingly realized that it denied huge areas of human experience. Like a great tide on the turn, the focus of philosophical enquiry began to change from the objective to the subjective, and a new generation began to explore the potential of emotion and instinct rather than the conscious mind, of integrity rather than obedience, of sufferings, sorrows and fear as well as joy, of the humble and natural instead of

3
Benjamin
West,
*Agrippina
Landing at
Brundisium
with the Ashes
of Germanicus,*
1768.
Oil on
canvas;
164×240 cm,
64⅝×94½ in.
Yale
University
Art Gallery,
New Haven

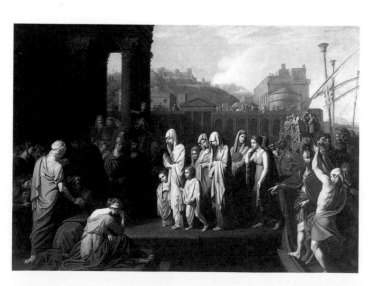

sophistication, of the idiosyncratic instead of the ideal. Meanwhile, artists looked for creative alternatives to the dominant forms of the classical tradition. Defying received wisdom, they looked within themselves for new creative directions. Not since the Renaissance had such a profound change come over the Western consciousness. But while the Renaissance had incorporated a collective ideal, the revival of skills and styles lost since Antiquity, Romanticism emphasized individual experience, feeling and expression.

This change relates to current historical phenomena. The first and most crucial of these are the achievement of American independence in 1776 and the French Revolution in 1789. In their aspirations to freedom and social equality, both events marked the climax of the Enlightenment's belief in progress and reason. Yet while republican America – despite its use of black slaves – was held up as a beacon of liberty and democracy to Europe, hopes of an ideal society in France were soon dashed. First the Revolution consumed itself in the Terror, when its opposing factions turned on each other, resulting in unknown thousands dying on the guillotine. Then Napoleon Bonaparte appeared, first as the heroic restorer of order and defender of the revolutionary ideal, then, increasingly, as a tyrant who plunged the European powers into warfare on an unprecedented scale through his vision of a continental empire with Paris as its capital. Italy, Germany and Spain were invaded and occupied, Britain and its growing empire stood in constant danger until Napoleon was finally defeated in 1815. For the French, he had brought both glory and suffering. His eclipse left them empty and bereft. Nor was the post-Napoleonic era a comfortable one for victors or vanquished. Economic hardship was widespread in Britain, which was already undergoing the immense social changes of its own Industrial Revolution, while in France, Germany, Spain and Italy the governments and restored monarchies were reactionary and uninspiring. Further revolutions followed, in France in 1830 and widely in Europe in 1848. Many Europeans felt caught up in events

beyond their control that were inexplicable by any rational conceptions. Napoleon's career even struck many as evidence of supernatural power, his defeat a judgement of God. Neoclassicism was at once too rigid and too tainted a form for the new reality. Promoted by the Revolution and then by Napoleon to revive in France the glories of ancient Rome, Neoclassicism was discredited with them.

Romanticism was born in opposition and sorrow, in social or national crisis and in individual trauma. Often associated with the revolutionary spirit of the time, it was really the consequence of its failure – a compensating revolution in hearts and minds, an alternative empire of the imagination. Its adherents were as often conservative or even reactionary as they were radical or liberal. When Baudelaire wrote of the 'sense of irreparable loss' afflicting his generation in France, he was thinking of those left high and dry by Napoleon's fall and alienated by the bourgeois regimes that followed. But while their nostalgia contributed to Romanticism, so did that of survivors of the *ancien régime* who yearned for earlier, feudal times. Similarly affected were the invaded Germans and Spanish, who mourned their lost freedom, and even English liberals like the poet William Wordsworth who, from comparative safety, had been appalled by the failure of the revolutionary ideal. It was a friend of Wordsworth's, Thomas Noon Talfourd, who in 1815 described a 'rending of the general heart' that had served to 'raise and darken the imagination' and bring about 'the great age of poetry that is now upon us'.

For the first use of the term 'Romantic' in an artistic context we must go to the German university town of Jena in 1798, when, in the first issue of his journal *Athenaeum*, the critic Friedrich Schlegel applied it to 'progressive universal poetry' that was to be distinguished from inherited and culturally specific forms. With his brother August Wilhelm, Schlegel was immensely influential. His short-lived journal attracted many contributors

among German writers and thinkers who were now testing Enlightenment ideas to destruction. For it was also at Jena that philosophers such as Johann Gottlieb Fichte and Georg Wilhelm Hegel were exploring radical concepts of the supremacy of the ego, of subjectivism, mysticism and historical evolution. In contrast to Jena, its nearby rival Weimar was associated with the classical tradition; it was the home of Johann Wolfgang von Goethe, then regarded as Germany's supreme literary guardian of classicism.

It was ideas such as those propounded by the Schlegels that, in mutated forms, had arrived to spark controversy in the Paris of Delacroix and Hugo. They had been imported mainly by the French-Swiss writer Madame de Staël – fittingly known for her romantic novels – in an enthusiastic account of German culture, *De l'Allemagne*. Her first attempt to publish this in Paris had been foiled by the Napoleonic authorities, who rightly suspected an anti-French agenda. For Schlegel's contrast of modern and established forms, of pluralist and classical culture, had indeed been more than an aesthetic formulation. He chose as his badge a word derived from 'Romance', admittedly once a description of the old French language used as a popular alternative to Latin but, more significantly, of medieval stories of courtly love or mysterious phenomena which appealed directly to the imagination. These were often Germanic in origin and represented the opposite of the classical tradition espoused by the French. For Schlegel's generation of Germans, classical culture was associated even more strongly with the impositions of Napoleonic France than with ancient Greece and Rome, and the 'Romantic' nostalgia that de Staël noted for times of 'chivalry and Christianity' was strongly nationalistic. Historical revivalism of the architecture, art or lifestyles of the Christian Middle Ages was to be one of the most distinctive ways in which Romanticism marked itself off from the mainstream, but there was often a paradoxically contemporary agenda behind it. It was not only in Germany that it would be associated with resistance to the dominant

political, religious or social ethos of the day, and with dreams of national revival.

It was Baudelaire who later gave 'Romanticism' the vaguer, more inclusive definition it has today. 'To say the word Romanticism', he declared, 'is to say modern art – that is, intimacy, spirituality, colour, aspiration towards the infinite, expressed by every means available to the arts.' The looseness of this definition implies that Romantic art need not *look* modern, and its means could include historicism. Baudelaire praised those artists who engaged with what he called 'the heroism of modern life', but he also identified the precondition for artistic creation in alienation from the artist's surroundings; indeed, in admiring *The Death of Sardanapalus*, he seems to have sensed that the detachment of Delacroix's ancient king echoed the bored impotence of the young Romantics themselves in post-Napoleonic Paris. Whatever the validity of this interpretation, one of Romanticism's enduring legacies has been the idea of the artist as rebel, marginalized and suffering. Artists themselves encouraged this view, constructing it as part of a new mythology of art. Although many, Delacroix included, became very successful in worldly terms, and the popular image of the tragic genius, with wild hair and staring eyes, starving in a garret, is only a caricature, it is nevertheless true that Romantic art often sprang from disillusion with the contemporary world – from that weary despair that the French called *mal du siècle* and the Germans *Weltschmerz*, whose symptoms ranged from disabling inertia to compulsive dreaming and longing. In an essay explaining 'why distant prospects [views] please', the English critic, former painter and frustrated radical William Hazlitt claimed that this was because their indistinctness gave the imagination free rein – space, in effect, to fill in the gaps. He took it for granted that such flights of the imagination were preferable to current reality, and that escapism lay at the heart of the Romantic instinct – escape into not only the past but also faraway or primitive societies, religion, dreams and fantasies, or meditations on infinity and

death, nothingness and the afterlife. The thirst for these things could never truly be quenched; as Friedrich Schlegel said of the sacred, it 'can never be seized because the mere imposition of form deforms it'. Nature was the most material refuge from a flawed or fallen human world, but was likely to be depicted by the Romantics in abstractions of light and colour or in largely symbolic form, remote from the realities of rural life.

Romanticism has been called 'spilt religion', and it is striking how often its experience – of nature, of the heroic, or even of the passions – has about it the quality of religious observance. This was less the consequence of a loss of faith than of its reinvention. Romantics rejected a judgemental, moralizing God and looked for the God in themselves, or for a religion that appealed to the emotions, the senses and the eye rather than the intellect. Hence Blake's elevation of the 'human form divine' over the hated lawgiver 'Nobodaddy', and the appeal of the Gothic, and of Roman Catholic ritual, to many Romantics. Their yearning for a lost Age of Faith was sincere.

If nostalgia was a constant Romantic state, irony was another. Romantics touched little without transforming it, sometimes to debunk. Satire and caricature were among the weapons they brought to a new sharpness. In particular, they used these to expose the complex multiple identities that they now suspected human nature to embrace. Their sense of complexity was reflected in their compulsion to innovate and change. The transformation of established categories of art, such as history painting and landscape, and the invention of new subject matter are features of Romanticism as striking as the development of new techniques and media. Only a Romantic could have dreamed of sculpting an entire French mountain, or of building a German chapel in which painting, poetry and music would permanently combine to form a 'total work of art' capable of inducing an ecstatic experience. Teachers, critics, collectors and the demands of the market were alike rebuffed if they threatened to correct or qualify an artist's

public statements. Instead artists paid new attention to more private, personal work – for example sketches or pictures from nature – that expressed their vision most directly. Because they sprang entirely from within, music and poetry were the supreme Romantic arts for the movement's first proponents. But colour was newly appreciated for its appeal to the emotions and senses – above all, in fact, by that supposed classicist, Goethe – and painting that seemed to grow organically, springing from the artist's mind and brush, rather than in a spirit of careful imitation, was closest to Romantic ideals.

Schlegel's *Athenaeum* article of 1798 provides an approximate date for the beginning of Romanticism as a self-professed artistic movement. Writing less than fifty years later, in 1846, Baudelaire signalled its end: 'few people today will want to give a real and positive meaning to this word.' Neither date can be applied absolutely. Although Romantic ideas found their strongest expression in the intervening years, some appeared much earlier. Historicism and a fascination with the exotic, the irrational and the subconscious are sometimes described as belonging to a phase of 'pre-Romanticism' from the mid-eighteenth century before coming to their full flowering. Similarly, Romantic ideas were incorporated into the later artistic movements of Realism and Impressionism, which are often said to have destroyed them. Romanticism appears at different times in different places; even within its own 'period' *c.*1798–1846 it was rarely if ever dominant and engaged artists to varying degrees. Nor was its break with the classical tradition total or even always deliberate; Romantics frequently sought to make classicism a living experience rather than a dead ideal, and aspects of Neoclassicism – especially in architecture – have been seen as a hybrid version of Romantic classicism. Finally, while some artists whose work reflects Romantic ideas rejected the label, others had no direct contact with any acknowledged Romantic circles and can hardly have been aware of their existence.

The phenomenon of Romanticism should therefore be approached with caution. This book offers only one reading of a complex period. It follows a thematic structure, investigating the main preoccupations of Romanticism and its artists. Fittingly for artists who believed that every work of art must be a unique and personal statement, it uses individual works as the starting point for the discussion of Romantic ideas – though these will often lead the reader beyond the visual arts. It attempts a more inclusive view of the movement than is sometimes given, reaching further back in tracing the origins of Romantic concerns and following their impact on later generations, while seeking to break down some of the barriers often thought to divide such artists as Jacques-Louis David (1748–1825) or Jean-Auguste-Dominique Ingres (1780–1867) from them. Like the Infinite it so often sought, the Romantic movement may seem to slip through our fingers. But to pursue it is richly rewarding, for while the contemporary contexts for its protest and passion have long since disappeared, its concepts of authenticity, integrity and inner truth remain relevant. They are fundamental to our concept, not only of art, but also of ourselves.

The Voice within You　A Portrait of the Artist

The Romantics were inveterate makers and consumers of myths and histories that dramatized themselves and their art. Previously, however famous, artists had been less important than what they produced – servants, not masters, in most aspects of their lives. The German historian Johann Joachim Winckelmann had prefaced his monumental book on ancient art (*History of the Art of Antiquity*, 1764) – a key text of Enlightenment Neoclassicism – with the proviso that it was a history of art, not of artists. He at least could claim that, from such early times, little was known of individual artists' lives. But there could be no Romantic art without Romantic artists. They thought at least as much about what it meant to be an artist as they thought about art itself. In self-portraits and portraits of their friends – as in the autobiographies or confessional poems, plays and music that poured from Romantic authors and composers – they probed the nature of the creative gift which, they believed, made them special. They turned to great artists of the past to form or sustain their sense of self; their visualizations of Raphael (1483–1520) and Michelangelo (1475–1564), Dante or Homer, say as much about themselves as about their subjects. Self-revelation lies at the very heart of Romantic art.

J M W Turner's seascape *Snow Storm – Steam-Boat off a Harbour's Mouth* (4, 5), exhibited at the Royal Academy in London in 1842, certainly does not look like a self-portrait, but in important ways it is. It proclaims the essence of the artist's genius, his unique vision of nature. When a friend complimented Turner by telling him that it reminded his mother of her own experiences in a storm at sea, he rudely demanded 'Is your mother a painter?' He had not, he said, intended to be understood: 'I wished to show what such a scene

4
J M W
Turner,
*Snow Storm –
Steam-Boat off
a Harbour's
Mouth* (detail
of 5)

was like. I got the sailors to lash me to the mast to observe it …
and I did not expect to escape: but I felt bound to record it if
I did. But no one had any business to like the picture.' Dramatic
as it sounds, Turner's story may not be true. Suspiciously
similar tales attached to other marine painters, and although
the work's subtitle announced that 'the Author was in this
Storm the Night the "Ariel" left Harwich', Turner's use of
the word 'Author' may imply a degree of creative licence –
astonishing as the picture is in its vortical, all-embracing swirl
of sea, sky and driving snow. No records have been found of

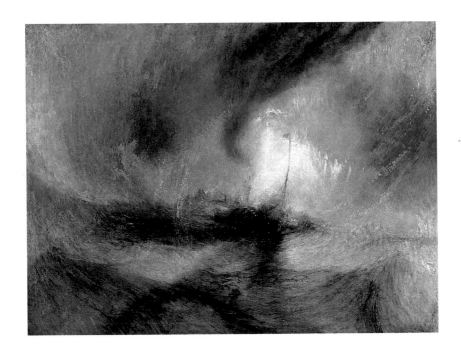

a ship called *Ariel* operating out of Harwich, and Turner had
perhaps named it after the 'airy Spirit' in Shakespeare's play
The Tempest. But fabrication or not, his story is no trivial
anecdote. It places Turner between his subject and the viewer.
He is its interpreter, who has gone to the limits of human
endurance in his quest for truth. His grumpy exchange with
his admirer takes us to the heart of how Romantic artists saw
themselves. No earlier painter would have centred himself in
the experience of his picture in quite this way, insisted so much

on the uniqueness of his interpretation and his mission to present it at all costs, and been so proudly heedless of whether it was liked or understood.

When in 1812 Georg Friedrich Kersting (1785–1847) painted his Dresden friend and fellow landscape painter Caspar David Friedrich, he too sought a pictorial equivalent for the artist's creativity. Friedrich was known for his visionary imagination, which Kersting emphasized by depicting him at work in a studio cut off from the external world (6). In this bare room the painter has his back to the window, its shutters open to admit only enough light for him to work. More striking still is Friedrich's isolation: this is a landscape painter who does not look outwards at nature but works instead to the dictates of his inner self, transforming his experiences and recollections into works of art that, as he said himself, operate on others 'from the outside inwards'. The artist's creative intercession, on which Turner had insisted in his account of the snow storm, is manifest in Friedrich's pictures in figures who stand with their backs to the viewer, looking into the subject. They are emblems of the artist himself, whose interpretation makes the world comprehensible to his audience. In his 1822 picture of his later studio in Dresden (7), the woman who looks through an open shutter at a glimpse of sunlit poplars and masts on the river is his wife Caroline; his own vision is communicated through the partner who had literally brought light into his life, and through whom, as he wrote, 'I has been changed into We.'

Since academic theory had accused landscape of being an imitative art like portraiture, landscape artists were likely to insist even more on an original vision, whether this was claimed as objective or as subjective, even visionary. The Romantics' insistence on the authentic, individual voice allowed both to flourish. For the third great landscapist of the age, John Constable, the artist's role as the agent of empirical truth is implied in his consistently autobiographical subject matter – the familiar Suffolk landscapes of his youth, the shore at

5
J M W
Turner,
*Snow Storm –
Steam-Boat off
a Harbour's
Mouth,*
1842.
Oil on
canvas;
91·5×122 cm,
36×48 in.
Tate, London

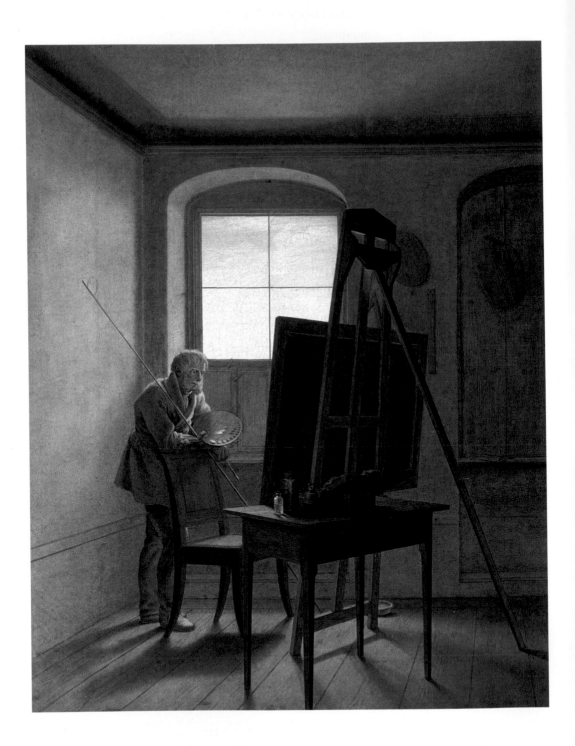

Weymouth in Dorset where he walked on his honeymoon, his father's barges being built by the River Stour – as much as in his habit of working from nature and (though this was a radical step) beginning pictures outdoors. No artist of the time was more driven than Constable to offer a new and purified account of the visible world, or one more utterly his own. In 1824, when his work was admired in the Paris Salon, the French critic Auguste Jal wrote that it showed 'nature itself ... a landscape seen through a window'. But the window, of course, was the artist's eye, and the indifference or shock that had

6
Georg
Friedrich
Kersting,
*Caspar David
Friedrich in
his Studio*,
1812.
Oil on
canvas;
51×40cm,
20×15³⁄4 in.
National-
galerie,
Berlin

7
Caspar
David
Friedrich,
*Woman at
a Window*,
1822.
Oil on
canvas;
44×37cm,
17³⁄8×14¹⁄2 in.
National-
galerie,
Berlin

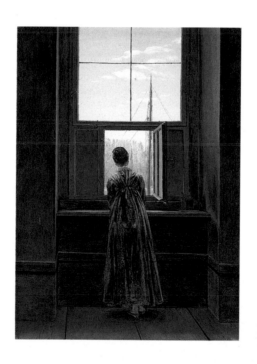

greeted Constable's work for so long in London was proof of how distinctive it was. His description of his late series of landscape prints, 'begun and pursued by the Author solely with a view to his own feelings, as well as his own notions of Art', was intended to justify his career and strikes a true Romantic note.

One of the most powerful Romantic myths was that of the 'innocent eye'. Applied especially to nature and landscape, an artist's natural, inborn vision supposedly led to a direct, truthful account free from academic training and from all

external constraints – aesthetic, economic or cultural. In reality, of course, artists' personal experiences and imagination exerted their own transforming effects. Constable's art was essentially one of experience: he painted what he knew, and in this sense his whole *œuvre* was a self-portrait. By contrast, the visionary transformations of the Kentish countryside that the young Londoner Samuel Palmer (1805–81) created around the same time are obviously the fruit of a rich inner life. The extraordinary self-portrait he drew around 1825, with hollow and haunted eyes (8), seems an attempt to understand the processes at work within him and projected on to the pages

8
Samuel Palmer, *Self-Portrait*, c.1825. Black chalk heightened with white on buff paper; 29·1×22·9 cm, 11½×9 in. Ashmolean Museum, Oxford

9
Philipp Otto Runge, *We Three*, 1804. Oil on canvas; 100×122 cm, 39⅜×48 in. Formerly Kunsthalle, Hamburg (destroyed)

of his sketchbooks. Palmer could personify the young artist whom the German writer E T A Hoffmann had in mind when, in 1816, he wrote: 'The painter who is initiated in the divine secrets of art hears the voice of nature recounting its infinite mysteries through trees, plants, flowers, waters and mountains. The gift to transpose his emotions into works of art comes to him like the spirit of God.'

This sense of divine inspiration, of a visionary gift, was common to many Romantics. It moved Friedrich's friend Philipp Otto Runge (1777–1810) to create a type of landscape

never before seen, in which the natural world was broken down into symbolic components. Runge believed that art and the community of artists had their own 'family language', concurring with Turner that they were not necessarily understandable to others. It is surely this private communion, as much as bonds of blood and marriage, that gives his self-portrait with his wife and brother, *We Three*, its mysterious power (9). A sort of Holy Trinity dedicated to the religion of

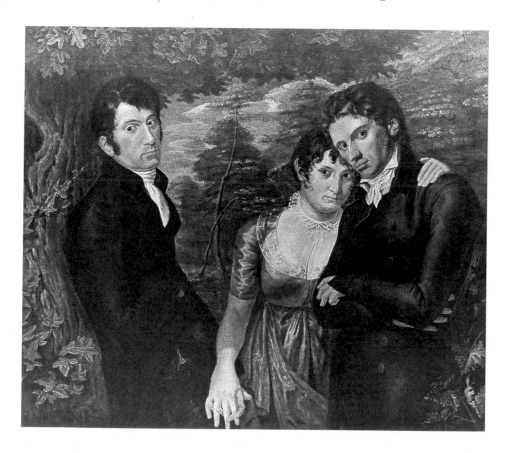

art and nature, the three figures, in their best clothes, appear almost as emanations from a lush woodland – actually one of the most literal fragments of landscape the artist ever painted. But the inner promptings of which Hoffmann spoke could refer to far more than the visible world of nature. What the American Washington Allston (1779–1843) characterized as 'the voice within you', or his English friend and fellow history

painter Benjamin Robert Haydon (1786–1846) expressed in his personal motto 'Wings at the heart', was quite simply the creative drive itself. This, more than skill or talent, was what Haydon and his friends called 'Genius' (they always used the capital) – the divine gift that conferred their vocation. Like religion itself, it could produce states of ecstasy and euphoria. It must be obeyed and understood. And it was a subject in its own right.

'High is our calling, Friend! Creative Art'. Thus William Wordsworth, the supreme Romantic poet of nature, addressed Haydon in a sonnet in 1815. Haydon was to repay the compliment later, by painting one of the most memorable portraits of Romantic inspiration, showing Wordsworth musing among the clouds, high up on the Lake District peak of Helvellyn (10). Haydon, like his subject, was describing a shared creative rapture, and it is no accident that the poet, wrapped in thought on his mountain, recalls Friedrich's alpine *Wanderer* (11), an image of the artist in communion with the mysteries of nature and of his own inner life. Poet and painter have climbed high to be closer to the God who has given them these insights, and the verses Elizabeth Barrett Browning wrote on her friend Haydon's picture could describe them both:

poet-priest
By the high altar, singing prayer and prayer
To the high Heavens.

For Wordsworth, to celebrate such experiences was not enough. He felt compelled to explain how he had been initiated into them.

In 1805 Wordsworth finished the most revealing of all Romantic creative autobiographies, his long poem *The Prelude*, which traces the growth of his poetic mind and its gradual opening to the world of nature. Wordsworth's poem was doubtless the inspiration for his friend Samuel Taylor Coleridge's *Biographia Literaria* (1817), an investigation into the origins of his own

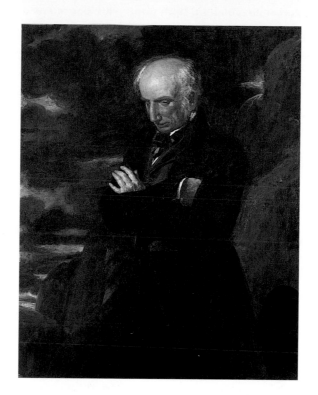

10
Benjamin
Robert
Haydon,
Wordsworth
on Helvellyn,
1842.
Oil on
canvas;
124·5×99 cm,
49×39 in.
National
Portrait
Gallery,
London

11
Caspar
David
Friedrich,
The Wanderer
above the
Mists,
*c.*1817–18.
Oil on
canvas;
94·8×74·8 cm,
37¼×29½ in.
Kunsthalle,
Hamburg

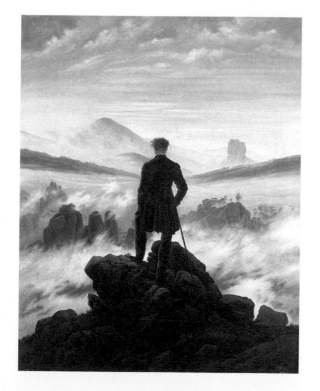

more mystical imagination. Both poets were conscious of the philosophical background to their notions of creativity and its attendant responsibilities. If it were true, as had been argued, that the world exists through human perceptions of it, so that each person creates a unique reality, then the artist who records his insights for everyone's benefit is clearly a superior being. Born of heightened awareness or imagination, acts of creation do not prove a formula, like a mathematical calculation, but are experiments, whose outcome cannot be predicted by existing standards. Where art had once aspired to repetition, to mirror its subject or conform to conventions through technical skill, now it was a voyage of discovery. More than this, it was a microcosm of Creation itself, through which the individual approaches the Absolute. If the artists' public felt privileged to share these remarkable processes, artists stood even more in wonder at themselves. Why had they been chosen? What made them what they were?

If Wordsworth – or Constable – saw themselves as seekers after truth, with a mission to observe and describe in accessible language, Coleridge exalted the faculty of imagination. 'IMAGINATION', he declared in significant capitals, 'I hold to be the living Power and prime Agent of all human Perception … A repetition in the finite mind of the eternal act of creation in the infinite I AM.' The artist, on such a measure, was little short of a god, and Coleridge's analysis is poised between egotism and awed humility. The younger poet John Keats sounds less effusive in a letter to his brother in 1819 – 'I describe what I imagine' – but he too insisted on this unique source of inspiration. Imagination, for the Romantics, was the artist's most precious gift, essential but ultimately inexplicable. It could produce rapture but also nightmares and despair. William Blake, the artist and poet whose work had helped to set the young Palmer on his visionary path, famously argued his right to see in the rising sun a heavenly host crying 'Holy, Holy, Holy' instead of 'a round disk somewhat like a guinea'. He usually depended less on transforming visions of the real

12
William Blake, *Elisha in the Chamber on the Wall*, *c*.1820. Sepia wash over pencil; 24·3×21 cm, 9⁵⁄₈×8¹⁄₄ in. (whole sheet) Tate, London

than purely imaginary insights, often divinely inspired. Of his masterpiece, the illustrated poem *Jerusalem* (1804–20), he claimed to be no more than the secretary, as 'the Authors are in Eternity', and among his metaphors for creative vision was the Old Testament prophet Elisha, foretelling her future son to the Shunammite woman who had given him a room for his meditations (12). There can be little doubt that Blake's bearded seer in his chamber was a more revealing record of himself and his art than a literal portrayal of his features could ever be.

Trained as an engraver, Blake evolved into a shamanic figure – mystic, philosopher, priest – compelled to set his visions before the world. They took the form of epic, quasi-biblical dramas of spiritual redemption addressed above all to his own nation, of whose contemporary condition he offered a robust critique. He

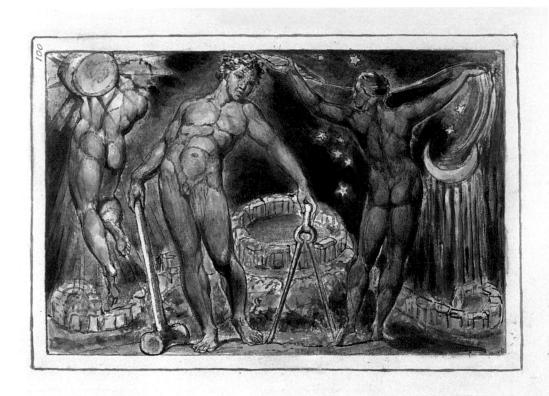

increasingly eschewed conventional media and published them in 'Prophetic Books' written and illuminated himself by processes of colour printing. His attempt to win recognition as a history painter in the Royal Academy met with scant success, and with other artists of the time, he took up graphic processes to communicate messages more urgent or subversive than were acceptable in officially sponsored exhibitions. Where these insights came from, how they formed themselves into order and system, and what obligations they gave the artist to communicate such truths were fundamental Romantic questions. Coleridge's *Biographia* shows the author's mind growing organically, like nature itself, free of external controls, but Blake spoke of being 'born like a garden ready planted and sown' – fittingly for a prophet whose gift is to foresee things already ordained. In his Prophetic Books, the character of Los exemplifies the artist's roles as seer, mystic and interpreter. The author of all art and literature, architect of a City of Art, Los is responsible for everything mankind sees and senses; he can look across time from the material to the eternal, and determines human understanding of good and evil. In *Jerusalem* he takes various forms, from a London nightwatchman to a blacksmith at his forge, but he is also Blake himself, a figure whose labours parallel his creator's. When the narrative reaches its last page, Los can only pause from his great task in a world in which the forces of good and evil, truth and falsehood are shown to be eternal; he rests from his smithy, but a temple of false religion is already extending to cover the land behind him as night follows day (13).

For many Romantics, their chosen image of creative Genius was the plant, germinating from its seed in its own cycle of life. It obeyed natural law, and could be stunted only by outside intervention. In a *View from the Artist's Window* (14) by the Danish painter Martinus Rørbye (1803–48), plants themselves create a portrait of the painter, who, at the age of twenty-two, was about to leave his parents' house and strike out on his own. On a windowsill overlooking Copenhagen harbour stands an

13
William
Blake,
Los,
plate 100,
Jerusalem,
1804–20.
Etching
with pen,
watercolour
and gold;
14·6×22·2 cm,
5³⁄₄×8³⁄₄ in.
Yale Center
for British
Art, Paul
Mellon
Collection,
New Haven

array of pots whose contents represent both his life and his art – an unsprouted seed, a protected cutting, a young agave, a flourishing hydrangea and a withered amaranth – together with casts of a child's and an adult's foot, and a sketchbook whose pages are waiting to be filled. A captive bird hangs in its cage above, doubtless yearning for its freedom. A mirror in the window is placed too high to reflect the artist, but his presence is everywhere in the work's symbolic programme. A plant is also a significant presence in the portrait that the leading Danish painter of the age, Christen Købke (1810–48), painted of his friend Frederik Sødring (1809–62) on his birthday in 1832 (15). The smiling, ruddy cheeked landscape painter is seated palette in hand. The vigorous ivy in a pot behind him has a multiple purpose, standing for the friendship that binds artist and sitter, and the creativity that enables him to mediate between nature and the ideal – represented respectively by the

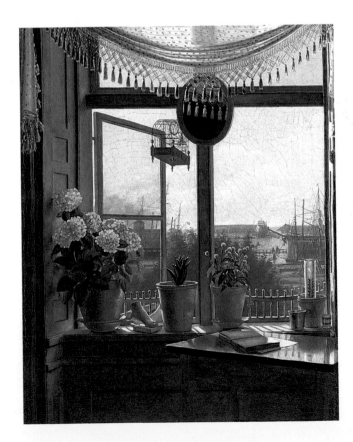

14
Martinus Rørbye,
View from the Artist's Window,
c.1825.
Oil on canvas;
38×29·8 cm,
15×11³⁄₄ in.
Statens Museum for Kunst, Copenhagen

15
Christen Købke,
Portrait of Frederik Sødring,
1832.
Oil on canvas;
42·2×37·8 cm,
16⁵⁄₈×14⁷⁄₈ in.
Hirschsprungske Samling, Copenhagen

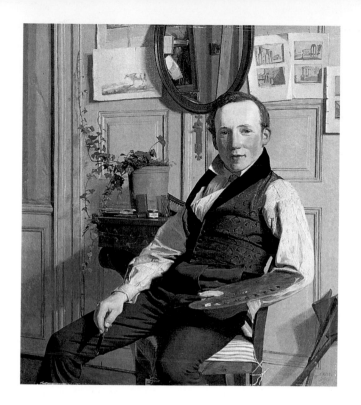

pictures of a cow and of Roman ruins pinned to the wall. Once again, while adopting the organic image of creativity common to Romanticism, Købke's picture presents a wholesome, outgoing impression of the artist's life.

By contrast, a disturbingly negative view of the creative imagination is suggested by Francisco Goya in the print of about 1798, which he underlined with the title, *The Sleep of Reason Produces Monsters* (16). Sinister creatures of the night torment the artist – presumably Goya himself – who lies slumped over his table, unable to work. Yet the real clue to Goya's print lies in its subtitle: 'Imagination abandoned by reason produces impossible monsters; united with her, she is the mother of the arts.' In truth, Goya's lynxes and owls are more absurd than terrifying, and far from being a statement of inertia, his print was intended as the frontispiece for one of his masterpieces, his series of bitterly satirical prints, *Los Caprichos*. It is not his own condition that is lamented, but the lassitude of

the corrupt and superstitious Spanish society on which, reinvigorated, he will turn in the succeeding plates. His written preface acknowledges his shocking and disturbed vision with pride: the artist who 'departs entirely from Nature' and puts before the public insights reclaimed from 'the darkness and confusion of an irrational mind' is sure to win 'high esteem'. Whether Goya really expected the same recognition for these prints as he had hitherto received as a court painter must be doubtful indeed, but he could at least venture a manifesto that would once have amounted to professional suicide. Few

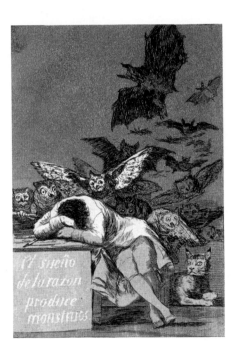

16
Francisco
Goya,
*The Sleep
of Reason
Produces
Monsters*,
plate 43,
Los Caprichos,
*c.*1798.
Etching and
aquatint;
21·6×15·2 cm,
8½×6 in

17
Francisco
Goya,
*Self-Portrait in
the Studio*,
*c.*1791–2.
Oil on
canvas;
42×28 cm,
16⅛×11 in.
Royal
Academy
of San
Fernando,
Madrid

Romantics, in fact, were to probe the inner psyche more deeply, and with more horrific results. Yet Goya, like Blake, also harnessed his art to a polemical critique of his time, and only at the end of his life, and perhaps not even then, was it pure indulgence. Through years of service to crown and state, Goya preserved a sense of independence that enabled him to observe and comment with a detached and dispassionate eye – whether in astonishingly frank portraits of his foolish and unlovely royal employers or in satires on the backwardness

of the church or the brutality of war. In the remarkable self-portrait that he painted in the early 1790s (17), he is at work on a large upright canvas, presumably a portrait, his eyes turned away from it towards his subject, which contemporary viewers might well have recognized as themselves. Bright sunshine floods from a large window behind the painter, and he wears a curious hat with candle holders on the brim, perhaps to

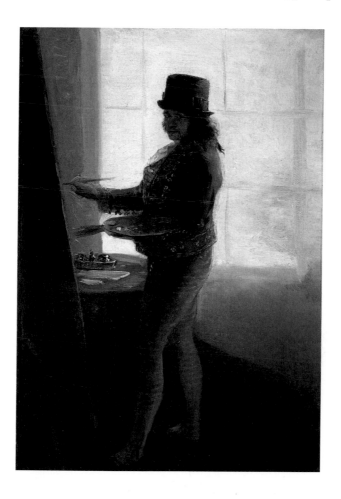

work through the night but also, surely, to mark the light that his own sharp perceptions will throw on a darkening world.

In old age, long since deaf and greatly disillusioned, Goya retreated to a private world, peopled with creatures of his imagination. Among the macabre images that haunt his late pictures and prints, one of the most mysterious is a city on a

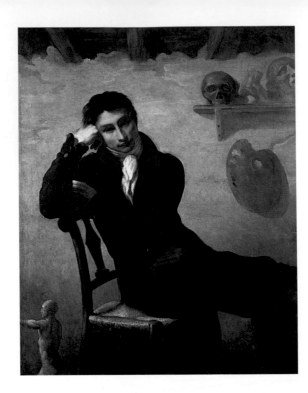

18
Artist
unknown,
*Portrait of
an Artist in
his Studio,*
*c.*1820.
Oil on
canvas;
147×114cm,
57⁷₈×44⁷₈in.
Musée du
Louvre,
Paris

19
**Horace
Vernet**,
*The Artist's
Studio,*
*c.*1820.
Oil on
canvas;
52×64cm,
20¹₂×25¹₄in.
Private
collection

rock, perhaps the symbol of his own withdrawal. It was of
Delacroix, years after his death, that a French critic wrote,
'Lonely upon a rock, high above all the noise of the universe,
his is the egotism of the gods. Let none require of him that he
should descend into the world of men.' If solitude was the last
resort of genius, it was also its precondition. The Romantic
artist often appears as a lonely figure, as in an anonymous
portrait by a French artist probably painted around 1820 (18).
That neither artist nor sitter are known (the picture used to
be thought to be a self-portrait by Théodore Géricault) only
adds to the poignancy of the subject. There are no growing or
living things in this bleak studio; only a skull, sculpted casts
and a palette that has seen little use. This is an artist whose
creative path seems to have led back into himself before it
has even begun, and it is tempting to read this, like Delacroix's
Sardanapalus, as an expression of the impotence and boredom
of post-Napoleonic Paris. But in fact this experience was widely
shared, and if this mysterious portrait seems to define a myth

of the studio as a place of tortured introspection, the picture
by Horace Vernet (1789–1863) of his own (19) shows it as a
crowded and social space, where work was more likely to be
interrupted by loungers and visitors, fencing matches and dog
fights, than by melancholy soul-searching. Yet in fact this too
is an image of frustration. The fall of Napolean had left the
once-fashionable Vernet bereft of subjects and patrons, and his
political views had excluded him from the Paris Salon of 1821.
He had been obliged to show in this very studio, including his
picture of it as an ironic symbol of the impasse to which he had
been brought.

Vernet's professional isolation – which was in any case tempo-
rary (his picture appeared in the Salon of 1824) – was forced
on him rather than chosen. In truth Romantic loneliness was
often more a myth than a reality – the product of philosophical
notions that held that the artist stood outside society, and that
such independence was vital to artistic discourse. As early as
the 1750s a teacher at the University of Frankfurt, Alexander
Gottlieb Baumgarten, had argued that art derived its value
from the artist's independent stance, and such ideas gained

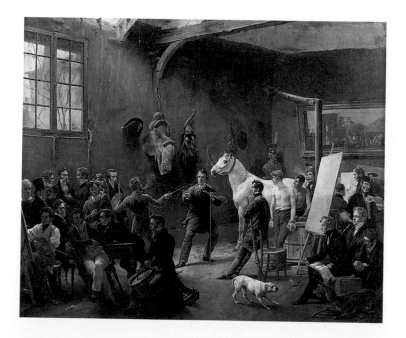

ground rapidly at the end of the century as Germans sought to
define a cultural identity of their own, distinct from that of
their aggressive French neighbour. The philosopher Johann
Gottlieb Fichte acknowledged the patriotic, nationalist moti-
vation for his own ideas when he contrasted those (Germans)
'who have within them a creative quickening of life' with those
(French) who have 'resigned themselves to represent only a
derivative, second-hand product'. The growing insistence
of German thinkers on autonomy as a deliberate spur to a
collective national resistence created obvious tensions between
individual and social concepts of expression. Fichte himself
concluded that only in a community of race or interest could
the individual realize his creative potential: 'the group alone
exists' was his definition of this apparent paradox. It was
together that the rebellious young philosophers who gathered
at his own University of Jena, or later in Berlin, developed their
notions of the individual as the model of the creative spirit.
This was also true of the the young German writers of the
1780s, who came to be known as the *Sturm und Drang* (Storm
and Stress) movement. It was in self-selecting clubs of like
minds that they stood against the world.

Both in their writings and, to a lesser but still significant extent,
in their own experience, the Germans invented some of the
most characteristic models of the Romantic artist's life. But to
the question of how the liberated, self-motivated artist should
relate to society they offered no single answer. For Goethe's
friend Wilhelm Heinse, the verdict was not at all: only by
abandoning all social, economic or moral norms could the
artist realize his destiny. His novel *Ardinghello* (1787) about an
imaginary Florentine painter was a hymn to unfettered genius.
The few characters that survive its blood-soaked plot retire to a
Utopian life of communal sexual freedom in the Greek islands.
This was fantasy as shock therapy, designed to reposition the
artist's role as the model for the liberation needed through-
out German society. But for Goethe, matters were not so
simple, and his own writings reflected a personal career that

saw the progressive reconciliation of his creativity with his responsibilities as a privy councillor in the court of Weimar. Usually regarded as a proponent of classicism, Goethe's main legacy to the Romantics was his famous novel *Die Leiden des jungen Werthers* ('The Sorrows of Young Werther', 1774). Though largely amorous, arising from his frustrated love for Charlotte who is betrothed to a friend, the hero's sufferings seemed those of all misunderstood youth, and his suicide a noble refusal to settle for less than his dreams. Goethe had

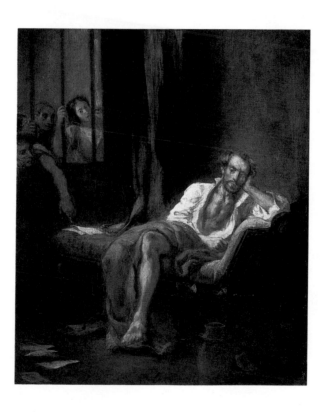

**20
Eugène Delacroix**, *Tasso in the Madhouse*, 1839. Oil on canvas; 60×50 cm, 23⅜×19⅝ in Oskar Reinhart Collection, Winterthur

soon rejected such a solution for himself, however, and turned instead to the history of art and letters for answers to his own predicament. In his play about the sixteenth-century Italian poet Torquato Tasso (1789), he identifies not only with the artist as victim of a doomed love and a patron's jealousy but also with his oppressors. For Romantics like Delacroix, Tasso, shut up in his Ferrarese prison, was to be the epitome of the artist-hero who suffers for his art and beliefs (20), but Goethe aimed to

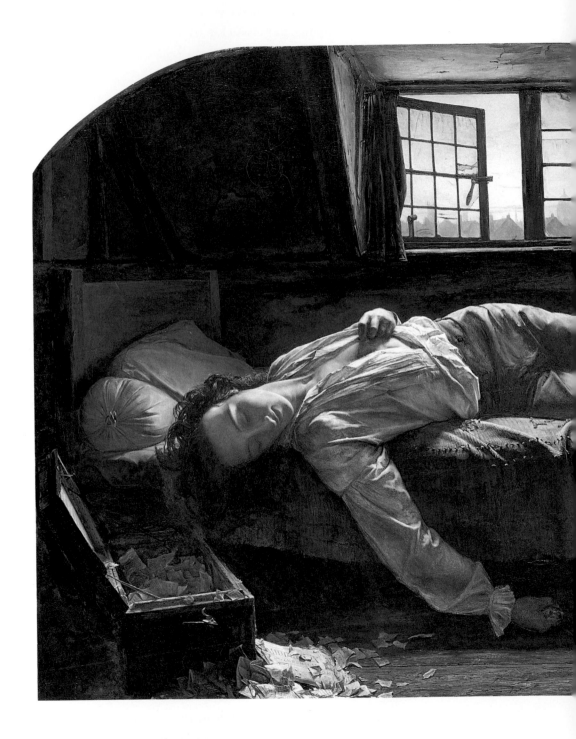

21
Henry Wallis,
*Death of
Chatterton*,
1855–6.
Oil on
canvas;
60·2×91·2 cm,
23³⁄₄×36⁷⁄₈ in.
Tate, London

explore more even-handedly the conflicts that had placed Tasso in crisis as those which all creative artists must confront.

Whatever compromises and sacrifices real life often demanded, the heroic refusal to 'sell out' became one of the proudest badges of the Romantic artist. Dying young saved many Romantics from compromise, and while others proudly committed economic or professional suicide rather than pander to a philistine world, those few who took their own lives found many admirers, even when they were less heroic than their martyrdoms might suggest. That the young English 'poet' Thomas Chatterton, whose suicide in London in 1770 was immortalized in a picture (21) by Henry Wallis (1830–1916), was actually a hack and forger hardly dented his tragic appeal as a misunderstood, unfulfilled genius. The jealous husband of his lover Kitty Bell represented the philistine obstructions all artists had to face, and the youth's decision to end it all became a noble refusal to submit. Perhaps his greatest appeal to the Romantics was that, in death as much as in life, he had created his own myth. Wordsworth, Coleridge and Keats all sang his praises, while for the French writer Alfred de Vigny, whose play *Chatterton* was a hit in Paris in 1835, his story was nothing less than 'the perpetual martyrdom and immolation of the poet'.

22
Ary
Scheffer,
*The Death
of Géricault*,
1824.
Oil on
canvas;
36×46cm,
14¹⁄₄×18¹⁄₈in.
Musée du
Louvre,
Paris

With rather greater justification, this was certainly the construction many of his friends put on Géricault's death at the age of thirty-three. This came about as a result of an infection following a riding accident, but the circumstances were never satisfactorily explained, and Géricault was thought to have neglected various ailments from which he was already suffering, and even to have attempted suicide. He had struggled to win artistic recognition, and there seemed a tragic inevitability about his end. It was fitting that the Salon of 1824 – often called the 'Romantic' Salon for including so many icons of the movement – should also have contained the moving memorial to Géricault painted by Ary Scheffer (1795–1858). Mourned by his friends, the painter lies on his

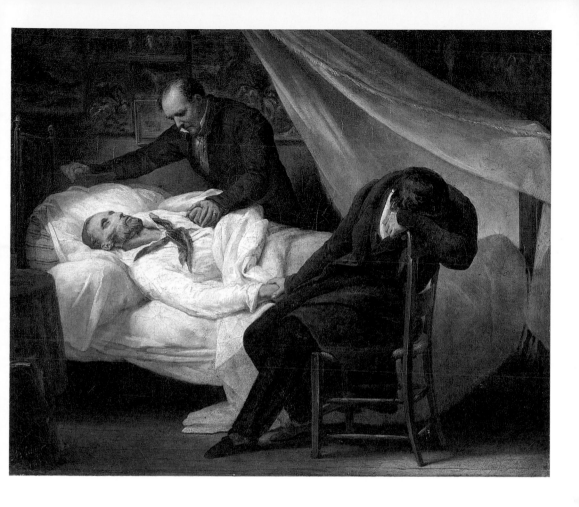

deathbed in his small room in the rue des Martyrs, his
favourite sketches and pictures on the wall above – indeed
a martyr to art (22).

The greatest example of the Romantic death wish, however,
was an imaginary creation. This was René, the eponymous
hero of a story by François-René, Vicomte de Chateaubriand.
There are few more Romantic characters than Chateaubriand,
nobleman, author, traveller and rampant egotist who, as he
declared, wrote ceaselessly of himself. As a young man he
attempted suicide, probably without intending to succeed.
Cast adrift by the Revolution, he fled to America, then
London where, poor and sick, he wrote *René* (1802), a fictional
self-portrait. Later he travelled to the Holy Land, seeking

escape in faraway places and the distant past. Though he returned to France, his antagonism to Napoleon left him an outcast, despite the growing fame of his writings. A diplomat under the Restoration, he returned to London, where he had once been an impoverished fugitive, as French ambassador. In his memoirs, written at that time, he nevertheless spoke of 'the groundless despair' in his heart. Restless, rootless, conscious of the instability of the modern world, Chateaubriand never quite reached the safe harbours of faith or belief that he sought, and there is an air of intense introspection in the portrait that Anne-Louis Girodet (1767–1824) painted of him in 1809, meditating on the ruins of Rome (23). In the still Italian air, Chateaubriand's hair is windswept (Napoleon mischievously said the portrait looked like that of a conspirator who had come down a chimney), hinting at the storms and passions that had lashed his best-known creation. In an equally striking picture by the German Franz Ludwig Catel (1778–1856), the shipwrecked wanderer René perches on a rock beneath a Gothic castle against whose walls waves surge and crash (24). World-weary and melancholy, René voyages in time and space just as the artist does in imagination, but finds no comfort and longs for death. Summing up his sad condition – 'infatuated with illusions, satisfied with nothing, withdrawn from the burdens of society, wrapped up in idle dreams' – a priest warns him, 'A man is not superior because he sees the world in a dismal light', suggesting that religion is his only hope.

As a portrait of the artist René is gloomy and deliberately extreme, but he soon acquired literary successors. It is no accident that Catel's René looks distinctly like Byron, for his closest literary relative is Childe Harold, Byron's own self-portrait. In his long narrative poem *Childe Harold's Pilgrimage* (1812–18), the hero travels across Europe and beyond to escape boredom and despair, haunted by dreams and fancies and dwelling on the past. Byron never tried suicide as such, but there can be little doubt that he expected to die in Greece when he enlisted with the Greeks in their war of liberation against

Turkey. His death at Missolonghi – though from cholera and not in battle – added him to the Romantic martyrology of art. Among his most passionate admirers was the Russian writer Alexander Pushkin, author of the verse novel *Eugene Onegin* (1823–31). His premonition of his own death in a duel is seen in the death of his fictional creation, Vladimir Lensky, shot by his rival in love, Onegin. Both Lensky and Onegin are self-portraits. Onegin is jaded, cynical and self-destructive. The more honourable and naïve Lensky writes poetry and has met German Romantic thinkers, and his loss only adds to the self-condemning despair of his killer.

Of course, Romantic longings for extinction have deeper roots than just an artist's professional frustration or yearning to be free. As Chateaubriand admitted, they could express a loss of faith. And for the pious German poet Wilhelm Wackenroder, such a waste of talent would have amounted to sacrilege. His own chosen guise, when writing historical tales about German art, was that of a monk. In his *Herzensergeissungen eines kunst-liebenden Klosterbruders* ('Heartfelt outpourings of an art-loving friar', 1797) he presented a vision of the artist's life akin to Blake's – the submission to a divine will that had endowed the artist not just with a special grace but also with responsibility. The creative gift was to be treasured in a spirit of humility, and Wackenroder cast himself, literally, as a worshipper rather than a practitioner. Though worlds away from Werther or René, Childe Harold or Onegin, Wackenroder's monk is no less a Romantic self-portrait. His musings had a liberating as well as a humbling effect – if artists are specially endowed by God, their expressions of his will are freed from criticism and analysis. And, since God's will is bound to express itself in different ways in different times and places, Wackenroder provides some of the earliest statements of the cultural pluralism urged by the Romantics. The author's monkish *alter ego* asks for 'Universality, Tolerance and Humanity' in the arts and declares, 'Whoever believes in *system* has banished universal love from his heart.'

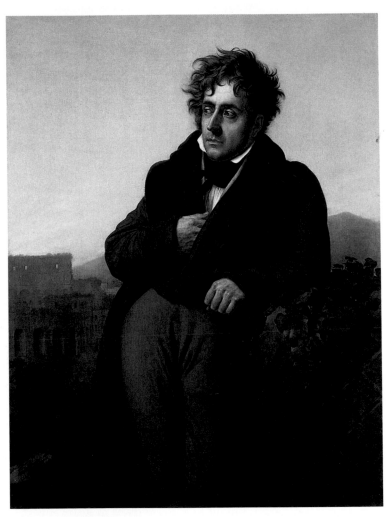

23
Anne-Louis
Girodet de
Roucy-
Trioson,
François-
René de
Chateaubriand,
1809.
Oil on
canvas;
120×96 cm,
47¼×37¾ in.
Musée
d'Histoire
et du Pays
Malouin,
St Malo

24
Franz Ludwig
Catel,
Night Piece
from the
Closing Scene
of 'René' by
Chateaubriand,
c.1820.
Oil on
canvas;
62·8×73·8 cm,
24¾×29 in.
Thorvaldsens
Museum,
Copenhagen

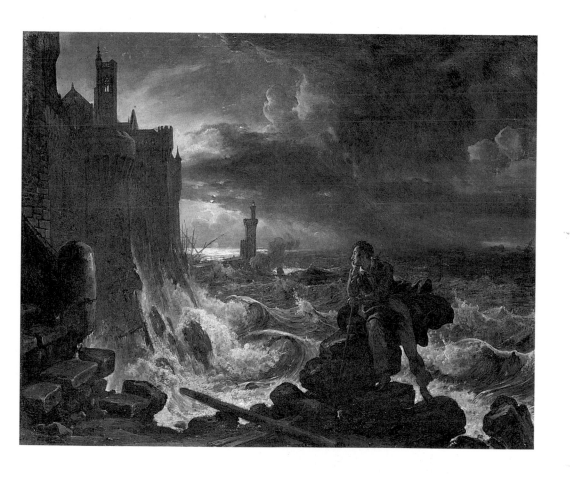

The implications of such statements were far-reaching. If all art was equal before God, criticism was rendered redundant, although perhaps few readers thought that far. For young artists in Germany and beyond, Wackenroder offered proof of what they already felt – that the teaching of art academies, with their insistence on rules and repetition, on the hierarchies of subjects and styles, and on the models of classical antiquity, was unnatural and wrong. Rebellion against such teaching became a rite of passage; by the 1780s there was hardly a promising art student who was not in some sort of conflict with it, especially against the protracted sessions of copying plaster casts of ancient sculpture. How far this rebellion went depended on the regime. In London the relatively recent foundation of the Royal Academy in 1768 meant that its methods had not become entrenched; complaints tended to be about the laxity of the teaching and discipline rather than their stringency. While the Academy's first president and greatest theorist, Joshua Reynolds (1723–92), was roundly condemned by Blake for his 'Opinion that Genius May be Taught & that all pretence to Inspiration is a Lie & a Deceit', the teacher whose inspiring personality made the greatest impression on the Romantic generation was Henry Fuseli (1741–1825), an early Romantic himself. In St Petersburg, by contrast, students had to wear the uniform of junior civil servants and were, in any case, often serfs who depended for their advancement entirely on the generosity of their aristocratic masters. Still more strictly regimented were German art schools such as those at Stuttgart or Düsseldorf – so harsh that it was known as Siberia – which were run as if their students were officer cadets. And it was in Germany that some of the most memorable acts of rebellion took place – acts which, in the Romantic mythology of the artist, were to assume near-legendary status.

There is no more vicious caricature of an academy of the period than the drawing made in the early 1790s by the Austrian Joseph Anton Koch (1768–1839) of his professors at the Hohe Karlsschule in Stuttgart (25), where, already inflamed with

revolutionary ideas, he found the strict regime maddening. In 1791, escaping as if from prison by a rope of twined sheets, he ran away across the French border, danced round one of the Trees of Liberty (then appearing everywhere) and, in a final gesture of defiance, gave himself the republican 'crop' by cutting off his pigtail, which he sent back to his enraged teachers. Disillusionment followed, and by 1812 Koch had so far turned against the French that he spent four years in Vienna to escape their occupation of his adopted Rome. His later stance as a landscape painter was to be notably conservative. But he told and embellished the story of his rebellion for the rest of his life, earning a place in the annals of artistic liberty. He had also, when first in Rome in the 1790s, been an admirer of an artist who had shown even more contempt for an academy – shockingly, while a teacher rather than a student. Even during his early studies at Copenhagen, the Schleswig-born Asmus Jacob Carstens (1754–98) had shown an independent streak, preferring to wander the cast gallery alone at night and make drawings from memory rather than in class. Appointed a teacher himself in Berlin, he departed for Rome on extended leave. When he overstayed his absence and was fired, he loftily replied that he belonged to Mankind, not to the Berlin Academy.

Koch and Carstens seem Romantic characters, if not Romantic artists, for their defiance struck an entirely new note and empowered others. This, to a far greater and more signifi-cant extent, was true of Jacques-Louis David, who was to have an inspiring influence on the Romantics through his life as much as his work. To contemporaries outside France, David represented an art of authoritarian, institutionalized Neoclassicism, in the portraits and history paintings that set the official style of the Revolution and the Napoleonic era; and as the founder of a school whose undoubted brilliance was totally subordinated to the service of the state. Nothing seems further from the individualism expected of the Romantic artist; yet in France he was seen very differently.

**25
Joseph
Anton Koch**,
*Caricature of
the Stuttgart
Academy*,
early 1790s.
Pen and
pencil
with wash;
35×50·1cm,
13³⁄₄×19³⁄₄in.
Staatsgalerie,
Stuttgart

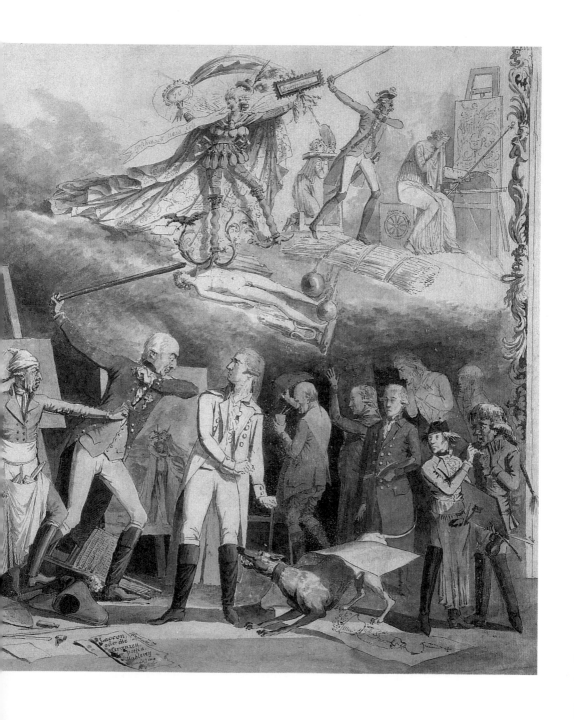

In fact David's own career had given ample evidence of his disdain for authority, and he encouraged the same in his pupils, spurring them to follow their own separate paths.

If little else were known of David, the self-portrait that he painted in May 1791 (26) certainly looks the image of a Romantic. Painted rapidly, with a spontaneous touch, it shows an excited, even wild young man, with freely curling hair, eyes aglow with almost visionary zeal. And David certainly had far-reaching plans which were far from the arena of establishment orthodoxy. Already intensely involved in radical politics, he had two months earlier presented a demand to the revolutionary Constituent Assembly for the dissolution of the French Academy – the culmination of prolonged opposition to its organization and methods. His objections were partly political, since the academy traditionally depended on the patronage of the crown, Church and nobility, but he was also opposed to the principle of academies, which seemed to produce only 'half-talents' and contained a 'destructive vice inherent in their fatal influence'. A few years earlier, while still himself a crown servant, he had encouraged his pupils to join him in defying the academic system and its royal master, testing official endurance to the limit. One of them in particular, the precocious Jean-Germain Drouais (1763–88), followed his teacher in being both brilliant and troublesome, refusing to submit to the 'martyrdom' of painting the Old Master copy that was expected of him after winning the academy's Prix de Rome, and insisting instead on a subject of his own. He had already rushed off to Rome, followed by David himself, before his award was properly confirmed, provoking the king's controller of the arts, the Count d'Angiviller, to rail against 'the youth of today, more confident than ever'. In Rome both artists painted pictures commissioned by the king, but not at all what he had expected: David's was the *Oath of the Horatii* (see 37), his pupil's the no less monumental classical composition *Marius at Minturnae* (1786).

26
Jacques-Louis David,
Self-Portrait,
1791.
Oil on
canvas;
64×53 cm,
25¼×20⅞ in.
Galleria
degli Uffizi,
Florence

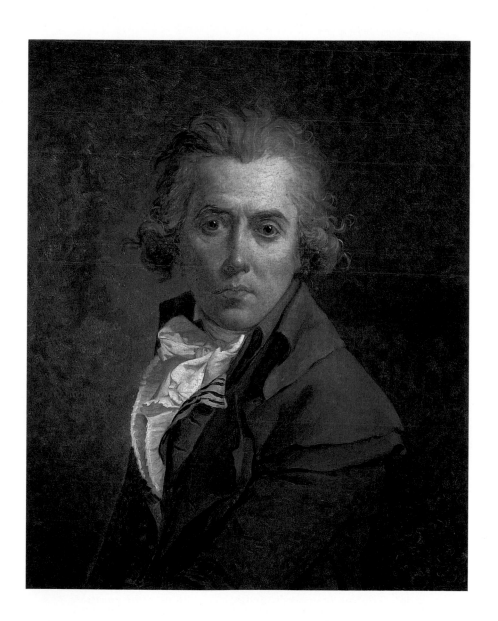

When David returned to France, Drouais remained in Rome
and dedicated himself to his work, isolated from his family
and friends. In 1788, aged just twenty-five, he died from a
combination of smallpox, overwork and self-neglect. Already a
legend in life, he became a hero in death. His young colleagues
in Rome erected a monument (27), initiating a cult that
blossomed further in Paris when a replica was installed in the

27
**Jean-Baptiste
Wicar**,
*Tomb of
Drouais*,
1788.
Graphite with
white chalk
on paper;
53·5×29·3cm,
21×11½in.
École
Nationale
Supérieure
des Beaux-
Arts, Paris

Musée des Monuments Français and David built a shrine in his
garden. The young genius's pictures, sent home to his mother,
were guarded by her in a state of perpetual grief. Of all the
legendary careers to develop under David's aegis, his was the
most affecting and mythic, since his memory remained frozen
in youth, and his pictures preserved David's style in its original

purity. But he was not the only celebrity among the master's pupils, who, as they grew in number, were seen to divide into distinct groups – 'revolutionaries', 'aristocrats' and others. Most were intensely loyal to David, who encouraged their diversity. But it was also in the great man's studio that one of the first truly secessionist groups of artists emerged in a reaction to his teaching. These were the 'Primitifs' or 'Barbus', so named on account of the beards they wore and their hankering for a pure evocation of ancient Greece. For a brief period, they withdrew to a Parisian convent where they wore ancient costumes, practised arcane rituals and took up vegetarianism. Monsieur David himself they taunted with such insults from the *ancien régime* as 'Rococo' and 'Pompadour'. If they regarded their teacher as out-of-date, it was because he was not out-of-date enough, and they were among the first to feel the revivalist nostalgia, the yearning for a lost world, that was to be so much a part of the Romantic condition.

While the Barbus' ideal was classical, for the young artists who bonded together in the Brotherhood of St Luke or 'Lukasbund' in revolt from the teachings of the Vienna Academy it was Gothic and medieval. Their heroes were earlier German and Italian artists whose style and spirituality seemed to belong to an age of faith, which they aspired to revive in their own work and in the monkish austerity of their lives. The numerous portraits they made of each other commemorate their fraternal commitment (see Chapter 4). What links these young French and German artistic brotherhoods was their recourse to the art of the past to nourish their own. But while the Lukasbund and their successors the 'Nazarenes' behaved as if they were themselves medieval artists, some of David's students, and artists like Delacroix who admired them, went further (as Goethe had done before them) in taking up the experiences of historical artists as subjects of their own. These tell us as much as portraiture of how they saw themselves and the artist's life. Thus Romantic depictions of earlier masters often concentrated on creative geniuses who had themselves

experienced suffering or eventual triumph. Delacroix, whose 1839 image of the imprisoned Tasso (see 20) projects a melancholy vision of the artist as hero-victim, a decade later made the same point in a picture of an anguished Michelangelo, brooding in his studio among his unfinished works (28). To emphasize the association of self and subject, the Renaissance master wears Delacroix's own neckerchief. As both poet and painter, a turbulent personality who had left a legacy of overwhelming masterpieces, Michelangelo was a fitting Romantic paradigm to whom Delacroix

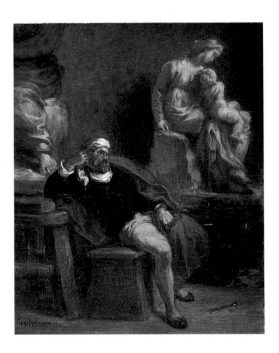

returned at difficult points in his own career, as after a critical savaging in 1833 when he sent a short biography of Michelangelo to the journal *Revue de Paris*, rebutting his own detractors by denouncing Michelangelo's. The master's great contemporary Raphael, supposedly cooler and more classical, and consequently admired by the academies, was often cast in a less favourable light by the Romantics.

By the early 1830s, such historical subjects were not only offered as examples of independent genius but were also

conveying more commercial messages – as if, alarmed at the isolation to which their acts of rebellion had brought them, artists craved a reconciliation with their audience. The French painter Jacques Stella (1596–1657), in prison in Rome as painted (29) by David's pupil François-Marius Granet (1775–1849), might seem another persecuted genius. In fact

28
Eugène
Delacroix,
Michelangelo
in his Studio,
1850.
Oil on
canvas;
40×33·5 cm,
15³⁄₄×13¹⁄₄ in.
Musée
Fabre,
Montpellier

29
François-
Marius
Granet,
Stella in
Prison,
1810.
Oil on
canvas;
194×144 cm,
76³⁄₈×56³⁄₄ in.
Pushkin
Museum,
Moscow

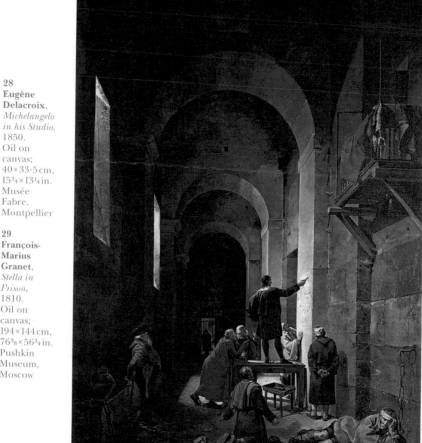

the Madonna and Child that Stella has drawn on his cell walls has attracted the admiration of his jailor and fellow inmates, and there is already the promise of hardship overcome. This was indeed to be Granet's own experience, not least as a result of the purchase of this picture by Napoleon's ex-empress,

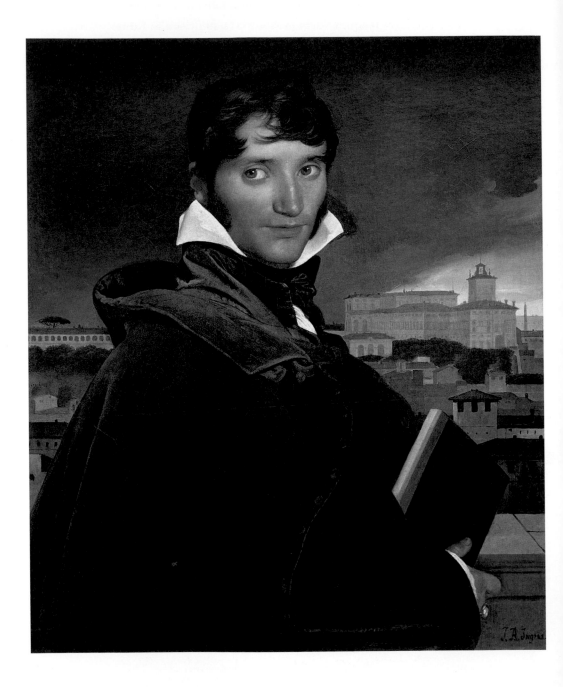

Josephine. Himself the subject of one of the most intensely Romantic of all artist's portraits, painted by his friend Jean-Auguste-Dominique Ingres while in Rome (30), Granet went on to enjoy great success for his historical and interior scenes. Another pupil of David's, Pierre-Nolasque Bergeret (1782–1863), went still further in acknowledging recognition, rather than lonely suffering, as the artist's proper destiny. Napoleon himself bought his influential picture *Honours Rendered to Raphael on his Deathbed* (31) from the Salon of 1806. Though Raphael had hardly been neglected in his lifetime, the picture conveyed an implied rebuke to any authorities inclined to ignore an artist's true greatness until too late. Bergeret went on to paint numerous other scenes

30
Jean-Auguste-Dominique Ingres,
François-Marius Granet,
1809.
Oil on canvas;
74·5×63·2 cm,
29³⁄₈×24⁷⁄₈ in.
Musée Granet,
Aix-en-Provence

31
Pierre-Nolasque Bergeret,
Honours Rendered to Raphael on his Deathbed,
1806.
Oil on canvas;
108×197 cm,
42¹⁄₂×77¹⁄₂ in.
Allen Memorial Art Museum,
Oberlin College,
Ohio

of genius receiving its reward, in which art is shown as a disciplined and profitable profession.

Although usually described as Romantic, on account of their evident nostalgia for the past, these pictures are ambiguous documents of Romantic attitudes to the artist – flattering as they do both artists and the powerful patrons who were wise enough to recognize their talents. Their sentimental narratives, often touching on doubtful or apocryphal incidents, reflect a new concern with humanizing personalities formerly known for their works. But as they often portray artists thoroughly assimilated into systems of patronage, they do not stress individualism for its own sake. Instead they represent a

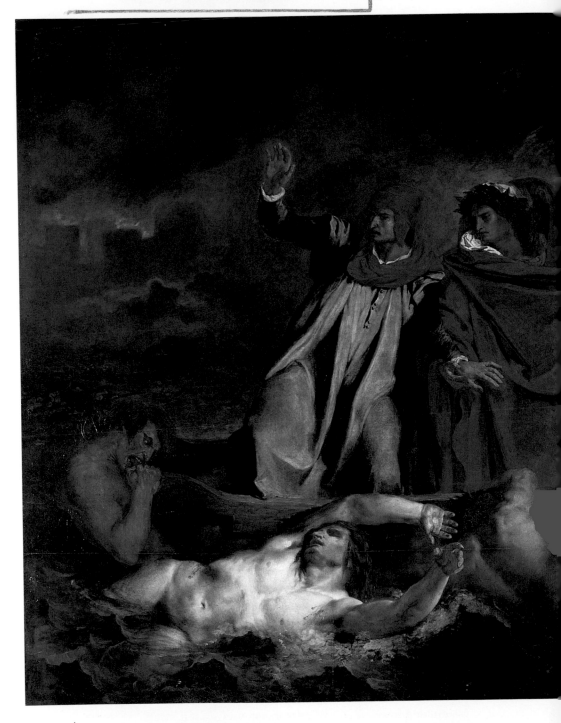

32
Eugène
Delacroix,
The Barque
of Dante,
1822.
Oil on
canvas;
189×246 cm,
74³⁄₈×96⁷⁄₈ in.
Musée du
Louvre,
Paris

movement towards reintegration, on the part of artists reacting against the more extreme manifestations of Romanticism. It is no surprise that such subjects found particular favour under the Bourbon Restoration that followed Napoleon's fall, and contributed to lively debates about the proper character and vocation of the artist taking place in Paris as the inevitable counterpart to the 'Battle of the Styles'. These issues were at the forefront of discussion in societies and clubs of painters, writers, musicians, collectors and critics – often then known as *cénacles* – such as the cultural salon hosted by Charles Nodier, librarian to the future Charles X, and frequented by Vigny and Victor Hugo, or the more radical *Grand Cénacle* started by Hugo in 1827 to explore artistic freedom further still. Painters, among them Delacroix, formed a *Petit Cénacle* of their own in 1830. At about the same time the journal *L'Artiste* was founded as an independent forum for new ideas. With the 1848 revolution, which brought the abdication of King Louis-Philippe and the short-lived Second Republic, it changed its name and politics to the *République des Arts et des Lettres*, and celebrated its history of defending the arts against external authority of all kinds.

Some who frequented these salons affected dandified or eccentric behaviour to express their disdain for patrician manners or bourgeois society, and it was now that the myth of the 'bohemian' life as somehow essential to artistic endeavour was born. But at this time of divided loyalties and values, there was still no consensus as to what the artist, past or present, really was, or how he or she should live, and even attempts to distinguish Romantic artists from those who were apparently not were far from reliable. Delacroix was uneasy with the Romantic label, but it was he who, in 1822, had submitted to the Salon a picture that in its bold composition, extreme emotion, exaggeration of pose, rich colouring and echoes of Michelangelo proclaimed all the essentials of the new movement. This was *The Barque of Dante* (32), surely the most powerful of all Romantic associations with historic genius.

A scene from Dante's *Divine Comedy*, it shows the medieval
Italian poet with his Roman predecessor Virgil crossing the
turbid waters of the Styx assailed by damned souls – genius
assaulted but transcendent. While at work on the picture,
Delacroix had been 'electrified' by passages of Dante read
out to him by a friend in the original Italian. His choice
of stimulus could not have been more significant, for
Dante, like Shakespeare, had long been admired for his
free poetic expression.

Delacroix was not consistent in his denial of Romanticism;
in fact he gave one of the best descriptions of it, which could
stand as the personal credo of the Romantic artist. 'If by
Romanticism one understands the free manifestation of my
personal impressions, my aversion to the models copied in the
schools, and my loathing for academic formulas, I must confess
that not only am I Romantic, but I was so at the age of fifteen.'
It remained for his friend, the landscape painter Paul Huet
(1803–69), to add a fourth equally vital ingredient, a liberated
yet inclusive attitude to his predecessors: 'we wanted to do
justice to all the great periods, even to David!' Like David
himself, Delacroix wanted not so much to destroy tradition as
to reinvent it in a way meaningful for himself. In this respect
his ideas were not so different from the historical synopsis
attempted in 1827 by Ingres in his great composition the
Apotheosis of Homer (33).

This assembly of great artists and writers of all ages gathered
to honour the ancient Greek poet before a classical temple
might look the epitome of hierarchical academicism. Its
formal composition and pale, sugary colours appear at the
opposite extreme to Delacroix's *Sardanapalus* (see 2), shown
in the same Salon. Delacroix's picture, like his earlier *Barque
of Dante*, seems far away from academic orthodoxy, while
Ingres's *Homer* looks like its ultimate endorsement. In the
current debates about who was Romantic and who was classical,
these pictures might seem easy to place. Yet they cannot be so

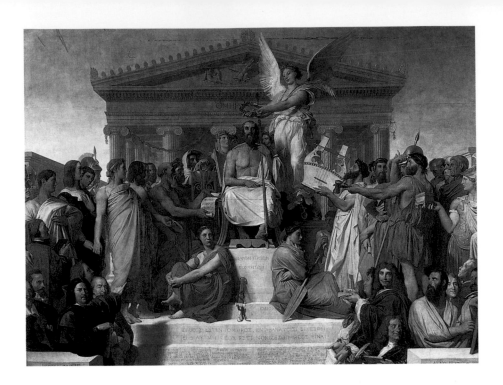

easily divided, for Ingres's picture too was conscripted into the
Romantic cause, by no less a person than Vigny, who, rather
anticipating his charitable view of the suicide of Chatterton,
saw Homer less as a triumphant exemplary figure than as
vulnerable in his blind old age, and the artists around him as
a Romantic lineage of 'glorious exiles, courageous victims
of persecution, of thinkers crazed by misery'. Intended by
Ingres as a ceiling decoration for the Louvre, the picture was
reconfigured by Vigny as an altar to tragic genius, peopled by
all the martyrs to art down the ages. There could hardly be a
greater demonstration of the Romantic principle that artists
must be judged by sensibility rather than style.

As in Paris, artists in London pondered the relationship
between past masters and their own creative identity. Even
more than Delacroix, Turner incorporated the styles and
subjects of the Old Masters into his own art; but his several
pictures of earlier artists tended to be frivolous – Rembrandt
intercepting a love letter addressed to his daughter; Raphael

33
Jean-
Auguste-
Dominique
Ingres,
*Apotheosis
of Homer,*
1827.
Oil on
canvas;
386×515 cm,
152×202 in.
Musée du
Louvre,
Paris

busier with his mistress than his art. That Turner was patently a sincere admirer of these painters enabled him to get away with such levity. For the painter David Wilkie (1785–1841) the heritage of the past was 'the great and leading question of modern art'. Wilkie too had learned much from the masters but had seen other artists prepared to rubbish them in order to promote their own interests. Some resented the longstanding preference for Old Masters among British collectors, others even feared the likely impact of London's new National Gallery, among them Constable who foresaw 'an end of the art in poor old England'. He feared that the connoisseurs who were prominent among its founders would use the public art collection to direct both art and taste. For Turner, by contrast, it was not an obstacle but an opportunity. It was to the National Gallery that he intended to leave a collection of his pictures, where, alongside the Old Masters themselves, he would claim his place at the forefront of the moderns. His works would be seen to move from respectful imitation of the past to the compelling, contemporary uniqueness of such pictures as his *Snow Storm* (see 5). The history of art, as it were, would end with himself. Of all the acts of self-assertion that Romantic artists committed, few compare with Turner's long-premeditated ambition for his pictures, setting his own terms for his place in history, while appearing patriotically altruistic.

If the National Gallery scheme fell through, Turner's pictures were to be placed in a gallery attached to a home for artists who had fallen on hard times. This alternative lends a particular weight to the moral of two pictures in which he reflected on contrasting extremes of the creative condition. In the same Royal Academy exhibition as his *Snow Storm*, he showed a pair of pictures, *Peace – Burial at Sea* (34) and *War, the Exile and the Rock Limpet* (35), both probably intended for his gallery. The first is a haunting tribute to Wilkie, who had died and been buried at sea off Gibraltar the previous year, on his way back from a visit to the Holy Land. The other, ostensibly of the exiled Napoleon on his island prison of

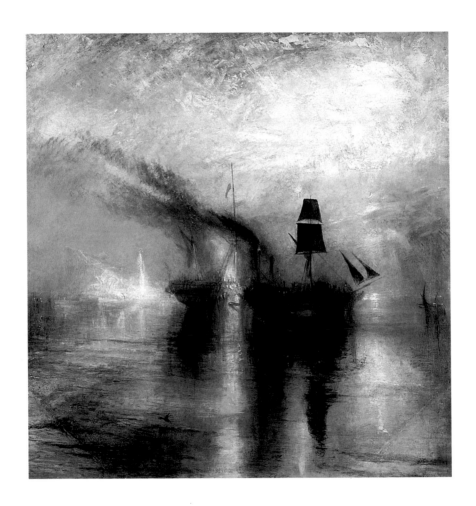

34
J M W
Turner,
Peace –
Burial at Sea,
1842.
Oil on
canvas;
87×86·5 cm,
34¼×34⅛ in.
Tate, London

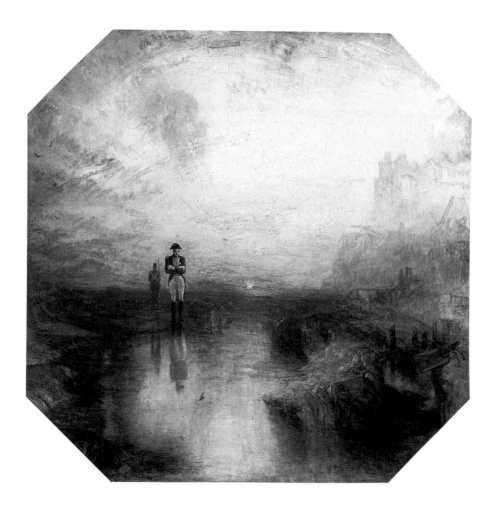

35
J M W
Turner,
War, the Exile
and the Rock
Limpet,
1842.
Oil on
canvas;
79·5×79·5 cm,
31¹₄×31¹₄ in.
Tate, London

St Helena, standing against a sky bloodshot as if with the carnage of his wartime campaigns, alluded to Wilkie's close friend Haydon. Haydon was famous both for his own pictures of Napoleon and for the egotism, paranoia and constant warfare with colleagues, critics and patrons that had by this time brought him to a state of professional exile. Wilkie, in fact, was among the few who remained loyal. *Peace* is more than a farewell to a friend: it signals approval for the exemplary harmony in which Wilkie had lived. Its companion piece is a warning and a rebuke. These images of war and peace, no less than Turner's *Snow Storm*, are about artists and the nature of art, lessons offered with the wisdom of one who knew himself to be among the greatest of the age and had taken steps to ensure that his own creative autobiography would include a constant reminder of the dramatic extremes of the artist's life.

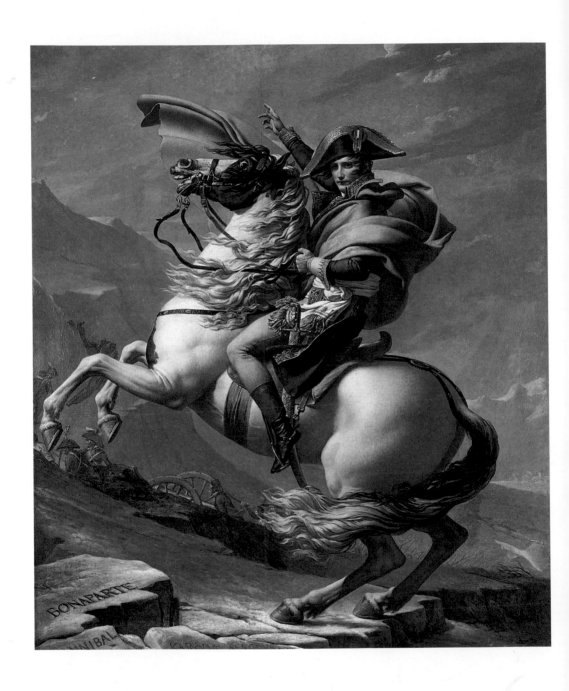

In 1846, just four years after Turner exhibited his *War* and *Peace*, Haydon was dead by his own hand – a martyr, as he saw it, to his art. Though it required both razor and gun to complete the grisly job, his suicide had been carefully prepared; among the papers he left at the scene was a note on his hero, Napoleon: 'I fear the glitter of his genius rather dazzled me.'

Even in an age of hero-worship, Haydon had been a pathological case, drawn to historical figures who, like himself in his own estimation, had striven for the greatest things but been cast down by lesser men. But he was not alone. Romantics were obsessed with heroes. Some, by direct engagement in the affairs of their turbulent time, took on a heroic status themselves – Byron by his death in the cause of Greek independence, or the German artists and writers who fought to liberate their country from Napoleonic occupation. But artists had also developed a near-heroic estimation of their own creativity, and saw in such great spirits the fulfilment they sought for their own genius.

Hero worship can seem one of the most irritating clichés of Romanticism, but it also leads us to the greatest of all Romantic paradoxes, and the one most responsible for the disabling disillusion and frustration that so many Romantics felt. For this was also the age that had heard the call for liberty, equality and fraternity, that believed in freedom, and was newly aware of the mass of the people. Works such as the *Lyrical Ballads* of Wordsworth and Coleridge (1798) honoured everyday life and used familiar language. As Wordsworth put it in a poem written in praise of a fighter for freedom, Toussaint L'Ouverture, who led a slaves' rebellion against colonial repression in Haiti, the age had heard the 'breathing of the common wind'. Toussaint was in fact a victim of Napoleon, shut up in Fort de Joux after

36
Jacques-
Louis David,
*Napoleon
Crossing the
Great Saint
Bernard Pass,*
1801.
Oil on
canvas;
260×221 cm,
102³⁄₈×87 ¹⁄ɪ.
Musée
National de
Malmaison

the French crushed his uprising, and Wordsworth was soon disillusioned with those who claimed to fight for freedom in France, as the Revolution descended into the Terror, and then into Napoleon's totalitarian rule and the slaughter of European war. If the hero was the ultimate manifestation of individual will, was it true that such will could be expressed only at the expense of the free will of countless others? And was not 'the holocaust of individuals offered up to "the People"', as the French writer Benjamin Constant put it in 1813, the tragic lesson of the age? For the Romantics, individuals all, these were their greatest dilemmas, and the implications for art were immense. Above all they transformed the art of history painting.

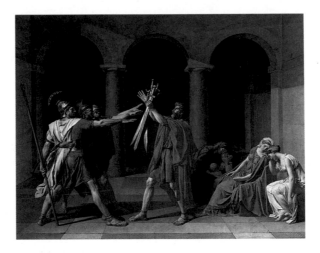

37
Jacques-Louis David, *The Oath of the Horatii*, 1784. Oil on canvas; 330×425 cm, 129⅞×162⅜ in. Musée du Louvre, Paris

38
David Wilkie, *Chelsea Pensioners Reading the Waterloo Dispatch*, 1818–22. Oil on canvas; 97×158 cm, 38¼×62¼ in. Wellington Museum, Apsley House, London

Long regarded as the highest form of pictorial expression, drawing its subjects from the biblical, mythological or historical past, history painting now confronted an extraordinary present. This required more than a change of subject matter and a new cast of heroes. It demanded a newly flexible artistic language, capable of merging history with reportage, the ideal and allegorical with the contemporary. These transformations are the subject of this chapter. Two very different pictures show how far-reaching they were. When David first showed his *Oath of the Horatii* (37) in Rome in 1785, his fellow artists threw down a carpet of flowers before it. An even greater

sensation followed its exhibition in Paris. In London's Royal Academy in 1822, so enthusiastic was the crowd that pressed around Wilkie's *Chelsea Pensioners Reading the Waterloo Dispatch* (38) that rails had to be put up to protect it. The first of these pictures was soon interpreted as a harbinger of the commitment and sacrifice demanded by the French Revolution; the second celebrated the end of the Napoleonic Wars. They could hardly be more different. The *Horatii* belongs mainly to the story of Neoclassicism, *Chelsea Pensioners* to Romanticism. The process that led from one picture to the

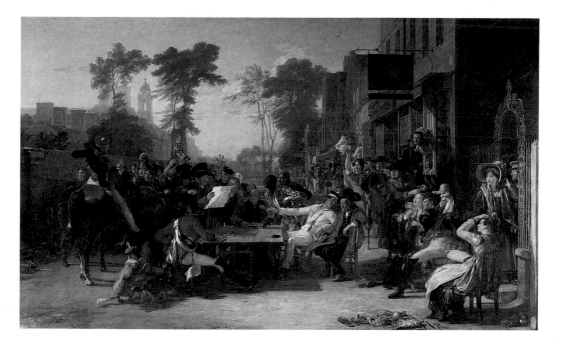

other is complex, but fundamental to it are the changing concepts of the hero, of the individual and of the crowd, that accompanied the Romantic movement and contributed so much to its art.

Both pictures were commissions ordered at the highest level. David, the most promising history painter of his generation, was commissioned by the French crown; Wilkie had his order from the Duke of Wellington, the victor of Waterloo. Both artists responded to their task with exceptional freedom. David,

without official permission, changed his subject – ceasing, as he said, to make a picture for the king and instead painting one for himself. He came up with an original variation on his classical theme and a design that, at a stroke, reinvented the language of historical art. Wilkie, who was merely asked by the duke for a picture of old soldiers outside a public house, raised his game to produce his own masterpiece, a work that at once celebrated his patron's victory and brought this decisive contemporary event within the realm of familiar experience by depicting the impact of its announcement on a crowd in a London street. Painted for a hero, it was a picture for the people.

Despite the radicalism of its austere design, based on the relief decoration of antique sarcophagi, and the extreme restraint of its emotion, David's picture fitted a recognized category. It was a history picture designed to inspire and instruct – what was known as an '*exemplum virtutis*'. An event, a small cast of characters, had been chosen from ancient history to serve as an example to the modern viewer. From Pierre Corneille's classic play *Horace* (1640), David had taken a simplified version of the story of the three brothers Horatii, who had defended Rome against raiders from the adjacent kingdom of Alba, and offered themselves for a symbolic combat with three other brothers, the Curiatii. The idea of the oath may well have been his own invention, and gave his picture its dramatic dynamism. Before their father, who clutches their swords, the brothers pledge their loyalty, while their womenfolk and children bow their heads, apprehensive of sorrow to come. The huge canvas proclaimed the virtues of heroic sacrifice and civic loyalty above family and self; the brothers are welded into a single instrument of national purpose by the unity of their pose and gesture. They are ideal beings, and their message when David painted them was one of patriotism. Had the Revolution not occurred, his picture would not have acquired the popular meaning it has never entirely lost. It was with hindsight that it seemed so prophetic, and became an emblem of allegiance to the French Republic.

Unlike David, Wilkie mounted more than a stylistic challenge to his audience's expectations. Known as a narrative painter, he took on a subject of modern history – *the* subject of the moment for his London public – but not in a manner recognizable as a history painting. His main hero, Wellington, is absent; he is of course still in Belgium, where the battle of Waterloo has just been fought. News of the battle, brought by the dispatch rider on the left of the picture, has been passed to an eager Chelsea Pensioner (a resident of the old soldiers' home, the Royal Hospital, Chelsea, in the background). A veteran of former battles, the old man scans it by the table, and must have read it aloud to the assembled mass of comrades, bar loungers and passers-by. Thus the key event is shared through a modern crowd; all can recognize something of themselves and their own feelings in the reactions aroused by the news. Wilkie's picture is as tightly structured as David's, in a pattern that at times seems more than coincidentally parallel to his design. The rider's legs, straddling his horse, echo the Horatii; the white sheet of the dispatch has the same focal impact as their swords; the old seated Pensioner who receives its content with equanimity, as if nothing else could properly be expected, is the counterpart of the brothers' father; the group of women and children on the right substitute their joy for the Roman women's fear; and behind them all, the arching trees close off the background like David's row of columns. These comparisons, however, serve only to emphasize the far greater differences. In place of David's economy and restraint, a lesson in themselves of behaviour as well as style, Wilkie offers variety; instead of the few exemplary types from a classic text, or any dominant personality, there is a modern crowd with whom the Academy visitors could identify.

It had been the Revolution and the Napoleonic Wars that had done most to bring about the sense of mass engagement with the tide of great events that is the real subject of Wilkie's picture. The Revolution was a creation of the people, driven from below rather than above; the succeeding wars had

involved unprecedented masses across the globe. There was a new sense of participation; and Wilkie had in fact sounded a warning against its effects in one of his earliest pictures, *Village Politicians*. Painted for Lord Mansfield in 1806 and based on a poem first published in 1795 at the height of post-revolutionary alarm in Britain, it showed village radicals gathered for seditious and whisky-fuelled rantings, the results of which would be their own alcoholism and the downfall of their families. Paradoxically, the popular impulses castigated in this very conservative work would prove to be greatly to Wilkie's advantage. He went on to become as much an establishment painter in London as David was in Paris, but was appreciated for his pictures of common life. His patrons and large popular audience could soon believe themselves more truly the defenders of liberty and human rights than Napoleon's military dictatorship. Most of the subjects that made his reputation were fictitious, but events themselves were meanwhile creating contemporary heroes and martyrs, who demanded a new expressive language. The implications for history painting, as well as portraiture and literature, would be immense, but it was in dealing with the present that the most profound artistic revolution took place.

Not surprisingly, it was in France that painting began to march most closely in step with political ideals. For centuries the main object of the history painter had been religious subjects. David, who as a young man reluctantly painted them to order, took a significant step in transferring attention to classical subjects, which in an age still steeped in classical education seemed more universally relevant. He would soon harness the language of 'high art', or what the British called the 'Grand Style', to modern subjects that were more relevant still. But David was not the first to employ the language of religious art in the portrayal of secular images – even contemporary ones. Fourteen years before David painted his picture, the American-born history painter Benjamin West had exhibited his *Death of General Wolfe* (39) in London. In this the mortally wounded

39
Benjamin West,
The Death of General Wolfe,
1770.
Oil on canvas;
152·6×214·5 cm,
60×84½ in.
National Gallery of Canada, Ottawa

British general lies slumped, surrounded by his officers like a dead Christ. And this was not the greatest of West's innovations; as he pointed out, Wolfe had died in 1759 on the Heights of Abraham near Quebec 'in a region of the world unknown to the Greeks and Romans, and at a period of time when no such nations, nor heroes in their costumes any longer existed'. Obvious as this may now seem, it had further implications for a cultural climate that preferred to see even contemporary events of an inspiring kind treated in the 'universal' language of classical art. Documentary details such as costume were considered by academic theory to distract from the requisite high moral tone, but West dressed his soldiers in their uniforms like portrait figures, reserving some token 'classical' nudity for a fictional Native American, who at once locates the event to North America and meditates on a tragic loss.

Wolfe had died in the cause of British colonialism, rather than that of liberty soon to be taken up in France. But it should be no surprise that David was among West's greatest admirers, for it was not long before he was confronting the task of finding an appropriate pictorial language for the new heroes of the Revolution. An early convert to the revolutionary ideal, David never afterwards departed from it. The passionate commitment he had brought to his art he also brought to politics; and it is with him that the enduring connection between art and the *avant-garde*, between paint and politics, begins. It was he above all who gave the French Romantics their partisan zeal, their urge to plunge into the contemporary epic – which contrasts so strongly with the movement's escapism and nostalgia. He took an active part in revolutionary affairs, as a signatory to the death warrant of his former patron Louis XVI, then as the revolutionary government's arts minister in all but name. He designed much of the apparatus of the fledgling Republic – uniforms, public ceremonies, funerals, pageants, coinage and memorial medals. He dismantled the Academy that had trained him for royal service and trained a new genera-tion for the service of the state in his own studio. And

he applied his huge talent and commitment to immortalizing his turbulent times.

By 1792 David could write, 'the history of no other people offers anything as grand or sublime ... I have no need to invoke the gods or myths to inspire my genius'; his theme would be the glory of the French nation. He began by heroizing the great men whose ideas had brought the Revolution into being, then the martyrs who fell as it took a bloodier turn. In 1790 the great Neoclassical church of Sainte-Geneviève in Paris had been completed to the designs of Jacques-Germain Soufflot (1713–80), just in time to be declared redundant as the revolutionary authorities dissolved its accompanying abbey as part of their dismantling of Church property. Their secular ideals, however, attracted them to Soufflot's vast basilica, which had been designed to resemble a pagan temple. It was transformed into the Panthéon, a burial place for those who fell in 'the great age of French liberty'. An art historian and critic, Quatremère de Quincy, was entrusted with adapting the building – his main intervention being to block up a number of windows so that the interior was plunged into a suitably sepulchral gloom. David designed most of the heavily symbolic festivals that accompanied the transfer of the new heroes' remains. Just as the idea of a pantheon for the great harked back to ancient Rome, these events were wholly classical in design, but they do not belong – any more than David does himself – entirely to the story of Neoclassicism. For they aroused emotions, loyalties and desires that gave onlookers a new sense of themselves and of their destiny.

The first of these ceremonial transfers, in July 1791, was of the writer Voltaire. Though this great philosopher of the Enlightenment had died in 1778, the Revolution's leaders worshipped him for the personal convictions – human rights, tolerance, rationalism – that shone through his writings. They claimed him as their ancestor, and it was as such that his body was exhumed and paraded through Paris to the Panthéon on a

magnificent carriage, attended by classically draped mourners, like some ancient hero brought home from war. Three years later similar honours were awarded to the writer and philosopher Jean-Jacques Rousseau, whose ideas of education, the natural man, the 'noble savage' and the 'Social Contract' made him an ancestor of Romanticism itself. While Voltaire's effigy had been crowned by an allegorical figure of Immortality, the nature philosopher's was carried seated under a tree.

These pre-revolutionary giants were manifestly admirable men of peace and heroes for all. But similar festivities were more controversially designed for the supposed heroes of the Revolution itself, of whom David also painted commemorative pictures. The first was Michel Le Pelletier de Saint-Fargeau, an aristocratic deputy to the revolutionary Convention who had voted for the king's death and who was himself murdered by a former royal guard the day before the king was guillotined in January 1793, thus providing a convenient victim of reaction whose martyrdom would distract from the trauma of the regicide itself. The second was Jean-Paul Marat, a radical deputy, writer and 'friend of the people', also murdered – this time by the treacherous Charlotte Corday. David's pictures flanked the President's rostrum in the former theatre where the Convention met; both portrayed their subjects nude, their wounds visible like the stigmata on the dead Christ, but they were otherwise very different. That of Le Pelletier showed the corpse more or less as David had arranged it for the funeral procession, with a sword suspended over it to symbolize his murder, and pointing to his vote for the king's death. Such a literal rendering was impossible in the case of Marat, who had been stabbed in hot July weather when his body could not be long preserved. Moreover, there were reservations about too public a ceremony for such a hero of the people, lest it provoke a cult that could eventually turn against the revolutionary leaders themselves. Accordingly David, who sincerely admired Marat, painted him 'at his last breath', in a context at once noble and openly pathetic, inviting both admiration and

sympathy (40). His wound still bleeding, he lies in the bath he often used to ease a skin disease. He has been working – of course for the good of the people. Built around the partial cross of bath and wooden box, on which David's signature and dedication are inscribed as if he were the donor of an altarpiece, the composition is a secular *pietà*, inescapably evoking memories of the dead Christ. Opposing instruments play on the viewer's feelings: the murderess's knife, Marat's

40
Jacques-Louis David, *Death of Marat*, 1793. Oil on canvas; 165×128 cm, 65×50½ in. Musées Royaux des Beaux-Arts, Brussels

quill pen; her false letter pleading for her intended victim's help, his own promissory note to a war widow, enclosing a banknote. Yet as much is concealed as revealed – and not merely most of Marat's stunted and diseased body. Corday had not used a begging letter but another, offering information on fugitives disloyal to the Convention. These relative moderates had been expelled from its ranks as more extreme factions

took over, urging the violent purges soon to be known as the Terror (of which Marat was an enthusiastic supporter). David's picture was a masterpiece of manipulation, turning a ruthless and in the end heartless political idealist into a near saint, striving at all hours to ease the distressed, and in its play with the emotions it broke the constraints of the classical tradition.

'Only the French', declared the Convention's leader, Robespierre, 'have thirteen-year-old heroes.' This distinctly dubious compliment referred to David's third and last revolutionary martyr, the boy Joseph Bara, who disguised himself as a hussar in order to accompany Republican troops against rebel forces. News of his death reached Paris late in 1793, and under pressure to acknowledge popular feeling and protect his government, Robespierre insisted on full Panthéon honours for the boy. The now customary Davidian combination of parade and picture was set in train. This celebration of selfless sacrifice coincided with Robespierre's adoption of the tactics of Terror by murder and guillotine. Within six weeks in 1794, 1,300 were dead – their own sacrifice, it was claimed, returning society to the state of childlike purity that Bara had supposedly represented. The boy whose last

words had reportedly been 'Long live the Republic' was also exemplary in his filial loyalty to his mother, to whom he had supposedly sent his pay. State and family were intertwined through the interdependence of mother and son, and while Robespierre now also proclaimed a sinister state of 'Supreme Being' or social perfection that would follow the cleansing violence, the boy was brought forth not just as a martyr but as an icon of collective rebirth. For his triumphant arrival at the Panthéon, David planned a larger procession, in which bereaved mothers would carry the remains of their own lost children, immortalized by banners bearing their portraits. But this was abruptly cancelled when, in a final twist, the Terror rebounded on Robespierre himself. Having threatened suicide, and been joined by David with the famous words 'If you drink the hemlock, I will drink it too', Robespierre went instead to the guillotine while the painter went to prison. What remained of this bloody episode, however, was the picture of Bara that David had already painted (41) – an extraordinary and haunting image of a pubescent youth. Naked and almost neutered by a twisted posture that conceals his genitals, yet undeniably homoerotic (in deference presumably to Robespierre's deepest feelings), he clutches his tricolour cockade to his bayonet wound as if it were a crucifix. Once again, sentiment and sensuality contribute to a quasi-holy image.

41
Jacques-
Louis David,
*The Death
of Bara*,
1794.
Oil on
canvas;
119×156 cm,
44⅞×61½ in.
Musée
Calvet,
Avignon

In the intensity of its emotion and its reductive simplicity, this picture breaks the bounds of academic Neoclassicism. Where could David go from here – once, that is, he was out of prison? His confinement was short, and he seems never to have been greatly at risk from the Terror; such was his prestige that he was indispensable, and he was adept at moulding himself to the convolutions of revolutionary politics. Under the succeeding government of the Directory, he turned back to ancient history for a classical subject intended to symbolize reconciliation – the Sabine women intervening to stop a bloody conflict. He began sketching it in prison and finished it in 1799, the year in which

Napoleon Bonaparte overthrew the Directory by a military coup. In common with much of the nation, David was no doubt alarmed by the brilliant and ambitious commander who had made his reputation with campaigns in Italy and Egypt. But Napoleon, like him, had been imprisoned after the fall of Robespierre, and seemed to offer the best hope of firm government while preserving the essential principles of 1789. There could be no return to the horrific blood-letting of the Terror when the Revolution had consumed itself. Far from winning their rights, the people had been ruthlessly manipulated for political gain, and their self-proclaimed representatives had turned on each other. Napoleon was the best hope for David too: during his years of power, as First Consul and, from 1804 until 1815, as Emperor, he was the painter's principal patron.

No single person exemplifies the Romantic hero-genius better than Napoleon. And if he did not create these types, his reputation both depended on them and brought them to their full flowering. He was the ultimate self-made man, the absolute image of wish-fulfilment – the individual who came from nowhere to realize an extraordinary destiny. At first he incarnated the twin ideals of devotion to the Republic and of the military code of honour. To the people, he was an inspiring force, making them believe they could do great things. The campaigns he led, the prospect he held out of a European empire, were the vital springs of his magic. He personified the Revolution's ideal of individual empowerment, and he maintained his hold as long as he kept his mystique as its saviour. Yet he was also a dictator driven constantly to extend his power. It was outside France, among liberal sympathizers of the Revolution such as Blake, Wordsworth or Beethoven, that his actions were first seen as a betrayal. For the French, the Napoleonic project later began to crumble with military failure and an unwillingness to continue with the sufferings that the war entailed. Yet Napoleon exerted an extraordinary fascination on friends and foes alike, which was far from ended

by his defeat and exile. All this is reflected in the art of the period. To Napoleon's years of glory belong the heroic images of the man himself, or conjoined with the heroes of history or myth. Even these are rarely conventional martial images, however: more often he appears as a man of feeling, compassionate before the wounded or sick, working for the good of his subjects, even apprehensive on the battlefield. As the tide began to turn, other faces appear – ordinary soldiers, reluctant conscripts, anxious families, wounded veterans, Parisian beggars; faces from the crowd who in the end could take no more. These, in their way, were the new heroes and martyrs. Yet it was actually Napoleon's fall that brought about his real apotheosis as a Romantic hero, the focus of the Romantics' love of lost causes.

Though Napoleon appointed David his official painter, effectively the head of his propaganda machine, the artist never recaptured the immediacy of his first revolutionary pictures. Moreover, it would be his pupils who outstripped him in the power and vigour of their contemporary reportage. It was the most brilliant of them, Antoine-Jean Gros (1771–1835), who painted the seminal image of the young Napoleon – eager, resolute, the leader of his troops but not yet the all-powerful dictator. His *Napoleon at Arcola* is an image of military determination rather than political authority. Napoleon's first Italian campaign in 1796 was ultimately a great success, but his troops, originally only a diversionary force, were poorly fed and undisciplined. He rallied them by promising the rich provender in the enemy's stores with the famous words, 'It's up to you to conquer them. If you want to, you can!' But at Arcola they had not followed him at once, fearful of murderous fire from the other side. Gros – then living in Italy – had witnessed it himself, and painted a bold sketch of the commander looking back, his lips pursed with displeasure at their reluctance (42). Gros was to be far the subtlest of Napoleon's propagandists, and this early portrait was a silent rallying cry. By the time a more finished picture appeared in the Salon of 1801, however,

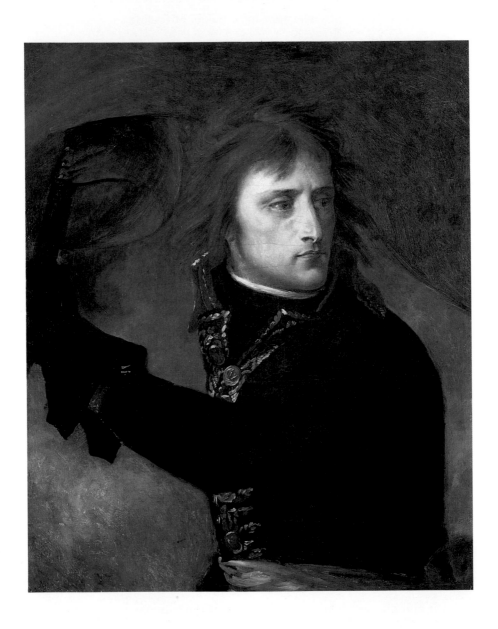

his hero's authority was confirmed, and there is neither anxiety nor actuality about his master David's *Napoleon Crossing the Great Saint Bernard Pass* (see 36) finished the same year.

This traverse of an Alpine pass had been a defining point in Napoleon's second Italian campaign. In May 1800 a French force dragged itself through the last of the winter snows, hauling its cannon on sledges, before descending to defeat the Austrians at Marengo and reclaiming north Italy. The crossing itself was a nightmare, and victory was eventually snatched from the jaws of defeat. But Napoleon's dispatches to Paris were skilfully edited, and it was he who suggested the concept of David's picture. Having actually crossed the pass in the rearguard of his army, on a mule led by local guides, he was instead portrayed at their head, on a rearing horse, confirmed in his authority by comparison with the great figures of history who had also passed this way – on a rock Bonaparte's name is inscribed together with those of Hannibal and Karolus Magnus (Charlemagne). David does allow glimpses of the toiling troops in the background; indeed it was in their collective conquest of nature that this epic crossing made its greatest contribution to Napoleon's legend. When in 1806 a critic, P J Chaussard, reviewed another artist's more literal picture of it in the current Salon, he praised the troops' ability to 'ward off the very elements, and, in a word, to transcend nature itself'. And one man had made this possible: 'A hero, far above all those of antiquity … has dared to attempt this crossing … His comrades-in-arms, electrified by his genius, excited by his courage, follow him joyfully … Under such a chief nothing is impossible to Frenchmen.'

Wisely, Napoleon did not restrict such praise to himself but continued to extend the gallery of Republican heroes begun by David. Crucial in securing his success in Italy had been the 'lion of Marengo', General Desaix, who had turned the battle by a surprise attack on the Austrians during which he lost his life.

42
Antoine-Jean Gros,
Napoleon at Arcola,
1796.
Oil on canvas;
73×59 cm,
28³⁄₄×23¹⁄₄ in.
Musée du Louvre,
Paris

Napoleon commissioned the Lombard painter Andrea Appiani (1754–1817) – who like many liberals in Milan had welcomed the French – to create a suitable memorial (43). In Appiani's subtle conception, the general is still very much alive, reading a service order; only his profile pose (a convention for pictures of the dead) and the distant allegorical figures of Time pursued by Death suggest a posthumous portrait. Rather than Italy, it is his former service in Egypt, where he had earned his nickname of 'Just Sultan', that is acknowledged by the two turbaned

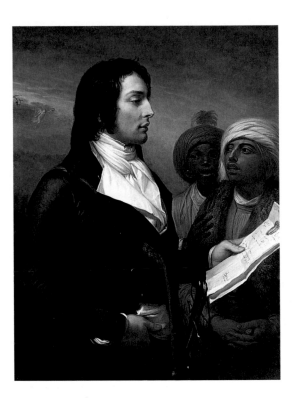

43
Andrea
Appiani,
*General
Desaix*,
1800–1.
Oil on
canvas;
115×88 cm,
45¼×34⅝ in.
Musée
National du
Château de
Versailles

Mamluks, and he appears in a peaceful role, with sword sheathed and in civilian clothes. Thus Napoleonic aggression and loss of life are occluded by other memories and myths, and the promise of glory. Similar processes were at work in other pictures too.

Farewell to the gods of Greece and Troy, hail to the heroes of the clouds who descend to converse with their earthly brethren. These, in sum, were the sentiments of the poet Creuze de

Lesser, reading to a meeting in honour of Napoleon in 1801. The title of his poem alluded to the mythic epic of Ossian, by now a cult throughout Europe. Its melancholy verses, set in a fog-bound, moonlit North and recounting the exploits of Fingal and his son Ossian, had been compiled by a Scot, James Macpherson, and published in the 1760s. This saga – actually a forgery – was much admired by Napoleon, who hung a portrait of the bard in his wife's library at Malmaison, and founded a Celtic Academy to try to establish a Celtic-Breton ancestry for him. But for David's student Girodet, Napoleon's enthusiasm provided an opportunity to acknowledge those who had already died for the ultimate hero – his patron – while distancing their loss from familiar reality. Such acknowledgement was due, but by locating it in the clouds of a mythic Elysium, the sacrifice lost much of its sting.

Desaix himself was among the ghosts of French heroes in a work (44) painted in 1802 by Girodet as one of a group of pictures commissioned for Malmaison. This complex allegory alluded to the current political scene, though it was soon overtaken by events. Its full title described how the shades of the French heroes, 'led by Victory, arrive to live in the aerial Elysium where the ghosts of Ossian and his valiant warriors gather to render to them in their voyage of immortality and glory a festival of peace and of friendship'. Girodet painted the picture at a time when there was hope of negotiating an end to the Napoleonic Wars, but the British were still resistant. At the heart of the picture Ossian himself embraces Desaix, and General Kléber, killed in Egypt, assists Desaix to support a trophy from his own service there while also greeting Fingal. The Ossianic Maids of Morven welcome the French, while a Victory figure hovers above, offering a caduceus, symbol of peace, to the Celts and symbols of their conquests to the French. Among the latter it is not only their leaders who are remembered: representatives of other ranks – hussars, sappers, dragoons, chasseurs – are also marked by their various uniforms.

44
Anne-Louis
Girodet de
Roucy-
Trioson,
Ossian
Receiving
the Ghosts
of French
Heroes,
1802.
Oil on canvas;
191·8×184·1cm,
75½×72½in.
Château
National de
Malmaison

45
Jean-Auguste-
Dominique
Ingres,
The Dream
of Ossian,
1813.
Oil on canvas;
348×275cm,
137×108¼in.
Musée Ingres,
Montauban

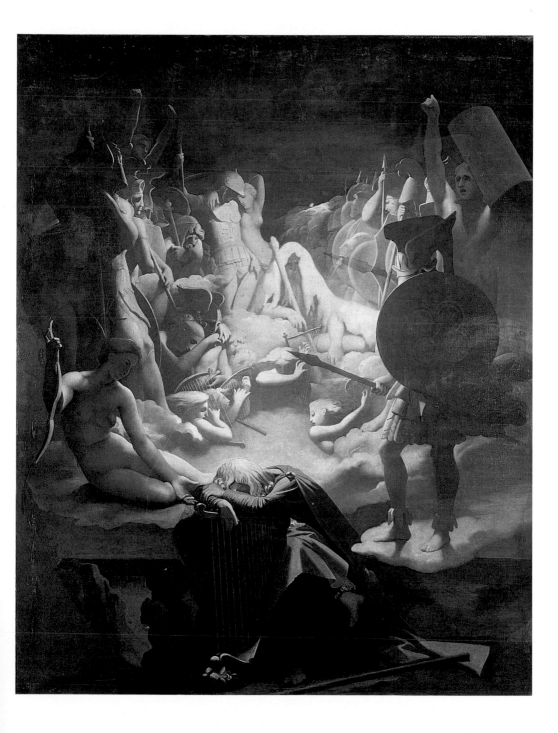

Rather than being conscience-stricken, Napolean probably responded positively to this picture with its complex justification of loss, its celebration of bravery in battle as the stuff of legend, and its projection of his armies as generous to the defeated. Moreover its unearthly pallor, in which – as David said – the Celts appear is if made of 'crystal', and its ethereal setting, removed it altogether from reality; it is a denial of the truth of war. Even more of an invitation to forget was another composition of Ossianic heroes, painted by Ingres in 1813. The year before, Napoleon had been forced to retreat from his disastrous invasion of Russia; defeated by vast distances and appalling weather, he had, in his own words, brought back an army of 'ghosts'. In retrospect, Ingres's *Dream of Ossian* (45) seems to have everything and nothing to do with this spectral retreat. Ostensibly it was painted as one of two commissions to celebrate a supposed triumph soon afterwards in Italy, Napoleon's annexation of the papal states and removal of the pope – his last and greatest arrogation of power. The picture was for the ceiling of the bedroom in the Quirinal Palace where he would sleep after his triumphant entry into Rome. Yet it is more than just an aid to slumber. Partly inspired by another of the earlier commissions for Malmaison, a picture by François Gérard (1791–1824) of Ossian calling up the shades by the music of his harp, it was based on the end of the bard's song, in which these visions, the heroic 'companions of my youth', are commanded instead to vanish. Indeed in Ingres's picture their serried ranks seem to fade, like melting ice.

A heroic mythology could be used to distance the horrors of war, just as battlefield scenes could sustain the pride of a modern ruler. But artists had also used these horrors to burnish Napoleon's image as a compassionate, feeling leader. Gros, back in Paris since 1800, had gone on to paint the Egyptian campaign, including an inspiring but spurious scene in which Napoleon brings succour to plague victims at Jaffa (see Chapter 5), the picture that in the Salon of 1804 really made his name. Its propagandist message was clear,

but Gros, that 'great soul in distress' as Delacroix would call him, and an artist gifted – or cursed – with an extraordinary capacity to empathize with suffering and visualize its effects, had already intruded his own sensibility on the subject. Four years later, in *Napoleon on the Battlefield of Eylau* (46), he went further still in the depiction of pain and death. This vast canvas, exhibited at the Salon of 1808, was officially commissioned as one of the series of *grandes machines* to immortalize Napoleonic rule, and referred to a battle fought in East Prussia against a largely Russian army in February the previous year. If this was a victory, it was a pyrrhic one, so terrible was the bloodshed. But Napoleon could, in a limited sense, claim he had not caused it: if the Russians had not interfered with his claims on German territory, he would not have had to fight. Thus Gros depicts his visit to the battlefield the next morning with his officers, when he is supposed to have declared, 'If all the kings of the world could contemplate such a spectacle, they would be less avid for wars and conquests.'

It was this noble sentiment, with its implicit denial of responsibility, that allowed Gros to put before the public what was surely the most gruesome account of the carnage of battle yet painted. And as reports of the massive toll of death could not entirely be suppressed, it was indeed wise to do so. Gros's foreground is filled with the giant figures of the dead. Blood is everywhere, spattered on the snow, oozing from wounds, on a bayonet – all now congealed and frozen. His thickly charged brush, worked with a bold touch that seems to belong more to a stage backdrop than an easel picture, nevertheless misses nothing, lingering almost lovingly over the grimmest details. Through this theatre of death, Napoleon and his retinue move, symbols of order in chaos. His brother-in-law Murat postures in rich, jewelled clothes. Gros agonized that he had privileged him too much, but in fact his vanity emphasizes his commander's sober dress and introspective air. Napoleon is unshaven and seems to have slept badly. He does not look at the battlefield; his eyes roll heavenwards. In the distance, under a lowering sky

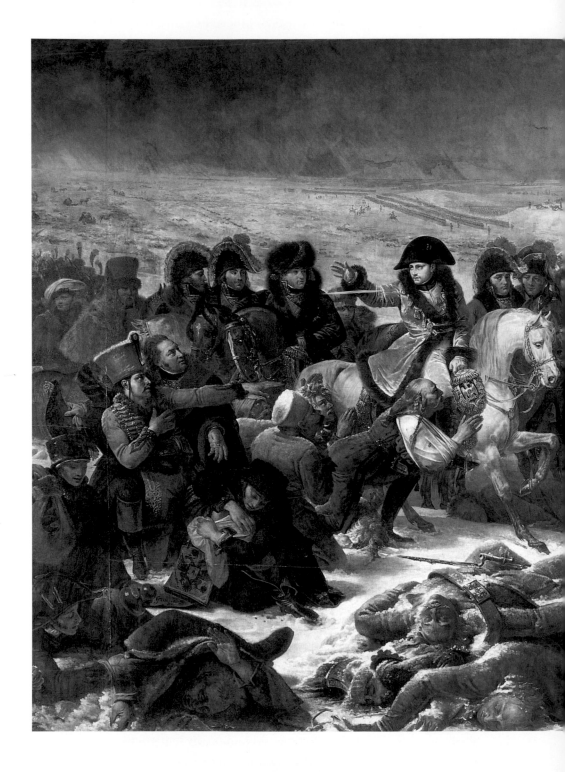

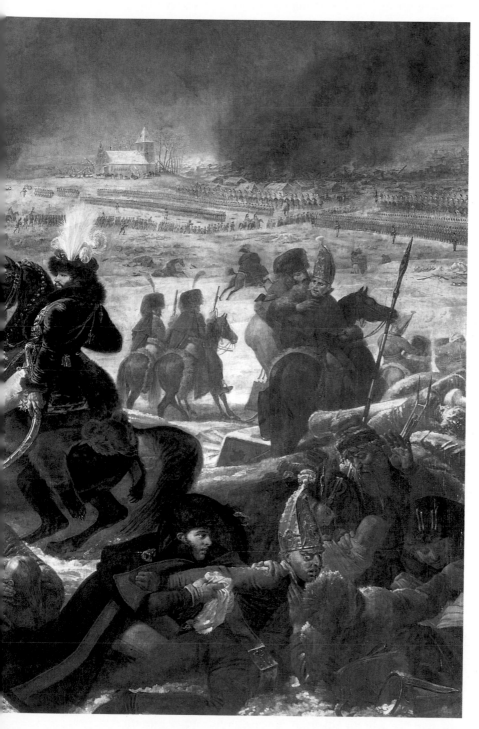

46
Antoine-Jean Gros, *Napoleon on the Battlefield of Eylau*, 1808. Oil on canvas; 533×800 cm, 209⁷⁸×315 in. Musée du Louvre, Paris

still clouded by smoke, the remnants of his imperial army assemble for review. The dying rise up at the emperor's approach, and French surgeons are already on the scene. As specifically required by the terms of the commission, the picture had to include a young Lithuanian hussar who had uttered the unlikely cry, 'Caesar, you wish that I live. Very well! If you heal me, I will serve you as faithfully as I did Alexander.' But the plea is for more than medical assistance. With their green uniforms and exotic pigtails, the Russian troops are represented as inferior beings, the exploited minions of the Tsar's autocracy, who can now embrace a humane new order.

Romanticism has been accused of celebrating violence. It would be truer to say that Gros's *Eylau* immortalizes suffering while, just, addressing the requirements of his official commission. Laid at the door of the Tsar, the slaughter can properly provoke Napoleon to reflect on historical forces he cannot completely control. Certainly he was well pleased with his own role in the picture. Yet it is hard to avoid the conclusion that Gros exceeded his brief, that the futility and waste of this icy cemetery had overcome him, and it was above all for its huge, freely painted foreground cadavers, and for the emotional insights of its portrayal of Napoleon, which Delacroix declared unsurpassed, that the French Romantics claimed *Eylau* as their own. At the time, however, few detected any real departure from David's school, and it was perhaps less that the Romantics were attracted by Gros's imagery for its own sake than that, from their later perspective, they saw in it a new awareness of the victims of war, and of the whole Napoleonic enterprise, that echoed their own disillusionment. As for Gros himself, tragic though he now saw this modern epic to be, it was indispensable to him. His glory faded with Napoleon's, and in 1835 he died by his own hand, unable to come to terms with diminished times and with the young artists who admired him so much. But extraordinary as Gros's achievement had been, he was not the only painter who had brought the plight of the common soldier into the foreground as French losses mounted and exhaustion grew.

47
Louis-Léopold Boilly,
Departure of the Conscripts in 1807,
1808.
Oil on canvas;
84·5×138cm,
33¼×54⅜in.
Musée Carnavalet, Paris

In the same Salon of 1808 hung two other pictures that seemed
a universe away from Gros's epic conception but also alluded to
the German campaign and its casualties. Louis-Léopold Boilly
(1761–1845) was known mainly as a painter of small, intimate
narratives, humorous, sentimental and largely apolitical. As a
young man he had painted a picture of a triumphant Marat but
panicked that it would embroil him too far in revolutionary
affairs; he had since steered clear of Napoleonic propaganda.
When he returned to the realm of current affairs for his
subjects, he did so from the perspective of ordinary people
rather than Napoleon himself. The imperial armies had long
been dependent on conscription, and as they were stretched
further, there were many abuses, especially of the age limits.
These, together with the recent carnage in Prussia, would
have been much in the minds of those who stood before
Boilly's *Departure of the Conscripts in 1807* (47). Most of the
raggle-taggle procession who pass beneath the Porte St Denis
in Paris have a jaunty air, but it strikes a false note; the men are
undisciplined and shabby, and are given a bitterly ironic echo
in the single figure on the extreme right of a blind man led by
his dog. As a counterpart to this, Boilly's *Reading of the Bulletin*

48
Louis-Léopold Boilly,
Reading of the Bulletin of the Grand Army,
1807.
Oil on canvas;
44·4×58·5cm,
17½×23in.
St Louis Art Museum

of the Grand Army (48) hinges on a family's concern for a son absent on the German front, as the boy's grandfather and father study a map. Again there are touches of black humour in the foreground, where children play war games and pets squabble, but the overriding impression is of the apprehensive concern of people caught up in the tide of events.

Though painted from the opposite point of view, Boilly's picture may be compared to Wilkie's vernacular narratives, such as *Village Politicians* (1806) or *Chelsea Pensioners* (see 38). Do Boilly's conscripts or Wilkie's 'politicians' really know what they are doing? If these are examples of popular revolutionary forces, how far could they be trusted? And the bust of Napoleon watching over Boilly's anxious family prompts other questions. Who is really the hero, the emperor or the boy soldier? If the leader was the supreme example of individual will, what of the countless individuals caught up in his designs? What choice did they have? How was their destiny their own? The Revolution had offered up leaders as expressions of the collective will of the people; but the contract could not hold for ever, and it is in the art of Théodore Géricault that it can be seen to crack and break.

Twenty years his junior, Géricault could have been another Gros. He longed to be a great history painter, and for the epic dramas and national patronage to nurture his career. But he was too late: by the time he reached maturity, the empire had entered its last act, and there was no sequel to inspire him. To some, the *Charging Chasseur of the Imperial Guard* that he painted in 1812 (49) still seems a last dash for glory. But there is a desperate recklessness about it: the great white steed rears up, checked in its headlong career by a maelstrom of fire and smoke, clearly terrified; the officer, like Napoleon in Gros's *Arcola* portrait (see 42), which Géricault surely had in mind, turns back, his sabre lowered; but his expression is pensive, as if struck by doubt. 'He turns towards us and thinks,' said the historian Jules Michelet in the mid-nineteenth century; 'This time, it is probably to die.' Géricault exhibited the picture at the Salon as a '*Portrait of M D*', a coded reference to its model Lieutenant Alexandre Dieudonné, who was indeed killed in Russia the following December. The lack of a full identification gave the figure a larger, representative role. But if this was the Grand Army, how long could it fight? The answer came two years later, when Napoleon fell for the first time, and Géricault painted *The Wounded Cuirassier Leaving the Field* for the Salon (50). Here, the apocalyptic fire-storm of the earlier picture gives way to an exhausted calm. The departing cuirassier's wound is barely perceptible – only a trickle of blood seeps from his temple – so that his scars seem as much mental as physical as, in the background, columns of the defeated wend their way home across the French countryside.

Géricault's figures are men of their time. Though painted on a monumental scale, they give way to interior questions of destiny and conscience. In their uncertainty they are the opposite of David's Alpine conqueror (see 36), no longer expressions of collective will but of feeling. The artist allows them both to be themselves and to convey what millions felt. More out of gloom at his prospects as a painter, and from a longing for adventure, than political conviction, Géricault now joined a cavalry

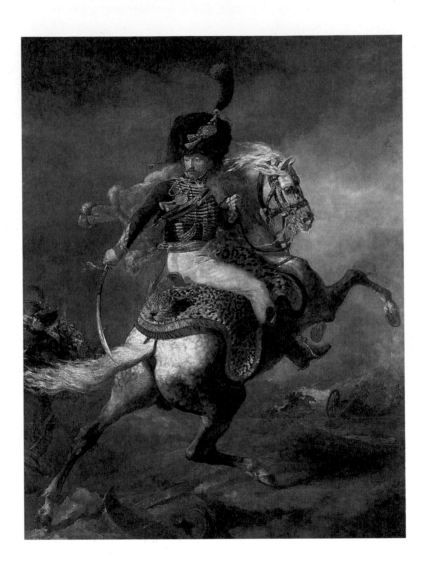

49
Théodore
Géricault,
Charging
Chasseur of
the Imperial
Guard,
1812.
Oil on
canvas;
349×266 cm,
137⅜×104¾ in.
Musée du
Louvre,
Paris

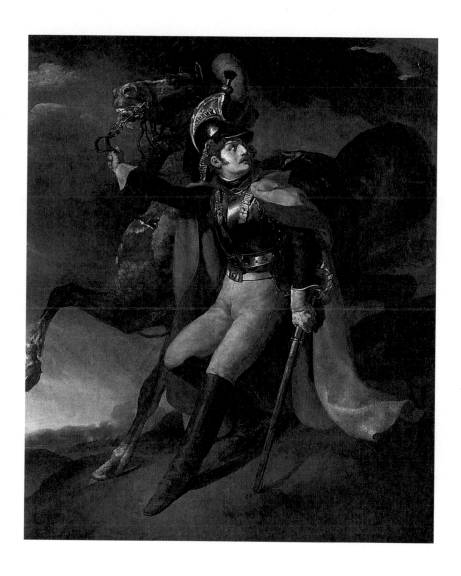

50
Théodore
Géricault,
The Wounded
Cuirassier
Leaving
the Field,
1814.
Oil on
canvas;
358×294cm,
141×115¾in.
Musée du
Louvre,
Paris

regiment in royal service, but he was hardly an enthusiast of the
Bourbon Restoration, and even among Napoleon's enemies the
final defeat at Waterloo in 1815 was recognized as a tragedy –
personal, national, even moral, for it signified the defeat of
the revolutionary ideal. The need to express these complex
emotions while acknowledging the sacrifices made on all sides
set artists extraordinary problems, which needed new solutions.
Géricault, Goya, Friedrich, Turner, the greatest of the age, were
compelled to reinvent their art and examine their consciences.
Nothing gave so great a spur to the Romantic movement.

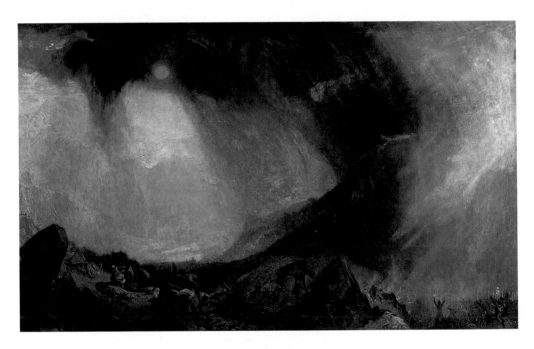

Géricault's *Chasseur* and *Cuirassier* belong to a new art, neither
quite portrait nor history. Their message was more complex
than the vaguely historicized portraits of the rulers and
heroes of the victorious allies that Thomas Lawrence
(1769–1830) painted for the Waterloo Chamber at Windsor
Castle, or the expatriate George Dawe (1781–1829) for a
similar commemorative scheme in the Winter Palace at St
Petersburg. They were, moreover, only the start of Géricault's
efforts to find a new vehicle appropriate to the feelings of the

time. In this, however, he had not been alone. In England
Turner, overcome by the same sense of imminent apocalypse
in 1812 as the French army marched into Russia, had his
own recollections of David's *Napoleon Crossing the Great Saint
Bernard Pass*, from a visit to Paris in 1802. He also remembered
a blizzard he had experienced in Yorkshire a couple of years
earlier. As a landscape painter deeply concerned with the
issues of his time and the fortunes of his country, he was as
much struck by Napoleon's pride in defying nature as in his
comparison of himself to Hannibal. *Snow Storm: Hannibal and
his Army Crossing the Alps*, which Turner sent to the Royal
Academy in 1812 (51), pits the ancient Carthaginian, a mere

51
J M W
Turner,
*Snow Storm:
Hannibal
and his Army
Crossing the
Alps*,
1812.
Oil on
canvas;
146×237·5 cm,
57½×93½ in.
Tate, London

52
J M W
Turner,
*The Field of
Waterloo*,
1818.
Oil on
canvas;
147·5×239 cm,
58×94 in.
Tate, London

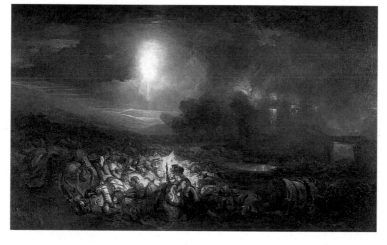

dot astride a distant elephant, against an all-consuming storm
and the onslaught of murderous Alpine tribesmen. Plainly as
much an allegory of Napoleonic hubris in its final stage as a
purely historical scene, it is nevertheless not just a premonition
of an enemy's defeat but a larger meditation on man and nature
with universally tragic implications. Moreover, when Turner
returned to the theme of the ancient wars between Rome and
Carthage in 1815 and 1816, it was as much to warn his own
compatriots against excessive pride in their victory as to make
comparisons between the fallen French Empire and the British.
His *Field of Waterloo* (52), painted in 1818 after a pilgrimage to

the battleground the previous year, is as horrifically convincing as Gros's *Eylau* (see 46) – which is surely its inspiration – but utterly dispassionate too. The mingled dead, common soldiers mostly, lie jumbled together, lit by the eerie light of the flares that were sent up to deter pillagers, 'in one red burial blent' in the words of Byron that Turner chose to accompany the picture in the Academy. Turner's is a democratic as well as an unprejudiced picture, for all the leaders have left the field, and the only figures to move among the men are their loved ones, searching for mementoes.

Turner must have felt the subject a moral imperative. His preferred art of landscape had itself already become a powerful agent of anti-Napoleonic resistance, above all in Germany. When German painters celebrated those who fell in the War of Liberation (the *Freiheitskrieg*) against the French, it was under the branches of the German forest, as in Georg Friedrich Kersting's touching *Wreath-Maker* (53), where a bereaved girl winds oak sprays to the memory of fallen heroes to pin to the trees whose trunks are inscribed with their names. But this modest picture is also more than it seems. Men like these had fought with sorrow in their hearts, for as liberals they had once been revolutionary sympathizers. Moreover, the governments restored to the German states after the French retreat were often reactionary: far from showing gratitude to Liberation heroes they forced many into exile. Kersting's picture was painted in 1815, when it was already unlikely that they would be given public memorial, and so his mourner has gone to work herself with the natural materials to hand. 'Where the people have no voice,' Kersting's friend Friedrich wrote the previous year, 'the people will not be allowed to be conscious of and honour themselves.' Friedrich's own memorial to exiled or discredited Liberation heroes, painted in 1823–4, was the complex allegory *Ulrich von Hutten's Tomb* (54). The tercentenary of this German patriot and humanist admirer of Luther, who had himself died in Swiss exile, coincided with the tenth anniversary of the Liberation War. Friedrich shows a man

53
Georg
Friedrich
Kersting,
Wreath-Maker,
1815.
Oil on
canvas;
40×32 cm,
15³⁄₄×12⁵⁄₈ in.
National-
galerie,
Berlin

54
Caspar
David
Friedrich,
*Ulrich von
Hutten's
Tomb*,
1823–4.
Oil on
canvas;
93×73 cm,
36⁵⁄₈×28³⁄₄ in.
Staatliche
Kunst-
sammlungen,
Weimar

in the old German costume favoured by the freedom fighters
paying homage to von Hutten's grave, on which are inscribed
the names of his modern counterparts.

Romantic artists frequently invoked nature and the past to
convey contemporary messages, but how to deal with the im-
mediate past posed a more urgent problem in 1815. Like
the German Romantics, or Appiani and his fellow liberals in
Milan, Goya in Spain had been sympathetic to the revolutionary
movement as the likely reformer of state corruption and the
superstition of the Church. While ruthlessly satirizing these,
he had nevertheless served the reactionary Charles IV as his
court painter. When the French invaded in 1808 and installed
Napoleon's brother Joseph on the throne, Goya's reactions
were ambivalent. He remained in Madrid, swore allegiance to
the new king and continued as painter to his upstart court.
He took no part in the resistance movement that struggled for
the nationalist cause, and whose leaders, like their German
counterparts, were expelled or executed when the French
eventually left and the Bourbon monarchy was restored. As a
public figure, so withdrawn had Goya appeared from nationalist
sympathies that he was to be accused of collaboration with the

French. But he was not the only artist in an occupied country to put his own career first, and his unpublished suite of etchings, *Disasters of War*, shows the dispassionate and lucid eye he turned on the atrocities he had witnessed during the French occupation of Spain. With their laconic titles, '*It will be the same*', '*Nor this*' (55) or simply '*Why?*', these images of pointless butchery take on a universal resonance that renders questions of personal alignment irrelevant.

Above all, these terrible prints show that it is the people who suffer for the ambitions of their leaders. Goya was probably right to decide that they were unpublishable. But he also produced *The Third of May 1808*, a very public painting on the same theme and the greatest single picture to emerge from the tortured atmosphere of the time. His plan, he wrote, was to 'perpetuate with [my] brush the most notable and heroic actions or events of our glorious revolution against the tyrant of Europe', and he applied for support from the restored Ferdinand VII for this and another picture. Goya was being merely pragmatic in this retrospective alliance with the resistance, but neither of the pictures he painted can be explained by this alone. They are not about heroics; the miseries of the people of Madrid, following the occupation

55
Francisco Goya, *Tampoco*, '*Nor this*', plate 36, *Disasters of War*, 1812–15. Etching; 15·8×20·8 cm, 6¼×8¼ in

**56
Francisco
Goya**,
*The Second of
May 1808*,
1814.
Oil on
canvas;
266×345 cm,
104⁷⁄₈×135⁷⁄₈ in.
Museo del
Prado,
Madrid

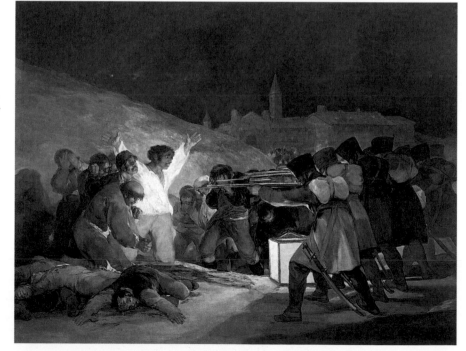

**57
Francisco
Goya**,
*The Third of
May 1808*,
1814.
Oil on
canvas;
266×345 cm,
104⁷⁄₈×135⁷⁄₈ in.
Museo del
Prado,
Madrid

of the city by Murat's troops, are his theme. *The Second of May 1808* (56) is a scene of almost demented savagery, in which Spaniards haul the loathed Mamluks, mercenaries in French service, from their horses and stab them to death. The companion picture (57) is more dreadful still. It records the French response the next day. Hundreds of civilians, including innocent bystanders, were executed – the shooting continued far into the night. Goya's central figure, white-shirted as if in a parody of surrender, stares in terror as a faceless firing squad prepares to add him to the bloody heap below. The squad's mechanically repeated postures, rifles raised, echo David's *Horatii* (see 37), but they occupy a different planet.

The Spaniard is nameless, yet he is among the defining martyrs of the age, and the political perspective against which Goya painted him scarcely matters. In his newly 'liberated' country, the painter had reached a condition of utter disillusionment. Institutions and ideals had failed, yet the abject condition to which the people had been reduced in the *Disasters* shows that no confidence could be placed in them either. Within a few years Goya retired to an inner world, peopled by imaginary monsters; his *Saturn* (58) consumes his own child in a bitter inversion of the once exemplary behaviour of painted gods and heroes. No other artist felt so bereft – save possibly Géricault. But Géricault was still young, ambitious and capable of anger as well as despair as he surveyed the ruins of France. In 1816 he left to spend nearly two years in Italy. The great picture he began and abandoned there, of the race of wild horses during the Roman carnival, was an attempt to wrest classic pictorial magnificence from animal energy. His remaining years would be marked by a heroic, and frustrating, search for focus. Like Goya he turned to printmaking, choosing the new technique of lithography to reach a popular audience. There is pity in his lithographs of the wounded returning from campaign, above all in *The Retreat from Russia* of *c.*1818 (59). Once again these exhausted soldiers stand for an entire nation; but that they have not lost their pride is clear from a companion print, in which a one-legged

58
Francisco Goya, *Saturn*, 1820–3. Oil on canvas (transferred from plaster); 146×83 cm, 57½×32¾ in. Museo del Prado, Madrid

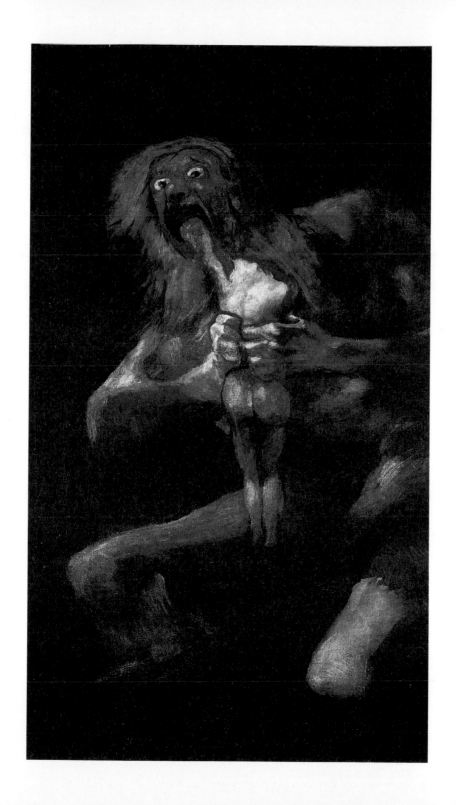

veteran defiantly shows off his campaign medals to a slouching
Swiss guard outside the Louvre, forcing him to present arms (60).

In Restoration France, liberal opposition to the monarchy
found an outlet in Napoleonic nostalgia, and it was not long
before Géricault was revisiting such highlights of Napoleon's
career as the crossing of the Great Saint Bernard Pass. He also
expressed his disaffection, and longing for dramatic subjects,
in prints of wars of colonial independence in South America.
But he could not find subjects for the sort of Salon vehicles
that had been available to Gros and the result was the bitter
ironization of the historical art that he had revered. From
scenes of glory he turned to violent or scandalous episodes
reported in the popular press. In 1817 he had experimented
with ideas based on the recent murder of a former magistrate,
Fualdès, for which a gang of extreme royalists was alleged to be
responsible. In the event it was another, and utterly unheroic,
colonial subject that Géricault chose to develop instead –
one that more openly reflected discredit on the Restoration
government, and could be painted on the grandest scale of
epic history painting.

59
Théodore
Géricault,
The Retreat
from Russia,
*c.*1818.
Lithograph;
44·5×36·2 cm,
17¹₂×14¹₄ in

60
Théodore
Géricault,
Swiss Guard
and Wounded
Veteran,
1819.
Lithograph;
39·3×33 cm,
15¹₂×13 in

On 2 July 1816 the *Medusa*, a naval frigate carrying French soldiers and settlers to the colony of Senegal, had run aground off the West African coast. The captain, a royalist who had recently returned to France with the new government, was held responsible for the blunder, but worse followed. After two days the passengers were abandoned on a makeshift raft by the ship's crew, who cut it away from the lifeboats so they could hurry to shore. Adrift at sea for thirteen more days, the raft's load of 149 men and one woman were reduced to unimaginable horrors, including cannibalism. There was a brief sighting of another ship from the original convoy, the *Argus*, but it did not see them. When the *Argus* did find the raft later the same day, only fifteen people remained alive. As reports reached Paris, the government tried to hush up the affair, handing out a lenient sentence to the captain and dismissing two survivors, including the ship's doctor, Henri Savigny, who had claimed compensation. Savigny, who with the engineer Alexandre Corréard wrote a gruesome bestseller on the affair, was Géricault's prime source for the picture that eventually appeared at the Salon in 1819, *The Raft of the Medusa* (61).

Géricault used a huge canvas and hired a special studio. After initial ideas of showing the most horrifying aspects of the story, he chose finally to concentrate on the first sighting of the *Argus*. From the heaped remains of their dead companions, the survivors rise up from their exhaustion and despair to wave frantically at the distant mast; but the outcome is all too clear from its remoteness, and the slumped resignation of the seated figure on the left. Futility and irony infuse the entire composition; for example the shirt-waving figure's muscled back is a cruel parody of the classical statue fragment known as the Belvedere Torso, long admired in the academies. As in classically inspired art, the figures are heroic nudes, not starving skeletons, yet they have the greenish pallor of the mutilated corpses that Géricault studied in the Paris morgues while painting the picture. Carried away by pointless hope, these people are martyrs to official incompetence, and no

61
Théodore
Géricault,
The Raft of
the Medusa,
1819.
Oil on
canvas;
491×716 cm,
193¼×282 in.
Musée du
Louvre,
Paris

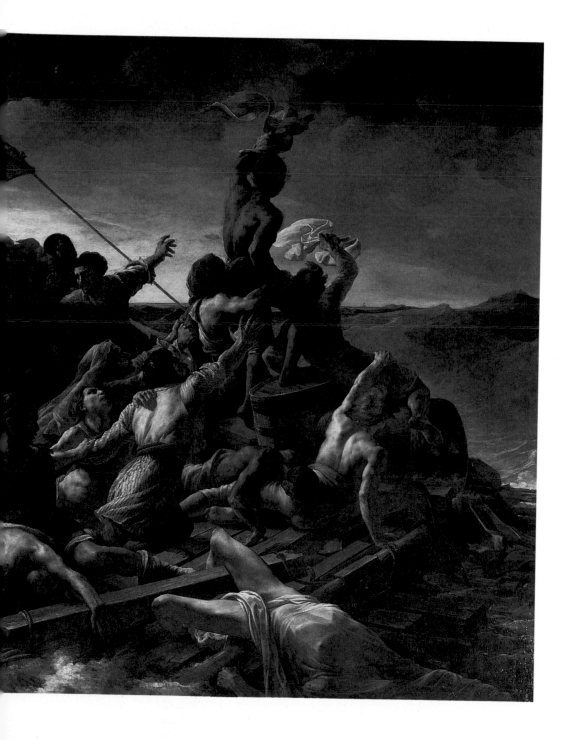

leader rallies them as Gros had made Napoleon rally the dying at Jaffa or Eylau. The message was utterly subversive, for as the critic Auguste Jal proclaimed, 'it is our entire society that is embarked on the *Medusa*'s raft.' And having set out to prove that modern France deserved only a sarcastic parody of heroic art, Géricault could hardly complain at the lukewarm response to the picture; although the government attempted to defuse his criticisms by awarding him a medal, most critics

62
Pierre-Narcisse Guérin,
Henri de la Rochejaquelin,
1817.
Oil on canvas;
216×142 cm,
85×55⅞ in.
Musée Municipal, Cholet

63
Horace Vernet,
Soldier-Labourer,
1820.
Oil on canvas;
55×46 cm,
21⅝×18⅛ in.
Wallace Collection, London

concentrated on the picture's failure to fit into a recognizable genre and quibbled about its accuracy as a record.

Of course, the royalist regime castigated by Géricault had its own heroes. There is nothing equivocal about the memorial portrait of *Henri de la Rochejaquelin* (62), painted in 1817 by Pierre-Narcisse Guérin (1774–1833) as one of a series of such anti-republican heroes commissioned by Louis XVIII for the

château of Saint-Cloud. This handsome general astride a
barricade, with the white Bourbon flag behind him and the
order of the Sacred Heart pinned on his breast, was plucked
from the early history of royalist resistance as a deliberate
counter to the republican icons of David and Gros. It was,
however, hard to find painters of this calibre prepared to
indulge the Restoration in such revisionism, and more often
the new establishment could be found bearing down on those
like Géricault's friend Horace Vernet, whose feelings about

the condition of postwar France are vividly portrayed by his
emblematic *Soldier-Labourer* of 1820 (63). This discharged
veteran of the Grand Army pauses to meditate after turning up
a French helmet on the field where he now works as a ploughman.
His eyes are haunted, resentful; but the tightly clenched
muscles of his arms hint at strength only partly suppressed.

When Delacroix left Géricault's studio, having seen the *Raft
of the Medusa* in progress, he was overcome with a strange

terror and broke into a run. But when men like Vernet's soldier rose again, in the July Revolution in 1830 that brought the 'Citizen King' Louis-Philippe to the throne, it was surely to the tumbled bodies on Géricault's raft, and to Gros's frozen corpses at Eylau, that Delacroix returned for the foreground of his own great picture, *The 28th July 1830: Liberty Leading the People* (64). The bodies over whose remains the revolutionaries rush forward leave no doubt that Delacroix had learned the lessons of the previous decades – that the People is itself no more than a mass of individuals caught up in events, followers as well as leaders, victims as well as heroes. There is a wild, inspiring energy about bare-breasted Liberty, flourishing her tricolour and her bayoneted rifle, and determination about her rag-bag following. But as so often with this complex painter, the message is mixed: Liberty is not absolutely the leader, for a Parisian *gamin* runs ahead of her, and her own followers include a top-hatted bourgeois. Mixed, also, is the artistic language in which history painting merges with reportage, the ideal and allegorical with the contemporary and real. Like the *Raft*, the picture was not well received when it appeared at the Salon in 1831, and although bought by the state, was long kept out of view as too likely to inflame populist violence. Brought to power by the barricades, the new government of Louis-Philippe feared seeing them thrown up against itself.

Delacroix's picture was, indeed, displayed again when, in 1848, Louis-Philippe's July Monarchy was itself swept away in a new revolution. Meanwhile, the artistic establishment favoured images of patriotic dedication, and firm but just rule. Representations of the first revolution, of republican and empire glory, outlawed during the Restoration, were acceptable, provided they showed their protagonists in a suitably disciplined light. It was under Louis-Philippe that Napoleon himself truly entered his destiny as hero and martyr. The Napoleonic Arc de Triomphe, begun in Paris in 1806 but left unfinished, was now completed and adorned with huge sculptures by François Rude (1784–1855). His *Departure of the*

64
Eugène
Delacroix,
*The 28th July
1830: Liberty
Leading the
People*,
1830.
Oil on
canvas;
260×325 cm,
102¼×128 in.
Musée du
Louvre,
Paris

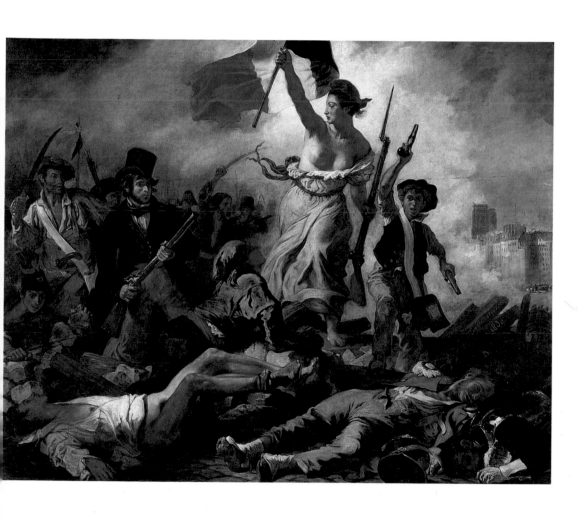

Volunteers casts the Republican army of 1792 in a formal language of heroic nudity, allegory and antique trophies that distanced it from the revolutionary street fighters of 1830. It was Rude, too, who carved an astonishing statue of Napoleon, 'waking to immortality' from his death-bed on St Helena (65). Commissioned by Captain Noisot of the small corps of grenadiers Napoleon had been allowed to retain during his first period of exile on Elba in 1814, this was finished in 1847.

65
François Rude, *Napolean Waking to Immortality*, 1846. Plaster model for bronze sculpture; 215×195× 96 cm, 84⅝×76¾× 37⅞ in. Musée d'Orsay, Paris

66
Paul Delaroche, *Bonaparte Crossing the Alps*, 1848. Oil on canvas; 289×222 cm, 113¾×87⅜ in. Musée du Louvre, Paris

Already in 1840 Louis-Philippe had consented to the return of Napoleon's body for a state burial in Les Invalides, thus officially incorporating him into French history. With its laurel wreath and epaulettes, and its expiring eagle breaking its chains, Rude's conception is again heroic, like the apotheoses by which Girodet or Ingres had immortalized the emperor's dead soldiers (see 44, 45). But with this continuing process of rehabilitation came a fresh appreciation of the great man's

vulnerable humanity. In 1848 Louis-Philippe's favourite history painter, Paul Delaroche (1797–1856), whose view of greatness was always sceptical, painted his own account of Napoleon's Saint Bernard crossing (66). Tired but determined, the guided mule plods on, a bedraggled Napoleon on its back. The contrast with David's artifice is extreme, but Delaroche's position was far from hostile. Like Haydon, he was fascinated by Napoleon, to whom he bore a strong resemblance, and

whose successes and reversals he compared to his own. In his view, the icon would not lose by being revealed as a credible man.

The same year that Napoleon was interred in Paris, the British historian Thomas Carlyle gave a series of lectures in London. His subject was 'Heroes, Hero-Worship and the Heroic in History', and his theme the 'transcendental admiration of great

men', which he found 'the most solacing fact one sees in the world at present'. Carlyle's own heroes were mainly of an authoritarian cast – Cromwell, Luther, Muhammad and, of course, Napoleon. He had little patience with the opposition such men encountered, and ultimately believed in totalitarian autocracy. This would, needless to say, be anathema to the Romantics, but they would at least have recognized the cult of heroes, as Carlyle did, as a kind of religion. They had been worshippers themselves, and had done much to create the pictorial icons on which this secular faith depended. For Romantic artists, however, the hero had meant above all the attainment of the personal fulfilment they sought for their art. The concept was inseparable from that of liberty itself, for only through the absence of constraint could they realize their true destiny. There was of course a basic conflict here, since, as the turbulent history of the time showed, one man's rampant individualism cost the freedoms and the lives of thousands. Some of the greatest Romantic works of art addressed these issues; but they begged as many questions as they answered, and it was from inevitable disillusion that the Romantics turned to other religions – to nature, to more distant times and places – and, in the end, back again to Christian faith itself.

At Christmas 1808, a few months after Gros's *Battlefield of Eylau* (see 46) appeared in the Paris Salon, a far more modest exhibition took place in Dresden. But few who came to the studio of Caspar David Friedrich to see his freshly completed *Cross in the Mountains* (67) could fail to sense that they were in the presence of something extraordinary. Even if nothing more were known of the painter, the so-called 'Tetschen Altar' would command attention for its boldness in creating a devotional image from the materials of landscape. It is both the first masterpiece of one of the greatest Romantic landscape painters and a manifesto for the art of landscape itself. It exemplifies two important achievements of early Romanticism: the elevation of nature to a kind of religion, and of landscape to equal or surpass history painting. While academic theorists had conceded that nature could appeal to the emotions and had even described wilder natural phenomena as 'romantic' long before the term acquired other meanings, they traditionally regarded landscape painting as imitative rather than expressive. The other great landscapists of the age, Turner and Constable, shared Friedrich's zeal to create a new art; but neither put so much of it into a single revolutionary picture.

The 34-year-old painter was inordinately proud of the work. It was the largest he had painted so far, in a medium in which he was still far from proficient, and he had designed the frame himself – a Gothic arch with the eye of God and the wheat and vine of the Eucharist. He had intended the picture as a gift to the Swedish king Adolphus IV, in recognition of his resistance to Napoleon, but was persuaded instead to sell it to Count von Thun-Hohenstein for his castle in Bohemia. With its splendid frame it was transformed from political gesture to religious image, but still it remained a landscape. Nature itself was imbued

67
Caspar David Friedrich, *The Cross in the Mountains*, 1808. Oil on canvas; 115×110 cm, 45¼×43⅜ in. Gemäldegalerie Neue Meister, Dresden

123 The Religion of Nature

with religious feeling. Friedrich saw no heresy here, and before it went to Tetschen he wanted the Dresden public to see it.

The exhibition was carefully stage-managed. The artist's austere painting room was darkened to suggest the meditative gloom of a chapel, and the picture stood on a table hung with a dark cloth as if it were an altar, lit by dim lamps. It was, however, like no altarpiece ever seen before. There was no episode from the Christian story; instead, a sunset landscape of almost brutal simplicity. Certainly, the rocky peak was surmounted by a cross, but this was not the crucified Christ himself but a wayside cross of the kind familiar to travellers in central Europe. Moreover, it was awkwardly turned away from the onlooker and almost dwarfed by the fir trees sprouting from the rock. The image is not easy to interpret: Friedrich provides no foreground or conventional perspective to fix the viewpoint, no clear indications as to how to read the subject. Is the work a landscape that ignores the conventions of landscape art, or a devotional work for a generation no longer convinced by traditional biblical imagery? Or – bearing in mind Friedrich's original plans – is it a political allegory, raising a symbol of the Christian North against the secular, Latin Napoleon?

Hundreds of people came to the exhibition and, according to Friedrich's friend Marie Helene von Kügelgen, they were suitably moved: 'Even the biggest loudmouths spoke quietly and earnestly as if they were in a church.' The arguments soon began, however. Frau von Kügelgen's husband and other progressive thinkers recognized that the picture created a new territory and demanded an unprejudiced response, but more conservative observers were shocked. Early in 1809 the journalist and self-appointed advocate of academic classicism Friedrich von Ramdohr launched a violent press attack. He was scandalized by the composition and technique, and by the greater aberration of allowing landscape to 'slink into the churches and creep on to the altar'. He rightly sensed that the picture sprang from a wider movement of thought of which he

thoroughly disapproved: Friedrich was clearly another victim of the 'Jena mysticism which like a narcotic vapour is at present insinuating itself everywhere, in art as in science, in philosophy as in religion'. The University of Jena was indeed a hotbed of advanced thinking (see Introduction). It had been there, a decade before, that the philosopher Fichte had caused such a scandal by his pantheistic association of God with the natural order of the universe that he had been fired from his professorship.

Friedrich would never again explain or defend his work, but on this occasion he was stung into writing a brief 'Description' and 'Interpretation' of the work. The sun, he pointed out, represents God but is shown setting, since he no longer shows himself directly on earth. The gilded figure of Christ reflects this diminishing light to mankind, whose continuing hope in the Redeemer is represented by the evergreen fir trees. The picture is thus a Christian allegory. But Friedrich's text does not explain the work's haunting power. Art, Friedrich once declared, is 'the language of our feeling ... even our devotion and our prayers'. Previously, only religious painting itself could have aspired to engender such feelings; but Friedrich's fir trees, yearning towards a gleaming cross, express them in a form which, once understood, would prove universally accessible.

Friedrich's transformation of the art of landscape was less radical than that attempted by Philipp Otto Runge. The artists were close from youth and shared similar backgrounds: both were born in Pomerania in northern Germany, the sons of prosperous tradesmen from peasant stock, and both studied at the academy in Copenhagen. Both were slow developers who gained little from their time there save skill in drawing. More important for each of them was their acquaintance with the poet and Protestant pastor Ludwig Theobul Kosegarten, who encouraged them in his own belief in the divine purpose revealed in nature and his sense of the special spiritual qualities of the Baltic coastline and offshore island of Rügen, which, he believed, was a 'land of the soul'.

In 1798 and 1801 respectively, Friedrich and Runge moved to Dresden, attracted by the city's progressive reputation. For them both, the prestigious annual art competition organized by Goethe in nearby Weimar would prove a turning point. Despite Weimar's reputation as a stronghold of classicism, it was Runge who in 1801 failed to take a prize with a Neoclassical composition with a Greek subject and Friedrich who in 1805 won an award – his first public recognition – for a fusion of landscape with a Christian procession. This confirmed Friedrich in his chosen direction, while Runge determined from that time on to dedicate himself to the development of entirely personal systems and symbols. Both artists believed that the painting of nature was a form of worship, a means of approaching the divine. Runge, however, was to carry the implications of his 'sense of kinship with the whole universe' far further than his friend, expressing in words as well as images the longing both of them felt for a new art that could reflect their own revelatory, transcendental experience of their place in the world.

In 1802 Runge wrote to his brother Daniel, 'everything tends towards landscape, looks for something certain in this uncertainty, and does not know how to begin … Is there not surely in this new art – landscapery [*Landschafterei*], if you like – a higher point to be reached? Which will be even more beautiful than before?' He spoke out of frustration with the conventional hierarchies of art: although he accepted the dominance of religious painting, he found it inadequate to his own purposes. Landscape, as it was then usually understood, was equally unsatisfactory. It was another friend, and pupil, of Friedrich, Carl Gustav Carus (1789–1869), who in 1840 recalled the 'rather cheerless state of affairs' that prevailed in late eighteenth-century Germany. Landscape, he declared, had been no more than 'superior wallpaper', describing what is in effect a pastiche of the classic compositions of the great French landscape painter Claude Lorrain (*c*.1604–82): 'A few dark, mannered trees to either side of the foreground, ruins

of an old temple or a mass of rock nearby, then in the middle distance figures on foot or on horseback … A river and a bridge and some cattle, a stretch of blue mountains behind and some pretty little clouds above. This was what was supposed to constitute a landscape.'

That it might be something very different had, in fact, already been envisioned by the time of which Carus spoke. But it was more often writers, poets and theorists who showed a new path, rather than artists themselves. The philosopher Jean-Jacques Rousseau, and his followers such as the writer Jacques Henri Bernardin de Saint-Pierre in his *Études de la nature* (1784) and his sentimental novel *Paul et Virginie* (1788), elevated nature as man's only moral guide, a source of innocence and timeless truth lost to civilization. This had implications far beyond landscape painting. But in *Ardinghello*, his fantasy novel about a painter, Wilhelm Heinse had prophesied that landscape would supplant all other artistic subjects; and eleven years later Ludwig Tieck, in his own tale of an imaginary pupil of Albrecht Dürer (1471–1528), put into a young knight's mouth a series of emotive word-pictures that predict the iconography of the coming generation of German Romantic landscape painters.

If I were a painter, I would depict desolate terrifying regions, fragile crumbling bridges … a deep chasm white with the foaming waters of a mountain torrent … Strayed wanderers, their garments fluttering in the wind … A chamoix hunter amid desolate and frightening rocks … lonely trees and bushes would express the loneliness even better. Or again, I would paint a stream and a waterfall with a fisherman and a mill turning in the moonlight. A boat on the water with its nets cast.

Chateaubriand, in a 1793 essay on the art of drawing, criticized French painters for 'not loving Nature enough', insisting that 'Landscape has a moral and intellectual bearing' and was capable of arousing 'dreams and reveries'. He wrote this in England, and his recommendation that artists should immerse themselves in 'concepts of the sublime taken to their furthest

limits' echoes the writings of the Anglo-Irish statesman Edmund Burke. In his *Philosophical Inquiry into the Origin of our Ideas of the Sublime and Beautiful* (1756), Burke had gone beyond mere description or categorization of nature and entered the territory of emotional response. He discussed the types of object that enable us to experience aesthetic pleasure – not just the delight engendered by the beautiful, but the elation, even fear, produced by the vast, mysterious or unknown. And Burke had soon been followed by theorists eager to define the middle ground that lay between his extremes. This was the 'Picturesque', whose name implied that it was like a picture even if it had not yet been painted, and whose chief elements, as described by its proponent Uvedale Price, were 'roughness and of sudden variation, joined to that of irregularity'. While Burke's more intense emotions really required a visit to Italy or the Alps, the Picturesque was uniquely adapted to Britain and could be found down almost any country lane. In its modest demands, it lent itself especially to the design of gardens and parks.

It was also in Britain that a new, emotional response to landscape first appeared in art. Though he spent his formative years in Rome and made his name with classic evocations of an ideal Italy, the Welsh-born Richard Wilson (1713/14–82) brought a new appreciation of light and atmosphere to even his grandest compositions. His beautiful *Vale of Narni* (68), with its arching stone pines and tender light, could never be described as 'superior wallpaper'. For the Romantic generation of Turner and Constable, Wilson was the one earlier compatriot they took seriously. Turner made copies of his work when he himself took up oil painting; Constable imagined him 'walking in the shadow of Milton and Linnaeus', a tribute to Wilson's special fusion of poetic imagination and direct observation of natural phenomena. It was Constable, also, who described the watercolours of John Robert Cozens (1752–97), an early influence on Turner too, as 'all poetry'. Certainly such works as his *Entrance to the Valley of the Grande Chartreuse in Dauphiné*

68
Richard Wilson, *The Vale of Narni*, c.1760. Oil on canvas; 66×48·2 cm, 26×19 in. Private collection

(69) interpret Burke's mountain Sublime with unparalleled intensity of feeling, economy of form and subtlety of palette. They also built on the tonal and compositional experiments in the watercolour medium of his father Alexander (1717–86), though their mysterious melancholy doubtless sprang in part from the incipient madness that was to lead to Cozens's death at the age of forty-five.

Poetry, as much as painting, would define the Romantic response to nature. It was in search of poetic stimulus that the young Wordsworth set out on a walking tour of the Alps in 1790. 'I love a public road', he wrote in his autobiographical *Prelude* (1805), cutting a figure that was to become a Romantic cliché – the Wanderer. But it was more than the beauty of the visible world that turned him into the poet he became. Like many of his generation, he had embraced the revolutionary ideal, only to see it shattered. Instead he discovered in the English landscape a mystic spirituality. In the Wye Valley near Tintern Abbey in 1798, he looked back on his youth when external impressions of the Sublime or Picturesque had been sufficient to move him:

The sounding cataract
Haunted me like a passion …
… a feeling and a love,
That had no need of a remoter charm,
By thought supplied, or any interest
Unborrowed from the eye …

But now he understood how,

To look on nature, not as in the hour
Of thoughtless youth; but hearing oftentimes
The still, sad music of humanity …

And with it came

… a sense sublime
Of something far more deeply interfused,
Whose dwelling is the light of setting suns,
And the round ocean and the living air,
And the blue sky, and in the mind of man:
A motion and a spirit, that impels
All thinking things, all objects of all thought,
And rolls through all things.

**Wordsworth's revelation of the divine, and his sense of
connectedness to creation as he looked on nature, was in
essence the same as Runge and Friedrich and countless others
across Europe were feeling. Coleridge put it another way: 'we
receive but what we give,/And in our life alone does Nature
live.' This could serve as an apt motto for the German painters;
even more than Wordsworth's lines, it is a reminder of how
their art sprang from parallel traditions. Fichte had proposed
that we invent or create the world as we look at it, that it has
no being beyond our own awareness of it. Such apprehensions
were shared by many of the Romantics, empowering them in
their subjective interpretations and their quest for feeling. But
if artists now approached nature with something of the same
reverence that had formerly been reserved for God, and the
experience of the natural world became a form of worship,**

69
**John Robert
Cozens,**
*Entrance to
the Valley of
the Grande
Chartreuse in
Dauphiné,*
1783.
Oil on
canvas;
26·2×37·7cm,
10¹₄×14⁷₈in.
Ashmolean
Museum,
Oxford

what form should it take? And where, and in what frame of mind, was nature to be experienced?

Friedrich's hybrid landscape/altarpiece provided one answer, and his art would continue the inquiry for some thirty years. It eventually came to encompass what emerged as the two main trends in the Romantic approach to nature: the visionary and the naturalistic. Turner would embrace a similar synthesis within the far greater scope of his art, while Constable, like Wordsworth, rooted his in his observation of reality. The very different lives and habits of these artists – Friedrich the studio painter, working from memory and imagination; Turner travelling constantly in pursuit of the new; Constable and Wordsworth drawing succour from the familiar landscapes of East Anglia and the Lake District – indicate the wide variety to be found in their contemporaries' experience of nature. Some found it necessary to study it in the open air, others reverted to an inner world. Some were drawn to the vast and remote, others to intimate corners – a country garden or a patch of green hidden at the heart of the city – or to the minute scrutiny of a flower or a leaf, revealing fragments of a cosmic whole. Some found it helpful to look through the eyes of earlier artists, others insisted on an original approach. Nowhere is the diversity of Romanticism more evident, nor the unifying authenticity of the individual's response.

Runge, whose art looked difficult or perhaps slightly mad even to his most sophisticated contemporaries, soon ceased to use the word 'landscape' in relation to it. To begin to understand it, one might turn to another art form that was itself being reinvented – music. The same year that Friedrich finished his 'Tetschen Altar', Beethoven wrote his *Pastoral Symphony*. Wandering in the woods near Heiligenstadt outside Vienna, Beethoven had fallen in love with the sights and sounds (for he was not yet wholly deaf) of nature, and experienced the same mystical sense of unity that Wordsworth had felt at Tintern. 'Woods, trees and rock give the response which man longs for,'

he wrote; or again, 'Every tree seems to say Holy, Holy.' It was these impressions he had gathered in his symphony, to which he gave the additional description 'Recollection of country life; the expression of sentiment rather than painting.' The impressions he had retained from his country walks include specific, isolated sounds of nature. Thus the orchestra mimics a thunderstorm, a burbling stream, even (though these he later claimed he had added in jest) the song of the nightingale and cuckoo. To compare this ever-popular work to Runge's complex allegories may seem strange, but Runge himself spoke of wanting to convey 'the great *Chime* and *Symphony* of nature', and in essence the motivation is the same. Runge's art is also an expression of love – in his case of family and children as well as of nature and God. Like Beethoven he expresses his feelings through isolating particular elements in which sounds played a vital part. He was profoundly conscious of the inadequacy of his medium to convey what he wanted to express, and dreamed of uniting poetry and music, and engaging all the senses in the experience of his art. 'A painter', he told his father, 'must also be a musician and an orator.'

Runge painted *The Nightingale's Lesson* to express his love for his new wife Pauline, the daughter of a Dresden shoemaker. He made two versions, the first in 1802–3 and the second, more elaborate one, in 1805; only the later work survives (70). Like Friedrich's 'altarpiece', Runge's picture fitted into no recognizable category. Like Friedrich's, too, it had an elaborate frame – in this case a painted frame-within-a-frame that was to be read as part of the work. Its various motifs – twining plants, oak leaves and small children – function as hieroglyphs, supporting the allegory. Though it was certainly not what would normally be understood as a landscape, it was based on an aspect of the natural world – one heard, not seen. Runge took his subject from an ode by the poet Friedrich Klopstock, in which Psyche – the female personification of the soul, shown as is usual with butterfly wings – instructs Cupid (Love) in song in an oakwood at evening, as the nightingales begin to sing; thus

the theme is interwoven with the sound of birdsong, a lesson in beauty that awakens the senses to the power of love. The interplay of these variations on a theme, and between the central motif and its isolated elements, led Runge to describe his picture as a 'fugue'.

Runge, in common with many Romantics, wanted to recover a child's view of the world, and his finest nature painting is to be found in his portraits of children, in which plant forms are at once observed with intense naturalism and vastly enlarged in scale as if seen from a child's level. In the portrait of the

70
Philipp Otto Runge,
The Nightingale's Lesson,
1805.
Oil on canvas;
104·7×88·5 cm,
41$\frac{1}{4}$×34$\frac{7}{8}$ in.
Kunsthalle, Hamburg

71
Philipp Otto Runge,
The Hülsenbeck Children,
1805.
Oil on canvas;
130·4×140·5 cm,
51$\frac{3}{8}$×55$\frac{3}{8}$ in.
Kunsthalle, Hamburg

three children of his friend and former employer Friedrich Hülsenbeck (71), the sunflower that rears up on the left over the baby in its little cart is part of a compositional pattern based on dizzying disparities in scale. The wooden fence, beyond which stretches a view of the countryside outside the Hülsenbecks' home near Hamburg, is absurdly low, and the two older children almost alarmingly big and strong as if competing with the sunflower's vigour – save for the central boy's arm raising its little riding crop. Runge later wrote of these anomalies as failures, but it is likely that he created a

deliberately primitive vision, recovering both the wondering vision of his child subjects and the unity between their living growth and that of the plants surrounding them. The larger theme – humanity's place in the natural world – is not forgotten.

To the seventeenth-century German mystic Jacob Boehme, Runge owed the concept that flowers can symbolize different

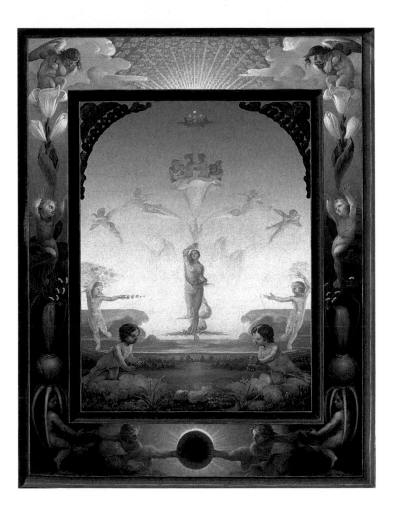

72
**Philipp Otto
Runge**,
Morning I,
1808–9.
Oil on
canvas;
152×113 cm,
59⁷⁄₈×44¹⁄₂ in.
Kunsthalle,
Hamburg

human states. With their cycle from first bud to death, their response to light, and as manifestations of God's purpose on earth, flowers were for Runge the most revealing of all natural forms. Together with small children and musical instruments they formed the allegorical base of his most ambitious work, a series on the theme of *Times of Day*. This was intended to take

the form of four huge oil paintings, and to be experienced in a Gothic chapel to the music of choirs and poetry by his friend the writer Ludwig Tieck. This grand plan never materialized; the designs were published in some rather unsatisfactory engravings in 1806 and 1807, while only one of the four subjects, *Morning I* (72), was developed in oil, in two versions (the larger was later cut into fragments, having failed to satisfy the painter himself). Although it is tempting to add this project to the Romantic pantheon of heroic failures, it represents a supreme statement of the nature mysticism associated with the movement, and is undoubtedly the masterpiece of Runge's short life. He began work on it in Dresden, where he had been greatly moved by Raphael's *Sistine Madonna* in the picture gallery, and his tightly structured, vertical compositions have some of the qualities of altarpieces. As in the earlier *Nightingale's Lesson*, they are surrounded by hieroglyphic borders, combining Christian and mythological symbolism. Individual plants, minutely scrutinized like botanical specimens, are integrated into visionary patterns, prompting comparison with Blake's illuminated books (see Chapter 1). In *Morning*, Runge was able to incorporate his researches into colour theory, based on association and the revelatory power of light. The small version contains a passage of sublimely lovely pure landscape painting – the summer meadow on whose carpet of flowers a baby wakes at dawn.

Goethe found the engravings of Runge's series, which hung in his music room, 'enough to drive one mad, beautiful and crazy at the same time'. After Runge's death, it was Friedrich's more pictorial, if no less visionary, painting that did most to establish symbolic landscape in Germany. His next important picture after the 'Tetschen Altar', the *Monk by the Sea* (73), was bought by the Prussian Crown Prince at the Berlin Academy in 1810. This official recognition came as a surprise, for the canvas had initially been met with bemusement, even from Marie von Kügelgen who had earlier admired his work. When she saw it in 1809, Marie described it to her friend Friederike Volkmann:

A vast endless expanse of sky … still, no wind, no moon, no storm – indeed a storm would have been some consolation for then one would at least see life and movement somewhere. On the unending sea there is no boat, no ship, not even a sea monster, and in the sand not even a blade of grass, only a few gulls float in the air and make the loneliness even more desolate and horrible.

Vividly accurate as her account is, Marie added that 'it does nothing to my soul'. The writers Heinrich Kleist, Achim von Arnim and Clemens Brentano in an article in a Berlin newspaper significantly titled 'Emotions in the Face of Friedrich's Landscape', sensed instead that it was to emotions that the picture made its appeal, however unsettling. Empathizing with the monk, they found nothing 'more unpleasant than this position in the world; the only spark of life in the vast realm of death, the lonely centre of a lonely circle', and added that 'the painter has broken completely new ground.'

Friedrich's theme is the insignificance of man before God and nature. To keep his unorthodox composition as austere as possible he actually painted out two ships, whose course through the sea would have indicated divine purpose but mitigated the monk's extreme solitude. But his is not a condition of despair or doubt; it was meant to be seen in conjunction with his burial in the companion picture, the *Abbey in the Oakwood*, exhibited with it (see 135). This suggests the hope of resurrection in its bright sky, in contrast to the dark clouds that loom above the figure on his Baltic shore. Friedrich's Lutheran faith had imbued him with an uncompromising view of individual destiny in which each person must find his or her own path to God. It was a pattern worked out as distinctly in his own life as in his art – in his rejection of academic teaching, suspicion of other people's theories, dislike of critics, mistrust of pupils and followers, and eventual retreat into himself. His vision was his own, and his compositions are precisely constructed to indicate

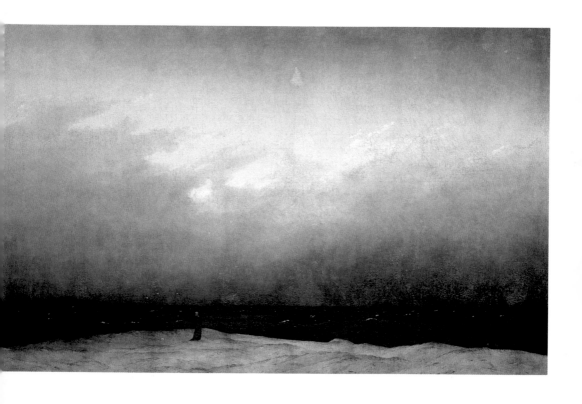

**73
Caspar
David
Friedrich**,
*Monk by
the Sea*,
1809.
Oil on
canvas;
110×171·5 cm,
43×67½ in.
National-
galerie,
Berlin

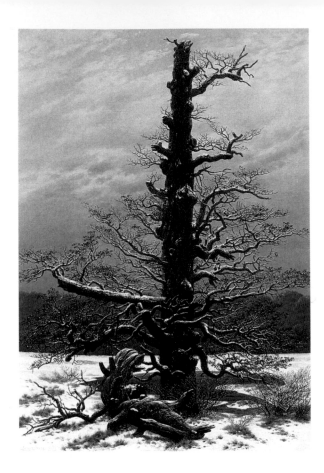

74
Caspar
David
Friedrich,
The Oak Tree
in the Snow,
1829.
Oil on
canvas;
71×48cm,
28×18⁷⁸in.
National-
galerie,
Berlin

a personal interpretation of the world. He said that one must
close one's bodily eye to see more clearly with one's spiritual
eye, and that art is the mediator between nature and ourselves.
Thus his figures who habitually turn their backs to gaze into
the horizon or stare from windows with rapt attention are
images of the artist. His *Wanderer* (see 11), frock-coated and
stick in hand, has climbed to a rocky peak above swirling
mountain mists; the viewer looks with his eyes, the angle of
vision being exactly aligned to their level in the picture
space. The foreground, the conventional plateau to give
the viewer a fix on the subject, has been entirely dispensed
with – something that Kleist had noticed in *Monk by the Sea*,
adding that its absence made it seem as if one's eyelids had
been cut away.

Figures play an ambiguous role in Friedrich's landscapes. They are important as interpreters, but are imposed by the artist, not indigenous to their locations. Nor are they the usual protagonists of historic landscapes. Often they have a precise symbolic meaning, expressing the painter's concern with fundamental issues of existence. Like Runge, Friedrich was preoccupied by the passage of time. The ages of man are mirrored by the seasonal cycle, and his vivid representations of winter snow and leafless trees contain the promise of spring growth, as in *The Oak Tree in the Snow* (74), which is both an image of striking naturalism and a complex allegory, painted late in Friedrich's life in a mood of retrospection. The German oak, a symbol of strength, is cruelly chopped and denuded, like Germany itself for much of the painter's life; its dead branches speak of a lost past. Yet at its roots spring new leaves, and the blue sky, reflected in the icy water, brings hope of renewal. This picture needs no figures, for the oak is really a collective figure of the German people, but in the ethereal *Two Men Contemplating the Moon* (75), human and natural symbolism are subtly interwoven. The moon, an old Christian sign of hope, gleams from behind another withered tree, watched by

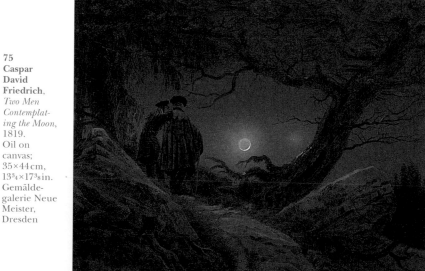

**75
Caspar
David
Friedrich**,
*Two Men
Contemplat-
ing the Moon*,
1819.
Oil on
canvas;
35×44cm,
13³⁄₄×17³⁄₈in.
Gemälde-
galerie Neue
Meister,
Dresden

two men, perhaps the artist and a pupil, in the 'old German' costume favoured by the resistance movement during the years of Napoleonic occupation. Painted, like the *Oak Tree*, after this threat had lifted, the picture links past, present and future through the cycles of time and season and the intercession of their human observers.

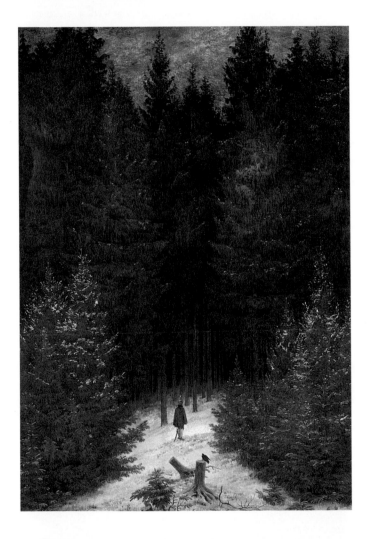

76
**Caspar
David
Friedrich,**
*The Chasseur
in the Forest,*
1814.
Oil on
canvas;
65·7×46·7cm,
25⁷⁸×18³⁸in.
Private
collection

Such pictures sprang from the two dominant trends in Friedrich's middle years, nationalism and naturalism. There is a paradoxical aspect to much of Friedrich's life that lends a particular edge to the search for reconciliation that underlies his art. The French occupation of Germany was also the period

of the painter's first success, much of which he owed to his
adoption of specifically nationalist themes. The Gothic
church, ruined or decayed, acquired a particular meaning for
him, as did the German forest. When in 1814 he celebrated
the expulsion of the French, it was with *The Chasseur in the
Forest* (76), a haunting image of a solitary French dragoon
lost in a wood of evergreens. It is a compassionate picture:
the invader's fate is just and inevitable, but also sad, and
seems to belong to the same higher natural destiny as the
forest's vigorous growth.

77
Johan
Christian
Dahl,
*Cloud Study
(Sky above
Dresden)*,
1825.
Oil on
paper;
21×22 cm,
8¼×8⅝ in.
National-
galerie,
Berlin

For Friedrich himself, the liberation of his country presaged
a period of happy stability, in which he was elected to the
Dresden Academy in 1816 and married two years later. It also
coincided with a new appreciation of the more naturalistic
painting practised by the Norwegian Johan Christian Dahl
(1788–1857), a master of vivid sketches from nature (77).
This, together with the removal of the stimulus of patriotic
resistance, rather diminished Friedrich's symbolic rigour. He
developed a broader handling of paint, and made a number

78
Caspar
David
Friedrich,
Morning
in the
Riesengebirge,
c.1810–11.
Oil on
canvas;
108×170 cm,
42¹₂×66 in.
National-
galerie,
Berlin

of studies of clouds and natural phenomena. The change
of interpretation and technique can be clearly seen in a com-
parison of two views of the Riesengebirge in the mountainous
area near Dresden known as 'Saxon Switzerland'. With his
friend Kersting he had made a tour of the mountains in the
summer of 1810. *Morning in the Riesengebirge*, painted shortly
afterwards (78), is another exposition of his theme of the cross
on a peak. The planes of earth and sky, representing the bodily
and the infinite, are bridged by the crucifix, lit by the morning
sun. Christ thus reveals himself in the vastness of nature, while
humanity's yearning path – to God, to understanding, and
ultimately to resurrection – is figured by a girl in white who

79
Caspar
David
Friedrich,
*The
Riesengebirge*,
*c.*1830–5.
Oil on
canvas;
72×102 cm,
28³⁄₈×40¹⁄₈ in.
National-
galerie,
Berlin

leads the climber up to the foot of the cross. In a later picture
of the early 1830s, however, Friedrich recollected his mountain
tour in terms of pure landscape, with only a shepherd to inhabit
it (79); the zones of earth and heaven are harmonized by
the melding vapour of morning mist. In *The Large Enclosure
near Dresden* (80), of 1832, Friedrich dispensed with figures
and delivered an almost surreal exposition of his mature
naturalism. There is a hallucinatory quality to this view of
marshy fields, in which the evening light is washed from the
sky and shadows reduce the distant trees to dark silhouettes.
Pools of standing water, reflecting the fading light, surround

**80
Caspar
David
Friedrich**,
*The Large
Enclosure
near Dresden*,
1832.
Oil on
canvas;
73·5×103 cm,
29×40½ in.
Gemälde-
galerie Neue
Meister,
Dresden

the viewer in a sweeping pattern. As so often with Friedrich, there is no foreground; the aerial viewpoint hovers somewhere over the middle of the field.

By 1835 Friedrich was paralysed by a stroke and largely abandoned oil painting. His last years were withdrawn, and he lived to see his work fall out of fashion or imitated by others who missed his subtleties. For the French sculptor Pierre-Jean David d'Angers (1788–1856), who visited Friedrich's studio in 1834, he was 'the only landscape painter who has yet been able to move all the faculties of my soul', one who has 'in fact created a new genre – the tragedy of landscape'. Dahl said that, of all his followers, 'none has yet understood how to recreate that silent sense of the spirit of nature that was characteristic of Friedrich's art.' Friedrich's use of symbol and allegory, his themes of transience and destiny, were easier to imitate than his crystalline colour, mysterious viewpoints and unique blend of realism and mystery.

By comparison, *The Banks of the Spree near Stralau* (81) by his Berlin admirer, the architect Karl Friedrich Schinkel

81
Karl Friedrich Schinkel, *The Banks of the Spree near Stralau*, 1817. Oil on canvas; 36×44·5 cm, 14¼×17½ in. National-galerie, Berlin

82
Karl Friedrich Schinkel, *Morning*, 1813. Oil on canvas; 76×102 cm, 30×40⅛ in. National-galerie, Berlin

(1781–1841), who took up painting when architectural com-
missions dried up during the Napoleonic occupation, is more
artificially composed within the span of an arch. On a stretch
of the Spree popular with river trippers from Berlin, two horn
players are ferried across after a day's festivities. At evening,
their work, like the fishing on the river, is done, and their
passage home becomes an image of human life, a crossing
with connotations of death, leading to a mysterious end. This
sort of apparatus was copied more often than Friedrich liked,
but Schinkel at least could use other symbolism, of a classical
type not used by his friend, and was capable of transcendent
natural effects. In his allegory of German regeneration,
Morning (82), painted in 1813 for the militant Prussian
nationalist August Wilhelm von Gneisenau, the view is
imaginary, leading to a classical city by a sunlit sea, antique
fragments of which lie overgrown in the foreground. This
Mediterranean culture is intended to denote the Renaissance,
and it is approached by two women in old German costume,

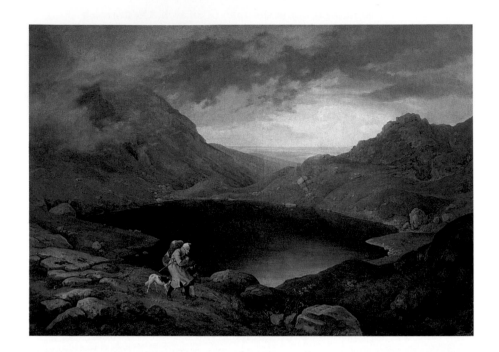

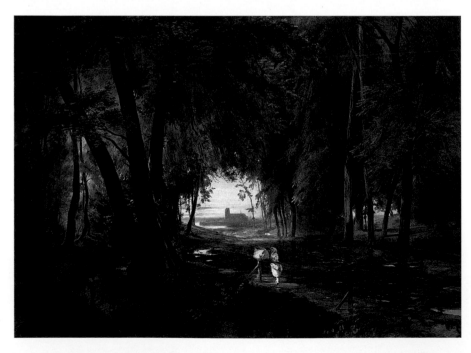

with their children rushing before them. Like Friedrich's chasseur, two guards in plumed helmets symbolize the Napoleonic order now passing.

Friedrich's programmatic paintings had not been universally admired. Among the dissenters were the young Dresden painter Ludwig Richter (1803–84), who in 1824 complained that Friedrich 'chains us to an abstract idea. He makes use of the forms of nature in a purely allegorical manner, as signs and hieroglyphs – they are made to *mean* that and that. In nature, however, everything expresses itself.' This implicit plea for a more expressive, less symbolically laden naturalism had in fact been answered by Friedrich himself in his later work, but the question remained – should artists impose their own interpretation, or seek to discover the 'spirit, the language' of nature itself? Richter's own attempts to do the latter include his *Pool in the Riesengebirge* (83), painted in 1839. The greater naturalism of this vivid scene, with wind and the empurpled clouds of sunset, certainly played a part in the subsequent direction of landscape painting in Germany. The Berlin painter Carl Blechen (1798–1840) had already returned from a visit to Italy where, like many young artists, he had practised outdoor oil sketching, to paint very freely handled park and woodland scenes such as *The Woods near Spandau* (84). But if Richter craved relief from the subjective, Friedrich's pupil Carus argued an opposite point of view, that pure naturalism missed its moral vocation.

Such issues were taken up in England by painters and also in the critical writings of John Ruskin (1819–1900). Ruskin praised Turner as the supreme painter of nature but in terms so personal that he more often described his own feelings than those of his subject. It was also Ruskin who christened the concept of the 'pathetic fallacy' – the idea that nature can express human emotions, or that we can imbue its inanimate forms with our own feelings. Such ideas were dear to the Romantics, but they were as likely to inspire pure invention as

83
Ludwig Richter, *Pool in the Riesengebirge*, 1839. Oil on canvas; 63×88 cm, 24³⁄₄×34⁵⁄₈ in. Nationalgalerie, Berlin

84
Carl Blechen, *The Woods near Spandau*, 1834. Oil on canvas; 73×101·5 cm, 28³⁄₄×40 in. Nationalgalerie, Berlin

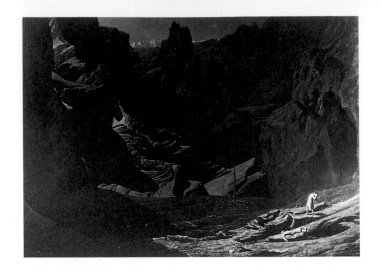

85
Francis
Danby,
*The Upas or
Poison Tree
of the Island
of Java,*
1819.
Oil on
canvas;
168·8×235·4cm,
66½×92¾in.
Victoria
and Albert
Museum,
London

a study of the real. The spine-chilling *The Upas* (85), by
Francis Danby (1793–1861), exhibited in London in 1820,
is a statement of loss of faith, realized through an imaginary
mountainous land laid waste by a poisonous tree; its full title
referred to Erasmus Darwin's poem *The Loves of the Plants*
(1789), a drama of quasi-human emotions in the vegetable
world. In truth, there was little difference between such
emotive fantasy and the desire to express pictorially the
sense of divinity in nature; in Runge's love of plant forms
(see 70–72) they had been combined.

James Ward (1769–1859), on the other hand, tried to express
his own emotionally charged faith through a masterpiece of
natural observation, his gigantic *Gordale Scar* (86) finished
in 1813. Here too, however, the towering expanse of rock
and thundering cataract, set beneath a stormy sky, takes on a
symbolism of its own. The encircling amphitheatre of the Scar
becomes a microcosm, and the beasts who graze or lock antlers
before it – few of which had actually roamed there since much
earlier times – emphasize its primordial state. The white bull
who watches over them is probably a very contemporary
mark of British resolve in the face of Napoleonic attack. Like
his great contemporaries, Ward had stretched the limits of
landscape; fellow artists recognized the poetic quality of the

86
James Ward,
Gordale Scar,
1811–13.
Oil on
canvas;
332×421cm,
130³⁄₄×165³⁄₄in.
Tate, London

picture, and a friend of its purchaser, Lord Ribblesdale, said it must be approached with 'Awe and a kind of reverential Expectation towards this Masterpiece of Nature's Wonders'.

If religious faith had moved Ward beyond what he called 'a rigid attention to truth' to a vision of a primitive universe, a similar motivation led a small and tight-knit circle of British artists towards an openly 'primitive' style, in which symbolism plays as strong a part as in Friedrich or Runge. Samuel Palmer and other young friends called themselves 'the Ancients' in recognition of their loathing of modern life and art, and retreated to the secluded village of Shoreham in Kent. Disciples of Blake, they were intensely moved by a set of tiny wood engravings Blake had made to illustrate a school edition of Virgil's *Pastorals* (1820); tender, elegaic and visionary, these struck Palmer with 'a mystic and dreamy glimmer as penetrates the inmost soul … unlike the gaudy daylight of this world' (87). They looked, too, at the hieratic, formally structured plates of Blake's *Book of Job*, and at prints by Dürer, Lucas van Leyden (*c.*1494–1533) and other early artists Blake himself admired. All these helped to suggest a pictorial language for their sense of wonder before a landscape abundant with God's purpose – trees cascading with blossom or fruit, ripe fields of corn,

87
William Blake, *Thenot and Colinet,* frontispiece to Thornton's *Pastorals of Virgil,* 1809. Wood-engraving; 6·2×8·4 cm, 2¹₂×3³₈ in. Tate, London

88
Samuel Palmer, folio 5 verso from a sketchbook, 1824. Pencil, brown ink and wash; 11·6×18·9 cm, 4½×7½ in. Victoria and Albert Museum, London

peacefully grazing sheep. 'Look for Van Leydenish qualities in real landscape, and look hard, long and continually,' Palmer noted in 1824 in a sketchbook whose pages preserve his transfiguring, enraptured imagination at work (88).

They are the source of his masterpiece, a set of varnished sepia and outline drawings of 1825, whose muscular, linear designs, exaggerations of proportion and selective focus are the deliberate marks of the innocence and *naïveté* Palmer brought to his vision. Here is a world seen and experienced afresh. In *Early Morning* (89) this sense of a new beginning, of spiritual rebirth, is made manifest through the rabbit climbing a sunlit path, and by the figures embowered by corn who have come out to hear the dawn chorus. On the mount Palmer wrote Chaucer's lines from his version of John Lydgate's *Complaint of the Black Knight*,

I rose anone and thought I would gone
Into the wode, to heare the birdes sing
When that misty vapour was agone
And clare and faire was the morning.

Palmer and his friends were transplanted Londoners. Their vision was intense but wishful, and could not be preserved for long. But for a few years it represented one of the peaks of Romantic nature-mysticism. Palmer wrote in 1828,

I doubt not but that there must be the study of this creation, as
well as art and vision; tho' I cannot think it other than the veil
of heaven, through which her divine features are dimly smiling;
the setting of the table before the feast; the symphony before
the tune; the prologue of the drama; the dream of antepast and
proscenium of eternity.

An archaic style was necessary to this vision of a cosmic
continuum, and in fact Palmer was aware, through mutual
friends of Blake in London, of the work of at least some
German artists who were pursuing their own revivalist trend in
landscape painting. By the second decade of the nineteenth
century, this was emerging as a strong counter to naturalism,
especially in Vienna, Munich, and among visitors to Rome.
The last, paradoxically, frequently joined their international
colleagues in oil sketching from nature but had very different
expectations from their pictures. Joseph Anton Koch, praised
by Friedrich Schlegel for the Germanness of such landscapes as

89
Samuel
Palmer,
*Early
Morning*,
1825.
Pen and
brown ink
and wash,
mixed with
gum arabic,
varnished;
18·8×23·2 cm,
7³⁸×9¹⁸ in.
Ashmolean
Museum,
Oxford

the spectacular *Schmadribach Waterfall* (90), actually rooted his
style of 'heroic landscape' in the very tradition of classicism
that Carus described as exhausted. This would have said little
to Palmer, but he would surely have recognized a kindred spirit
in Koch's friend Ferdinand Olivier (1785–1841), who used a
'primitive' style of tight hatching, reminiscent of woodcuts by
Dürer, to achieve the intense effect of his *Meadow before Aigen,
Friday* (91). In fact Olivier made marvellous nature studies of
twigs and leaves but looked for more than mere truth in his
finished works. His drawing of Aigen was one of a series of
scenes around Salzburg and Berchtesgaden made for a set of
prints of the *Seven Days of the Week* (1823), each of which was
associated with a particular sentiment or experience. Like
Palmer's sepias of three years later, these are landscapes of
association, in this case of the reward that comes with the
harvest, but also of a great if vanished age of German art.
The artist was later to become a member of the Lukasbund
(Brotherhood of Luke), whose historicizing art will be
discussed in Chapter 4.

Among English painters, none was better informed about
German artists than Turner. He met them in Rome and
travelled widely in Germany. It may come as a surprise,
therefore, that his encounters with German artists, and
German taste, were so unhappy. Late in life, he sent a picture
for exhibition in Munich of the classical structure known as
the Walhalla, built by King Ludwig I of Bavaria by the Danube
in honour of the German past. Intended as a compliment, the
picture was laughed at and returned damaged. Meanwhile,
in Rome in 1828 Koch led his German-speaking colleagues
in scurrilous attacks when Turner exhibited some new, perhaps
unfinished, paintings he had made during a summer residence
in the city. Lack of finish, or what one observer of the Munich
fiasco called 'want of exactness of portraiture in the place
represented', was the crux of the problem, for the Germans
found Turner's free and expressive handling incomprehensible.
'Oh painter!' Koch's satire ran, 'crapped is not painted.' But

90
Joseph Anton Koch,
The Schmadribach Waterfall,
1821–2.
Oil on canvas;
131·8×110cm,
51⁷⁸×43³⁸in.
Neue Pinakothek, Munich

91
Ferdinand Olivier,
Meadow before Aigen, Friday, from *Seven Plates in Salzburg and Berchtesgaden,* 1823.
Lithograph;
19·5×27·2cm,
7⁵⁸×10³⁴in

for Turner, reproducing through paint the energy and flux of natural forces, whether of waves or clouds or of the sparkle of light, was central to the dramatic character of his landscape art. It was through this sense of drama that he sought to provide the kind of new direction for landscape that Runge and Friedrich had claimed, and paint was the language in which it must be acted.

For a landscape painter, Turner was remarkably uninterested in the substance of landscape. His trees are schematic, if elegant; plants are rarely recognizable. Only mountains are allowed convincing material form. Climate fascinated him, the seasons far less. Long and complex as his picture-titles could be, heavy with historical or mythological baggage, the most revealing are those that describe pure effects or abstractions – *The Sun Rising through Vapour* from early in his career, or the late *Rain, Steam and Speed* (see 100). Already in 1816 the critic William Hazlitt charged him with painting less 'the objects of nature than … the medium through which they are seen', and by the end of his life his art had largely resolved itself to the play of the elements. But the natural phenomena Turner painted are not necessarily – as for Friedrich, Runge or even Constable – symbolic revelations, or evidence of the divine; they have an arbitrary life of their own. While light was, for him, a supremely liberating force, it could also be cruel, and in one of his Roman exhibits of 1828, *Regulus* (92), it dazzles and appals. The Roman general Regulus had had his eyelids cut off by the Carthaginians, leaving him to be blinded by the North African sun, and Turner seems to have left his tragic hero out of the picture so that we experience the blazing glare in his place.

Like so much of Turner, *Regulus* is at once almost perversely conservative and startlingly new. It apparently reworks familiar seaport compositions by Claude Lorrain, but deconstructs them through shimmering refractions of light. The art of the past, and the urge to outdo and transform it, had been central

to Turner's development. No artist of the age was more conscious of history, or more ambitious to make his original mark. As a young man he was found in tears of frustration before pictures by Claude in the house of his patron William Beckford. He would never be able to paint anything like them, he said; but in time he found the confidence to require that two of his own pictures should hang in perpetuity with Claude's in the National Gallery – as they still do today – and that his own collection of his work should be housed in an adjacent Turner Gallery. By this time, his art had an almost encyclopaedic range, spanning nearly every recognized field of subject matter as well as new subjects that he had made his own, and the styles of many great artists of the past, both literally echoed and transformed. Turner's output was, as he well knew, unique in its time, and his demanding claims for it reveal an almost exhibitionist side of his professional character. He delighted in such opportunities to shock and surprise as the 'varnishing days' at the Royal Academy, when pictures were finished for exhibition and he could put on a display of his idiosyncratic technique, making sense from sketches that, to one colleague, appeared at first 'without form and void, like chaos before Creation'. The contrasts and opposing dynamics of his art, expressed so palpably in his treatment of paint itself, were mirrored in his character. For he was also a reclusive, deeply private man, obsessed by his work, many of whose pictures can only have been painted for himself; a profound pessimist who wrote fragments of a poem called 'The Fallacies of Hope' to attach to his exhibits; and a depressive whose resolve, in old age, had so far flagged that he could not be bothered to look after the works he intended for posterity. No artist of the age comprised more completely within himself the Romantic arrogance of genius, and its compulsion to hermetic withdrawal.

Turner's beginnings were modest. A London barber's son with little real education, he had thought of becoming an architect but got no further than the drawing offices of other architects. He took up the popular and lucrative business of topographical

92
**J M W
Turner**,
Regulus,
1828,
reworked
1837.
Oil on
canvas;
91×124 cm,
35⅞×48⅞ in.
Tate, London

watercolours, often made for engravers. For much of his life he kept up this sort of work, though taking increasing control of it himself and striking demanding deals with publishers. His considerable wealth owed much to his clever management of this aspect of his business. He was well paid, for his images made for publication rapidly progressed from literal descriptive views to complex, animated designs rich in allusion. Topography, moreover, soon led to more ambitious work in watercolour, for which he undertook a routine, maintained for most of his life, of summer travelling, first in Britain during the long years of the Napoleonic Wars, then often on the Continent, to gather material to work up in his studio during the winter. As early as the mid-1790s, his experiences of natural scenery, on the way to such popular 'commercial' sites as abbeys, castles or cathedrals, had given him a new feeling for pure landscape, and his technical command of watercolour was outstanding.

Studies at the Royal Academy raised Turner's ambitions but inculcated no respect for the traditional heirarchy of genres. He was determined to make landscape his own, and demonstrate that it had an inherent moral significance. This required him to take up oils, and even an early picture, *Morning amongst the Coniston Fells* (93), the result of a tour in the north of England in 1797, shows an original awareness of the drama of nature with its subtle play of early sunlight and dispersing mist. There is no overt religiosity, as in Friedrich's cross (see 67), but Turner also chose the upright format associated with the altarpiece, and added further significance by quoting verses alongside his picture in the Academy catalogue. He never painted a purer landscape, and the forces of nature take the place of human or mythological protagonists.

It was in marine painting, then regarded virtually as a branch of landscape, and in mountain subjects that Turner's personal vision was first clearly seen. In both the Old Masters played a part. His first exhibited oil had been a moonlit sea-piece, and

93
J M W
Turner,
*Morning
amongst the
Coniston
Fells,*
1798.
Oil on
canvas;
123×89·7 cm,
48³⁄₈×35¼ in.
Tate, London

94
**J M W
Turner**,
*Dutch Boats
in a Gale (The
Bridgewater
Sea-Piece)*,
1801.
Oil on
canvas;
162·5×221 cm,
63×87 in.
National
Gallery,
London

95
**J M W
Turner**,
*The Fall of an
Avalanche in
the Grisons*,
1810.
Oil on
canvas;
90×120 cm,
35³⁄₈×47¹⁄₄ in.
Tate, London

it was as a companion to a picture by the Dutch painter Willem van de Velde (1611–93) that the future Duke of Bridgewater commissioned *Dutch Boats in a Gale* (94) in 1801. Turner responded with a vivid account of churning seas and a sky divided between storm clouds and breaking sunshine, in which all is moving and changing. His vigorous painting of waves, viewed from within their troughs, showed his urgent sense of the medium. Impressed by such reinventions of the masters, a consortium of his patrons clubbed together to send him to Paris, during an interlude of peace in 1802, to study in the Louvre. He first embarked on a tour of the Alps, whose bleak splendour and subjection to constant climatic and geological change taught him the awesome scale and mutability of nature. The Alpine tour resulted in some spectacular watercolours but also, later, in paintings that progress to a more universal, and disturbing, statement of humanity's place in the world. He had not, in fact, witnessed an avalanche in 1802, but news of a devastating one in the Grisons in 1808 seems to have prompted him to his picture of 1810 (95), in which huge rocks, driven before the weight of snow, crush a tiny chalet. Without a single human figure, it is a terrible revelation of human vulnerability and natural power – and of the potential of landscape as a 'Grand Style' in its own right.

The raw energy and propulsion of this picture seems to mirror the forces at work in Turner's own development. After 1802 his art pursued diverse directions, in which the only real consistency is his inquiry into elemental effects and the power of light. While the mythological and classical background to the triumph of light over dark, good over evil, was explored in Old Masterly history pictures – Jason in search of the Golden Fleece, Apollo outwitting the dragon Python – its actual operation in the visible atmosphere was studied in more modest views of the pastoral English landscape and the Thames Valley. The Yorkshire scene *Frosty Morning* (96) has an air of numbing chill, with rime glistening on earth and wild plants. His classical subjects still looked to Claude and Nicolas

Poussin (1594–1665), his English subjects to the Dutch painter
Albert Cuyp (1620–91), but in both Turner was demonstrating
his own contribution to their tradition and, in the latter, the
benefits of study direct from nature. As visions of his own
country, and its 'national' river, under transcendent effects
of light, his English subjects had something of the same
patriotic message of Friedrich's wartime landscapes. Already,
however, he found himself accused of parody by conventional
critics and connoisseurs like Sir George Beaumont, and it is

difficult to resist the impression that he was aware of the
liberation to come in his art: that the Old Masters were a
burden that must be thrown off before he could emerge as
completely himself.

By the time Turner reached his forties, the art of the past
pressed uneasily on his own impressions, and the ideal on his
view of nature. These tensions are clear in the huge picture
he painted after his first visit to Italy in 1819, *Rome, from the*

Vatican (97). Few other pictures display such a blend of conservatism and prophecy. Intended as the tribute to Italy that he presumably felt was expected of him, it focuses on the figure of Raphael, seen with his mistress and model, and specimens of his own and other artists' work beneath his decorations in the Vatican Loggia. But the picture goes beyond Raphael's own High Renaissance era, extending its view across the arcades built later by Gianlorenzo Bernini (1598–1680) around St Peter's Square, and then to the distant mountains. Its subtitle declares it a history picture – Raphael 'preparing his Pictures for the Decoration of the Loggia' – but should not be taken literally; nor should the anomalies of perspective by which Turner (by now the Academy's professor of perspective) compresses as much as possible into his view. His purpose is to show *all* that Italy meant to him, and it is striking that the brilliant azure sky claims as much attention as anything below it. From the urban arena of art and history, Turner looks out to sun and air – and into his own future.

96
J M W
Turner,
*Frosty
Morning*,
1813.
Oil on
canvas;
113·5×174·5 cm,
44³⁄₄×68³⁄₄ in.
Tate, London

Turner's second Italian visit in 1828 reawakened his interest in classical themes but encouraged a still more penetrating exploration of the Italian atmosphere; *Regulus* (see 92) brought these elements together. It is no accident that Turner's subjects in the second half of his career often contrasted past and present – ancient and modern Rome, Venice in her historic prime or his own Britain flush with mercantile and industrial success. These contrasted pictures, intended to function in pairs, appealed to current notions of cyclical movements in history and a Romantic fashion – encouraged by the poetry of Byron that he liked to quote – for finding beauty in the sadness of decay (see Chapter 4). But they also expressed the changes that he recognized in nature and strove to match in the physical act of painting. Hazlitt's famous comment on his work – 'Pictures of nothing, and very like' – applied only to his abstract handling, and his themes, even those in the broad tradition of 'historic landscape', were chosen to function in counterpoint to his revelations of the play of elements, and the power of light

97
J M W
Turner,
Rome, from
the Vatican,
1820.
Oil on
canvas;
177×335·5 cm,
69³⁄₄×132 in.
Tate, London

and colour. This did not mean that the private studies in oil of sky or waves (98), or even of apparently pictorially 'complete' landscapes like the famous *Norham Castle, Sunrise* (99) painted in the 1840s as a reconsideration of an earlier composition, should be given undue significance any more than the water-colour 'beginnings' that he had made for his designs since at least the 1820s. It is unlikely that he intended many of them to be exhibited. In public, Turner sought a synthesis of subject and meaning, and of the visual impact of his understanding of nature, in which he was uniquely inventive. While he could use the traditional theme of the biblical Flood to contrast opposing spectra of lights and darks, and their associations of negative

98
J M W
Turner,
*Waves
Breaking on
a Lee Shore,*
*c.*1835.
Oil on
canvas;
60×95 cm,
23¹₂×37¹₂ in.
Tate, London

99
J M W
Turner,
*Norham
Castle,
Sunrise,*
1845.
Oil on
canvas;
90·8×121·9 cm,
35³₄×48 in.
Tate, London

and positive as described in his own, richly annotated, copy of Goethe's *Theory of Colours* (*Farbenlehre*), he was also the first to bring the new industrial achievements of steamships and railways into his art as counterparts to his exploration of natural energies. In *Rain, Steam and Speed* (100), the natural drama of sunshine and passing showers sets a stage for the dark engine trundling across the Thames near Maidenhead, its smoke mingling with mist and its speed still – just – matched by the hare running before it, a single material form brought forth from the diffuse textures of Turner's paint. This extraordinary picture has the same fugal quality as Runge's *Nightingale's Lesson* (see 70).

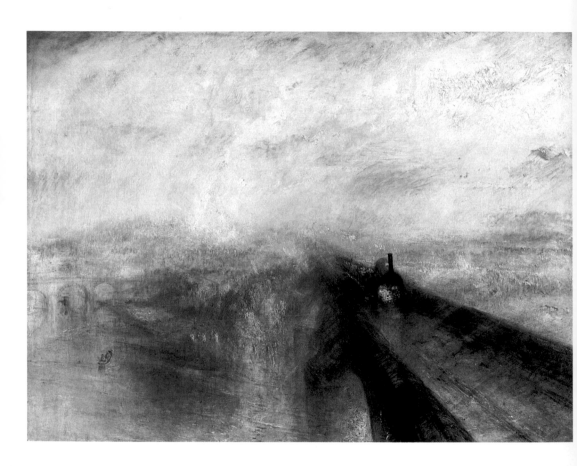

100
J M W
Turner,
Rain, Steam
and Speed,
1844.
Oil on
canvas;
91×122 cm,
35³⁄₄×48 in.
National
Gallery,
London

In late nineteenth-century France the Impressionists came to treasure the atmospheric effects of such pictures while rejecting in many others 'the exuberant romanticism of his fancy'. The complex, synthetic patterns of Turner's meanings must be reconstructed from his point of view, not theirs. For the French Romantics, it was Turner's near contemporary, Constable, whose more overtly naturalistic landscapes had most to offer. In 1824 Constable sent his *Hay Wain* (101) to the Paris Salon, where it created a remarkable impression, not least on Delacroix who repainted the foreground of his *Massacres at Chios* (see 170) in imitation of its shifting lights achieved through broken colour and flickering brushwork. The near-definitive naturalism of this large English landscape – now so familiar it is impossible to retrieve any sense of its original impact – was the considered (perhaps too considered) statement of a mission undertaken some nineteen years earlier. In 1802, the same year that Runge longed for a new 'landscapery', Constable had written to his friend John Dunthorne of his proposed summer visit to his parents in the East Anglian village of East Bergholt: 'I shall endeavour to get a pure and unaffected manner of representing the scenes that may employ me. There is room enough for a natural painture.'

Constable's wording may be idiosyncratic, but his meaning – a newly truthful landscape art – is clear. The radicalism of this statement must be judged against the background of a wider contemporary movement towards pictorial naturalism resulting from Romantic attitudes to nature, and the contradictory pressures emanating from Constable's immediate training and circle. In this and the following decades, artists in Britain and elsewhere variously attempted a clear-eyed view of familiar scenes of nature. John Linnell (1792–1882), who in 1811–12 painted the realist working landscape *Kensington Gravel Pits* (102), was along with William Mulready (1786–1863) one of a group of pupils of the watercolourist John Varley (1778–1842), who took them on sketching expeditions by the Thames and urged them to 'go to nature for everything'. They went much

101
John
Constable,
The Hay Wain,
1821.
Oil on
canvas;
130·2×185·4cm,
51³⁄₈×73in.
National
Gallery,
London

further than most in assimilating the implications of nature study into pictures meant for exhibition, and in this sense their outdoor oil sketches, like those made by Constable himself, are not to be compared to those made by Continental artists in the same period to train their hand and eye, or to assemble a library of motifs for incorporation into studio compositions. But Constable disliked Linnell and Mulready, comparing the effect of their vernacular pictures to being 'smothered in a privy'; indeed their approach was sometimes more 'unaffected' than his own, not least in its portrayal of labour. Though Constable's is certainly a working landscape, with man-made mills, dams and canals, it is always harmonious. His view is proprietorial and paternalistic, strongly qualified by his status as the son of

102
John Linnell,
*Kensington
Gravel Pits*,
1811–12.
Oil on
canvas;
71·1×106·7 cm,
28×42 in.
Tate, London

a prosperous miller, a representative of the employing class suspicious of a workforce that was increasingly restive. Today it may seem that his pictures created instant nostalgia for an urban audience not qualified to judge their truth. Yet it was this same audience that wanted pictures to look like the painted landscapes they knew; who urged on him a greater adherence to the Old Masters; and who denied him professional honours such as those lavished on Turner. It was these attitudes that prompted Constable to his other main resolve in 1802: to stop 'running after pictures and seeking the truth at second hand'.

An artist so clearly committed to a personal manifesto must be judged on his own terms, and with Constable the results are

mixed. His sceptical attitude to the Old Masters resulted not in rejection but in a selective reinterpretation, as in the upright view of his native landscape, *Dedham Vale* (103), painted in 1802 as a tribute to a painting by Claude, *Hagar and the Angel*, then owned by Constable's early mentor Sir George Beaumont (and now in the National Gallery, London). Constable recast the scene in a fresh, sparkling palette of greens and golds and with a light touch with the brush. These were qualities that he admired in Peter Paul Rubens (1577–1640), by whom Beaumont also owned an important picture, the *Château de Steen*. Constable identified with Netherlandish painters' dedication to their own characteristic landscape and strong sense of place. They were, he said, 'a *stay-at-home* people – hence their originality'. While he conducted his own, more subtle, dialogue with the Old Masters, Constable saw no need to follow Turner in looking at landscapes in Italy or the Netherlands; he never went abroad, citing the remark of a Suffolk villager that crossing the River Stour was like departing from his homeland. Apart from a rather unsatisfactory visit to the Lake and Peak Districts in 1806 – where 'the solitude of mountains oppressed his spirits' – he kept to the south of England and mainly to the scenery of his youth. For all his attachment to the Stour Valley, however, he spent most of his life in London and constructed his vision of it as a summer visitor whose outlook had become metropolitan, and – as he admitted – distanced by time: 'I associate "my careless boyhood"', he wrote in 1821, 'with all that lies on the banks of the Stour; those scenes made me a painter, and I am grateful.'

The autobiographical character of his art is a large part of what makes Constable a Romantic. So too is his emotional conviction. It was on this same occasion that Constable declared that 'Painting is with me but another word for feeling', emphasizing the processes of reflection and recollection that conditioned his picture-making. Thus, though Constable soon came to the conclusion that pictures must be rooted in direct observation, and based on sketches made on the spot, he also

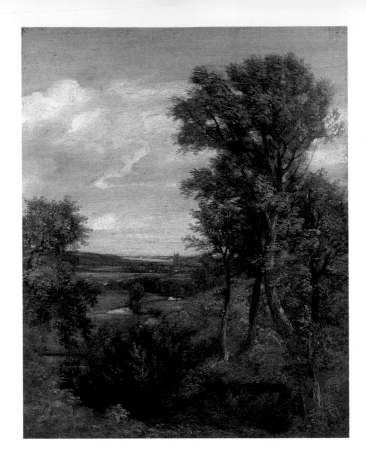

103
John
Constable,
Dedham Vale,
1802.
Oil on
canvas;
145×122 cm,
57⅛×48 in.
Victoria
and Albert
Museum,
London

believed that a sketch 'will not serve to drink at again & again –
in a sketch there is nothing but one state of mind – that which
you were in at the time'. For him, the relationship of a sketch
to a finished picture came to correspond to that of vivid
childhood memory to subsequent experience.

Constable fully shared the Romantic view of the divine purpose
in nature – 'on whatever object I turn my Eye that sublime
expression of the Scripture "I am the resurrection and the life"
… seems verified about me', he wrote in 1819 – and to study it
was a form of communion. But Constable's oil or pencil sketches
do not have the obviously devotional quality of, say, one of
Friedrich Olivier's studies of a dying leaf. Oils like *Flatford Mill
from a Lock on the Stour* (104) are instead bravura displays of a
thickly loaded brush or palette knife, worked at speed in rich
colours, setting out bold masses and forms as well as transient

effects of weather or time, and they are usually already complete pictures in embryo rather than fragments of the whole. Moreover, their subjects are as often the works of man in nature as nature itself, tending and using the landscape. Here indeed – and Constable was an admirer of Coleridge – 'we receive but what we give,/And in our life alone does Nature live.'

In the case of *Boat-Building on the Stour* (105), Constable seems to have first attempted to bring together the sketch and the picture, claiming he had painted the work entirely on the spot. However, the existence of a pencil drawing, from which this composition differs little, must qualify his account; in any case the spontaneous verve of his 'pure' sketches is certainly absent, as is any real sense of outdoor lighting. The picture has the unmistakable air of the studio about it, and demonstrates Constable's difficulties in preserving the immediacy of his impressions in the more considered versions he believed it necessary to produce. The problem became acute in the series of large 'six-footer' canvases on which he staked his reputation, and for some of which he painted full-size oil sketches. Ironically the French admirers of the *Hay Wain* thought that it was itself a 'sketch', but the differences in Constable's own conception can be judged from comparison of the two versions of the *Leaping Horse* (106, 107). This belongs late in the series, when, from the noble serenity of the *Hay Wain*, he sought to progress to a greater sense of theatre. Here he has tried to freeze a sudden action – the leap of a barge horse over a cattle barrier on the Stour towpath. But to the modern observer his own description of the picture, written shortly before it was ready for the 1825 Academy exhibition – 'calm & exhilarating, fresh & blowing' – applies more happily to the sketch; the greatest sufferer in the finished canvas is the sky, which has lost its bubbling clouds.

Since the early 1820s Constable had made oil studies of the sky that were often carefully annotated with time, place and effect. He called it his 'skying', and it showed the empiricism that

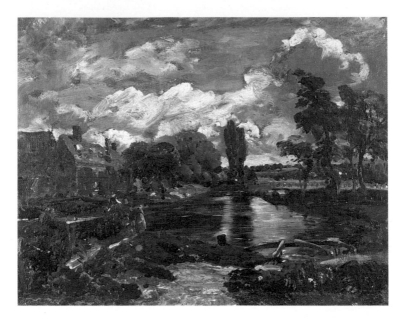

**104
John
Constable**,
*Flatford Mill
from a Lock
on the Stour*,
*c.*1811.
Oil on
canvas;
24·8×29·8 cm,
9³₄×11³₄ in.
Victoria
and Albert
Museum,
London

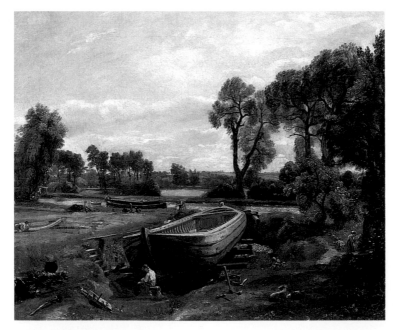

**105
John
Constable**,
*Boat-Building
on the Stour*,
1814–15.
Oil on
canvas;
24·8×29·8 cm,
9³₄×11³₄ in.
Victoria
and Albert
Museum,
London

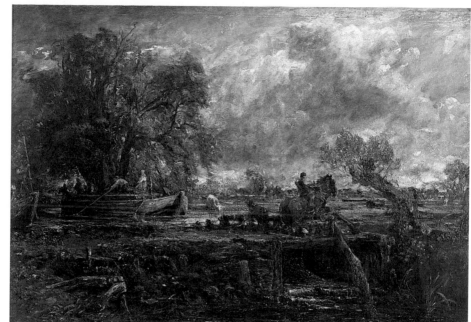

106
John Constable,
Sketch for
The Leaping Horse,
1824–5.
Oil on canvas;
129·4×188 cm,
51×74 in.
Victoria and Albert Museum, London

107
John Constable,
The Leaping Horse,
1825.
Oil on canvas;
142×187·3 cm,
56×73¾ in.
Royal Academy of Arts, London

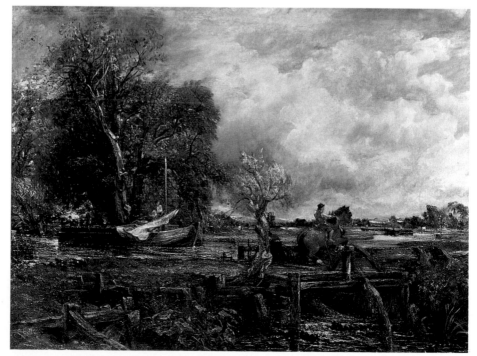

underlay his concept of his profession – 'a science … pursued as an inquiry into the laws of nature' as well as a branch of 'natural philosophy'. But the purpose of his observations was as emotive as pictorial, to inform his pictures' 'key note, the standard of scale, and the chief organ of sentiment'. In his later years his experience of sombre, stormy or twilight effects fed directly into an increasingly dark and melancholy view of the world. He spoke of the 'chiaroscuro of nature', of its 'bolder phenomena', not merely as the source of uplifting revelations like the double rainbow that slices the stormclouds in a late watercolour of Stonehenge (108) or of the drama of light that plays through the series of mezzotints *English Landscape Scenery*, created by his friend David Lucas (1802–81) from his pictures, but as the counterpart of inner distress, and the turmoil he sensed in modern life. The death of his wife in 1828 darkened his mind, and even before this, news of agrarian hardship in Suffolk and unrest among the rural labourers – the combined result of recession after the Napoleonic Wars and of mechanization on the farms – dealt a fatal blow to his sense of natural harmony. His essentially conservative mind feared the worst

108
John
Constable,
Stonehenge,
1836.
Watercolour;
38·7×59·1cm,
15¹⁄₄×23¹⁄₄in.
Victoria
and Albert
Museum,
London

109
John
Constable,
Sketch for
*Hadleigh
Castle,*
*c.*1829.
Oil on
canvas;
122·6×168cm,
48¼×66in.
Tate, London

from liberal measures like the 1832 Reform Bill, the first step
towards creating democratic voting procedures, and he brooded
on the decline of the Church. While such concerns are absent
from his subject matter, they affected his style, and the handling
of such late pictures as his sketch for *Hadleigh Castle* (109)
became nervous and febrile. The animated brushwork he had
developed to show the sparkle of light on water, the trembling
dance of leaves in the wind or the billowing of summer cumulus
seemed briefly to lose direction. Yet Constable found the act of
painting itself some consolation and his now-sombre effects a
release: 'still the darkness is majestic and I have not to accuse
myself of ever having prostituted the moral feeling of Art … My
canvas soothes me into forgetfulness of the scene of turmoil
and folly and worse.'

Constable's 'natural painture' never amounted to realism.
It certainly elevated the familiar and prosaic – never before
made the subject of large easel pictures – but it was always
modified by his aspirations towards 'moral feeling' and his
high sense of 'Art'. Nevertheless, it had been radical enough
to hold him back from professional recognition until late in
his career, and to impart a sense of struggle and frustration

to much of his life. Unlike Turner, he was often not so much controversial as ignored.

A somewhat parallel experience was that of his French admirer Théodore Rousseau (1812–67), whose even more direct and homespun landscapes were often excluded from the Salon. Rousseau was a leading figure in a group of young artists who came to work around the village of Barbizon in the Forest of Fontainebleau in the 1830s, and whose depictions of the wooded and marshy scenery set new standards of realism uncompromised by emotion. Rousseau was exceptional among them, however, and his *Oaks at Apremont* (110), of 1852, adds a Turnerian sense of the wonder of midday sunshine and a Romantic appreciation of the majesty of nature to its essentially humble subject. To the realist trend shown by the Barbizon painters – which generally led away from Romantic emotionalism, although their retreat to work in a secluded landscape exemplifies the movement's idealizing escapism – the career of Jean-Baptiste-Camille Corot (1796–1875) constituted the leading French exception. His early works followed his experience of open-air oil sketching on a youthful visit to Italy, and were criticized for their very modesty and clarity. But he moved to a haunting evocation of landscapes of memory and wistful, ideal harmony, expressed in a distinctive tremulous technique (111). He was, in effect, a late convert to Romanticism when others had moved on.

The intensity of feeling and individual response in Romantic landscape painting could not long survive the erosion of the strong religious sense that informed it. The Impressionists were to take over the technical and atmospheric achievements of Turner and Constable, but not their belief in the morality of nature and art. The quest for a sense of place in the eternal universe that inspired Friedrich, Runge and Palmer had nothing to offer them in their pursuit of the momentary. In a Europe becoming remorselessly urban and industrial, Carus's cloaked wanderer trudging away into the

110
Théodore
Rousseau,
*Oaks at
Apremont,*
1852.
Oil on
canvas;
63×99 cm,
24⁷⁄₈×39 in.
Musée du
Louvre,
Paris

111
Jean-
Baptiste-
Camille
Corot,
*The Gust
of Wind,*
1865–70.
Oil on
canvas;
40×56 cm,
15³⁄₄×22 in.
Musée du
Louvre,
Paris

high mountains with his pilgrim's staff (112), though painted about 1820, strikes a suitably symbolic farewell to the Romantic religion of nature. It was in the New World, which could still be seen with a fresh eye and whose vastness and splendour offered its European settlers a unique revelation of divine providence and human destiny, that the Romantic vision was preserved longest. Wordsworth found an heir in the French-Scottish writer Henry David Thoreau, who retreated to a cabin at Walden Pond in Massachusetts to chart its wildlife

112
Carl Gustav Carus,
Pilgrim in a Rocky Valley,
*c.*1820.
Oil on canvas;
28×22 cm,
11×8⁵⁄₈ in.
National-galerie,
Berlin

113
Asher B Durand,
Kindred Spirits,
1849.
Oil on canvas;
117×92 cm,
46×36 in.
New York Public Library

and seasons, who appointed himself 'inspector of snow-storms and rain-storms', and – not entirely in jest – 'a mystic, a Transcendentalist, and a natural philosopher to boot'. About the same time, in 1849, Asher B Durand (1796–1886), a leading figure in the 'Hudson River School' of American landscapists, painted *Kindred Spirits* (113) in memory of his fellow painter Thomas Cole (1801–48), who had brought his own strong faith, and a style honed on Turner and other

European Romantics, to bear on the American wilderness in pictures like his *Falls of the Kaaterskill* of 1826 (114). Durand painted Cole and the poet William Cullen Bryant standing on a rock over a ravine in these very mountains (the Catskills) sharing a moment of communion with the visible world and its creator. Despite a prosaic technique, there are few more Romantic landscapes, nor more revealing glimpses into the Romantic mind.

114
Thomas Cole, *Falls of the Kaaterskill*, 1826. Oil on canvas; 109×92 cm, 43×36 in. Warner Collection of Gulf States Paper Corporation, Tuscaloosa, Alabama

On 12 May 1842 the young Queen Victoria and her consort
Prince Albert held a spectacular costume ball at Buckingham
Palace. Nothing if not sensitive to the needs of their subjects
and the requirements of British manufacturing, they had
become concerned at the plight of the Spitalfields silk industry,
a luxury trade now under pressure from mass production.
It was ostensibly to give it some much-needed business for
extravagant fabrics that they chose to return their guests to a
time long before industry was imagined – the golden age of
English chivalry. 'I wish you cd. see', Victoria wrote excitedly to
her uncle Leopold of the Belgians; 'we are to be Edward III and
Queen Philippa, & a gt number of our Court to be dressed like
the people in those times, & very correctly … so many silks &
Drawings & Crowns, & God knows what, to look at, that I, who
hate being troubled about dress, am quite confuse.' The royal
couple's costumes – for the queen a surcoat of blue and gold
brocade bejewelled and lined with miniver, beneath a silver and
gold mantle; for the prince a golden surcoat styled from the
funeral effigy of Edward III in Westminster Abbey – can be seen
in the commemorative double portrait (115) commissioned by
Victoria from her favourite painter, Edwin Landseer (1803–73).
Two Gothic chairs replaced their thrones for the occasion.

'Masques', declared the *Illustrated London News* in its report
of the ball, 'have been in all ages the recreations of Courts.
The name brings with it reminiscences of romance, history,
and poetry.' The period recreated in this case, the Middle
Ages, was imagined as a time of chivalry, Christian faith and
a paternalistic monarchy and nobility. The ball marked a
magnificent climax of a 'Gothic Revival' that encompassed not
only Britain, but continental Europe and even America. How
and why that revival developed, what it meant to its enthusiasts,

115
Edwin
Landseer,
*Queen Victoria
and Prince
Albert at the
Costume Ball of
12 May 1842*,
1844.
Oil on canvas;
142·6×111·8cm,
56⅛×44in.
Royal
Collection

193 The Romantic Sense of the Past

and why nations vied with each other to claim the Gothic style as their own, will occupy a large part of this chapter. For while it was far from being their only historical concern, it was the outstanding manifestation of the Romantics' nostalgia for the past.

Yet the Gothic had been largely forgotten, or actually reviled, only a century before. An early sign of change came in a novel published in 1764 and still popular eighty years later, Horace Walpole's *The Castle of Otranto*. It begins with a gigantic medieval helmet crashing to the ground, the first of a series of alarming manifestations of the ancient lord of the fortress, Alfonso the Good, whose ghost eventually demolishes the castle. Walpole claimed he was inspired by a dream of a monstrous mailed fist – 'a very natural dream for a head filled like mine with Gothic story'. But such dreams, and Gothic stories, were not natural at the time. The helmet is a thunderbolt from history, a message from the Middle Ages to disturb Walpole's classically educated contemporaries. His book was an instant hit, among the first and most influential of the 'Gothic' tales – shocking, ridiculous and 'horrid', set in tumbledown fortresses or gloomy ruined abbeys – that were to be a favourite Romantic literary form, raising the emotional temperature of their characters and readers to extremes unimaginable in more ordinary surroundings. Like William Beckford, his rival as a 'Gothic' writer, who later built the monomaniacal Fonthill Abbey (116), Walpole was also a pioneer in medievalizing architecture and decoration. In 1765 he told a friend, 'Though I write romances, I cannot tell how to build all that belongs to them.' But within a decade he had completed most of Strawberry Hill, his famous house at Twickenham. With its stained glass, fan vaulting and collections of armour and other antiquarian relics, all described in an elaborate illustrated guidebook, it was a personal manifesto. More or less single-handedly, Walpole launched the Middle Ages as the Romantics' period of choice.

116
Charles
Wild
*Fonthill
Abbey*,
c.1799.
Watercolour;
29·2×23·5 cm,
11½×9¼ in.
Victoria
and Albert
Museum,
London

The vaulting in the Gallery at Strawberry Hill (117) was based
on Westminster Abbey but was made of papier mâché rather
than stone. Some visitors to the house were put off by its
undeniably sham atmosphere, yet it could also leave lasting
impressions. Walpole had a soft spot for foreign visitors, one
of the most interesting of whom was a French antiquarian,
Seroux d'Agincourt, friend of Voltaire, Rousseau and the
Enlightenment *philosophes*. Showing him around, Walpole
advised him to go and look at real Gothic cathedrals, which
Seroux went on to do in the Netherlands and northern
Germany – a formative influence on his ambition to do for the
Middle Ages what other writers had done for antiquity. Seroux's

great history of art 'from its decadence in the third century to its revival in the sixteenth', copiously illustrated with specially commissioned images of buildings, frescos, sculptures and relics, was eventually published in Paris in 1823, nine years after his death. It showed him to have been a pioneer in reclaiming a lost age, who adopted an exceptionally comprehensive and sensitive approach to history. He showed that art was itself a measure of history, a key to human experience. His writing, moreover, evinced an imaginative empathy with past lives, as when he described the frightened Christians hiding from Roman persecution in the Catacombs. In one of the most touching plates from the book, Seroux himself appears in those melancholy vaults, meditating by lamplight over an open tomb, while the names of the dead can be seen inscribed on the tablets scattered around him (118).

117
Thomas Pitt
and John
Chute,
The Gallery,
Strawberry
Hill,
1760–3

Seroux's book was prophetic. A new interest in the history of art, expressed both in the study and in the imitation of past styles of architecture and painting, decoration and dress, and a yearning somehow to connect with the dead were to be central to the Romantics' historical sense. In his imaginative sympathy with his subjects, Seroux went further than Edward Gibbon, whose *Decline and Fall of the Roman Empire* (1776–81) appeared in time to influence his work. Gibbon's great book is the climax of the eighteenth century's preoccupation with the classical age, and also of its dominant rationalism; the author expected his historical characters to think and behave like his eighteenth-century readers, and judged them by their standards. Seroux made no such assumptions. What these two historians shared, however, was a new sense of history's potential as a warning: both feared that the decline and decadence they described could happen again.

The concept of history as an epic panorama, stretching across time and space, embracing the present and even the future in a continuum, was central to Romantic thinking. Though they acquired a special appeal, the Middle Ages were only part of

118
*Seroux
d'Agincourt
Meditating
in the
Catacombs*,
print from
Seroux's
*Histoire de
l'art par les
Monuments*,
Paris, 1823

this panorama, which now came to include non-classical periods
and cultures – prehistoric, primitive or exotic – as well as the
classical world itself. This inclusiveness sprang from the en-
larged historical theories of pre-Romantic philosophers such
as the German Johann Gottfried Herder, whose 'philosophy
of history' challenged the absolute standards held to descend
from ancient Greece. He argued instead that human achieve-
ments and actions must be judged by their historical context,
and in this light had equal validity. The effect of this thinking
was to expand awareness of the world and its multitudinous
cultures (see Chapter 5) and of historical time. This was what
the English historian Lord Acton meant when he judged that
Romanticism had 'doubled the horizon of Europe' by bringing
into play 'the whole inheritance of man'. This expansion was
profoundly unsettling, for it did away with the Enlightenment's
faith in progress, to which both Seroux and Gibbon still held
true. It was no longer possible to believe that all past ages –
save Classical Greece – were somehow inferior to the present,
and had been but stages leading up to it.

The Romantics were obsessed by the past. It was they, rather than Enlightenment thinkers, with their passion for organizing and classification, who did most to create the modern concept of the museum. They were passionate antiquarians, collectors of relics of past ages – furniture, armour, costume. Such collecting was not in itself new, but the emotional forces that drove the Romantics to collect were of a different order. Their trophies were not gathered merely as rarities, curiosities or even documents, but as vehicles of imaginary engagement with past ages.

This passion for history was also expressed in the historical novel, opera and drama. Painters, composers and writers across Europe and beyond, took inspiration from the most celebrated of the period's historical novelists, Walter Scott, whose tales of Scottish history, covering the late Middle Ages to the rebellion of 1745, were imbued with the author's own obsession with recreating 'authentic' period detail. The Italian Alessandro Manzoni, author of the magnificent novel *I promessi sposi* ('The Betrothed', 1827), set in seventeenth-century Lombardy, spoke in the novel's preface of a 'mighty war against time', in which the historian snatches back 'the years imprisoned ... calls them back into life, passes them in review, and sends them back once more into battle'. But 'pure' history, too, came to be written in a new way – with detail, incident, sentiment, and the same imaginative projection that Manzoni described.

For the French historian Jules Michelet, the historian's task was to establish kinship with the dead: 'Now they lived with us, and we feel ourselves to be their relatives and friends. Thus a family is formed, a common city between the living and the dead.' Just as the concept of the hero was modified by Romantic individualism (see Chapter 2), so Michelet was to assert a new 'total' history, written as much from the perspective of common experience as from the deeds of the great. There was space for ordinary people to contribute to the collective consciousness of the past, just as they could now

embody the present and create the future. While Scott showed this happening in his novels, Michelet was a historian of the French Revolution, the greatest proof that the flow of history could be directed by common 'citizens'. This democratizing process could also occur, as it were in reverse, with the great being shown to share the experiences and emotions of the people. And in these retrievals and reanimations of the past, painters played a special part. It was to artists that people looked for credible realizations, both of events and individuals. The painting of history was now to become very different from what the eighteenth century had conventionally understood as 'history painting'. Designed to be exemplary and universal, this had emphasized the gulf between its subjects and their admirers. Now the role of the artists was to make their subjects familiar. Some went further, treating their historical subjects in deliberately historicist styles, as if their pictures actually belonged to the period depicted, or even themselves adopting the lifestyles of earlier artists. At the same time, architects, designers and craftsmen constructed their own recreations of the past in which historical fantasies could be lived day by day.

If Walpole's Strawberry Hill was one essentially frivolous sign of a changing historical sense, another, more significant, was the rediscovery of Shakespeare, whose history plays presented events from the perspective of the low-born as well as the high, and whose varied characters were all vividly realized, accessible beings. In Germany Shakespeare was taken up by the *Sturm und Drang* writers for his mastery of varied dramatic forms, blending of tragedy and comedy, and expressive, irregular language. All these qualities offered blessed relief from the canonical classical literary forms, represented in their highest state by the plays of seventeenth-century French dramatists such as Racine and Corneille. By the 1820s the contrast was being appreciated in France itself, whether by the novelist Stendhal, in his pamphlet *Racine et Shakespeare* (1823, 1825), or the young Romantics – Delacroix, Hugo, Vigny, the composer Berlioz – who were thrilled by the English actors who brought

Shakespeare to Paris in 1827. In London Shakespeare had been a popular resource for painters since Alderman Boydell's establishment in 1787 of a Shakespeare Gallery showing pictures from his plays. The Irish historical painter James Barry (1741–1806) contributed his *King Lear Weeping over the Dead Body of Cordelia* to the Gallery in 1788 (119), bringing the passion and despair of Shakespeare's tormented king vividly to life in an archaic, primitive Britain on the edge of recorded history. The stone circle in the background, reminiscent of Stonehenge, is a reconstruction of the sort of actual remains that were now coming under antiquarian scrutiny.

Shakespeare's British plays did much to focus attention on the national past, especially that of the Middle Ages. Just as the Shakespearean revival spread beyond Britain, so too did the medievalism pioneered at Strawberry Hill. In Germany Herder's influence helped the young Goethe to reassess Strasbourg Cathedral – a building he would once have condemned as 'unnatural' – as a masterpiece of German genius. In it he saw the organic forms of nature translated into soaring towers and arches. Yet Goethe's is still a transitional case. He had received a strictly classical education, and much as he grew to admire the cathedral, he saw it as a work created in contrast to the age that had produced it, rather than as a product of it. His essay *Von deutscher Baukunst* ('On German Architecture', 1772–3) claimed it as the distinctive result of the operation of 'the strong, rugged German soul on the narrow, gloomy, priest-ridden stage' of the Middle Ages. These words suggest that he still had some way to go in appreciating the religious basis of medieval society that was its particular appeal for later Gothic Revivalists, though he also looked sympathetically on the courtly chivalry of the age in his play *Götz von Berlichingen* (1774), about a sixteenth-century German knight.

This play inspired one of the first examples of truly historicist, medievalizing painting. It was as a present for the author on his

119
**James
Barry**,
*King Lear
Weeping over
the Dead
Body of
Cordelia*,
1786–8.
Oil on canvas;
269·2×367 cm,
106×144½ in.
Tate, London

birthday in 1785 that their mutual patron and employer Duke
Carl August of Weimar commissioned an otherwise exemplary
Neoclassicist, Johann Heinrich Tischbein (1751–1829), to paint
the play's central scene – one that was later to be admired by
Scott for its sentiment and historical sense. In the picture,
which was reproduced in a splendid print (120), Götz and
his old friend Weislingen have found themselves fighting on
opposing sides, but after Götz captures Weislingen in battle,
a noble impulse compels them to renew their friendship.
For Goethe it was such high manners, rather than religion,
that reflected the best qualities of the period, but he was
also developing an antiquarian interest in its art and artefacts.
Tischbein assembled a wealth of these – arms, armour, hunting

horns, drinking vessels – in the shadowy interior in which he set his action, and his picture might be seen as a reconciliation with a neglected period as much as between its actual protagonists. Undertaken at a time when the Middle Ages were still widely seen as 'dark' and 'barbaric', it invited a genuine reassessment. Not only was a denigrated era shown as the setting of acts as exemplary as those of the heroes of Greece or Rome, but national history was asserted as a source of pride.

Although such subjects were soon to develop distinctly nationalist overtones for German artists, it was in Britain and France that they first acquired patriotic connotations, and painters were specifically encouraged to look for inspiration to their national histories in the medieval period. The British needed to boost their morale after the loss of the American colonies was formally recognized by the treaty of Versailles of 1783. As Walpole told a friend, 'in that state, men are apt to imagine how great their ancestors have been ... the few, that are studious, look into the memorials of past time; nations, like private persons, seek lustre from their progenitors.' It was probably Richard Hurd, author of *Letters on Chivalry and Romance* (1762), who encouraged George III to commission Benjamin West to paint a series of large compositions (1786–9) of Edward III's victories over the French in the Hundred Years War (121) for the Audience Chamber at Windsor Castle. Victoria and Albert may well have had these pictures in mind when choosing the historical characters for their ball.

Meanwhile, across the Channel, the *ancien régime* was keen to assert its own noble ancestry, and in 1773 the French Ministry of War ordered a cycle of scenes from the life of St Louis (Louis IX of France, who had spent the six years 1244–50 on a crusade) for the Chapel Royal of the Military Academy. Subjects relating to the first Bourbon king of France, Henry IV, were also encouraged, as were scenes of the selfless courage of the nobility. Some of these were sufficiently potent to hold more than purely national appeal, and West's first medieval

120
Johann
Conrad
Susemihl
after
Johann
Heinrich
Tischbein,
*Götz von
Berlichingen
and
Weislingen*,
1790–1.
Etching and
aquatint;
72·4×58·1cm,
28½×22⅞in

work, exhibited in 1773, actually represented an episode of French heroism, *The Death of the Chevalier Bayard*. This sixteenth-century knight had been mortally wounded in Lombardy during a French retreat from the Holy Roman Emperor Charles V; he had refused to be taken away and had calmly awaited the enemy. The picture was acquired by George III as one of three – also including *The Death of General Wolfe* (see 39) – illustrating noble deaths, but as West's biographer observed, it was also revealing of 'the heroism and peculiarities of the middle ages'.

It is hardly a coincidence that this historicist passion took off just as the French Revolution attempted to draw a line under the past and set humanity on a new path. This ambition was encapsulated in the new revolutionary calendar, which claimed to begin time anew, and enacted in brutal vandalism against the former property of Crown, Church and nobility. But people were not so easily to be returned to year zero and this futile aim was soon repudiated; there was to be no shrewder manipulator of the past than Napoleon. Aristocratic classes

across Europe, meanwhile, understandably became even more nostalgic for earlier centuries when their privileges had gone unchallenged. In those countries whose identity, or very existence, came under threat from revolutionary France, national histories gained a new potency. In Britain, such artists as the young Turner or his fellow watercolourist Thomas Girtin (1775–1802), and their wealthy patrons, who before the war would have travelled on the Continent, turned their enthusiasm for antiquarian topography towards the national heritage of cathedrals and castles. Their motivation was mainly to study such structures before they fell further prey to the ravages of time, but their researches soon acquired a chauvinist element as scholars debated whether the Gothic style had originated at home or abroad. While the British tended to look no further than France as the rival source, the Germans claimed it as uniquely theirs, proof of the genius of their own proud but threatened race, and of a spirituality that might yet overcome the secular materialism of the modern age.

It was through a retreat into the past, in search of their national and religious roots, that otherwise progressive German thinkers and writers such as Tieck and Wackenroder sought to recover from their disillusionment as news of the Terror spread. Having first welcomed the Revolution as a modernizing force, they turned back to the Middle Ages for the healing and inspiration that Wordsworth sought in nature. Wackenroder's 'Outpourings' devoted one of its most important chapters to an essay on the sixteenth-century painter Albrecht Dürer, the product of 'the only age when Germany could boast of its own native art', while Tieck's *Franz Sternbalds Wanderungen: Eine altdeutsche Geschichte* ('Frans Sternbald's Excursion: An Old German Story', 1798) took as its hero a painter who was a student first of Dürer and then of Lucas van Leyden. Soon a new generation of German artists would be modelling their work and lifestyle on such predecessors, while the resistance fighters who enlisted in the brigades to fight against French occupation adopted 'Old German' costume. Meanwhile,

121
Benjamin West,
The Burghers of Calais,
1789.
Oil on canvas;
100×153·3cm,
39⅜×60⅜in.
Royal Collection

Wackenroder and Tieck made an architectural tour together
in Franconia and along the River Main in 1793, looking at
medieval towns such as Nuremberg and Bamberg, 'where one
is always expecting to meet a knight or a monk'. Although
both men were Protestants, they were moved by the Catholic
ritual that had created some of the greatest buildings they saw.
Tieck was insistent that the surviving monasteries should on
no account be destroyed.

At the same time elsewhere in Germany, the reality of the
revolutionary threat was all too evident. In 1794, as part of
their 'defensive' war against other European powers including
Prussia, French forces entered Cologne. They imposed the
same brutal secularization as had taken place in France,
ravaging the city's churches and religious houses, and taking
sculptures, manuscripts and pictures back to Paris. The city's
huge but still unfinished cathedral was later requisitioned as a
hay store or quarters for prisoners of war, and even listed for
demolition. Among those appalled by the sacrilege was a young
merchant, Sulpiz Boisserée (1783–1854), who with his brother
Melchior was already a collector of medieval books and art, and
an avid reader of Wackenroder and Tieck. He devoted himself
to rescuing as much as he could of the city's art treasures,
which if not actually seized or destroyed were languishing in
junk shops or on scrap heaps for building materials. More ambi-
tiously, in 1808 he began producing engravings of the cathedral
as it might look if finished, commissioning structural surveys,
and preparing plans for the construction work. He failed to
persuade Napoleon to adopt the project in expiation of the
earlier French vandalism, and his vision was only realized
towards the middle of the century, as a national project for
a revived Germany under the patronage of the Prussian
monarchy. Nevertheless, he gave immense impetus to the
medieval revival; his collection attracted many visitors and was
eventually bought by Ludwig I of Bavaria for his new museum in
Munich, and he influenced friends such as Friedrich Schlegel,
who joined him on a tour of Gothic cathedrals in Belgium and

the Rhineland in 1804, and followed him into the Catholic faith. Schlegel developed Goethe's idea of Gothic as an expression of German genius; but unlike Goethe he saw it also as the visible form of spiritual aspiration, the natural product of medieval Catholic society.

Such ideas were constructed as the German antithesis of French revolutionary iconoclasm and anticlericalism, and then of Napoleonic imperialism. They depended on a patriotic pride in an era united under the pious governance of the Germanic Holy Roman Empire (originally established under Charlemagne in 800 but from the mid-tenth century associated with rulers of Germany), which Napoleon abolished in 1806, and also on an appreciation of the structure of medieval society. This was seen as a time in which the Church assumed such welfare tasks as the care of the sick and the feudal network of municipal guilds and burghers modified the power of central authorities. This anti-French nostalgia continued to develop in Germany as part of a nationalist programme long after the provocations that had brought it into being had ceased in France itself.

Meanwhile, the French too were becoming newly sensitive to the Middle Ages as part of a larger reconsideration of history promoted by Napoleon. There is little to divide the celebration by the German poet Novalis (Friedrich von Hardenberg), in his *Christendom or Europe* (1799), of those 'beautiful and glittering times when Europe was a Christian country', from the French-man Chateaubriand's evocations in his *Génie du Christianisme* ('Spirit of Christianity', 1802). Chateaubriand's Catholic nostalgia was inspired as much by his conservative opposition to Napoleon as by religious sentiment. But in fact the greatest spur to a reconsideration of history came from Napoleon himself. With his wife Josephine he was to become a pivotal patron of the medieval revival. The roots of his interest, and the first significant reversal of the revolutionary destruction of the past, can be traced as far back as 1795, when – just a year after the desecration of Cologne – there opened in Paris

a depot for displaced monuments. This soon evolved into a remarkable museum, which was also, in its way, a work of art.

The Musée des Monuments Français was the creation of Alexandre Lenoir (1761–1839), a painter turned antiquary who had been appalled at the wanton damage to Church sculpture, tombs and decorations that had accompanied the state's seizure of ecclesiastical property in 1791. Like Boisserée, he had been struck with the collecting passion and driven to salvage all he could. He assembled his trophies in the precincts of the Petits Augustins, a former convent that had been requisitioned as a store with himself employed as its caretaker. Works were arranged in a series of chronological displays laid out as period rooms. Many pieces were greatly restored, not always very accurately, and not all were what they claimed to be. But this hardly mattered, for everything depended on the total effect, like stage sets in a theatre. The time span ran from the early Middle Ages to the Renaissance, and in each room the light level increased, to indicate the progress of civilization. In the last, visitors could admire the tombs of Louis XII and Francis I, but many were most impressed by the chamber devoted to the thirteenth century, its vaulted ceiling painted blue with gold stars, its shadows penetrated by coloured light from stained glass rescued from the abbey of St Germain-des-Près (122). The exhibits were mainly tombs and funerary sculpture, and these Lenoir hoped would reawaken the sense of kinship with the past that had been so brutally fractured by the Revolution. Without it, he believed, the national psyche was dangerously disorientated, and his salvaged and reconstituted tombs would speak to a damaged race of its lost ancestors. This pious hope took still more potent form in the museum's concluding display, the Elysian Garden constructed in the grounds. Here, in the shade of evergreens, monuments of great figures from French history inspired the 'sweet melancholy that speaks to souls of sensibility'. Lenoir's greatest *coup de théâtre* was the somewhat spurious monument to the medieval poet-cleric Abelard and his lover Héloise; his guidebook encouraged his

visitors to imagine they heard their soulful calls to each other, and thus across time to them.

What Lenoir did not intend to encourage was a revival of interest in Catholic culture. Indeed, his 'damp, gloomy, ruinous assemblage of monkish horror' was intended to make a mockery of it. In this sense he was still a child of the Revolution, and differed from it only in his concern to rehabilitate individuals from a past it had discredited and rescue works of art from decay. Soon, however, he was obliged to play down his anticlerical stance, when his own most prominent admirer, Napoleon, embarked on a policy of reconciliation with the Church. For Napoleon this formed part of a broad strategy to assimilate to himself all the institutions of the state, and in this the past played a vital part. But it was not only France's national past that interested him. When Napoleon visited Lenoir's museum in 1800, he was struck less by the French exhibits than by those arranged to demonstrate the curator's theory that the Gothic style had Arab origins. His official blessing on the museum's work came with the words, 'Lenoir, you transport me to Syria', a reference to the recent campaign in which he had first demonstrated his sense of affinity with the past in a calculated and public form.

Cécile del. Réville sculpsit Tardieu et Sellier Sc.

Napoleon's invasion of Egypt and Syria in 1798 was undertaken to disrupt Britain's trade routes to India. As a military adventure it was doomed, and the British drove the French out in 1801. During their three years of occupation, however, the French pursued a parallel intellectual campaign. With the army of 38,000 men went a peaceful force of 175 *savants* – scientists, botanists, geographers, scholars of all kinds as well as artists – to document their observations. History was among their main concerns, for the antiquities of ancient Egypt, which had aroused intermittent interest for much of the century, were now the subject of intensive study. But history offered a more than archaeological appeal to Napoleon himself. Addressing his troops before the Battle of the Pyramids, which consolidated his initial hold on Cairo, he exhorted them to remember that 40,000 years of history looked down on them. Men who not long ago had been taught to overthrow the burden of the past

123
François
Cécile,
Frontispiece
to *Description*
de l'Égypte,
1809

124
Thomas
Hope,
Armchair,
c.1802.
Ebonized
and gilt
beech and
oak with
bronze and
gilt brass
mounts;
h.120 cm,
47¼ in.
Powerhouse
Museum,
Sydney

were now rallied by it. Napoleon now set himself to revive the glories of the pharaohs, while the man responsible for the supervision of the scholars, Dominique Vivant Denon (1747–1825), had developed a taste for antiquities in Naples as a diplomat under the *ancien régime*. Despite his privileged past, Denon skilfully avoided retribution when the Revolution came, and his luck held in the following years. His Egyptian posting was the first of a succession of official favours. It was perfect for Denon, whose keen historical imagination and subtle sense of the contemporary application of history were brilliantly combined in his account of his Egyptian travels, published from 1802, and in the magnificent volumes of the *Description de l'Égypte* (1809–28), in which his scholars' researches were published. Their splendid plates were the first serious visual record of the monuments of the Nile Valley, many of which were brought together in the frontispiece (123) to the first volume, designed by the engineer François Cécile (1766–1840).

These great books were immensely influential. A generation tired of the familiar antiquities of Greece and Rome was ripe for the more exotic lost world of Egypt, whose vast remains and mysterious hieroglyphs were powerful spurs to the imagination. An Egyptian revival joined Gothic as a Romantic alternative, and not only in France. It was actually in London, in the Duchess Street house of the leading proponent of Neoclassical taste, Thomas Hope (1769–1831), that one of the earliest and most impressive Egyptian re-creations was to be found as early as 1804. Hope's Egyptian Room, with furniture (124) designed by himself, painted in black and gold, and decorations adapted from mummy cases and papyrus scrolls, was at once theatrical and scholarly, a showcase for his collection of real Egyptian antiquities, which demanded a setting different from that of his classical marbles and casts. Yet impressive as Hope's reconstruction was, it was really only a variant of the antiquarianism that he applied to the classical past. For the French, the appropriation of Egyptian antiquity

helped to overcome the humiliation of the expedition's military failure. Brief as Napoleon's kinship with the pharaohs proved to be, and though many of his trophies ended up in British hands after the expulsion of the French army, the French intellectual contribution to the understanding of ancient Egypt could not be taken away.

The invocation of the past for present glory – or, as in Egypt, for consolation – was a constant feature of Napoleon's campaigns. It was to ancient Rome that he most consistently looked, as in the great festival of 'Liberty and the Arts' held in Paris in 1798 to mark the arrival in the capital of the plunder of his first invasion of Italy. Despite his own absence in Egypt, a splendid procession, with all the pomp of a Roman triumph, passed through the streets led by one of the most celebrated sculptures of classical antiquity, the *Apollo Belvedere*. Depicted some years later on a vase made by the Sèvres porcelain factory (125, 126), this might look like the pinnacle of Napoleonic Neo-classicism, but while its purpose was undoubtedly to mark the glory of the conqueror, the treasures brought to Paris on this and later occasions included works of art from many periods and of many styles. Like the Egyptian campaign, it showed his incorporation of the past on a larger, more panoramic scale, as well as an ability to finesse acts of war as grand cultural and scholarly projects.

Their magnificent outcome was the Musée Napoléon, the galleries of the old palace of the Louvre where the booty of the French campaigns joined former royal and noble collections to form the world's greatest museum of art. Its first curator was none other than Denon, appointed in 1802 on the strength of his achievements in Egypt. He arranged the collection with taste and discrimination, and – much as a modern curator would recommend purchases – drew up lists of works to be looted by Napoleon's troops to render the displays complete. He proved a born 'museum man', but never lost sight of the importance of his project to the image of his master, Napoleon. In an allegorical

**125–126
Sèvres**,
Vase
showing
transport of
the *Apollo
Belvedere*
from Italy as
Napoleonic
plunder,
arriving at
the Louvre,
1810–13.
Enamelled
porcelain;
h.120 cm,
47¼ in.
Musée
National de
Céramique,
Sèvres
Far right
Detail

127
Benjamin
Zix,
*Allegory of
Vivant Denon
in his Study*,
1811.
Pen and
brown ink
and wash;
46·9×40·9 cm,
18½×16⅛ in.
Musée du
Louvre, Paris

128
Fleury
Richard,
*Valentine of
Milan
Mourning
the Death of
her Husband,
the Duke of
Orléans*,
1802.
Oil on
canvas;
55·1×43·2 cm,
21¾×17 in.
State
Hermitage
Museum, St
Petersburg

drawing (127) by Benjamin Zix (1772–1811), a sculpture of
Napoleon himself is the inspiring presence behind Denon as he
works in a splendid imaginary office, surrounded by antiquities.
An Egyptian obelisk joins sculptures from Greece and Rome,
books, prints and a printing press – all the resources that
Denon used to serve his master. Denon created a similarly rich
and eclectic atmosphere in his Paris apartment on the quai
Voltaire overlooking the Seine, where he continued to receive
visitors late into his retirement after Napoleon's fall.

Neither Denon's Musée Napoléon nor Lenoir's museum
survived the era that had brought them into being. With the fall
of Napoleon, many of the captured works of art in the Louvre
were repatriated to Italy and Spain, while its galleries of French
art received those sculptures from the Petits Augustins that
could not similarly be returned. Both, during their brief heyday,
had an immense effect. Lenoir had seen his more intimate
museum of French history and personalities as a necessary
complement to Denon's encyclopaedic holding of world art,
and, as Denon himself appreciated, it was more in tune with
current sentiment. The historian Michelet recalled that it was
among those shadowy tombs that his vocation was awakened.

There too, a new art was born which prompted its own re-consideration of history and style. From its evocation of the world of the medieval Provençal poets, this was soon christened 'troubadour'. Among its founders were some of David's students, who, to the considerable dismay of their master, 'abandoned the Museum of Antiquities in the Louvre to frequent the one in the Petits Augustins'. It was there that one of them, Fleury (or Fleur-François) Richard (1777–1852), dreamed up the idea for his first notable picture, *Valentine of Milan Mourning the Death of her Husband, the Duke of Orléans* (128). This was remarkable for showing a significant historical figure in a moment of private emotion. Her lament is for lost love, but could equally be for the lost past; it was a formulation of the very purpose of Lenoir's museum, with its tombs in

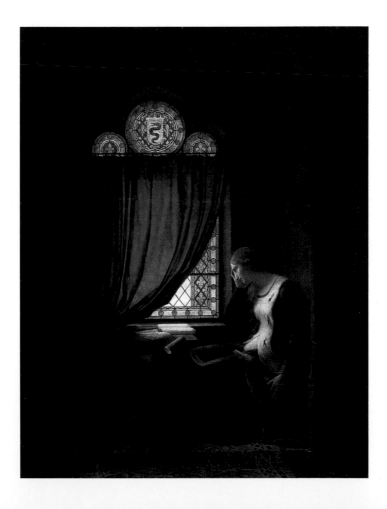

every room. Richard had been inspired by the inscription on Valentine's monument, 'Naught is left me, I am myself naught', and he took Valentine's costume from the same source, placing her in a Gothic interior before a stained-glass window whose light is veiled by a green curtain. His intention was to 'speak to the heart', and the picture's intense effect was enhanced by its small size, which set it apart from conventionally monumental historical compositions. Enthusiastically reviewed by the Parisian critics, who recognized in it a minor revolution, it was sold in 1805 by its first owner, Monsieur Maurin, to the Empress Josephine, who had already acquired another small historical scene by the same artist, of Francis I and the Queen of Navarre. Later, when purchasing her eighth Richard from the Salon of 1808, she proposed to arrange a special shrine for them at her house at Malmaison, with the artist's bust in the centre. Her patronage of the artist was continued by her children, Prince Eugène and Queen Hortense of Holland.

Official support for this new and intimate interpretation of the past, from the very heart of Napoleon's court, carried the same authority as commissions for the great canvases of contemporary history being painted by David or Gros. The Empress may have owed some of her enthusiasm to Lenoir, who was also curator of her collections at Malmaison, but she was introduced to Richard by Denon. In 1804 he drew the Emperor's attention to the painter's Salon contributions, noting their 'mixed genre between history and anecdote', and in 1810, when it was clear that this new category embraced a number of other young artists, he reported: 'One of the very remarkable things about the exhibition this year, Sire, is the multiplicity of pictures in a genre whose pedagogic delicacy makes it peculiarly French. It is anecdotal history, or the representation of figures whose historical lives make us want to get close to them … and learn something about their private lives.'

Denon's own desire to 'get close' to the departed was celebrated in an extraordinary little picture painted by another

of the young artists who gathered at the Petits Augustins, Alexandre-Évariste Fragonard (1780–1850). Like Lenoir, Denon had a passion for collecting relics of the great – bones of Abelard, a tooth of Voltaire, whiskers from Henri IV's moustache – and Fragonard depicts him replacing in its tomb, after an evidently minute examination, the skull of the semi-legendary eleventh-century Spanish hero El Cid (129). In a subtly edited form, this referred to events during the French siege of the Spanish city of Burgos in 1808, when a regiment

129
Alexandre-
Évariste
Fragonard,
*Vivant Denon
Replacing El
Cid's Remains
in their Tomb,*
*c.*1811.
Oil on paper
laid on
canvas;
40×34·5 cm,
15¾×13⅝ in.
Musée
Antoine-
Lecuyer,
St Quentin

of dragoons, hoping to find gold and jewels, destroyed El Cid's monument in San Pedro de Cardena near the city. The French governor of Castille, appalled at this sacrilege, salvaged what he could of the remains and built a new monument in Burgos, but not before he had presented Denon with a parcel of the great man's bones. Far from replacing them where they belonged, Denon kept them for the rest of his life. There can be no better illustration of the paradoxes of destruction and

nostalgia, plunder and research embodied in Napoleon's campaigns and Denon's activities, than Fragonard's picture. It is another telling visualization of the emotions felt by Denon and by his artist friends when they visited Lenoir's reconstituted tombs.

The 'Troubadour' style proved both adaptable and durable. Having appealed to the Napoleonic élite as an engaging alternative to grandiose compositions of 'national' subjects, such pictures claimed a new significance under the restored Bourbon monarchy for their celebration of a courtly, aristocratic past that was free of the abuses of the eighteenth century. Later Troubadour paintings assumed a more self-consciously 'primitive' style, based on closer study of early paintings and miniatures. Among the most assiduous in such borrowings, though generally a classicist, was the young Ingres, as can be seen from a picture painted in 1821, *The Entry of the Future Charles V into Paris* (130). This piece of blatant Bourbon propaganda was created for the pro-Bourbon comte Amedée-David de Pastoret – of whom Ingres was to paint a splendid portrait for the Salon of 1827 – and shows his ancestor, Jean Pastourel, a fourteenth-century president of the Paris parliament, greeting the future king at the city gates after he had survived a peasants' insurrection in 1358. The work signalled the patron's loyalty to the restored monarchy and his recent refusal to cooperate with Napoleon. Its royalist chivalric subject, taken from the fourteenth-century chronicles of Jean Froissart, was matched in an appropriately archaic style, learned from the illuminations of Jean Fouquet (*c.*1420–*c.*1481) and from early pictures seen in Rome, where Ingres began the work, as well as in the Louvre.

It is no accident that Ingres's picture resembles one completed eleven years earlier by the Viennese painter Franz Pforr (1786–1812). His *Entry of Rudolph von Habsburg into Basle* (131) can claim to be the first large medieval subject painted in a deliberately historicist manner, and arose from his own more

130
Jean-Auguste-Dominique Ingres,
The Entry of the Future Charles V into Paris,
1821.
Oil on canvas;
47×56cm,
18¹⁄₂×22in.
Wadsworth Atheneum, Hartford

131
Franz Pforr,
Entry of Rudolph von Habsburg into Basle in 1273,
1808–10.
Oil on canvas;
90·5×118·9cm,
35⁵⁄₈×46³⁄₄in.
Städelsches Kunstinstitut, Frankfurt am Main

committed attachment to medieval chivalry and spirituality. Its flattened perspectives, awkward figures and bright colours are all calculated to achieve an effect of child-like innocence and *naïveté*. The work reflects the artist's nostalgia for a proud period of Germanic unity under the Holy Roman Empire and his admiration for the first monarch of the Habsburg dynasty to be elected Emperor. Like Ingres, Pforr had his own political point of reference to the past. The Middle Ages, he wrote in 1810, were a time 'when the dignity of man was still fully apparent', adding that 'the spirit of these times is so beautiful and so little used by artists.'

Ingres had come into contact with friends and followers of Pforr in Rome, where they had formed a tight-knit community utterly opposed to the contemporary Europe of Napoleon and to official trends in modern art. It had been their rejection of both that, in 1809, led Pforr and three of his friends including Friedrich Overbeck (1789–1869) to break away from the Vienna Academy to form the Lukasbund or Brotherhood of St Luke. They took their name from medieval fraternities dedicated to the artist saint, which they believed to have been painters' guilds. Inspired by spiritual as well as aesthetic ideals, they looked to the Middle Ages as an age of faith which they sought to revive in their own lives, while taking German and Italian art of the fifteenth and sixteenth centuries as the basis of their own. Notwithstanding the Napoleonic occupation of Rome that had driven many foreign artists away, they colonized the disused monastery of San Isidoro and adopted a monkish regime of prayer, seclusion and self-denial, growing their hair long and wearing archaic clothes. Overbeck was known as their 'priest', and his portrait of Pforr painted in 1810 placed his friend as 'he would perhaps feel happiest', in medieval clothes in a Gothic porch before a medieval church, set in an idyllic town beside the sea. The virtuous wife of his hopes knits as she reads, and an affectionate cat rubs against the artist's elbow (132). Around the painted frame, a vine and grapes refer to Christ's Passion, as does a skull surmounted by a cross

(also the emblem chosen by Pforr at the foundation of the Brotherhood). Thus symbols of faith, devotion and friendship are interwoven in an almost dreamlike manner, evoking Pforr's belief that the way to artistic greatness was 'identical with the path of virtue' and his ideal of the 'quiet retiring life'.

Nowhere are the archaic style, intimacy and pious spirit of the Brotherhood seen more clearly than in Pforr's own commentary on his friendship with Overbeck, the allegorical *Shulamit and Maria* painted in his cell in San Isidoro in 1812 (133). The painting was based on a fable that Pforr had written for Overbeck, casting the two girls as sisters who were to become their brides. Overbeck was known as the Raphael of the Brotherhood, Pforr as its Dürer, in honour of the two early artists they most admired, and the painting also represents the contrasting styles of these two masters. Shulamit, taken from the Song of Solomon and bearing a name meaning 'peace' in Hebrew, sits cradling her baby in a lovely, light-flooded garden like a Raphael Madonna. Overbeck, in monkish garb, approaches his 'future wife'. Maria, Pforr's unattainable love, sits alone brushing her hair in a shadowy room like that in which Dürer had set the hermit St Jerome in a famous print. This suggests the melancholy isolation falling upon Pforr, who was by this time terminally ill with consumption. His death later that year, aged only twenty-four, was a crushing blow to Overbeck and broke up the tight-knit circle of the Brotherhood.

These early pictures invoked the past, and used a historicizing style, to tell intensely personal stories as well as to assert a collective opposition to prevailing contemporary trends. The subsequent development of Overbeck and his surviving friends was markedly different, though no less indebted to the past. Rechristened the Nazarenes by their Roman colleagues on account of their long hair and beards, they attracted new adherents and embarked on a more outgoing, didactic – and less stylistically naïve – phase under the influence of Peter Cornelius (1783–1867), who joined them in 1812. A native of

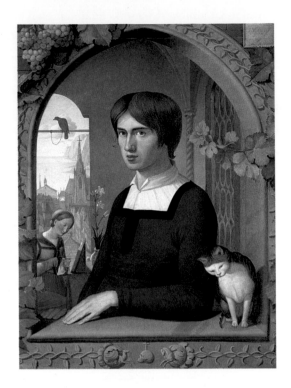

**132
Friedrich
Overbeck**,
Franz Pforr,
1810.
Oil on
canvas;
62×47 cm,
24³⁄₈×18¹⁄₂ in.
National-
galerie,
Berlin

**133
Franz Pforr**,
*Shulamit
and Maria*,
1811.
Oil on wood;
34·5×32 cm,
13⁵⁄₈×12⁵⁄₈ in.
Museum
Georg
Schäfer,
Schweinfurt
am Main

**134
Peter
Cornelius**,
*The
Recognition
of Joseph by
his Brothers*,
1816–17.
Fresco with
tempera;
236×290 cm,
92⁷⁄₈×114¹⁄₄ in.
National-
galerie,
Berlin

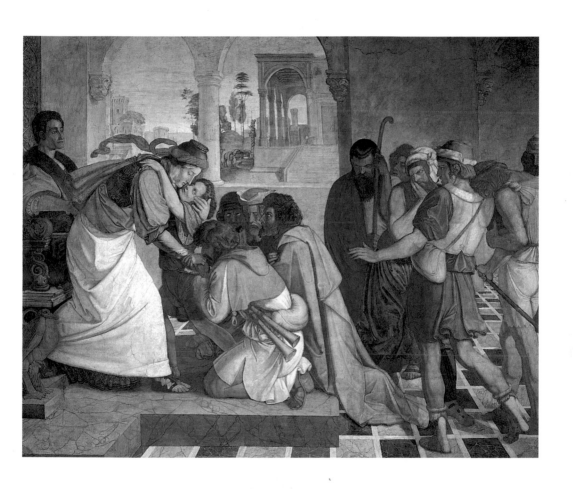

Düsseldorf, he had known the Boisserée brothers, shared their medieval enthusiasm and also passionately admired Dürer and Raphael. But his ambitions were larger, more public, than those of the retiring Pforr and he intended to forge a truly national art of which a resurgent Germany might be proud. His chosen medium was fresco – itself regarded as archaic – and his great opportunity came in 1816, when with other Nazarenes he began to decorate the ante-room of the residence of the Prussian Consul in Rome with scenes from the life of St Joseph. In his own main contribution, a frieze-like reconciliation scene, *The Recognition of Joseph by his Brothers* (134), since removed to Berlin, Cornelius led his colleagues away from their fairytale vision of the Middle Ages to a more monumental style based on the High Renaissance. It was this, rather than the more extreme archaism of their earliest works, that brought the Nazarenes international fame. For Cornelius himself it won a major commission from Crown Prince Ludwig of Bavaria, who came to Rome in 1819. Cornelius returned with him to Munich to help him realize his vision of transforming his capital into an 'art city', with public buildings adorned with decorative schemes – many lauding the achievements of his own Wittelsbach dynasty – for the edification of the populace.

For its high-minded, Christian principles, the Nazarene style became the national style of post-Napoleonic Germany. It also won admirers throughout Europe, not least in England, where in the mid-century it helped inspire a new brotherhood of archaizing, morally committed painters, the Pre-Raphaelites. The Nazarenes' international appeal reflected the fact that their own art had been nurtured outside Germany and owed as much to Italian models. But artists inside Germany had continued to develop the patriotic combination of stylistic historicism, nationalism and religion that had emerged in the 1790s. When in 1817, at the instigation of Goethe, the Weimar Friends of Art attempted to check the more archaic stylistic trends in contemporary painting, publishing a hostile review of what its author Heinrich Meyer termed 'neo-German religious-patriotic

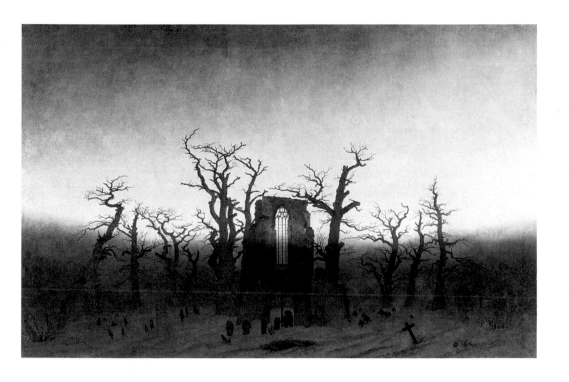

**135
Caspar
David
Friedrich**,
*Abbey in the
Oakwood*,
1809–10.
Oil on
canvas;
110·4×171cm,
43$\frac{1}{2}$×67$\frac{1}{4}$in.
National-
galerie,
Berlin

art', their targets included not only the Nazarenes but also the landscapist Friedrich. It was Friedrich's religious mysticism (see Chapter 3) that had tempered Goethe's early admiration; but the Napoleonic invasion of Germany and the consequent War of Liberation had added a patriotic dimension to Friedrich's subjects of north German ecclesiastical buildings in ruins or, in imagination, raised again. While the essential message of the *Abbey in the Oakwood* of 1810 (135) is the passing of the earthly life, its fog-bound ruin and blasted, leafless trees inevitably evoked the contemporary state of Germany. By contrast, plans Friedrich made later with his brother for a neo-Gothic restoration of the Marienkirche in the Baltic town of Stralsund might be associated with ideas of national resurgence. Such interpretations are over-simplified, since the Protestant Friedrich was no great admirer of the Catholic Gothic buildings now lying in decay, and as a convinced liberal and German patriot did not welcome the repressive monarchism of post-Napoleonic Germany. Yet there can be no question that Friedrich had shared the nostalgia for an old Germany united under the Holy Roman Empire that drove his contemporaries' enthusiastic medievalism.

The *Abbey in the Oakwood* was shown at the Berlin Academy in the same exhibition as a design by the architect Schinkel for a Gothic mausoleum for the Prussian Queen Luise (136). This warm-hearted patron of the arts was much mourned, and Schinkel chose the Gothic style both as a patriotic expression, and for its echoes of organic natural forms, hinting at nature's processes of renewal (his hope, also, for Germany) and thus of eternal life. The complex patterns of vaulted arches receding into a light-filled interior evoke the German forests. As things turned out, the grieving king preferred a classical scheme, which still stands in the park at Charlottenburg, and economic conditions after the War of Liberation left Schinkel's grander vision for a vast Gothic cathedral in Berlin unrealized. It was only on canvas that Schinkel could raise the cathedral of his dreams, in a patriotic fantasy of the Prussian king's return from

136
Karl
Friedrich
Schinkel,
*Study for a
Monument to
Queen Luise,*
1810.
Watercolour;
72×52 cm,
28³⁄₈×20¹⁄₂ in.
National-
galerie,
Berlin

the field after the expulsion of Napoleon. In his *Medieval City
on a River* (137) of 1815, an army follows its prince homeward,
towards a vast church set among German oak trees. Stormy
clouds give way to a rainbow, emphasizing renewal, and one
tower of the cathedral is still under construction, indicating
the architect-painter's interest in the building process and the
current concern for completing the unfinished projects of
the Middle Ages.

Schinkel was, however, far from an exclusive Goth. He believed
that his reconstructed nation should incorporate all the best
of past achievements, and a companion picture to this, now
lost, depicted an ancient Greek city in the morning. Schinkel
had in mind the Athens of Pericles, a place habitually invoked
by nations at a time of victorious euphoria and cultural pride.

137
Karl
Friedrich
Schinkel,
A Medieval
City on a
River,
1815.
Oil on
canvas;
95×140·6 cm,
37⅜×55⅜ in.
National-
galerie,
Berlin

**138
Wilhelm
Ahlborn after
Karl Friedrich
Schinkel**,
*View of Greece
in its Golden
Age*,
1836.
Oil on canvas;
94×235 cm,
37×92½in.
National-
galerie, Berlin

Some sense of what Schinkel's vanished picture must have looked like can probably be gained from a copy by Wilhelm Ahlborn (1796–1857) of a picture (also lost) that Schinkel painted in 1824–5 as a gift from the city of Berlin on the betrothal of the Princess Luise to Prince Frederick of the Netherlands. This *View of Greece in its Golden Age* (138) was Schinkel's most ambitious painting, but it alluded primarily to his ambitions as an architect who had been turning post-war Berlin into a classical capital on the Athenian model. Historicism is thus given a very modern slant, and this dream city embodies the synthesis of ideal form and functionalism so evident in Schinkel's own buildings. As his friend Bettine von Arnim perceptively wrote to Goethe, 'the artist knows how to make common cause with the ceremonial and significance of Greek public life … One feels: there, people must live, or there I would wish to live.'

Schinkel's medievalism largely failed to outlast the particular conditions of wartime Prussia. It was associated with opposition and resistance, and the classical style became for him an equally appropriate expression of German resurgence. The same was true in the Munich of King Ludwig I, who seems to have regarded Gothic less as patriotic than as liberal in its connotations, and therefore dangerous to monarchy. He preferred the classical creations of his own architect, Leo von Klenze (1784–1864); it was his son, Ludwig II, who gave way to such extravagant medieval fantasies as the vast castle of Neuschwanstein, started in 1868 in the mountainous setting of southern Bavaria and still unfinished when he was declared mad in 1886 (139). As the epitome of the age of chivalry, the Gothic style could still be associated with anti-absolutist opposition, just as it had been by those opposed to Napoleon, and this helps to explain the preference of restored monarchies like the Bourbons for classical architecture. In Britain's more liberal postwar democracy, there was room for both. While John Nash (1752–1835) remodelled London's West End and surrounded Regent's Park with terraces worthy of Greece

139
Christian
Jank, Eduard
Riedel and
others,
Neuschwan-
stein,
Bavaria,
from 1868

or Rome, an eclectic and picturesque medievalism was the choice of Sir Jeffry Wyatville (1766–1840) for his remodelling of Windsor Castle between 1824 and 1837 (140).

Although a revival of interest in the classical past and classical styles certainly followed the Napoleonic Wars, medievalism was in fact more rampant than ever. In both Britain and France there was a boom in antiquarian and architectural publications, such as the *Voyages pittoresques* of the half-French, half-Irish Baron Taylor, illustrated with views of early buildings to serve the postwar generation of tourists. The taste for Norman, Gothic or styles '*à la cathédrale*' filtered down from royal palaces or public buildings, through elaborate middle-class creations,

140
Windsor
Castle,
from 1170s

141
**Anthony
Salvin**,
Harlaxton
Hall,
1835

to quite ordinary houses and villas from Europe to America. What had been nurtured in a spirit of resistance or spiritual aspiration had become another lifestyle choice. The luxurious small pictures of the troubadour painters had by the mid-1820s spawned a fashion for what one horrified critic called 'troubadour clocks', and entire rooms could be furnished with similar shoddily made and wholly spurious wares.

There were still, however, voices to defend a higher vision. While political interpretations of the Gothic style differed widely, a growing appreciation of its religious roots lent it a powerful social purpose. Where once the Revolution and the Napoleonic

threat had turned minds back to the past, now broader social trends of urbanism, democratization and industrialization were seen to be creating a soulless, homogenous world from which its critics longed for escape. Belying their progressive title, followers of Benjamin Disraeli's Young England movement, active in the 1830s, often united their reactionary, almost feudal, political ideas with Catholicism in the hope of national revival. While their leader laid the foundations of the modern Conservative Party and dreamed of the rule of aristocracy supported by the people, they built themselves country houses

in the styles of various English 'olden times' – medieval or, increasingly, Elizabethan, as in the case of Harlaxton Hall (141) in Lincolnshire, built by Anthony Salvin (1799–1881).

Higher still were the political and religious ideals of the architect and designer Augustus Welby Northmore Pugin (1812–52). The son of French immigrants, Pugin converted to Catholicism in 1835. He too looked to the medieval past for superior moral values, and more than any of his revivalist predecessors regarded the classical or 'Grecian' as an

THE SAME TOWN IN 1840.

1. St. Michael's Tower, rebuilt in 1750. 2. New Parsonage House & Pleasure Grounds. 3. The New Jail. 4. Gas Works. 5. Lunatic Asylum. 6. Iron Works & Ruins of St. Marie's Abbey. 7. M. Evans Chapel. 8. Baptist Chapel. 9. Unitarian Chapel. 10. New Church. 11. New Town Hall & Concert Room. 12. Wesleyan Centenary Chapel. 13. New Christian Society. 14. Quakers Meeting. 15. Socialist Hall of Science.

Catholic town in 1440.

1. St. Michaels on the Hill. 2. Queens Cross. 3. St. Thomas's Chapel. 4. St. Maries Abbey. 5. All Saints. 6. St. Johns. 7. St. Peters. 8. St. Alkmounds. 9. St. Maries. 10. St. Edmunds. 11. Grey Friers. 12. St. Cuthberts. 13. Guild hall. 14. Trinity. 15. St. Olaves. 16. St. Botolphs.

142
A W N
Pugin,
Contrasted
Towns, from
Contrasts,
2nd edition,
1841

143
Charles
Barry and
A W N
Pugin,
The
Palace of
Westminster,
1835–68

144
H C Jussow,
Löwenburg,
Kassel,
1790–9

expression of evil. The opening plate of his famous polemic, *Contrasts* (1836), compared the spires of a 'Catholic town in 1440' with the lunatic asylum, gas works, socialist hall of science and host of Nonconformist chapels of 'the same town in 1840' (142). Pugin's almost mystical Romanticism was realized both in his church architecture and in his Gothic exterior and interior designs for London's Houses of Parliament rebuilt, after a fire, between 1835 and 1868. In this triumph of patriotic historicism, it had been decided to use the supposedly national styles of Gothic or Elizabethan. Though Pugin denounced the building's structure, designed by Sir Charles Barry (1795–1860), as 'pure Grecian' in its essential symmetry, he redeemed it by elaborate, fluidly mobile surfaces in the English Perpendicular style of late medieval architecture (143).

Together with his follower John Ruskin, whose own crusade for Gothic began with his book *The Seven Lamps of Architecture* (1849), Pugin gave new impetus to the Gothic Revival at a time when it might have descended into trivia. They looked to an idealized past to redeem a degraded present, and campaigned for the use of Gothic as a bastion against moral decay or political interference. But the Romantics also found in the style the paradoxical attraction of decay itself; its organic nature seemed to imply the possibility of change and mutation, of the ruin which had already befallen many real medieval buildings. And, while this could be held at bay by restoring them, it also inspired a spate of artificial, pseudo-medieval ruins which, in the words of Achim von Arnim, evoked 'the peculiar sensation of transience so welcome to many a melancholy soul weary of the present'. Typical of these were the sham ramparts that the Landgrave Wilhelm IX of Hessen built to surround a fake castle, the Löwenburg at Kassel. The castle itself evoked an even subtler sense of the passage of time, since it was built in a sequence of styles, suggesting progressive alteration and repair as well as ultimate decay (144).

Though the Löwenburg had been built in the 1790s, as a retreat from the realities of French aggression into a mythic German past, it was the fall of Napoleon that did most to nourish Romantic historical fatalism. The scale of his ambition and defeat embodied the classical notion of hubris – of the pride that is followed by a fall. For the defeated, there was despair; for the victors, triumph at first, followed by anticlimax and disappointment. For many Romantics, this was the cycle through which history moved, a cycle which was verified by the parallels between past ages and their own. The collapsed or vanished civilizations of the world gained a prophetic resonance, as in the great pair of pictures on the theme of the rise and fall of Carthage that Turner exhibited soon after the end of the Napoleonic Wars. These reflect both on the history of that doomed empire and on the current condition of Britain; the fading sunset grandeur of *The Decline of the Carthaginian Empire* (145) was more a warning of the fate that might ultimately follow British complacency in victory than a comment on defeated France. Similarly, in St Petersburg the Russian painter Karl Pavlovich Bryullov (1799–1852) was among the many Romantics who turned anew to the ruins of Pompeii – originally discovered in 1748 but now the subject of fresh study and excavation – for the quintessential subject of a civilization at the point of destruction. His huge *Last Day of Pompeii* (146) was finished in 1833, a year before Lord Lytton published his famous novel on the same theme. That Pompeii was obliterated by a natural catastrophe, suggestive of divine retribution, only added to its significance, and Bryullov was well aware of its implications for a politically resurgent but fatally despotic and divided society like his own.

It was in America, however, still in the first flush of independent nationhood and democratic pride, that one of the most impressive of these prophetic meditations on historical inevitability was painted. Thomas Cole had studied Turner in London and took as his motto a quotation from Byron, describing humanity's progress from freedom and glory to vice and corruption.

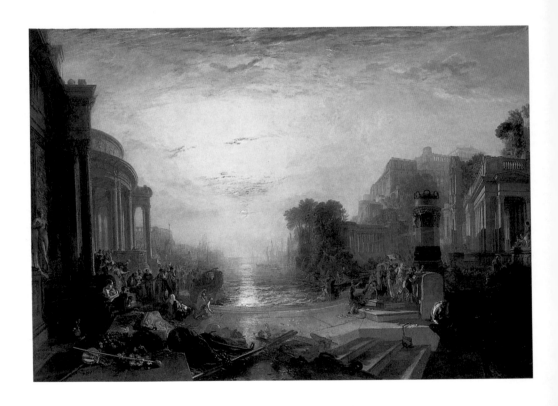

145
J M W
Turner,
The Decline
of the
Carthaginian
Empire,
1817.
Oil on canvas;
170×238·5 cm,
67×94 in.
Tate, London

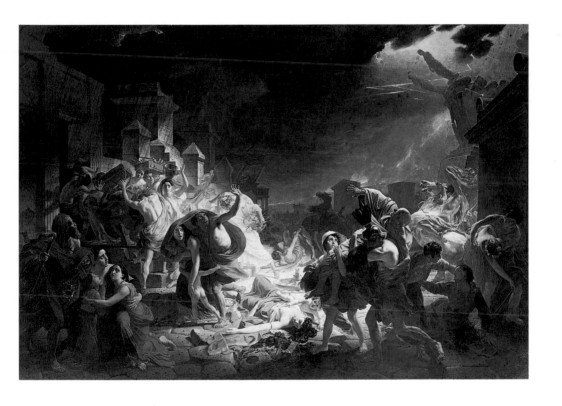

146
Karl
Pavlovich
Bryullov,
Last Day of
Pompeii,
1833.
Oil on
canvas;
465·5×651cm,
183¼×256¼in.
State Russian
Museum, St
Petersburg

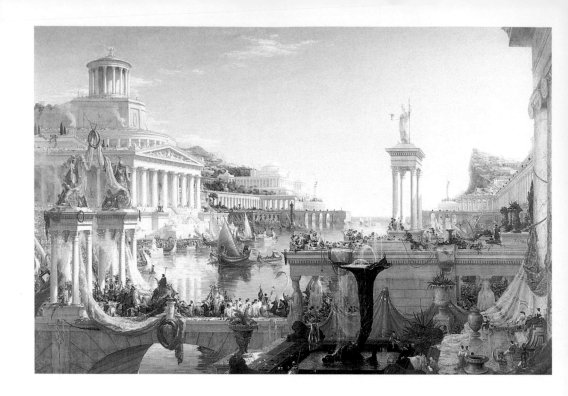

Yet his five-part allegory *The Course of Empire* (1834–6), and its accompanying printed descriptions, carried a cautionary message for his own people. In its central picture, *The Consummation of Empire* (147), the hero returning from some glorious war is an allusion to President Andrew Jackson, whose divisive and arbitrary leadership was said by his opponents to make him a modern Caesar, preparing the way for destructive internal conflict.

It was certainly not true, as the German poet Heinrich Heine would claim, that the Romantics judged the past and foretold the future but ignored the present. Rather such historical pictures had clear contemporary relevance or offered lessons for the future – even if these were often ambiguous. Thus when Paul Delaroche showed his *Princes in the Tower* in Paris in 1831 (148), his depiction of the terror of the young Duke of York and Edward V before their murder in 1483 on the orders of the Duke of Gloucester, the future Richard III – a 'usurption of their rights' as the painter emphasized in the Salon catalogue –

seemed all too clearly a comment on the circumstances of Louis-Philippe's accession in the July Revolution. Delaroche declared he had started the picture before the July Revolution began and went on to win the new king's favour, but such a sinister subject, showing that the Middle Ages were not all honour and chivalry, could serve either as a reprimand to those who had conscripted the period into the service of the Restoration or – in Heine's own interpretation – to the July 'usurpers' themselves. In any case Louis-Philippe had his own motives for manipulating historical attitudes in the great galleries of national history that he established at Versailles in 1833. Despite their synoptic dedication to 'all the glories of France', these actually presented a revisionist editing of French history to reflect and legitimize his own middle-of-the-road policies.

When Michelet saw Nash's terraces in Regent's Park, he was reminded of the pictures of John Martin (1789–1854) – a somewhat backhanded compliment since Martin recreated the cities of antiquity – Babylon or Nineveh, Sodom and Gomorrha – only to break them asunder by storm, deluge or divine judgement. Horrors to come were a Romantic

147
Thomas
Cole,
*The Consum-
mation of
Empire,*
1836.
Oil on
canvas;
130×193 cm,
51×76 in.
New York
Historical
Society

148
Paul
Delaroche,
*The Princes in
the Tower,* or
*Edward V
and the
Duke of York
in the Tower,*
1831.
Oil on
canvas;
43·5×51·3 cm,
17¹⁄₈×20¹⁄₄ in.
Wallace
Collection,
London

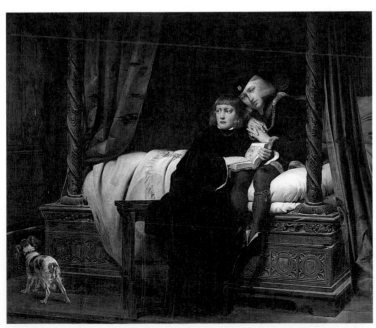

obsession – whether natural cataclysms, wars or revolutions. Some feared that these would be more terrible, more final, than anything in history. Friedrich Schlegel was not alone in thinking that 'the drama of human history' might be nearing its end; and Chateaubriand believed he lived 'not only in the decrepitude of Europe, but in the decrepitude of the world'. In the telling characterization of 'victims' of history, first devised by the French historian Augustin Thierry, can be discerned further apprehensions of our own times. Thierry could not have foreseen the full extent of modern genocide, but he spoke for a generation whose own suffering and trauma had left it newly alert to the evil and tragedy of the past, and extraordinarily preoccupied by lost or marginal peoples. The Celts, the Gauls, the German tribes, the Russian or Polish peasantry, were studied, their languages or folklore collected, just as the art and architecture of vanished ages were. Like these, they made their appearance in art, both as symbols of independence or resistance and showing the pathos of defeat. During the Napoleonic threat a number of British painters had taken up a parallel theme from their own history, the suppression of the Celtic Welsh by the English King Edward III, epitomized by the destruction of the ancient bards. Martin's vision of a lone bard driven to a rocky wasteland by the invading army (149) comes close to another apocalyptic Romantic conception, the 'last man'.

149
John Martin,
The Bard,
*c.*1817.
Oil on canvas;
127×101·5 cm,
50×40 in.
Yale Center for British Art, Paul Mellon Collection, New Haven

Such forebodings of the end of history might be mitigated by hope of eternal life, and indeed Martin played on the hopes and fears of his popular audience, who were widely infected by the millenarian belief in an approaching apocalypse then current in Nonconformist churches. This is also the vision underlying Blake's great *Jerusalem* (1804–20), itself a work of history and prophecy. In it the giant Albion – conceived as an amalgam of the British nation in all its historic ethnic diversity, but also as a universal individual – passes through his own course of life to eternity, falls sick in disunity, then into a long sleep, and at last awakens to a glorious transfiguration

(see 192). Modelled on the Bible, Blake's theme is the redemption of his own nation, and the transformation of London into a city of gold – but it is also an allegory of mankind in time. Time is seen as a continuum – in Albion 'All things Begin & End' – and the imitative concerns of contemporary history painting have no place. As Blake announces, 'the history of all times and places is nothing else but improbabilities and impossibilities'.

Yet Blake's visionary prophecy was rooted in the historical prejudices of his own time. It is 'the classics & not Goths or Monks, that desolate Europe with wars', he observes, and medieval illuminated manuscripts may have inspired the brilliant pigments and gold paint with which he adorned a single coloured copy of *Jerusalem*. His use of historical parallels is similarly entirely contemporary, drawn from his own excursions into folkloric research. Albion's long sleep, the mirror of the suffering and self-denial that Blake ascribed to the British people, corresponds to the suppression of the primitive Welsh, whose early bardic literature he was collecting while working on *Jerusalem*. Romantic antiquarianism fuses with visionary history and prophecy. Blake's great work sold only a handful of copies, however. For too many of his contemporaries, historical nostalgia and imagination – 'the only paradise from which we cannot be expelled' in the words of the German writer Jean Paul – had so far overtaken religion as to diminish the responsibility to prepare for eternity, and the hope of redemption, that Blake had to offer.

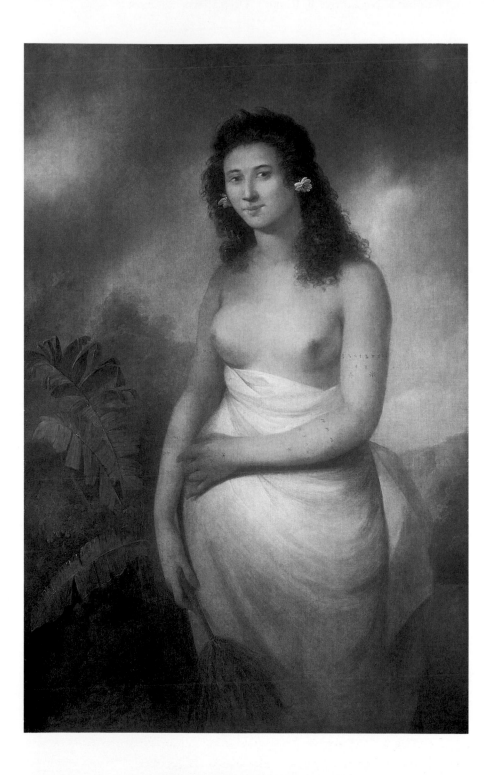

In 1834 a young French painter, Prosper Marilhat (1811–47), showed a view of Ezbekiyah Square, Cairo and three other Egyptian scenes at the Paris Salon. Like many of his generation, he had felt a restless urge to travel and had joined a scientific expedition led by an Austrian baron, Karl von Hugel, to the Near East and India. In fact he got no further than Egypt, which he found so seductive that he stayed for a year. He returned to France aboard the appropriately named *Sphinx*, which was carrying the ancient obelisk from Luxor that now stands in the Place de la Concorde in Paris. Napoleon's Nile campaign (see Chapter 4) had established a vogue for such antiquities, and the Egyptian Pasha, Mehemet Ali, who was currying diplomatic favours with France and other Western powers, was well aware how welcome this trophy would be. Marilhat's pictures, on the other hand, were among the first to show Parisians what modern Egypt really looked like.

The artist was to die, insane, aged just thirty-six, and his Cairo scene survives only in a print (151). The work is remembered in part for a review by Théophile Gautier, an enthusiastic exponent of Romanticism, who was establishing himself as one of Paris's leading critics. Gautier wrote that he recognized in Marilhat's 'ardent' painting his own 'true fatherland' from which he had been exiled by the accident of his birth. He had convinced himself that he was really an Oriental, descended from a race which had given the 'obscure regions of the West, religion, the sciences, all wisdom and poetry'. He later became a keen traveller in Algeria, the Ottoman Empire and Egypt, immersing himself in their cultures, while his daughter fantasized that she was a Chinese princess. Once, to compliment Delacroix, he likened him to an Indian maharajah who had received a perfect education at Calcutta.

150
John
Webber,
*Portrait of
Poedua*,
1777–85.
Oil on
canvas;
142·2×94 cm,
56×37 in.
National
Maritime
Museum,
London

Affected as it may seem today, such longing for the faraway and exotic was felt by many Romantics. Nothing better illustrates the extremes of fact and fantasy that characterized their responses than the artist's sharp-eyed descriptions and writer's invented nostalgia. Distant places joined the distant past as destinations of Romantic escapism, to be experienced as part of a voyage of discovery into the inner self. Encounters, real or imagined, with distant peoples, cultures and places became almost a badge of integrity for progressive artists and writers, symbolizing the regeneration they claimed for their work and

the liberation they sought in their lives. From them, it was hoped, would spring a more vigorous, pluralistic culture in which the classical tradition no longer held sway. In 1817, in an address to the French Academies, David's pupil Girodet put one of the burning questions of the age: 'How can the artist, driven as he is by curiosity into remote regions, and seeing as he does in each of the peoples of the world the different and peculiar ideas it has of the beautiful … remain a firm adherent to the healthy doctrine of absolute beauty?' His

words implied regret at the passing of a common ideal, but most of his generation welcomed it with open arms.

They were looking not just for new styles or subjects but for a purer, more honest way of life that might be learned from peoples who preserved a natural if 'savage' vigour. Delacroix, who as a young man noted down Girodet's words, was later to write: 'One needs great boldness if one is to be true to oneself; it is above all in our time of decadence that this quality is rare. The primitives were bold in a naïve fashion, without knowing … they were so.' And the 'primitive' was to be an important Romantic alternative to the status quo. Just as the organic forms of a Gothic cathedral spoke of a more spiritual age, so a Pacific islander, Native American or desert Arab now appeared a more natural man. While Jean-Jacques Rousseau had introduced the myth of the 'noble savage', the German pioneers of Romanticism – Herder, the Schlegels – had argued

151
Prosper
Marilhat,
*View of
Ezbekiyah,
Cairo,
c.1835.*
Engraving

for a view of the world in which each culture or society should be appreciated on its own terms rather than judged by the standards of a supposedly superior race. Their motive was mainly to enhance appreciation of their own German culture, but the implications of their thinking were far-reaching, challenging their contemporaries to widen their horizons. Wackenroder's art-loving monk (see Chapter 1) spoke for them all: 'We, the sons of this century, have the advantage that we stand on top of a high mountain, and that many countries and epochs are open to our eyes … So let us use this good luck, let our eyes wander freely over all eras and peoples, and let us strive always to find in all their varied feelings and the products of this feeling the human spirit.'

These writers taught and published at a time when travel to distant places was becoming a reality, at least for a few, and when consciousness of the wider globe was expanding through exploration and research. A fascination for the exotic was not in itself new, however. For more than a century Europe had been in thrall to dreams of 'Cathay', a visionary China

compounded of travellers' tales, the spoils of the various
European companies established to develop trade with India
and Asia, and a large measure of wishful thinking. Crossed
with the eighteenth-century Rococo style of elegant, playful
decoration, the Chinoiserie style had spread from St Petersburg
to Palermo, Dresden to Drottningholm, so that hardly a palace
was complete without its pagoda or tea-house. Painters such as
François Boucher (1703–70) incorporated vaguely Oriental
costumes or decorations into their luxurious erotic fantasies
(152). These often combined Chinese and Turkish styles,
drawing on the visits of influential Europeans to the Ottoman
Empire; they were never intended to be tested against reality.
What was new in the second half of the eighteenth century,
however, was a great burst of colonial expansion – notably
by the British in the Americas and India – and of maritime
exploration. Early colonial rivalry between Britain and France
erupted in the Seven Years War (1756–63), shortly followed by
the American War of Independence (1775–83). But despite the
drain of these long-distance conflicts, both Britain and France

152
François
Boucher,
*La Pêche
Chinoise,*
*c.*1750.
Oil on
canvas;
38·1×52·1cm,
15×20½in.
Museum
Boijmans
van
Beuningen,
Rotterdam

continued a programme of empire-building and exploration. Captain Cook's three voyages (1768–79), and the doomed expedition of the Frenchman Jean François de Galaup, Comte de La Pérouse (1785–8), which encircled the globe, attracted huge international attention. They were accompanied by artists and scientists, and the voyages documented in elaborate illustrated publications. These had the effect of making the world a more finite and knowable place, and brought more of it within range of the European imagination.

The tensions between imaginative projection and recorded experience that lie at the root of Romantic perception were intensified by these ventures. They are already to be found in the contrast between two contemporary Englishmen whose enthusiasms for distant places led to very different conclusions: the writer and collector William Beckford and the naturalist Joseph Banks. William Beckford's exotic dreams were stimulated first by the 'Turkish' and 'Egyptian' rooms added by his parents to the family home at Fonthill, then by reading the *Arabian Nights* and dabbling in comparative religion and Russian and Oriental languages. They came to have the same subversive function as his passion for the Gothic. By avoiding the classical stereotyping of the Grand Tour – though in fact he went twice to Italy – he pursued liberation in his personal life. For Beckford's coming of age party at Christmas 1781, the Alsatian émigré painter and stage designer Philippe Jacques de Loutherbourg (1740–1812) transformed Fonthill into a 'necromantic' Oriental fairyland, for a 'voluptuous festival' lasting three days and nights. Although none of the designs survive, they helped provide the background for Beckford's hugely successful Oriental tale *Vathek* (1786), a book which did for the Orient what Walpole's *Otranto* did for the medieval. A study of evil and the pursuit of power whose caliph-hero abandons himself to every cruelty or sensual luxury, it gave vent to Beckford's own youthful longings, and launched an enduring genre of Oriental stories dealing in similar journeys of imagination and wish-fulfilment. Beckford's mythic East was

no longer just a source for interior decoration and dressing-up, but a stage for the fantasies of the interior life.

Joseph Banks, whose portrait by Benjamin West was shown at the Royal Academy in 1773 (153), had really seen distant places as exotic as the wildest literary fantasy. Few men might appear to have less in common. Yet while Beckford had reluctantly submitted to two Grand Tours, Banks refused one altogether because, as he said, 'every blockhead' now went to Italy. His own ambition had been a trip round the world, and Cook's first voyage on the *Endeavour* (1768–71) gave him his opportunity. He joined the expedition, saw to it that its original brief to observe the transit of Venus from Tahiti in 1769 gained a wider scientific and anthropological remit, and supervised the artists, scientists and biologists who accompanied it. In West's portrait he wears a Maori cloak and stands beside other trophies from New Zealand and Polynesia, as if in rebuke of his more conventional contemporaries who were portrayed in Rome with their purchases of classical antiquities.

Banks's eagerness for new experiences was not always understood. In a brilliant satirical drawing (154) by Thomas Rowlandson (1756–1827), he is shown about to tuck in to an alligator, an allusion to his zoological interests which together with botany and ethnography he did so much to promote, sometimes in opposition to more conservative members of London's learned societies. Inclined to be pompous, Banks also fell out with Cook, and stormed off the ship when he was denied the extravagant personal retinue, including a band of musicians, that he wanted to bring on the second voyage. But he continued to take an interest in the artists and researchers who went instead, and few men did more to introduce exotic imagery into the European consciousness. Although he re- quired no more than 'accuracy of drawing' from the travelling artists, they were to make some significant contributions to London exhibitions, opening the eyes of the public to faraway places and manners. Their supposedly objective accounts were

153
Benjamin
West,
Joseph Banks,
1773.
Oil on
canvas;
234×160 cm,
92¹⁸×63 in.
Usher Art
Gallery,
Lincoln

154
Thomas
Rowlandson,
*The Fish
Dinner*,
1788.
Pen and
grey wash;
16×21·3 cm,
6¹⁴×8³⁸ in.
Tate,
London

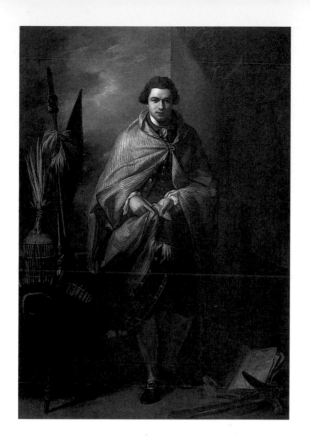

soon exploited by writers and artists of more imaginative temperament, and gave birth to the myth of the South Seas, even more enduring than that of the legendary Cathay.

Cook had been preceded in Tahiti by a fellow Englishman, Captain Wallis, and the Frenchman Louis de Bougainville. The latter named the island 'Nouveau Cythère', after the Greek island where Venus was worshipped. This was a tribute to the beauty and innocent nakedness of the Tahitian women, and it was the fleshly delights of a people who 'had no God but love' that established its reputation as an earthly paradise. While Cook's sailors took every advantage, two questions troubled the philosophers. If such a paradise could exist without Western constraints, were they really needed? And was it right that Westerners should interfere with it, corrupting it by their fatal combination of Christian morality and commercial and sexual exploitation? Such issues arose in response to the first published accounts of the voyages, which tended to dwell on amorous matters, and in the more conspicuous predicaments of two South Sea islanders brought back to Europe: the young Polynesian Omai, who returned to London with Cook's second expedition (1772–5), and Aotourou, brought by Bougainville to Paris. Each arrrived in a capital eager to receive a personification of the 'noble savage', and each was tragically spoilt by the experience. Both were eventually returned to their own people, but could never settle again and ended their days suspended between two worlds.

Reynolds's portrait of Omai (155) was exhibited at the Royal Academy in 1776, when the youth was being shown off in London society by Banks. As a compliment to his good manners – such, according to Dr Johnson's friend Mrs Thrale, that he was less likely than his hosts to cheat at chess – Reynolds dignified him with the classical pose and toga-like robes of a Roman senator, somewhat out of place in the lush tropical setting. Significant pictorial evidence of Omai's homeland had to wait until Cook's second voyage, when William Hodges

155
**Joshua
Reynolds**,
Omai,
1776.
Oil on
canvas;
236×146 cm,
92⅞×57½ in.
Castle
Howard,
Yorkshire

(1744–97) was the accompanying artist. Although he too was
predisposed to see the ancients reborn in the Pacific peoples
and to apply conventional principles of composition to the
scenery, he rose above his preconceptions and emerged as
the true poet of Cook's South Seas, and later of British India.
His studies were full of documentary detail, but the paintings
developed from them for exhibition at the Royal Academy
were fully resolved works of art. In *Tahiti Revisited* shown in
1776 (156), the admittedly rather classical landscape is filled
with carefully observed details such as the native house,
banana trees and the tattooed buttocks that so astonished
Europeans. The sensual physicality of the bathers perhaps plays
to expectations in London, but in the sultry heaviness of the air
there seems also a sense of the fragility of this innocent world.

The marvellously atmospheric handling of this and other
pictures owed much to Hodges's practice of making oil studies
directly from the large window of Cook's cabin. Critics back in

London, however, were not yet ready to accept such images as serious art, and Hodges's pictures were given short shrift. The artist chosen to join Cook's third Pacific voyage (1776–9), the Swiss John Webber (1751–93), was hired with a deliberately more limited brief as an illustrator, to prepare plates for the account Cook intended to publish when he returned. His many detailed drawings focus mainly on the life and habits of the local peoples, subject to constraints now imposed by Cook, who was anxious not to provoke the same gossip about sexual licence that had followed his first voyage, and at the same

time not to deter his country's colonial ambitions by too explicit depictions of the region's customs. Even before his tragic death – the result of an outbreak of violence following his habitual practice of hostage-taking to guarantee safety at anchor – Cook had become disillusioned with the people of the South Seas, whose innocence (if it was such) he realized he had himself corrupted. Webber's illustrations turned out as Cook would have wished – nudity demurely covered; a human sacrifice taking place under his watchful eye, his hat removed

as a mark of respect; hands shaken rather than noses rubbed in greeting. But Webber, like Hodges, wanted to make exhibition pictures from his experiences, and Cook would have been less pleased with some of these. Poedua, the chief's daughter from the Society Islands whose portrait appeared in the Academy in 1785 (see 150), had in fact been one of Cook's hostages, and Webber painted her while she was locked in his quarters. But, for his London audience, she stands in a lush Tahitian setting, bare-breasted, mysteriously smiling, a Pacific *Mona Lisa*.

For the Frenchman La Pérouse, whose expedition followed Cook to the Pacific in 1785, the immediate impression was not

156
William
Hodges,
*Tahiti
Revisited*,
1776.
Oil on
canvas;
97·7×138·4cm,
38½×54½in.
National
Maritime
Museum,
London

157
Jean-Gabriel
Charvet,
*Savages of
the Pacific
Ocean*
(detail),
wallpaper
produced
in Mâcon
by Joseph
Dufour
& Cie,
c.1805.
Woodcut
printed in
gouache.
National
Gallery of
Australia,
Canberra

of the people's harmony with the natural abundance around them, but of the contrast between their savagery and its beauty. But if the South Seas were a flawed paradise, and their islanders less noble than European idealists had wanted to believe, their myth endured. Skirmishes with their European visitors are relegated to the background while idyllic lives seem to be led by the 'Savages of the Pacific Ocean' in scenic wallpapers produced on the theme of Cook's voyages by the Mâcon firm Dufour in about 1804–5 (157). Instructions to artists in 1839 for wall-paintings for the Louvre's Musée de la Marine – where La Pérouse's salvaged relics were displayed –

specified similar stereotypes, including 'Tahitian girls abandoning their lovely bodies to the waves, swimming like the Nereids and bewitching the sailors'. But physical prowess or erotic charm were not the only impressions brought back from the Pacific; ritual and religion were also studied. When de Loutherbourg, working from Webber's drawings, devised the décor for Covent Garden's hit pantomime for Christmas 1785, *Omai, or a Trip Round the World*, his set pieces included a realization of the walled burial grounds with their stone graves and carved totems that Webber had seen on the Hawaiian island of Kauai. A more sober educational purpose was thus added to the storms, eclipses, icebergs and exotic costumes – including a 1·5m (5 ft) headdress of tree ferns – with which the designer astonished his audience.

Funerary rituals were among the most striking aspects of 'primitive' societies to European eyes, suggesting a different but equally rigorous morality. While they attracted ethnographic research, they were also among the few subjects which translated to familiar art forms of history or narrative. Thus artists in India, led by the German-born Johann Zoffany (1733–1810) who arrived in 1783, gave a distinctly classical feeling to depictions of *sati* – the theoretically voluntary and virtuous act of a widow throwing herself on her husband's funeral pyre. The British eventually outlawed this practice, and it is unlikely that earlier painters witnessed it closely. But their renderings chimed with those themes of heroic virtue and noble death taken up in Europe in the years before the French Revolution. Although these were mainly taken from the ancient world, it was to the New World, and to the Native American peoples, that Joseph Wright of Derby (1734–97) looked to demonstrate a widow's unwavering loyalty in a remarkable picture of 1785. Wright had never crossed the Atlantic, but reading James Adair's *History of the American Indians* (1775) he had found an account of the vigil kept by the widow of a brave 'for the first moon … under his mourning war-pole', and had painted his *Widow of an Indian Chief* (158) to join three other

158
Joseph
Wright
of Derby,
*Widow of
an Indian
Chief,*
1785.
Oil on
canvas;
101·6×127cm,
40×50in.
Derby
Museum
and Art
Gallery

159
Anne-Louis
Girodet de
Roucy-
Trioson,
*The
Entombment
of Atala,*
1808.
Oil on
canvas;
207×267cm,
81½×105in.
Musée du
Louvre,
Paris

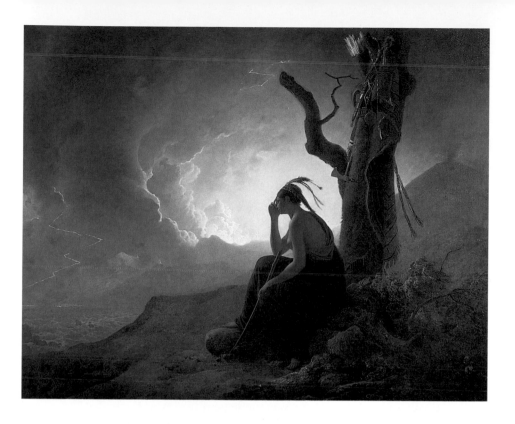

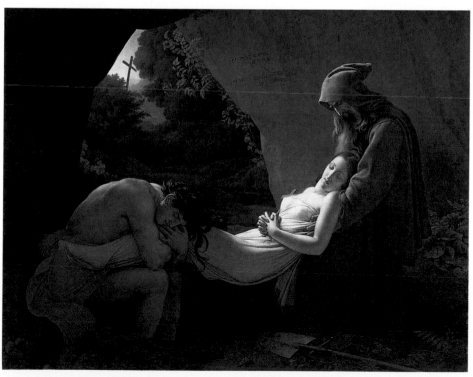

pictures of women empowered by virtue, love or loyalty – the Lady from Milton's *Comus* emboldened by moonlight to resist a lecherous god, Homer's Penelope, weaving her shroud to deter suitors in Ulysses' absence, and the Corinthian Maid, inventing painting by tracing her lover's shadow. In Wright's remarkable quartet, a Native American formed part of a very Neoclassical display of feminine virtue. Her bearing is that of an antique statue, while the stormy shore with its volcano has more to do with Naples, which Wright had seen as a young man, than with America. But still she must have appeared as an extraordinary creature from another world – at once the most striking and the least familiar of Wright's virtuous women.

Mourning and sacrifice are also the themes of *The Entombment of Atala* (159), the moving picture that David's pupil Girodet showed at the Paris Salon in 1808. Here too the scene is set in America, but the circumstances are more complicated. In a reversal of Wright's subject, it is the Native American brave Chactas who mourns, clasping the legs of his lover, the half-Spanish converted Christian Atala, who expires before him, comforted by a friar. But he is not virtuous: he has violated her vow to remain a virgin or die, and as she meets her punishment his lithe sexuality and dangerous power can still be felt. With its wild New World setting, intensely realized emotions and almost supernatural lighting, the picture moves outside classical rules to contrast 'civilization' and 'barbarism' in highly ambivalent terms. Who is the victim here? Whose the better life? Girodet took his richly suggestive narrative from a popular story published seven years earlier by Chateaubriand, who had gone to America in 1791 to escape the Revolution. The author saw the Native Americans in Rousseauesque terms as 'ideal savages', and was much preoccupied by the harmful consequences that followed from their contact with 'civilization'. In a longer story, *The Natchez*, he carried his fears to their logical conclusion, writing of the actual destruction of a tribe – increasingly a tragic reality.

The fate of Native Americans, like that of the Australian Aboriginals or the victims of the European slave trade in Africa, would come to epitomize the worst outcome of European colonialism, during the very period when cultural and ethnic diversity was finding a new appreciation. At least the slave trade was curbed, late in the century, by abolition movements in England and France. Certainly such destruction of indigenous societies by newcomers who seized their land would have appalled the early German advocates of cultural pluralism. More in tune with their thinking, perhaps, was the early stage of British rule in India. It was true that India, more than other regions that fell under European control, gave manifest evidence of former wealth and civilization, whether in its legacy of magnificent buildings from the Mughal era, or in the mysterious complexities of the Sanskrit language. Friedrich Schlegel, having studied Sanskrit in Paris, urged his fellow Europeans to look to India as an antidote to their corrupting materialism. True Romanticism, he even declared, could be found only in the East. But while Indian culture commanded respect, credit must still be given to the enlightened attitude of Warren Hastings, the British Governor General of Bengal from 1772 to 1785, under whose rule genuine co-operation, extending from adoption of Hindu law to mixed marriage and exchange of dress and customs, flourished between the British and the Indians.

All this rubbed off on the artists who made their way to the subcontinent. Like the early pictures of the South Pacific, those brought back from India played their part in changing the rules of art and creating a climate of curiosity. Zoffany witnessed this period of easy exchange not only in Calcutta but also in the notably relaxed court of the Nawab of Oudh. His lively picture of a cock match between the Nawab's bird and that of the Englishman Colonel Mordaunt (160) had no pictorial precedent, and revels instead in intimate detail, narrative and vivid colour. Before Delacroix's pictures of Morocco, there are few more telling examples of a new subject and setting

160
Johann
Zoffany,
Colonel
Mordaunt's
Cock Match,
*c.*1784–6.
Oil on
canvas;
103·9×150 cm,
41⅞×59 in.
Tate, London
Right
Detail

producing an original style. The British and Indians, while carefully differentiated, appear as equals in the contest and Mordaunt's pointed Indian slippers show him adopting the local fashions. If some of the British officers seem somewhat stiff, and the Indian servants excitable, the difference is as much of class or caste as of race, and it must be remembered that, as a German, Zoffany could observe each dispassionately. He has placed himself at the right of the scene, pencil in hand, looking on with sardonic amusement.

Zoffany painted this picture for Hastings, also a generous patron to Hodges, who arrived in India in 1779. In his work for Hastings, and in the *Select Views in India* collected in 1785–8 from drawings made on the spot, Hodges struggled to respond independently of classical or picturesque expectations, though backsliding occasionally in Benares, for example, when women carrying water jars reminded him of 'fine antique figures'. He was determined to overcome criticism of his exotic subjects as 'curiosities', believing that pictures should not be evaluated merely as specimens of a painter's genius but would rate higher 'were they connected with the history of various countries, and did faithfully represent the manners of mankind'. Rather than its people, however, Hodges's real passion was for the buildings of India, and in his book *Travels in India* (1793) he developed an earlier dissertation on the 'Hindoo, Moorish and Gothic' styles, claiming the same organic roots for these that others were then finding for the Gothic cathedral. Minarets, he believed, derived from the pointed rocks he saw in India. At the same time Hodges condemned the Neoclassical preference for 'Grecian' architecture as 'erroneous and servile', and it is hard to imagine him having much sympathy with the grand Neoclassical buildings then being erected by the British in Calcutta as symbols of their power.

Architectural eclecticism was already being seen in Britain and Europe. Among its pioneers were John Vardy (1718–65) whose interiors at Spencer House in London (1755–66) are richly

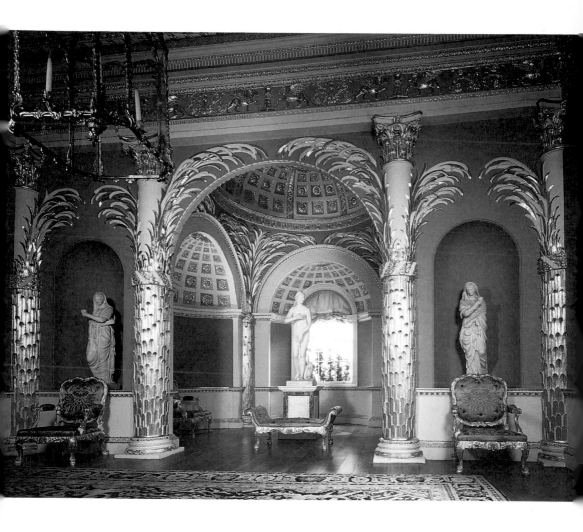

**161
John Vardy**,
The Palm
Room,
Spencer
House,
London,
1756–66

ornamented with stucco palm trees and other exotic features
(161), and William Chambers (1723–96), who had begun
his career in the employ of the Swedish East India Company
in Canton. Chambers promoted exotic forms, combined
with an inspired sense of fantasy, in a *Dissertation on Oriental
Gardening* (1772), while he added 'Hindoo', Turkish and
Chinese elements to his various buildings for the royal gardens
at Kew. His fellow architect Sir John Soane (1753–1837) was
later to combine these in a remarkable lecture illustration
for his students at the Royal Academy (162). The visionary
character of this design was calculated to release their

imagination. In a similar fashion Chambers was also influential
on the Continent, for example at Wörlitz near Dessau in
Germany, where Friedrich Wilhelm von Erdmannsdorf
(1736–1800) mixed the exotic with the classical to create
what Goethe called a 'dream place' for his patron, the anglo-
phile Prince Franz of Anhalt-Dessau.

Meanwhile the Hindu and Moorish styles were promoted by
British East India Company officials home from India – the
'nabobs' who had grown rich from trade. One of the most
remarkable examples of neo-Mughal architecture in Britain

is Sezincote in Gloucestershire (163), a grand country house built in about 1805 by the architect Samuel Pepys Cockerell (1753–1827) for his brother Sir Charles, a retired Company administrator. With its minarets and great copper dome, it used advanced engineering to create a nostalgic fantasy. It was after a visit to Sezincote that the landscape designer Humphry Repton (1752–1818) first fired the imagination of the Prince Regent, the future George IV, with the idea of an Indian pavilion at his favourite seaside resort of Brighton; but it was to be John Nash, hitherto mainly known as a purveyor of classical and Gothic, who eventually turned a modest classical villa into the Brighton Pavilion, the undoubted masterpiece

162
Sir John
Soane,
Lecture
diagram
showing
all the
buildings
at Kew
Gardens,
c.1806.
Pen, ink and
watercolour;
73×128cm,
28³⁄4×50³⁄8 in.
Sir John
Soane's
Museum,
London

163
Samuel
Pepys
Cockerell,
Sezincote,
Gloucester-
shire,
c.1805

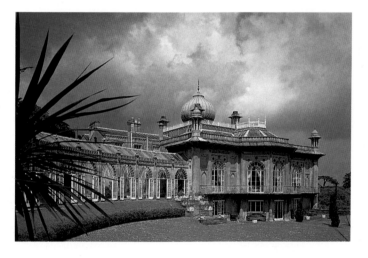

of Romantic exoticism in architecture and interior design. The transformation took place between 1815 and 1823, and must have appeared almost a work of magic as onion domes, minarets and crenellations sprouted from the little palace. But however dazzling, the exterior only hinted at the flamboyance within: in the main rooms, such as the banqueting room (164) with its dome lined with painted and sculpted plantain leaves and suspended dragons, and its walls decorated with Chinese figures, Nash and the Regent's craftsmen and designers created a fairy-tale vision of the Orient never to be surpassed in the West. It was the built equivalent of the 'stately pleasure

dome' envisioned in Coleridge's poem *Kubla Khan* (published 1816). Combining Chinese, Hindu and Gothic with glorious abandon, the Pavilion is not remotely literal or antiquarian in its references. In this it is unique and cannot be compared to the antique reconstructions of contemporary Neoclassicism or the recreations of ancient Egypt popular in Paris and London at the time.

If it seems as if the British initially led the way in introducing exotic imagery to Europe, this is mainly because earlier French claims on India had been substantially reduced by the 1763 treaty of Paris that ended the Seven Years War, and because the

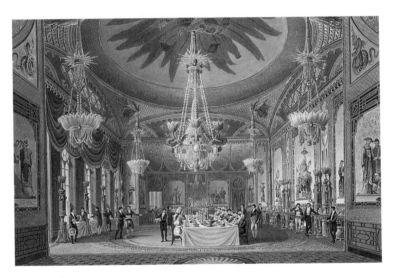

164
John Nash,
The Banqueting Room, Royal Pavilion, Brighton, 1826. Etching and hand-coloured aquatint; 26·5×39 cm, 10¹₂×15³₈ in

wreck of La Pérouse's expedition in the Pacific in 1788 meant that Cook's voyages brought back more information. But it was to be the French experience in Egypt that did most to concentrate the Romantic imagination on the Orient, both in France itself and beyond. It is ironic that, while Napoleon's strategy in occupying Egypt had been to cut off British routes to India, the French experience there often appeared as a distorted reflection of British experience in the subcontinent. Napoleon had hoped to foster a similar spirit of harmonious exchange, based on pragmatic mutual interest, and until the military situation deteriorated, he enjoyed escaping from the

'wearisome constraints of civilization', wearing his turban and riding his camel, and even making a show of converting to Islam. While he was keen to show off French inventions like the balloon, he was fascinated by the relics of ancient Egypt and flattered by the more sophisticated Arabs he met in Cairo. His guests there were likely to find themselves presented with both the Koran and Thomas Paine's *Rights of Man*. And while his teams of scholars scrutinized Egypt's archaeological remains, he saw himself restoring the greatness of the pharaohs, to whom he compared himself, by bringing the benefits of an advanced modern society to a once-great nation now fallen into 'barbarism'. When his enterprise collapsed, however, the local laws were invoked, not as by Hastings in India for peaceful governance, but to provide a suitably brutal Islamic punishment for the murder, in 1800, of Napoleon's acting commander, Jean Baptiste Kléber. And having experienced it for themselves during an earlier uprising in 1798, the French put the savagery of the Egyptian Mamluks to good use, conscripting them as mercenaries. It was they who, as we have seen in Goya's painting (see 56), were unleashed on the citizens of Madrid in 1808.

All this meant that French experience in Egypt was highly ambivalent, presenting real problems of interpretation for those called upon to depict it. The campaign had to be seen as something other than a failure; Napoleon must be redeemed from defeat; and the modern Arabs presented as in need of his intervention while their ancient forebears and Islamic culture also deserved the attention of French scholarship. How these needs were answered was to have a lasting effect on Romantic attitudes to the Orient, and on Romantic art itself. It was then that Orientalism began to take on the characteristics assigned to it in the late twentieth century by the cultural historian Edward Said – the appropriation, restructuring and domination of the East by a West determined to preserve its own superiority. In this analysis, it differs substantially from the other aspect of Romantic exoticism, the attraction of the 'primitive' as a challenge to Western values.

While the achievements of the scholars in due course offset the national humiliation in Egypt, Napoleonic propaganda demanded a more immediate corrective from those painters, chiefly Gros, Girodet and Guérin, who took up themes from the campaign. In so doing, they were answerable to Denon, their prime source of information on Eygpt, who in 1802 had been promoted to the administration of the Salon exhibitions as well as the curatorship of the Louvre (see Chapter 4). He had clear ideas as to how the Napoleonic legend should be preserved and polished. Since none of these artists had witnessed the real events in Egypt – Gros, however, had longed to go – they were free to create their pictures at a lofty remove, and with regard to entirely domestic requirements of historical revisionism. This might seem to deny them the authenticity required of Romantic art, but in fact they responded to their material with such passion and convincing simulation of realism, that they put themselves at the forefront of the newest movements in French painting. Their Egyptian pictures were to play a crucial part in interesting Delacroix and his generation in the Oriental world. None of them portrayed the Orient in a remotely appealing light, but rather as a foil to French achievement.

Degradation and extreme violence are the local conditions against which the painters chose to set the magnanimity or bravery of their own nation. For Gros, the East is a barbarous, disease-ridden hell in which the heroic Napoleon appears almost as a god, even when the truth had been the very opposite. His epic *Bonaparte Visiting the Plague-Stricken at Jaffa* (165) of 1804 shows Napoleon bravely touching a sore on a visit to his afflicted troops, who rally in his presence while the conquered Orientals languish in a dark corner. This invention was designed to remove the sting of altogether more discreditable episodes in this Palestinian city: the summary execution by the French of its surrendering Turkish defenders, and Napoleon's abandonment of his own soldiers who had caught the plague from the inhabitants. Napoleon had indeed paid one visit to his dying men, but shortly afterwards he had

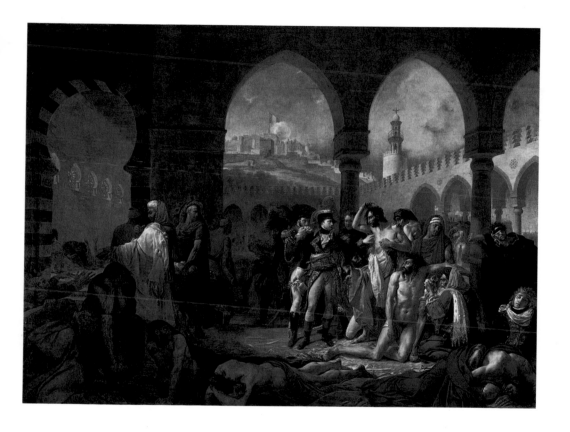

165
**Antoine-Jean
Gros**,
*Bonaparte
Visiting
the Plague-
Stricken at
Jaffa on 11
March 1799,*
1804.
Oil on canvas;
523×715 cm,
206×281½ in.
Musée du
Louvre, Paris

166
Pierre-
Narcisse
Guérin,
Napoleon
Pardoning the
Rebels at Cairo,
1808.
Oil on canvas;
365×500 cm,
143³⁄₄×197 in.
Musée
National
du Château
de Versailles

ordered them to be poisoned lest they delay his army. Gros's imaginative grasp of the facts of their condition – their sweat and sores and stench, to offset which the fastidious Marshal Berthier presses a handkerchief to his nose – makes the epic illusion of Napoleon as heroic leader persuasive, and the picture was Gros's greatest Salon triumph. Guérin's *Napoleon Pardoning the Rebels at Cairo* (166) of 1808 at least has a grain of truth, since Napoleon had shown clemency to the Mamluk leaders of the 1798 rising – but only after the slaughter of most of the insurgents. Guérin burnishes Napoleon's myth even more subtly than Gros, placing his hero to the rear and rather dwarfed by those he has pardoned, in a sort of inverted modesty. If the rebels are allowed dignity in defeat, it is to emphasize the magnanimity of the victor.

Gros and Guérin, of course, were principally concerned with the demands of Napoleonic imperialism, and with the cult of the Emperor himself. The primitive passivity of the plague house and the conquered ferocity of the Mamluk rebels are, in this line of thinking, proof of a fallen race, and legitimize the French intervention in their affairs. This point of view was soon to be taken up by Chateaubriand, who on a tour to Palestine begun in 1806 found evidence by the Nile of the recent French occupation and concluded that Napoleon – of whose politics at home he was no admirer – had been the last crusader, bringing justice, leadership and unity to races 'fallen again into a savage state'. It was left to Girodet, who is said to have found the Egyptians 'electrifying' for their looks and energy and to have used Mamluk models in his Paris studio, to give them back some of their dignity. His own *Revolt at Cairo* of 1810 (167) accords equal degrees of heroism to the French and to the Egyptians defending their mosque during their 1798 rebellion. In this it seems almost subversive: an Arab appears as a classically beautiful nude, both struggling and supporting a fallen Pasha, while the handsome, uniformed Frenchman who charges into a Muslim horde seems as doomed as he is brave. 'Imagine shifting an ancient vase and discovering a nest of vipers', wrote

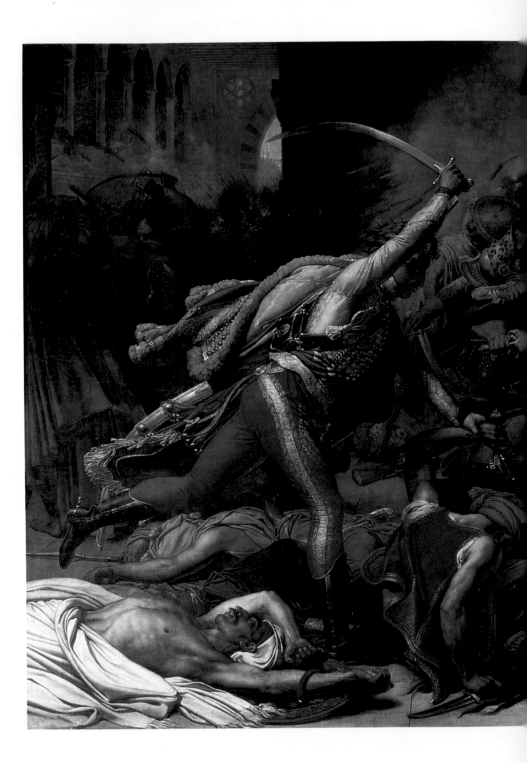

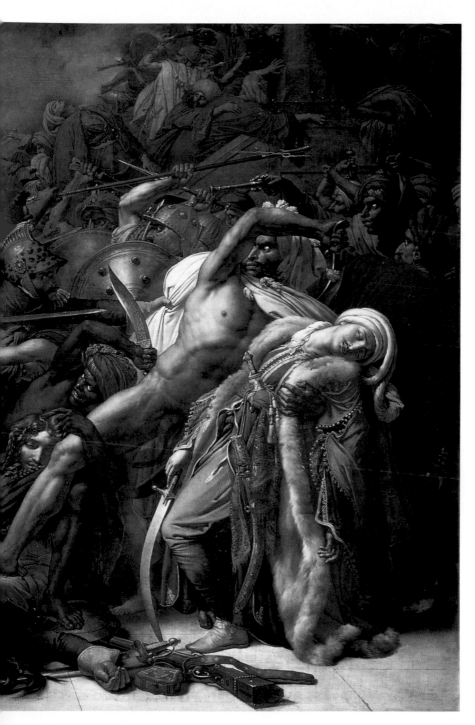

167
Anne-Louis
Girodet de
Roucy-
Trioson,
The Revolt
at Cairo,
1810.
Oil on canvas;
356·2×499·7 cm,
140¼×196¾ in.
Musée
National
du Château
de Versailles

Stendhal of Girodet's picture, and certainly it is a shock to find such physical beauty embroiled in writing violence. But that violence has also an undeniable glamour, and the beauty a certain poignancy. Cultural and artistic values are here transformed.

To these gruesome visions of the history painters, Ingres provided a luscious antidote in 1814 in the form of his monumental *La Grande Odalisque* (168). Violence and horror now gave way to the erotic. For many in the West, the idea of the harem with its available or exploited women trapped in their own closed world was as much proof of the fallen or

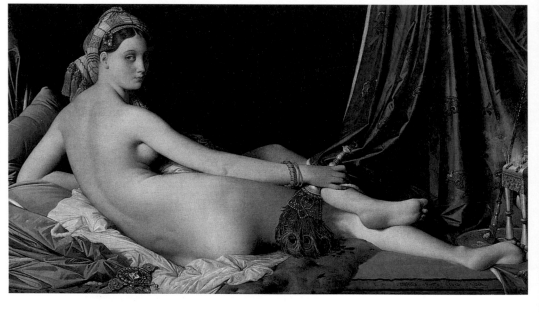

primitive state of the East as was its supposed savagery. But it was also infinitely titillating. Ingres's picture is more than this, however. A sense of loss was inevitably embodied in French perceptions of the East after their defeat in Egypt, and it was perhaps because it sublimated unattainable desires that the theme of the Oriental nude, bather or harem girl gained such a haunting appeal. Ingres is remarkable for combining a frank allure with a chilling perfection of flesh. Ingres never went anywhere near the East, but he had picked up his discreet hints of the harem – a turban here, a fan there – from the accounts

of an earlier traveller in the Ottoman world, the Englishwoman
Lady Mary Wortley Montagu, and from Oriental artefacts and
miniatures in the collections of Gros and Denon. They serve to
locate his nude, who otherwise could really belong anywhere,
in a sensuous Orient of the imagination. Its luxury and languor
were persuasive because – scholars and soldiers aside – visitors
to the East were still very few. And such visions offered a
tempting retreat for a nation whose actual embrace of the
East had been frustrated. For the French Romantics, the East
became a space for dreaming, a place of otherness. Even real
travellers could not be relied on for dispassionate reportage:
while Chateaubriand's *Itinéraire de Paris à Jérusalem* (1811)
established what became a standard route, it was less a
descriptive travelogue than a characteristically subjective
reconstruction of the Orient he had expected to find. For
Victor Hugo, no journey was necessary to write his collection of
poems *Les Orientales* (1829), the classic literary interpretation of
the Orient as mirage, or as he described it, 'as an image and as
a thought'. Such a world could never be lost, for it did not exist.

Of all writers it was Byron who was to be the most influential
in forming painters' views of the Orient. Byron's experience
of it began in 1809, when he made a tour through Spain and
Portugal round the Mediterranean to Greece, Albania and
Constantinople. Following his student days at Cambridge, he
had been determined to 'take a wider view than is customary
with travellers', and first considered India, then hoped to
extend his itinerary to Egypt and Syria. Neither were to be,
but the tour was exotic enough to satisfy his escapist cravings
and extend the scope of his long semi-autobiographical
narrative poem *Childe Harold's Pilgrimage* beyond the familiar
Grand Tour territory. Byron's persona in the poem – restless,
disenchanted, seeking solace in distant lands – is quintes-
sentially Romantic. It was caught to perfection by Thomas
Phillips (1770–1845) for a portrait shown at the Royal Academy
in 1814 (169), in which the poet appears as one of the century's
first honorary Orientals, wearing an outfit of the Albanian

168
Jean-
Auguste-
Dominique
Ingres,
*La Grande
Odalisque,*
1814.
Oil on
canvas;
91×162 cm,
35⅞×63¾ in.
Musée du
Louvre,
Paris

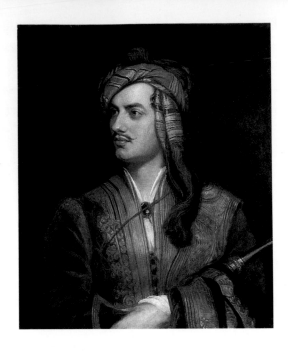

169
Thomas Phillips, *Byron in Arnaout Dress*, 1835.
Copy by the artist from his painting of 1813.
Oil on canvas; 76·5×63·9 cm, 30⅛×25⅛ in.
National Portrait Gallery, London

Arnaout tribe that he had bought in Epirus in 1809. But it was the Oriental tales like *The Giaour* that he wrote on his return, with their rich local colour and stormy passions, that were to prove the most inspirational to painters. Their dashing piratical heroes appealed to female fantasies of dangerous and exotic liaisons, and doubtless expressed some homosexual fantasies of the author's, much as the harems and bathers of the Orientalist painters played to male desires. Byron's vivid word-pictures cried out for illustration.

It was Madame de Staël who encouraged Byron to take up Eastern themes; the public, she declared, was 'orientalizing' and this was 'the only poetical policy'. Beckford's *Vathek* had launched an increasingly popular genre, and Byron's Oriental tales were certainly calculated to be commercial. But for Byron the East also engaged his moral and personal commitment. He had been both intrigued by Ottoman culture and repelled by what he saw as its indifference to human life, and especially by Turkish domination of Greece, which formed a reluctant part of the Ottoman Empire. This political issue came to a head in 1821, when the Greeks began a War of Independence against

their Turkish masters. Byron joined them as a volunteer, and died at Missolonghi in 1824. While his writing stirred up sympathy for the Greek cause and, by historical analogies, offered the prospect of their release from tyranny, it was this practical intervention, leading to what was perceived as a symbolic sacrifice, that established Byron as *the* hero and martyr of the Romantic movement.

Rich in stereotypical symbolism as a conflict between civilization – descended from the ancient Greeks – and the barbarism of the 'infidel' Turks, the Greek war was a focus for all the residual revolutionary passion and liberal sentiment that had been scattered and discredited since the fall of Napoleon. Led by Byron, writers and artists across Europe rallied under the banner of Liberty. The cultural and social renewal demanded by the Romantics now had a specific political dimension. Philhellenism, the movement supporting the Greek cause, became widespread but was especially felt in France, where support for the Greeks mirrored opposition to the overbearing conservatism of the Restoration. For French artists the war at last provided the sort of heroic subjects for which there had been no call since the glory days of the empire. Once Egypt, now Ottoman Greece in its tragic and stirring struggle gave them the material they needed to forge a new art.

At the forefront of this movement was Delacroix. Byron's poetry and the Greek war were the twin themes of his most radical early pictures. It was in 1824, the year of Byron's death, that he turned to the war for his *Scenes from the Massacres at Chios* (170), a grim depiction of the cruelties inflicted by the Turks on their Chiot subjects two years earlier, in reprisal for the Greek insurrection in Morea and the demands for independence issued from a National Assembly in Epidaurus. Delacroix's account of Turkish violence and Greek despair is unequivocal, and created an aesthetic revolution of its own. Only Delacroix's second major picture, this was the first to which critics applied the description *romantique*, intending

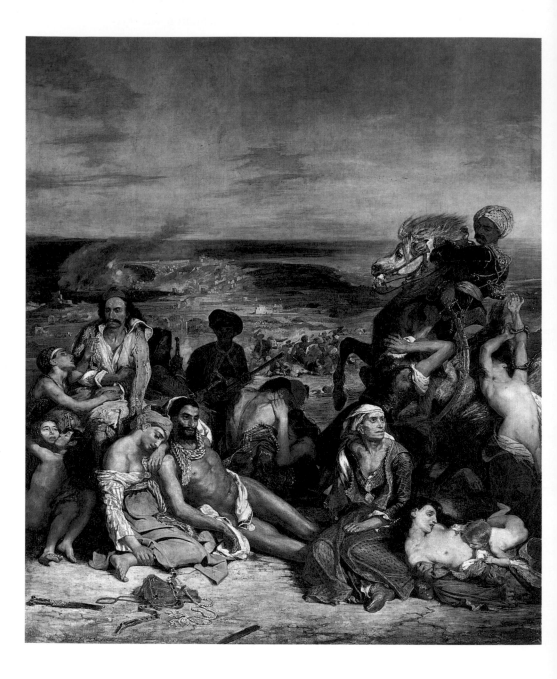

to distinguish its vivid execution and brilliant colour (based on recent experience of English painting), intensely realized expressions of suffering and free-flowing composition from the high finish, restrained emotions and structural harmony of the classical tradition. Here was a picture that seemed to turn ugliness into a moral crusade. The work was also important for signalling the painter's determination to comment on contemporary events from his own independent perspective – though Stendhal reprimanded him for doing so only at second hand, and not having enlisted in the cause himself. Reviewing it, the critic Auguste Jal declared that he had now had enough of the ancient Greeks; it was the modern ones that mattered. He saw the picture as the epitome of a new mood: 'Romanticism runs at full flood in society, and as painting is the mirror of society, painting is becoming Romantic.'

170
Eugène
Delacroix,
*Scenes from
the Massacres
at Chios*,
1824.
Oil on
canvas;
419×354 cm,
165×139¼ in.
Musée du
Louvre,
Paris

Delacroix was a passionate admirer of Gros, and for this, his first scene of the Orient, he followed Gros's plague scene at Jaffa in presenting it as a barbaric and degraded place. He had also collected information from a French volunteer in the Greek cause, Colonel Voutier, and his depiction is ominously convincing. The picture is a polemic, intended to arouse horror and sympathy. But Delacroix also already shared the Orientalist tastes of his generation, to a degree that somewhat divided his sympathies. He noted that Voutier had found himself attracted as well as repelled by the Turks, being unable to shoot a Turkish soldier during the siege of Athens because he had a beautiful head. Delacroix likewise was not immune to the glamour of Turkish men, making a number of attractive studies of Turks smoking, reclining or caressing their horses. For these Delacroix raided the collections of a friend, the sculptor Jules-Robert Auguste (1789–1850), who had travelled in North Africa, the eastern Mediterranean and Near East and returned with trophies of weapons, costumes, horse-trappings and the like, and a fund of drawings and stories. The sketches of 'Turks' that Delacroix made at this time are, in truth, little more than exotic costume studies, but they show how the

appeal of a fantasy Orient continued to overcome ethnic distinctions or loyalties.

Auguste had also been a friend of Géricault, who, against the stereotype of the savage Turk, could oppose his personal experience of the quiet and melancholy Mustapha, a ship-wrecked Turkish sailor he had found in a Paris street and brought home as a model and companion. Asked to leave by the artist's father, Mustapha remained in contact and walked,

171
Théodore
Géricault,
*A Turk
(Mustapha)*,
*c.*1820.
Black chalk
and water-
colour;
30·1×22·6cm,
11⅞×8⅞in.
Musée du
Louvre,
Paris

distraught, in Géricault's funeral procession. It is probably his features, dark eyes sad beneath his turban, that are depicted in several late studies of a Turk that strike the viewer as warmly individualized portraits (171). French artists were not alone in seeing an attractive side to the Turks: in 1827 Parisian ladies who subscribed to Greek funds were also reported to be enthralled by a fashion for Turkish turbans, while the play *Irène*

at the Cirque Olympique proved a hit that same year because of a 'brilliant cavalcade' of the Turkish army, complete with camels. Soon a perceptive journalist, Gaston Deschamps, would remark how 'the Romantics plundered the jewellery of the Levant', being unable to decide whether they really preferred the 'heroism' of the Greeks or the 'fierceness' of the Turks.

Touching or comical as these conflicts of taste could be, they hinted at deeper dilemmas. It was of course absurd to write off Islam as wholly savage; and the Greeks' claim to represent the forces of 'civilization' rested on their being heirs to the very classical tradition that the Romantics challenged. Moreover, the alliance belatedly formed in 1825 between Britain, France and Russia to eject the Turks arose largely from their wish to weaken the Ottoman Empire and strengthen their own hold on the eastern Mediterranean. In London, the Elgin Marbles, masterpieces of ancient Greek sculpture rescued in 1816 from the Athenian Parthenon, became a focus for Greek sympathies and inspired fresh appreciation of the supreme achievements of Classical Greece. But they were there entirely as a result of an earlier British alliance with the Sultan, for it had been the British role in throwing the French out of his Egyptian possessions that had induced him to permit the removal of the sculptures.

Few painters of the period were to meditate more deeply on divided loyalties and conflicting allegiances than Delacroix. His mature statements on such themes would be delivered through the medium of history painting. Meanwhile, for pictures for an exhibition in aid of Greek relief in Paris's Galerie Lebrun in 1826, he chose fictional subjects from Byron. His *Combat of the Giaour and the Pasha*, which he repeated in various versions (172), illustrates the conflict in Byron's poem, in which the Christian Giaour, an outcast Venetian warrior, is about to slay the Turk Hassan to avenge his mistress, Leila, who had fled from the Turk's harem. On being recaptured, she was flung into the sea, her punishment for infidelity. With it Delacroix

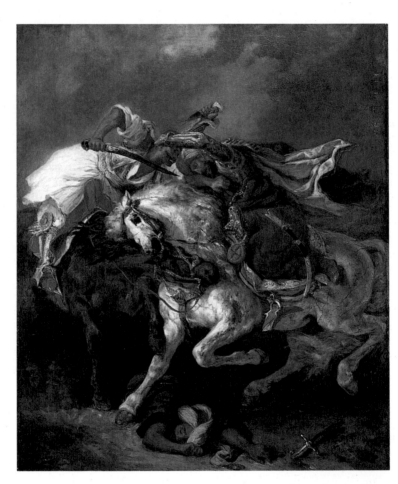

172
Eugène
Delacroix,
Combat of
the Giaour
and the
Pasha,
1835.
Oil on
canvas;
74·3×59·7cm,
29¼×23½in.
Musée du
Petit Palais,
Paris

173
Eugène
Delacroix,
Greece on
the Ruins of
Missolonghi,
1826.
Oil on
canvas;
209×147cm,
82¼×57⅞in.
Musée des
Beaux-Arts,
Bordeaux

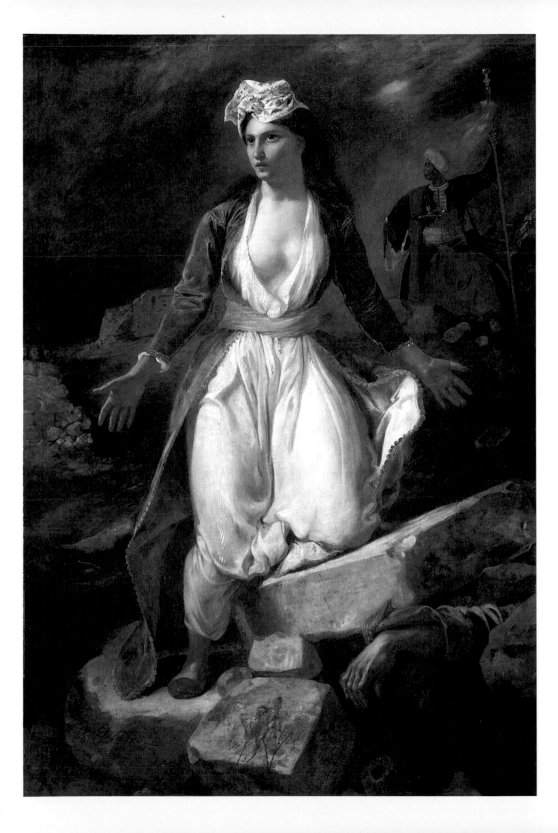

showed the emblematic *Greece on the Ruins of Missolonghi* (173), in which, in a kind of secular altarpiece, the tragic female personification of Greece kneels in despair on a bloodstained stone, her hands outstretched in supplication. In the background a black Oriental, presumably an Egyptian in Turkish service, raises the Islamic standard. The heir of ancient Greece is now the slave of a slave, and a disembodied hand in the foreground suggests both her people's broken state and perhaps also Byron's death in this very place.

Byronic Orientalism, so dramatically introduced in the scandalous *Sardanapalus* (see 2), remained consistently the channel through which Delacroix's Romanticism was released in its most extreme form – violent and sensual, rich in colour and exotic detail. No doubt he hoped to find this imaginary world brought to life when, in 1832, he travelled to Morocco – his single actual experience of the East. It was on the advice of a famous Parisian actress, Mademoiselle Mars, that the diplomat Comte de Mornay took him with him on a mission to the Moroccan Sultan Abd al-Rahman, whose support Louis-Philippe's government hoped to secure for their annexation of Algeria. The Sultan proved intractable, but for Delacroix the experience of five months in North Africa, together with a short visit to Spain, was a revelation. Confronted with reality, notions of the East nurtured by Gros and Byron proved to have been misleading. The powerful impressions of the trip modified his earlier extremism and encouraged a more documentary realism. At the same time, they put him in mind of the classical world while increasing his contempt for pictorial classicism as understood in France. The Arabs in their long robes struck him as truer Greeks or Romans than the stilted recreations of David. From Tangier he wrote to the critic Jal: 'I now know what [the ancients] were really like; their marbles tell the exact truth, but ... they are mere hieroglyphs to our wretched modern artists.' He concluded with the famous phrase 'Rome is no longer in Rome.'

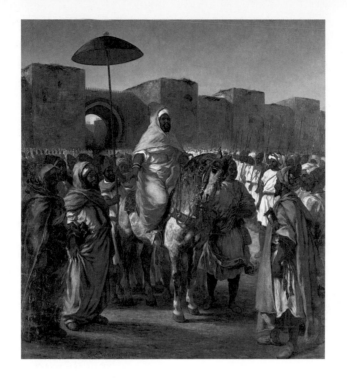

174
**Eugène
Delacroix**,
*The Sultan
of Morocco
and his
Entourage,
1832,*
1845.
Oil on canvas;
38·4×34·3 cm,
15¹⁄₈×13¹⁄₂ in.
Musée des
Augustins,
Toulouse

Delacroix's expedition was his own Grand Tour, and certainly
there is the grandeur of a Roman triumph about *The Sultan of
Morocco and his Entourage, 1832* of 1845, depicted at the official
reception of de Mornay at Meknès (174). The work also reflects
the fact that the French had come to the Sultan as suppliants,
aware of the damage he could do to their colonial enterprise.
There could be no question of a subordinating portrayal, even
though, by the time the picture was painted, the Sultan had
rejected French advances. Delacroix's most immediate pictorial
response to his experiences in North Africa, the *Women of
Algiers in their Apartment* exhibited at the Salon in 1834 (175),
evokes a similar sobriety and order from its exotic setting,
and is also, in its way, about power or its tantalizing effects.
More directly than in Ingres's earlier nude, and with more
documentary truth, it presents what would soon become a
classic subject of Orientalist painters – the listless claustro-
phobia of the harem. Both captive and captivating, these
women are far from submissive. But their world does not offer
the promise of a more liberated life (Baudelaire compared

them to bourgeoise Parisiennes). Delacroix's picture is both teasing and melancholy – the more so because of its rich and sensuous colour and sense of pattern. The subject haunted him, and years later he revised it, distancing the figures and cloaking them in deep shadows as if to mirror their absorption into his memory or subconscious – the ultimate proof of its power over the artist.

By 1852 Delacroix could write: 'I did not begin to do anything worthwhile from my North African journey until I had so far

forgotten the small details as to recall only the striking and poetic aspects', until he felt 'free of the love of exactitude that the majority take for truth'. While sensual beauty played a large part in Delacroix's memories of the Orient, and proved very amenable to commercial exploitation, so too did energy and violence, the synthesis of experiences that had shocked him at the time – as when he had to hide to avoid being stoned as a Christian interloper at a Muslim procession. In time the specifics became assimilated into images of furious skirmishes

and spectacular displays of horsemanship that he may never actually have seen, but for which he returned to his earlier Byronic inspiration and other sources. The significantly titled *Fantasia*, which he painted in several versions (176), referred not only to one of a set of commemorative watercolours made for de Mornay but also to his own recollections of horse-racing from his visit to London. It produced a fusion of primal forces, human and animal, which, as Gautier remarked, passes by at a gallop. The same wild energies are liberated in Delacroix's recurrent theme of the lion hunt, to which, with a number of biblical subjects, he was able to contribute motifs from his 1832 tour while not depicting specifically Moroccan scenes.

175
Eugène Delacroix,
Women of Algiers in their Apartment,
1834.
Oil on canvas;
180×220 cm,
70⁷⁸×90¹⁸ in.
Musée du Louvre,
Paris

176
Eugène Delacroix,
Fantasia,
1833.
Oil on canvas;
60·5×74·5 cm,
23³⁴×29³⁸ in.
Städelsches Kunstinstitut,
Frankfurt am Main

Not all Delacroix's Oriental compositions can be taken seriously. Many simply repeat commercially popular motifs familiar from lesser painters. But as part of his process of imaginative synthesis, he continued to meditate on the confrontation between East and West, between advanced and 'primitive' cultures. His impressions of classical calm and dignity in Morocco, and his later images of Oriental violence and cruelty, can seem paradoxical, but both reflect opposition to familiar aesthetic or social constraints, and imply nostalgia and escapism. His reactions would be shared by many artists and writers. That his own view of the 'civilized' world was

177
**Eugène
Delacroix**,
*The Taking of
Constantin-
ople by the
Crusaders*,
1840.
Oil on
canvas;
411×497 cm,
162×195½ in.
Musée du
Louvre,
Paris

eventually ambiguous if not wholly disillusioned is evident
from important works he made in response to the official
commissions he received in later life, from 1838 to 1847. For
Louis-Philippe's new historical galleries at Versailles he painted
a characteristically independent, if not actually subversive
account of *The Taking of Constantinople by the Crusaders* (177).
Depicting the climax of the Fourth Crusade, largely a French
initiative, this might have been thought a glorious theme, as
well as a nod towards that latter-day crusader Napoleon. But
the campaign had been fatally tarnished by the pillage it
visited upon Constantinople, and Delacroix allows his victors
no pleasure in their conquest. Like Gros's Napoleon at Eylau
(see 46), their leader, Baldwin of Flanders, turns away from
the vanquished infidel, remorseful or uncertain what to do
next, and even his horse stoops as if in sorrow. Meanwhile,
Delacroix was raising similar issues, even more movingly, in
another official project – his ceiling decorations for the library
of the Palais Bourbon in Paris. The programme was designed
to reveal the benefits of knowledge, but Delacroix's narrative
ends in disaster, with the sack of Italy by Attila the Hun, and
the benefits of earlier progress are presented in a questionable

light. In an echo of his depiction of wild lions, in the other major narrative scene Achilles must learn the arts of peace from a centaur; the savage ancient Greeks, whose descendants the artist had defended in their enslavement, look on with astonishment at Orpheus who has come to civilize them; and in the most beautiful subject – which Delacroix later repeated in easel pictures (178) – the poet Ovid, banished from Rome, sits dejected among the wild Scythians who try to succour him with milk and honey. Spoilt and rejected by his own society, he finds no comfort in theirs; his is perhaps the ultimate despair of the Romantic exile, lost between two worlds.

Delacroix's decorations brought to the very seat of officialdom and Western learning a plea for a more inclusive cultural view. In part the plea had been answered already by Louis-Philippe, whose personal interest in diversity was reflected in his official patronage and collecting. He was, for instance, a pioneer in the appreciation of Spain, and commissioned pictures for a 'Spanish Gallery'. He had been impressed by Baron Taylor's picturesque tour to the Iberian peninsular (published in 1823), where Taylor had revelled in the confrontation of Gothic and Moorish, anticipating a growing enthusiasm for a kind of surrogate Orient that was still relatively undiscovered – 'the wild unpoached game reserve of Europe' as Wilkie described it in 1827 while on a visit of his own. Spain, in fact, was soon

178
Eugène Delacroix,
Ovid Among the Scythians,
1859.
Oil on canvas;
87·6×130·2 cm,
34¹₂×51¹₄ in.
National Gallery,
London

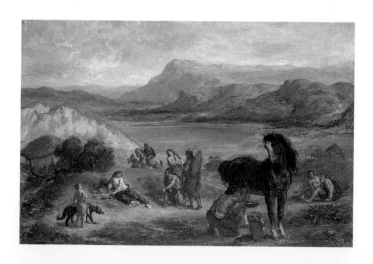

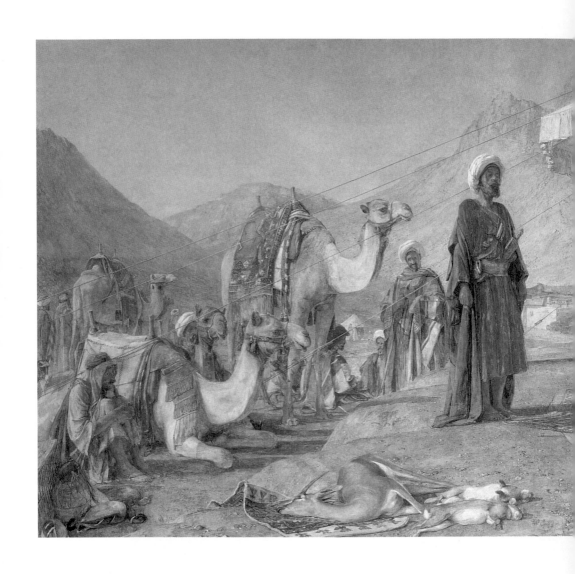

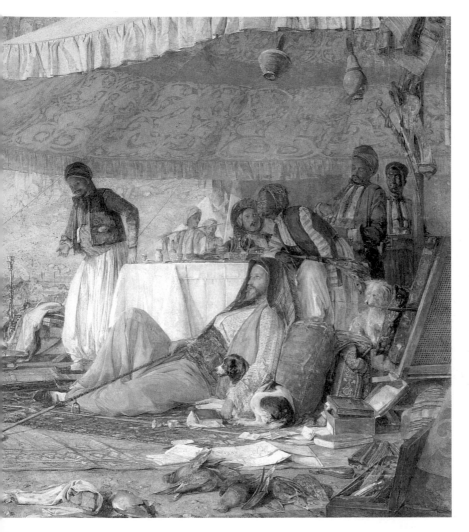

179
John
Frederick
Lewis,
*A Frank
Encampment
in the Desert
of Mount
Sinai, 1842,*
1856.
Watercolour
and gouache
over pencil;
64·8×143·3cm,
25½×56⅜in
Yale Center
for British Art,
Paul Mellon
Collection,
New Haven

featuring with the East on the itineraries of many of the more adventurous artist-travellers of the period. The watercolourist John Frederick Lewis (1805–76), for example, spent a period in Seville with his friend the author Richard Ford, whose *Handbook for Travellers in Spain* (1845) introduced the country to the British. The fascination of Ford and Lewis for the handsome bandit José Maria, who made a good living holding up travellers like themselves, matches Delacroix's admiration for the wild energy of the Moroccans.

In Spain and later in Cairo and the Holy Land, Lewis's meticulous and brilliantly coloured interpretations followed the conventions of topographical watercolour and belong to the broadly realist tradition of exotic representation (179). Wilkie's visit to Jerusalem, culminating with his death off Gibraltar on his way home in 1841, was intended to furnish more accurate

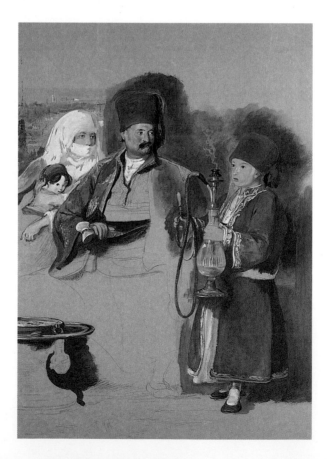

180
David Wilkie,
Sotiri,
Dragoman
of Mr
Colquhoun,
1840.
Watercolour,
gouache
and oil
over pencil;
47·5×32·8 cm,
18³⁄₄×12⁷⁄₈ in.
Ashmolean
Museum,
Oxford

181
John Glover,
*A Corroboree
in Van
Diemen's
Land,*
1840.
Oil on
canvas;
77×114·5 cm,
30³⁄8×45 in.
Musée du
Louvre,
Paris

documentation for biblical subjects, which he saw as the logical
conclusion of his progress from narrative to historical painting.
The beautiful coloured studies of the people he encountered,
mainly in Constantinople where he was delayed for some time
(180), were incidental to this greater ambition.

It was because of the monarch's known interest in the wider
world that John Glover (1767–1849) sent Louis-Philippe six
of the pictures he had been painting in the British colony of
Van Diemen's Land (Tasmania), where he had moved to join
his sons in 1831. Known earlier in London as a painter in the
classical style of Claude, he had begun again, painting the
exotic landscape and its people in a manner that is surely
consciously naïve, both in its extreme descriptive clarity and
in the sinuous trees that seem exaggeratedly different from
European forms. In one of the pictures chosen by the king
(181), such trees arch over one of Glover's favourite subjects,
the moonlight corroboree, when the Aboriginals danced at
night, clutching green boughs. On the back Glover noted,
'I have seen more enjoyment and Mirth in such [an] occasion
than I ever saw in a Ballroom in England.' For a time Glover's
pictures hung at the royal château at Eu on the Channel coast,
but were soon demoted by the curator as curiosities, works of
ethnography not art.

Glover loathed his settler neighbour for using Aboriginal mercenaries to drive their own people off his land, and he was a troubled witness to the destruction of a race. Clearly he had pondered the relative benefits of civilization as deeply as Delacroix, and with similarly melancholy conclusions, but his Tasmanian pictures were little noticed, either in Paris or in London where he sent sixty-seven for an exhibition in 1835. By contrast the American George Catlin (1796–1872), who addressed himself to documenting Native American peoples in the face of their own imminent destruction, attracted the attention of both Delacroix and Baudelaire, who could not agree about the artistic merits of his work but did about its interest. Both – in what will by now be a familiar reaction – saw ancient Greeks and Romans in the persons of the Native Americans portrayed in the 'Indian Gallery' that Catlin sent to Paris in the 1840s after it had toured in America and Britain. Catlin had abandoned a successful career as a portrait painter in Washington to document the lives and culture of Native Americans west of the Mississippi. One of the pictures in the gallery, *The Last Race, Mandan O-Kee-Pa Ceremony* (182), dates from 1832, the year Glover painted his first Aboriginal subject. It shows a similarly innocent style, purged of academicism. But despite Catlin's genuine zeal to preserve the 'monuments of a noble race', he accepted that the Native Americans were 'doomed and must perish', and that their ultimate destiny was to yield their land to white Christian settlers. Delacroix knew this too, and mourned it; in 1835 he completed a painting (based on Chateaubriand's story) of a Native American couple fleeing from the massacre of their Natchez tribe, with their little son, new-born by the Mississippi but also doomed to die (183).

Glover and Catlin painted the two indigenous societies most thoroughly destroyed by colonization. Both were part of the process, though the latter acknowledged it more openly. And indeed it was in the doctrine of Manifest Destiny, by which the new Americans justified their appropriation of the land from

182
George
Catlin,
The Last Race,
Mandan
O-Kee-Pa
Ceremony,
1832.
Oil on canvas
mounted on
aluminium;
58·8×71·3cm,
23³⁄₈×28¹⁄₈in.
National
Museum of
American Art,
Washington,
DC

183
Eugène
Delacroix,
The Natchez,
1823–35.
Oil on canvas;
90·2×116·8 cm,
35½×46 in.
Metropolitan
Museum
of Art,
New York

184
John
Vanderlyn,
Columbus
Landing at
Guanahani,
1492,
1837–47.
Oil on canvas;
365×548 cm,
144×216 in.
Rotunda of the
US Capitol,
Washington, DC

the native peoples, that the Romantic yearning for cultural diversity, for other places and other societies to which they might escape, met its most resounding defeat. These settlers had no doubt of their own superiority, and of the legitimacy of their claims to take land or even lives. To them, the indigenous peoples were too primitive to compete. They had no wish to take on their habits but imposed their own. At about the same time as Delacroix was painting the Palais Bourbon, John Vanderlyn (1775–1852), an American whose revolutionary sympathies had led him to study and work in Paris in the early days of the empire, painted a fresco in the American Capitol in Washington (184). His theme was *Columbus Landing at Guanahani, 1492*, glorifying the arrival on this West Indian island of the historical figure who was regarded as the founder of the white and Christian Americas. He allowed himself few of Delacroix's subtle ambiguities: his Indians crouch like wild animals, frightened and puzzled, and some of the explorer's Spanish sailors crawl on the ground, already hunting for gold. But Delacroix could never have painted Vanderlyn's Columbus and his retinue – brilliant Europeans who raise their crosses and standards heavenwards, stunning the heathen into submission. In their pride and moral superiority important Romantic dreams are extinguished.

'I have known some', Coleridge wrote to his friend Thomas Poole in 1797, 'who have been rationally educated ... They were marked by a microscopic acuteness, but when they looked at great things, all became blank and they saw nothing.' The Romantics, of course, saw more than met the eye. Dispensing with rational empiricism, they claimed to reach deep within and far beyond themselves. For them, creative art was by its very nature irrational, the product of an altered state of being, of an unconscious or subconscious will. They were not yet certain what to call the source of such mysterious impulses – Wordsworth, in *The Prelude*, speaks of both an 'undersoul' and an 'underconscious'. But they anticipated modern psychology in suspecting that the self is, as Oscar Wilde was to write at the end of the century, a 'multiform creature that bears within itself strange legacies of thought and passion'. Many Romantics believed that if they could only connect with this inner world, they would discover eternal unities. For others it was a glimpse into the abyss.

The visual arts were not the prime vehicle for Romantic irrationalism. Music, as a purely abstract form coming straight from the soul, was for the Romantics the truly magic art. Once attributed to divine inspiration, it now also became associated with madness itself, or demonic possession. 'Mad people sing', said Hazlitt, and indeed they do in the many mad scenes of Romantic opera, while crazed musicians are constantly encountered in the popular stories of the day, their derangement presenting a voyeuristic thrill to those who suspected that the urge to make art might itself be a kind of madness. Distanced by the stage or concert platform, such internal fears could be externalized while taken to dramatic extremes. The visual arts, on the other hand, operated within

185
William
Blake,
*Nebuchad-
nezzar*
(detail of
190)

traditions of imitation or replication. Yet they played their own leading role in the Romantic attack on rationalism. Dreams, the supernatural, subcultural traditions and superstitions, the natural grace of childhood or the primal energy of the animal world, the condition and treatment of the insane, the turbulent inner character that lies behind external appearances – all these came to the fore in Romantic art. They account for its extraordinary range of imagery and emotion, from transcendental visions of innocence and harmony, paradise lost and found, to extremes of terror and despair.

Among the Romantics' immediate predecessors, one of the first artists to access a seemingly subconscious impulse – one of fear – was Giovanni Battista Piranesi (1720–78). Coleridge and Thomas de Quincey, author of *Confessions of an English Opium Eater* (1821), suspected that Piranesi's series of prints (186) of fantasy prisons, *Carceri d'Invenzione* (c.1745–61), showed a mind under the early effects of the drug – or 'in the delirium of a fever' as de Quincey euphemistically put it, concluding, 'With the same power of endless growth and self-reproduction did my architecture proceed in dreams.' In fact these two opium addicts probably did Piranesi less than justice, for those who have used drugs are often too inclined to recognize their effects on others. Nevertheless, drug use among the Romantics is well documented. It sharpened Coleridge's sense of the distinction between fancy and imagination – the one capricious and misleading, the other positive and inspiring – and Baudelaire's of the imagination corrupted as illusion. It is the inspiration or even the plot of many works – Gautier's *Opium Pipe* (1838), for example, or Berlioz's *Fantastic Symphony* (1830). The latter is partly based on a French travesty of de Quincey's *Confessions* by Alfred de Musset, and contains musical representations of the artist-hero's haunting visions – first of his beloved, then, after he has attempted suicide with opium, of his execution – which have been likened to a bad trip. But stimulants were only some of many Romantic assaults on the rational mind. Wherever they

186
Giovanni Battista Piranesi,
A Prison,
plate VII,
Carceri d'Invenzione,
c.1745–61.
Etching;
55×41cm,
23¼×16¼in

came from, Piranesi's hallucinatory images – which Coleridge called 'dreams' – presaged the Romantics' own disturbing imaginative experiences, and opened a subconscious world that they recognized as their own. His evident use of his fantasies to probe deeper, to reach a more intense level of expression, was ahead of his time.

Piranesi was best known to his contemporaries for his views of Roman antiquities, in which ruins, palaces and churches loom over diminutive figures, often ragged or crippled, with a crushing grandeur. Architecture was also his medium for his fantasies – not real, but drawn and, above all, etched in his celebrated prints. His choice of subject can be related to the illusionistic designs of Baroque theatre, or the fanciful *capricci* and *scherzi* of his fellow Venetians, Marco Ricci (1676–1729) and Giambattista Tiepolo (1696–1770). These fantastical architectural compositions were only one aspect of a long tradition of the grotesque and bizarre in art, which had served mainly to divert and entertain. But Piranesi was clearly evoking a more enigmatic, disturbing mood, and it is interesting that, in 1734, Jesuit lexicographers should already have ruled that the *capriccio* was an art of 'mental derangement'. Such a judge-ment was characteristic of these feared disciplinarians of the Catholic church, but their view was later borne out by both Piranesi's and Goya's use of the term for works which frankly embraced the irrational. It is no surprise that Goya was both an admirer and collector of Piranesi, whose work he encountered on an early visit to Italy.

To look at Piranesi's labyrinthine vaults, with their pointless, perverse ramps and steps leading nowhere, and fiendish machines of torture, is to be glad that they exist only on paper. It is also to wonder whether he was mapping the confines of his own diseased mind. Yet only a transcendent imagination could have invented them. In a treatise on architecture written in 1765, Piranesi pitted a free spirit against a classicist who ridicules his 'crazy freedom to work on caprice'. Perhaps it is

187
George
Stubbs,
Lion
Devouring
a Horse,
1763.
Oil on canvas;
69·2×103·5 cm,
27¼×40¾ in.
Tate, London

really the constant doubts and frustrations of an artist susceptible to both points of view that are represented in the prisons and explain their enduring appeal. They reveal a complex psyche, and are not merely designed to titillate or surprise. Although it was in the new language of Burke's 'Sublime' that they were first described, they speak of what are perhaps universal fears and conflicts.

It was in the darkness of the forest, Burke claimed, that the Sublime creeps up on us in the form of the tiger or the lion. Less than a decade after Piranesi began his prisons, the young George Stubbs (1724–1806) made a journey to Rome. He was already known as a painter of animals, and his earliest biographer recorded his failure to make the usual studies of classical monuments. But the suggestive power of one antiquity in particular, a pre-Hellenistic sculpture of a horse attacked by a lion in the Palazzo dei Conservatori, moved him to his own depiction of fear. Perhaps the natural reality of wild beasts as predators on each other suggested something of the same sinister cyclical motions as Piranesi's prison gangways, or perhaps already – as they would be for Delacroix – these creatures *in extremis* were a source of vicarious energy and release. For thirty years Stubbs meditated on this theme of conflict, producing at least seventeen works in oil or enamel, clay or mixed-method engraving, adopting an episodic, four-part sequence beginning with the horse's first terrified sight of the lion emerging from its cave and ending – closest to the Antique source – with its exhausted collapse beneath its attacker (187). Seen first as a pair at the Society of Artists in London in 1763, the first and last episodes were greeted by Horace Walpole – also an extravagant admirer of Piranesi – in 'Sublime' terms as revelations of 'apprehension, horror, hatred, fear'. To express these human emotions with such intensity through animal subjects was new. In the one theme in which this fundamentally realist painter laid claim to historical invention, he had reached out to the human terror of violence and pain, and a surrounding universe whose laws are immune

to rational thought. It is the more remarkable that such insights should have been prompted in him by the Antique, which his contemporaries revered as the supreme human achievement.

Stubbs was not the only artist whose failure to be conventionally impressed by the Antique opened him to revelations of a different kind. The young Henry Fuseli, in the late 1770s, portrayed himself reduced to despair before the vastness of Rome's remains (188). Since he had spent eight years studying in the city, his awe was doubtless exaggerated, but it was also a

188
Henry Fuseli,
The Artist
Moved by the
Grandeur
of Antique
Fragments,
1778–9.
Red chalk on
sepia wash;
41·5×35·5cm,
16³⁄₈×14in.
Kunsthaus,
Zurich

premonition of the powerful emotions that were to be released in his art. Born in Zurich to a family of artists and writers, Fuseli was brought up among the writers and thinkers of the *Sturm und Drang*. No painter went further in anticipating the Romantic pursuit of the irrational. In Rome he was at the centre of a group of young artists who experimented with bizarre and exaggerated themes and cultivated a vividly spontaneous style of drawing. Back in London he exhibited

The Nightmare (189) at the Royal Academy in 1781. Slightly ridiculous as this work may seem today, with its squatting goblin and fiery steed, Fuseli's generation took it very seriously indeed. In a review written in 1806, Blake defended Fuseli's 'innocent and vulnerable madness and insanity and fury, and whatever paltry, cold-hearted critics cannot, because they dare not, look upon'.

Fuseli once declared that dreams were 'one of the most unexplored regions of art'. In *The Nightmare* and in other pictures he pioneered a new interest in their revelatory powers. He could already claim a quasi-scientific explanation for the work, for the propensity of pubescent girls to nightmares and hallucinations was a current topic of investigation. Just as his youthful artist had been overcome by excitement at the ruins of Rome, so his sleeper is burdened by a fantasy of sexual assault. The grotesque incubus squatting on her breast embodies the nightmare's oppressive power, while the stallion, parting the background curtains, is a still more potent image of rampant virility and the invasive violence of rape. These manifestations are not to be understood as the actual substance of the girl's dream but as metaphors. As for the sleeper herself, her languor seems not so much terrified as enraptured – as so often with this painter, the drama is erotic, and it has been suggested that his preoccupation with the *Nightmare* theme resulted from an early, unrequited love affair that haunted his own dreams. Many other scenes of violence, sexual passion and perversion, domination and submission suggest a personal surrender to extreme desires, fantasies or mania as much as a wish to create a new pictorial language – or even simply to shock.

Grounded as he was in the most progressive German thinking, Fuseli would have subscribed to the view of dreams expressed by the Prussian philosopher Johann Georg Hamann as 'journeys to the Inferno of self-knowledge', and his apparent use of a recognizable dream symbolism has lent itself to Freudian interpretation. It was an admirer of Friedrich's dreamlike

landscapes, the Dresden doctor Gotthilf Heinrich von Schubert, who in 1814 would go furthest in anticipating Freud (whose *Interpretation of Dreams* would be published in 1900) when he published his *Symbolik des Traumes* ('Dream Symbolism'); the fascination for these mysterious phenomena was by then widespread. The Romantics believed that dreams were a second life, lived on another plane; they connected the dreamer with eternal unities lost to the rational mind, and transcended time by recalling a spirit past or foretelling the future. In 1831 the French writer Charles Nodier went so far as to declare dreams the 'sweetest but also the truest experiences in life', and sleep the most empowering and lucid state of mind. But while Nodier certainly captured the importance of dreams for the Romantics, he also drew an important distinction between pure dream and fantasy, and helped explain why descriptions of actual dreams are less common in their work than flights of the waking imagination. Fantastic art, for Nodier, is the product of 'the sleep of the dead' – that is, of his own decadent age. It was precisely because his contemporaries did not really believe in legends, fairy stories and other tales embodying mysterious or otherworldly phenomena that they had to invent them in their imagination. He might have added that these superstitions and folk tales were also being collected, researched, edited and illustrated with an enthusiasm that far outstripped their credibility. As Coleridge recognized, disbelief need not limit their appeal; rather their very implausibility opened the mind to new impressions. Both 'real' dreams and fantastic tales offered glimpses into a past state, the recovery and preservation of which was all the more important in a sceptical age. Fuseli certainly exploited them, not only producing the seminal dream images of his day but also embracing obscure or neglected northern European myths and legends.

Nevertheless, Fuseli found himself increasingly unsympathetic to the 'romantic reveries' appearing all around him. However expressive and emotive its language, he believed a work of art

**189
Henry
Fuseli**,
*The
Nightmare*,
1781.
Oil on
canvas;
101×127 cm,
39³⁄₄×50 in.
Detroit
Institute
of Arts

should be clearly and forcibly understood and had little patience with enigma. Above all, this qualified his admiration for Blake. He thought his friend went too far in cultivating a visionary mysticism, although he wrote the introduction to Blake's moving illustrations to Robert Blair's poem *The Grave*, and acknowledged the power of these transcendental images to 'connect the visible and invisible world'. In fact this was the message of most of Blake's work, but he claimed to draw inspiration from dreams and visions of distant times, places or people, rather than just to imagine them as Fuseli did. Moreover he defended the more substantial harvest of his visionary imagination, the complex characters and stories of his Prophetic Books, as 'not a cloudy vapour or a nothing' but components of a distinct universe that must be 'minutely articulated'. Blake's visions were cumulative, and self-induced; as Hazlitt recognized, they were 'voluntary excursions into the preternatural'. The dream metaphor was useful primarily for emphasizing how far, by adopting independent working methods, designing, printing and publishing his own works, he had liberated his creativity from conventional professional disciplines.

Blake's work was more coherent than Fuseli allowed – let alone Coleridge and others who doubted his sanity. But it nevertheless constituted a passionate protest against eighteenth-century rationalism. For Blake, reason – and for that matter religion, as currently and conventionally understood – were the roots of evil. They had corrupted and divided man, cutting him off from the things of the spirit. Over rule and thought, Blake urged impulse, sensation, feeling, sight; and over learning and science, the original purity of the child and of primitive times. Conventional Christian morality and the idea of human progress were turned on their head. The animal state to which man had been reduced after the Fall, so vividly personified in the crouching form and sullen stare of his *Nebuchadnezzar* (see 185 and 190), one of a series of large colour prints on themes of oppression which Blake produced in the mid-1790s, was less

the result of sexual sin than of separation from the inner life of the soul. In another plate from the same set, he identified one of the culprits, Isaac Newton, whose science and mathematics had killed the human spirit (191). In a telling gesture, Newton plots his fatal calculations with a pair of dividers. It is a characteristic irony that Newton is given a beautiful body straight from Michelangelo, instead of the bestial form allotted to Nebuchadnezzar, for Blake's attitude to contemporary artistic hierarchies was consistent with his moral and social ideas. He revered Michelangelo and other great artists of the past, but like all Romantics he rejected the academic theorists who had conscripted them into a value system that crushed the imagination.

It was the divisions epitomized by such emblematic images that Blake sought to reconcile – mind, body and spirit, the child and the man, man and God. Uniting his own poetry and colour-printed illustrations, his *Songs of Innocence* (1789) and *Songs of Experience* (1794) set out opposing states of being in ironically complementary form. The child-like lyrics of the former, describing a natural state of goodness and peace, are echoed in the latter's disillusioned messages. But the *Marriage of Heaven and Hell* (1793), as its title proclaimed, attempted more than a synthesis of word and image. If Newton and his kind were Satans to Blake, the Devil himself was recast as a harbinger of a primal energy that is 'Eternal Delight'; true evil was the corruption of such natural forces by man-made laws and systems. As a law-giver, God himself was culpable, though the victim of his earthly interpreters, while Jesus and the Apostles were as 'Artists' to Blake – free creatures of the spirit. Christ had been 'murdered' by the Pharisees just as humanity had been crushed throughout history. Blake's great Prophetic Books were created to show those pressures at work up until his own age of revolution – in which he placed the highest hopes – through the epic struggle of mythical characters with biblical overtones. The spiritual redemption of Albion in *Jerusalem* (see Chapter 4) offers the prospect of a final

190
William
Blake,
Nebuchad-
nezzar,
1795.
Colour print
finished in
pen and
watercolour;
44·6 x 62 cm,
17⅝ x 24⅜ in.
Tate,
London

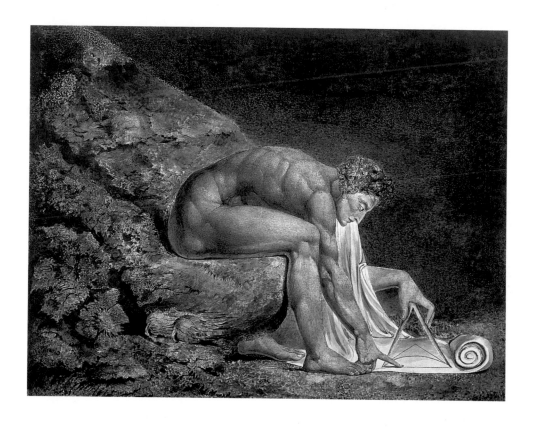

191
William
Blake,
Isaac Newton,
1795.
Colour print
finished in
watercolour;
46×60 cm,
18⅛×23⅝ in.
Tate,
London

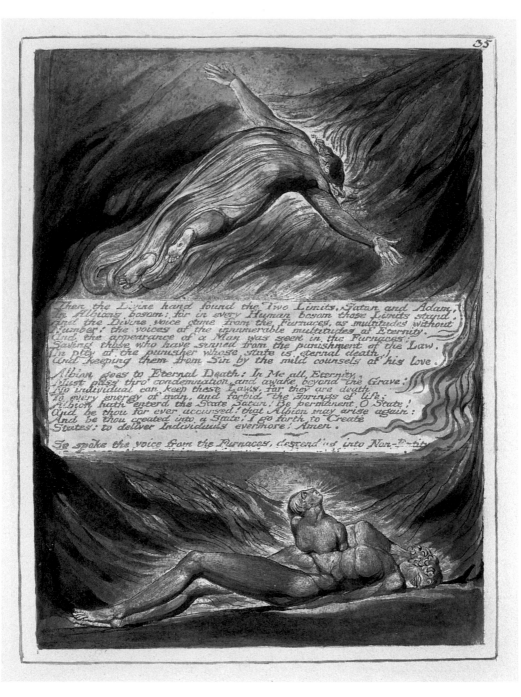

35

reconciliation of all nations and all contraries. In an early page of this great drama, the sleeping Albion is visited by Christ, who awakens his dormant desire for salvation. Though Albion is not yet conscious of Christ's sacrifice, its promise is foreshadowed by the new body that begins to emerge from his breast (192). The motif has the feeling of an unfolding dream, and there can be no more telling expression of the prophetic and transfiguring power of the subconscious in which Blake and the Romantics believed.

Blake was apparently well aware of the parallels between his chosen medium of relief etching, essential to his publishing projects, and the visionary insights they contained. The biting of a copper plate with acids to reveal the image was, he wrote, an 'Infernal method', involving 'corrosives which in Hell are salutary and medicinal melting apparent surfaces away, and displaying the infinite which was hid'. This purgative process of revelation and exposure, described here in a technical context, could apply to Blake's art and to much else in this chapter. It was just such a concern for what lay beneath the surface that drew both Blake and Fuseli to the current preoccupation with physiognomy. Fuseli translated and illustrated the *Essays on Physiognomy* by his fellow Swiss, Jean Gaspard Lavater, which attempted to bring some rather spurious order to the contemporary theory that external facial or cranial formation revealed the character – most of all in extreme conditions of madness or crime.

It was as an illustration to Lavater that Fuseli prepared and Blake etched the extraordinary *Head of a Damned Soul* (193) which, understandably, has been mistaken for Satan himself, but is surely an image of suffering and indeed belongs to one of the condemned in Dante's *Inferno*. Lavater in fact based his theories on bone structure rather than facial distortions caused by emotion and mood, but for the Austrian sculptor Franz Xavier Messerschmidt (1736–83), such distortions became his all-consuming subject (194). In his case they were not

192
William Blake,
The Descent of Christ,
plate 35, *Jerusalem*, 1804–20. Relief etching, printed in ink, finished in water-colour; 21·9×15·9 cm, 8⅝×6¼ in. Yale Center for British Art, Paul Mellon Collection, New Haven

193 Overleaf left
William Blake,
Head of a Damned Soul, print after Fuseli, c.1787–8. Etching and engraving; 43×32 cm, 16⅞×12⅝ in

194 Overleaf right
Franz Xavier Messerschmidt,
Self-Portrait, 1770. Alabaster; h.43 cm, 17 in. Österreichische Galerie, Vienna

uncontrollable expressions of feeling but artificially created for a specific purpose – to ward off the evil spirits who had haunted him since he recovered from a severe illness in 1774. He sought to arrange his grimaces into a scientific system which, believing it would benefit others in similar distress, he portrayed with great realism in sixty-four self-portrait busts. Messerschmidt was genuinely mad; his excruciating outer transformations were the product of torments which Fuseli or Blake could only imagine. But the search for the inner state of mind or soul

DOUBLÛRES of Characters; – or – striking Resemblances in Phisiognomy. – "If you would know Mens Hearts, look in their Faces."
Lavater.
I. The Patron of Liberty. | II. A Friend to his Country. | III. Character of High Birth. | IV. A Faithful Patriot. | V. Arbiter Elegantiarum. | VI. Strong Sense. | VII. A Pillar of the State.
Doublûre, The Arch-Fiend. | Doub: Judas selling his Master. | Doub: Silenus debauching. | Doub: The lowest Spirit of Hell. | Doub: Sixteen-string Jack. | Doub: A Baboon. | Doub: A Newmarket Jockey.

reflected in the outward form was to have far-reaching effects on Romantic art. It lent a special poignancy to portraiture, and it gave a forensic rigour to the popular arts of satire and caricature. These flourished in the political ferment of the 1790s, with their mission to unmask the motives or vices that their subjects would rather conceal. It was as a direct parody of Lavater that the greatest London caricaturist, James Gillray (1757–1815), designed his plate *Doublûres of Characters* in 1798,

alluding to the allegedly sinister revolutionary motives of the radical politician Charles James Fox and his friends in the Whig party by depicting them with their grotesque doubles, the 'Arch Fiend', Judas or the drunken Silenus (195).

Caricature also ironized the pretensions of more serious art forms, above all history painting, by making their language absurd. A popular print in a London shop window could well be the grotesque 'double' of a high-minded picture in the Royal Academy. Fuseli, with his own propensity for fantastic imagery, was a predictable victim of the caricaturist's barbs, but they are likely to have had a more subtle and reciprocal relationship to Blake. It is precisely the subversions of caricature that are at work in his contemporary allegory *The Spiritual Form of Nelson Guiding Leviathan*, one of a group of 'Experimental Pictures' that Blake exhibited – to general bemusement – in 1809 (196). The national hero, shining and transfigured, is surrounded by a terrifying sea-serpent in whose coils the nations of the earth are caught. Though this had claims to be a history painting, it did not function at all in the exemplary manner usually expected of such works, and it is as much through its transformation of the language of art as through the apotheosis of Nelson himself that it transmits its messages. These are, at every level, both positive and negative, since Blake's view of Nelson was itself divided – Albion's hero being also the agent of a suffocating militarism, which in turn was to be distinguished from his nation's ultimate destiny as an all-encompassing New Jerusalem.

If the caricaturist exposes his victims from a position of cynicism, inflaming expectations of corruption, Blake's attitude was more sceptical. For all Blake's claims for him, Los, the artist-figure of his Prophetic Books, is fallible, prone to compromise and to empathize with his subjects. It is his duty to give form to Blake's most sinister creation, Urizen, the restrictive embodiment of reason after it had broken away from the other faculties of the mind. But he feels pity for him, and becomes the slave of his own creation, whom he pictures more

195
James
Gillray,
*Doublûres of
Characters*,
1798.
Etching and
engraving;
23·5×32·7cm,
9¹⁄₄×12⁷⁄₈in.
Private
collection

196
William
Blake,
*The Spiritual
Form of Nelson
Guiding
Leviathan,*
1805–9.
Tempera
on canvas;
76·2×62·5 cm,
30×24⁵⁄₈ in.
Tate, London

as a kindly patriarch than a bigoted tyrant. This parable, showing
that Blake well knew how easily the artist falls prey to worldly
power or patronage, has a particular resonance for Blake's
own time – the *Book of Urizen* was first issued in 1794, the year
after David painted his *Marat* (see 40) and other revolutionary
martyr-heroes. Blake's own passionate independence and
complex, multiple messages prove that it was, even then,
possible to rise above such enslavements. So, in its own way,
does the art of Goya.

As a dreamer and fantasist, explorer of the subconscious to
the point of madness, and savage critic of the follies and
superstitions of his age, Goya was more than Blake's equal.
Like Blake, he was humbly born, and used the forms and
language of popular culture as well as high. But as an artist

whose career was as public as Blake's was private, court
painter to the Spanish monarchy before and after the French
occupation of his homeland and still officially active during it,
he operated under greater constraints. While Blake attacked
reason as the greatest constraint of all, the young Goya had
seen how Enlightened ideas had briefly brought hope to his
more backward country. His own excursions into the bizarre,
the violent, the cruel and crazed would be pursued in the name
of reason. He did not attack it – though he was acutely aware
of its contradictory outcomes, above all of how the Revolution,
to which he had been no less sympathetic than Blake, went on
to plunge his generation into a new dark age.

Central to Goya's duties as court painter was portraiture, but
he brought to it an exceptional quality of revelation, so that
its subjects took on their own suggestive power. His sitters,
moreover, occupied an increasingly unreal world. In 1788 his
first royal employer, the reforming Charles III, died, and his
successor, Charles IV, proved unable to sustain his pragmatic
programme in the face of revolutionary threats from France.
Instead he presided over a sad retreat into political repression,
in which institutions such as the Jesuit order and the infamous
Inquisition were harnessed to silent dissent. It was probably
in this critical year of succession that Goya painted one of the
most penetrating of all his early portraits, that of the child
Manuel Osorio Manrique de Zuñiga (197) – one of a series of
portraits made for the prominent Altamira family. From the
libraries of his liberal, cosmopolitan patrons, he would have
been aware of new concepts of childhood and education,
emanating from Rousseau, which suggested that the natural
instincts of children should be encouraged, even imitated,
rather than repressed. Newly a father himself, he must have
been even more conscious of such messages. He produced not
merely a portrait but a profoundly disturbing allegory in which
the little boy's air of self-absorption and innocence is woven
into a meditation on the hopes and fears for his future life and
afterlife, and on the relationship between painter and sitter. In

his red suit and glistening white silk sash, the child is seen from his own height, not looked down upon from an adult level, but he holds by a string a magpie that has picked up Goya's trade card in its beak, as if to beg the question whether the painter is in thrall to youthful innocence, or the captive of his aristocratic patrons like the boy's pet goldfinches in their cage. The three cats, staring fixedly at the bird from the shadows, portend future dangers. As a younger son of a noble family, Don Manuel would have been destined for the Church, which doubtless explains both the underlying Christian symbolism of the composition and its air of menace, for Goya was increasingly to regard the Spanish Church as a repressive force. This single picture embodied the tensions between innocence and experience, the inner and the outer world as grippingly as anything by Blake. Very probably, it troubled his patron, for the Altamiras seem not to have given him any further commissions.

197
Francisco
Goya,
*Portrait of
Manuel Osorio
Manrique
de Zuñiga,*
*c.*1788.
Oil on
canvas;
127×101·6 cm,
50×40 in.
Metropolitan
Museum of
Art, New York

The reassuring presence of children, guaranteeing a line of succession, marks Goya's greatest official portrait commission, the large group of Charles IV and his family painted in 1800–1 (198). This is often interpreted today as a piercing account of stupidity, decadence and cunning behind its veneer of static formality – almost as a caricature in disguise. It is certainly candid, and Goya presumably had no illusions about the family who stand before us, glittering with jewels and orders, the king florid and expressionless in ruby velvet, the dark-haired queen Maria Luisa sensual, haughty and imperious in yellow silk. If we know that Charles would soon be swept away by events; that his wife, the real centre of the picture, was the power behind the throne and the lover of her husband's chief minister, Godoy; that the blue-coated Ferdinand, who stands in the left foreground, was to plot with Napoleon against his father, the work appears full of irony. Yet it was also a sincere attempt to emulate the royal portraits of Goya's great predecessor in the Spanish court, Diego Velázquez (1599–1660), and intended to convey an image of stability and continuity in unstable times. The king, who was fond of Goya, saw nothing untoward and

198
Francisco
Goya,
*The Family of
Charles IV,*
1800–1.
Oil on
canvas;
280×336 cm,
110³⁄₈×132³⁄₈in.
Museo del
Prado,
Madrid

accepted the picture. Goya can hardly have intended to deliver a vicious character assassination. Yet, rather as Gros could not entirely keep his own sensibilities out of his Napoleonic epics, Goya too painted a work rich in tension, with its background transition from light to shadow, from the bright landscape hanging on the right to the dark, undefined picture to its left. In the shadows, Goya placed himself, this time working at his easel and fixing the viewer with an expression as intense as the eyes of his royal employers are dead.

If the internal dynamics of this picture seem at odds with its purpose, so there was now a contradictory aspect to the behaviour of the court itself. Even as it was threatened by popular unrest, the nobility from the queen downwards continued a long flirtation with the habits and styles of other classes. The most fashionable role models were the *majos* and *majas*, aristocrats of the underworld – 'beaus and bullies of the lower class' as the French ambassador called them – who affected their own flamboyant styles of dress such as the mantilla. Resurgent Spanish nationalism, following the outbreak of war with France in 1793, had only encouraged

'majism', since the objects of its admiration supposedly represented the essence of Castilian blood and tradition. But this essentially decadent movement ultimately undermined respect for authority by its elevation of the marginal or sub-cultural, and was to play an undoubted part in the collapse of the monarchy. For Goya, it was understood in both its erotic and political implications, and it was for Godoy himself, a clever but upstart politician who was widely supposed to have won advancement through his sexual relationship with the queen, that Goya painted his two extraordinary portraits of a naked and a clothed *maja*, the one verging on the porno-graphic, the other resplendent in silk and lace (199, 200). The model, who draws such explicit attention to the patronizing and exploitative aspects of majism, is unknown, but her appear-ance in and out of costume only emphasizes its elements of fancy dress. Her exposure seems more than the exercise in titillation that Godoy doubtless expected, not least because her personality commands more attention than her sex. Like the royal portrait, these pictures prompt questions of identity and character: who is the more real, the naked or the clothed figure, and which more alluring, the body or the costume? Is she an aristocrat or a real *maja*, both of whom, after all, were engaged in pretence? The tradition that she was Goya's own lover, the Duchess of Alba, cannot be upheld, but these pictures certainly allude to such relationships – possibly offering a secret satire on Godoy's with the queen, whom Goya painted in her own *maja* mantilla in 1799.

The ironies of majism, with its mutual dependency between classes and sexes, were clearly not lost on Goya. Nor was the regressive tendency of a concurrent revival – also part of the nationalist mood – of Spanish popular culture with its folk tales of witches, monsters and grotesque beasts. These too could have their licentious aspect, and it was to divert the aristocratic Duchess of Osuna, in the bedroom of her country house, that Goya painted a witches' sabbath. One of a set of small pictures for the duchess on themes of popular superstitions, this plays

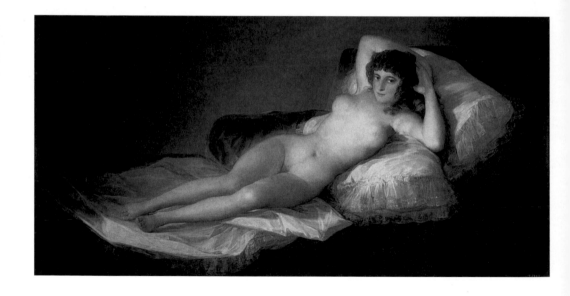

199
Francisco
Goya,
The Nude
Maja,
*c.*1798–1800.
Oil on
canvas;
97×190 cm,
38¹⁄₄×74⁷⁄₈ in.
Museo del
Prado,
Madrid

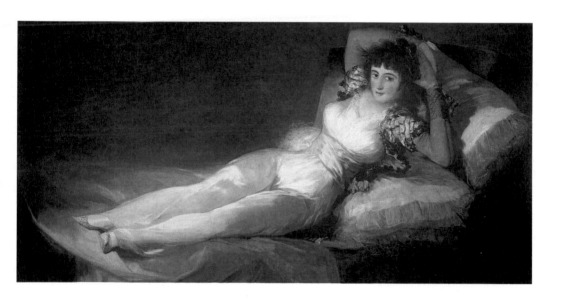

200
Francisco Goya,
The Clothed Maja,
*c.*1798–1805.
Oil on canvas;
95×190 cm,
37$\frac{1}{2}$×74$\frac{7}{8}$ in.
Museo del Prado, Madrid

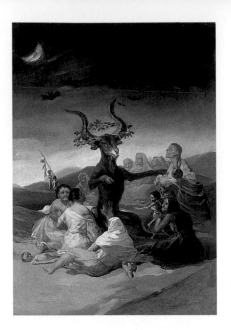

201
Francisco
Goya,
The Witches'
Sabbath,
1797–8.
Oil on
canvas;
43·3×30·5 cm,
17×12 in.
Museo
Lázaro
Galdiano,
Madrid

crudely on the association of witches with female sexual
abandon and of the Satanic he-goat, who rears above them
to receive their gruesome child sacrifices, with male potency
(201). Like Goya himself, the Osunas were advanced liberals,
keenly aware how such traditions – absurd to them but sinister
to others – held progress in check. Goya would doubtless have
had them in his sights even if their imagery had not come to
assume a more sinister significance for him. But in 1793 he
had been plunged into a very real darkness of his own.

This took the form of a physical and mental breakdown.
Variously interpreted today, from syphilis to lead poisoning,
it produced noises in his head, hallucinations and permanent
deafness. His recovery was gradual, and assisted by the pro-
duction of more small pictures that offered a respite from
the demands of portraiture and a release of his inner demons.
Of these he wrote that he had 'managed to make observations
that commissioned works ordinarily do not allow', involving his
'fantasy and imagination'. Among them was a sinister *Yard with
Lunatics* (202), in which it is clear that he had looked with terror
and understanding at the plight of the crazed, confined to their

yard in the Saragossa asylum, rather than with the detached curiosity or even amusement that was the usual response of visitors who treated madhouses as if they were zoos. Goya's picture is a glimpse into an abyss into which he must have felt himself falling. It is also compassionate, a cry for a new understanding. By the end of the decade Goya was to turn increasingly from his public role at court to the condition and sufferings of the people, from easel painting to the more democratic graphic arts, to convey his most personal messages. He turned, also, to satire, and it was the language and imagery of popular culture, of street theatre and folk tales, with their

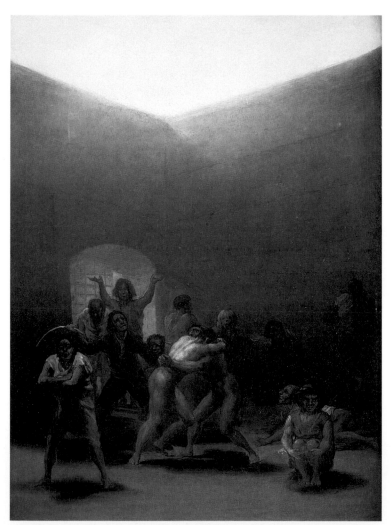

202
Francisco
Goya,
*Yard with
Lunatics,*
1793–4.
Oil on tin
plate;
43·5×32·4cm,
17⅛×12¾in.
Meadows
Museum,
Dallas

203
**Francisco
Goya**,
*To Rise and
to Fall*,
plate 56,
Los Caprichos,
1799.
Etching and
burnished
aquatint;
21·7×15·2cm,
8½×6in

characteristic love of pun and word play, that combined with his
own darker insights to furnish its powerful metaphors. In Goya,
the subcultural and the subconscious found a unique fusion.

In 1799 Goya put his first great series of satirical prints, the
Caprichos (*Caprices*) on sale in Madrid. They were, he declared
in his advertisement, 'extravagant subjects, invented and
etched' by himself, intended to expose the 'multitude of follies
and errors common to every society'. By this of course he
meant his own, with its special fads of majism and witchcraft as

well as its corruption, snobbery, sexual licence and repressive religion. Just as Blake combines image and word, so Goya's prints carried mordant captions whose messages would have been more immediately obvious to his contemporary audience than they seem today. Unlike Blake's invented, mythic characters, however, their protagonists were recognizable types or individuals. Goya claimed originally to have conceived of the series as a set of *sueños* (dreams), but the irrational constructions of his own mind, whether in sleep or disease, fell only too clearly into step with the real world. His advertisement further warned that 'it would suppose too great an ignorance of the nature of the fine arts to declare that in no composition has the author intended to ridicule the particular defects of any individual'. Thus the beautiful but capricious Duchess of Alba appears in scenes of inconstancy, while the grandly dressed person raised aloft by a satyr in the plate named *To Rise and to Fall* (203) is surely Godoy. Elevated over the globe by a symbol of lust, his phallic sword dangles at his side; two falling figures indicate that such successes are transitory and always come at the expense of others.

While Goya created a savage lampoon of modern politics, he was also the recipient of Godoy's favours and responsive to his charm. He painted his portrait as a charismatic military leader and was flattered by his willingness to learn sign language to communicate with him. This imparted a distinct ambivalence to his position, which can also be felt in his images of the people and the popular *majo* heroes. While their pride and machismo are absurd, their consequences touch the heart. Similarly, it is not always possible to be sure whether Goya is more enthused or revolted by his grotesque subject matter. The temporary loss of his own reason, indeed, may have infected his attitude to the Reason from which he claimed to speak. The double meaning of the word *sueño* – as both dream and sleep – might indicate that his *Sleep of Reason* (see 16) was as much a post-revolutionary warning that Reason could itself be a false enchantment as that its abandonment opened the gate to

nightmares. Whatever the case, this self-portrait introduced the second part of the *Caprichos* as Goya finally arranged them, presenting more extreme denunciations of the frailties and follies exhibited in the earlier plates. The owls and bats who torment the prostrate artist presage the witches and demons who invade these later subjects, yet Goya does not lose sight of his essential purpose, to use fantasy to illuminate reality. The wakeful lynx, whose crossed paws echo the sleeping artist's arms, recalls the watching cats behind the boy Don Manuel (see 197). It stands for the conscious, observant artist, translated to another form – a necessary disguise, surely, for a critic and satirist operating from within.

204
Francisco
Goya,
Disparates,
plate 18
(?frontis-
piece),
*c.*1816.
Etching with
aquatint;
24·5×35 cm,
9⁵⁄₈×13³⁄₄ in

205
Francisco
Goya,
*The
Madhouse,*
*c.*1816.
Oil on
panel;
45×72 cm,
17³⁄₄×25⁵⁄₈ in.
Museo de
la Real
Academia
de Bellas
Artes,
Madrid

His next great series of prints, *The Disasters of War, c.*1810–15, portrays actual occurrences during the French occupation of Spain. Goya had no need to reach into his subconscious to plumb the depths of human depravity. But, with the French expelled from Spain after the Battle of Vitoria in 1813, he soon returned to even more grotesque fantasy to castigate what he called 'harmful ideas commonly believed'. He was spurred very largely by his extreme disillusionment with the restored Ferdinand VII, whose government seemed bent on returning the country to autocratic rule. In Madrid in about 1816, he worked on a series of prints and related

drawings which he called *Disparates* (*Follies*). Goya did not name all of them, nor specify a particular sequence, leaving their interpretation a matter for speculation, but once again they expose the dehumanizing consequences of misrule. With their haunting play of light and shade, these are images of a terrible beauty despite their brutish content. Besides dislocating reversals of human and animal – an elephant taught from a book, people perched bird-like in trees – there are recurrent images of phantoms and visions. Once again, Goya uses the metaphor of the dream, and depicts himself rising from his sleeping body to point contemptuously at the hovering manifestations of ignorance and evil (204). The dividing figure might almost be an echo of Blake's sleeping Albion (see 192), but it proclaims rage instead of hope.

Goya consistently used the irrational to plead for a more rational world. Yet there can be little doubt that his increasing focus on the most mindless and sadistic in human nature put this ever further beyond his reach. In one of four small pictures painted for a friend, Don Manuel Garcia de la Prada, between

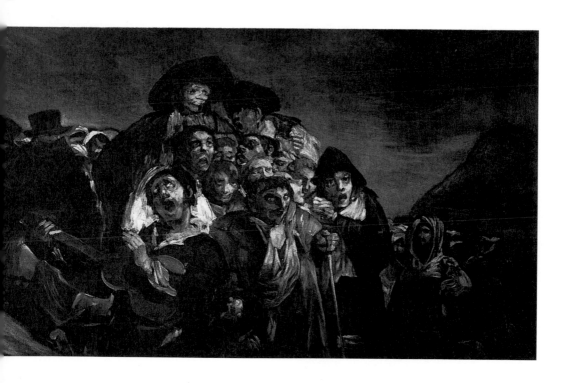

206
Francisco
Goya,
The
Pilgrimage of
San Isidro,
*c.*1821–3.
Oil on
plaster
transferred
to canvas;
140×438 cm,
55⅛×172½ in.
Museo del
Prado,
Madrid

about 1815 and 1819, he took up his recurent theme of the madhouse to present a universal allegory of derangement in which rulers and leaders – pope, king, savage chief or military commander – act out their delusions (205). At the end of 1819, illness filled Goya's mind with new demons. Now he withdrew to a remote house on the outskirts of Madrid, the Quinta del Sordo (House of the Deaf Man), and concentrated on painting his visions on its walls – *Judith Slaying Holofernes*; *Saturn* (see 58); a procession of hideous figures on a pilgrimage, gripped by diabolical frenzy as they wend their way over the hills (206); a witches' sabbath. These 'Black Paintings', executed with a breadth and expressiveness of handling unique for their time, occupied him for the next three years. In a bitterly ironic parody of the programmatic approach of the history painter and decorator, he arranged their subjects over two floors and on long and short walls in complementary or contrasting relationships; but they were made only for himself.

If they were deliberately cathartic, they seem to have performed their task of exorcism, for despite deafness and failing sight, Goya's spirits revived, and his last years in self-imposed exile in France from 1824 to 1828 were full of activity and invention. Of all painters of the age, Goya had looked deepest into its heart of darkness, and his art is surely that of a man who shared Chateaubriand's conclusion that it was impossible to live in such a time. He left instructions that his skull should on no account be detached from his body, lest it should fall into the hands of researchers curious as to the internal causes of his genius – or madness. Goya would have sympathized with the view of Géricault's patron Dr Georget, that madness was caused above all by social or political stress, and occurred 'among people agitated by factions and parties, subject to the violent political movements which overturn all the elements of society, and to the revolutions that compromise all interests'. An official at the Salpêtrière hospital in Paris, responsible for criminals and lunatics, Georget was among the first to see madness as a treatable disease with its own causes and

207
Théodore Géricault, *Man with Delusions of Military Command,* c.1819–22. Oil on canvas; 81×65 cm, 31⅞×25½in. Oskar Reinhart Collection, Winterthur

208
Eugène Delacroix, *A Mad Woman,* c.1822. Oil on canvas; 41×33 cm, 16⅛×13in. Musée des Beaux-Arts, Orléans

symptoms. The only rivals in Romantic painting to Goya's visions of the insane is a set of portraits of the doctor's patients, which Géricault probably painted for him as case histories. Victims of social trauma, they expose through their compulsions society's sickness and the special malady of the age – none more so than the old man whose 'delusions of military command' mirror the failed ambitions of Napoleon and his marshals (207).

It is no surprise that France, which had suffered the trauma of defeat and a national identity crisis after the Emperor's

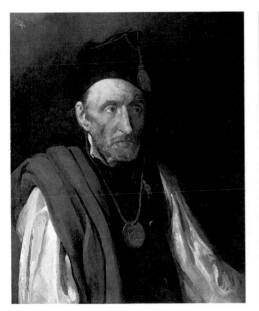
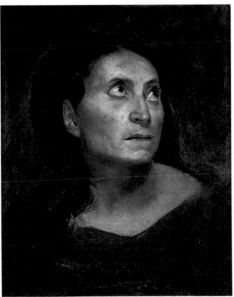

fall, and continued to endure successive phases of hope and disillusion as governments came and went in the revolutions of 1830 and 1848, should produce some of the most compelling images of personal trauma and of escapist fantasy. The madness and frenzy of Géricault's starving castaways on the *Medusa*'s raft (see 61) were no less the products of their time and nation than the inmates of the Salpêtrière, while Delacroix's suffering Chiots (see 170) offered their own melancholy comment on policy at home as much as abroad. On a visit to Paris in 1824, Goya saw in the Salon Géricault's

last, posthumous exhibits as well as Delacroix's *Massacres at Chios* and a haunting oil study of an old woman in despair, prepared for the *Massacres* but taken from a Parisian model (208). One can imagine how these must have struck a chord, and for his part Delacroix had already seen and copied plates from Goya's *Caprichos*. They stirred him, much as Piranesi's prints had stirred Goya himself.

The most outwardly cultivated and urbane of men, Delacroix was fascinated by everything elemental and irrational – by violence, destruction, wild energy and instinctive passion, human and animal – and by madness itself. He felt the fragility of civilized social values. His *Sardanapalus* (see 2) had been an Antique vision of all-consuming destruction, and in 1838 he painted Medea, who in her jealous despair after her abandonment by Jason slaughters her own children. Shakespeare's Hamlet and deranged Ophelia, Goethe's Faust and his pact with the devil were fascinations for him. Like many of his generation he took up the story of Mazeppa, told by Byron after Voltaire, in which a Polish page is swept off on the back of a wild horse as a punishment for an affair with a noblewoman – a Romantic metaphor for Reason carried off against its will by an uncontrollable force. Like Stubbs, he was thrilled by wild beasts in combat with each other, by the primal energy of lions, tigers and horses. These would join with his memories of Morocco, but he was also immensely stirred by his visits to the Paris zoo, and, on visits to London, by the turbulent animal paintings of James Ward.

For the same reasons, at first at least, Delacroix admired the animal bronzes of Antoine-Louis Barye (1796–1875). He was one of a new generation of French sculptors who from the 1820s were transforming a medium hitherto considered among the most perfectly classical of the arts, through revitalized techniques and a new focus on transient expression. Barye's *Tiger Devouring a Gavial Crocodile of the Ganges* (209), a sensation in the Salon of 1831, is an extraordinarily vivid

209
Antoine-
Louis Barye,
*Tiger
Devouring
a Gavial
Crocodile of
the Ganges*,
1831.
Bronze;
l.100·3cm,
39½in.
Musée
d'Orsay,
Paris

rendering of insensate ferocity. Placed in a contemporary
political context, however, his works are not always quite as
liberating as they seem. He won the Légion d'honneur for a
group of a lion crushing a serpent which, two years later, was
generally interpreted as an allegory of the July Revolution
that had brought Louis-Philippe to power. Though opinions
differed as to whether the lion represented the people who
had triumphed over the previous Bourbon monarchy or the
new July monarchy itself, the work was clearly an assertion of
human legitimacy and discipline rather than just a celebration
of animal passion. Despite this attempt at ingratiation, Barye
suffered exclusion from the Salon later in the decade. In his
case the objections to his work were probably mainly aesthetic,
since there remained a prejudice in favour of idealizing figure
subjects. For many other artists, however, they were directly
political, for Louis-Philippe's government soon took a repres-
sive turn, introducing censorship both of the press and of the
exhibitions. Outwardly, it professed to be establishing a *juste
milieu* or golden mean, but in reality it was opposed to all the
freedoms that the Romantics claimed as their right. It was no
accident that the era of the *juste milieu* was also that of the most
unbridled Romanticism in France. Nor that this encompassed
both extremes of fantasy and irrationalism, and a boom in the
art of caricature.

Astonishingly, in 1834 the Salon jury accepted a work by a
young sculptor who had been to school with two literary

apostles of the fantastic and extreme, Théophile Gautier and Gérard de Nerval, and studied with David d'Angers, a sculptor of small portrait medals exceptionally revealing of character and mood. This was Auguste Préault (1809–79), and his contribution a bronze relief called, laconically, *Tuerie* (*Slaughter*). Nothing could be further removed from the ideology of the July monarchy than this vision of mindless violence, as terrible, and inscrutable, as anything by Goya (210). In circumstances left to the viewer's imagination, a bearded and helmeted warrior and a black man are engaged in the massacre of a family. As Baudelaire recognized, there is a dreamlike quality to the swirling flow of the forms as they thrust from the surface and then recede, catching the shifting play of light and shade. The mood is brutal yet almost sensual, orgiastic, as in Delacroix's scenes of violence, and there is such a relish for the gruesome detail that one wonders if Préault had looked at the dead in Gros's *Eylau* (see 46) as well as at *The Raft of the Medusa* (see 61), from which he took two of the heads. Wounds gape, figures tear at each other like wild beasts, the black man seems transported by insane delight in the havoc around him. The work affirms that brutality and evil are in us all, beneath our civilized veneer.

Préault was not shown again under Louis-Philippe. By exhibiting *Tuerie*, the artist was effectively allowed to destroy his career: it was hung, wrote one observer, Théophile Silvestre, like a criminal on a gibbet. Préault found it hard to survive, though there was a market for his funerary sculpture which could achieve a calm as mysterious as his terrors. Still he dreamed of sculpting a whole volcano, and of himself he wrote, on a drawing for a portrait relief of Delacroix, 'I am not for the finite. I am for the Infinite' – a manifesto fit for all Romantics. It was to the small artists' commune in which Préault lived that one of the regime's most robust critics, Honoré Daumier (1808–79), had come to stay the previous year following his release from prison on a charge of sedition. Daumier's weapon was caricature, and it had landed him, for

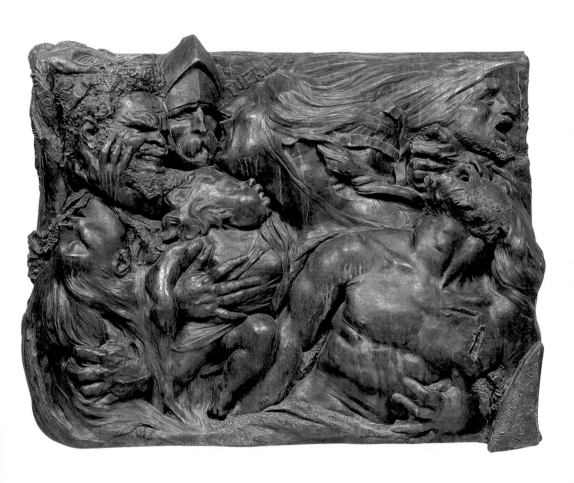

210
**Auguste
Préault**,
Tuerie,
modelled
1834,
cast 1850.
Bronze;
109×140 cm,
43×55 in.
Musée des
Beaux-Arts,
Chartres

211
Honoré
Daumier,
*Charles
Philipon*,
*c.*1833.
Unbaked
clay, tinted;
16·4×13×
10·6cm,
6$\frac{1}{2}$×5$\frac{1}{8}$×
4$\frac{1}{8}$in.
Musée
d'Orsay,
Paris

the winter of 1832–3, in Paris's Sainte-Pélagie jail. The maga-
zines he worked for, *La Caricature* and *Le Charivari*, had been
founded by Charles Philipon in 1831 and 1832, exploiting the
relative press freedom that existed early in the July monarchy.
The climate had since changed, and by 1835 he had to deal
with aggressive censorship. This did not prevent him building
a huge following for his lithograph cartoons, which mocked
the emerging bourgeois capitalism of the time. To aid him in
drawing its typical characters he turned to sculpture, modelling
a series of small exaggerated busts in unbaked painted clay.
Probably made from his 'almost divine' memory rather than
surreptitiously from life, as has sometimes been claimed,
these can be positively diabolical, occasionally absurd. Even
his friends were not exempt. Philipon with his porcine
snout (211) seems both probing and benign, as if deserving
Baudelaire's paradoxical verdict on Daumier himself: 'The
energy with which he paints evil and its works proves the
beauty of his heart.'

Daumier used the grotesque to illuminate reality, and like
all the artists in this chapter, looked behind appearances to

reveal what lay within. His little models would have been inconceivable without the continuing interest in physiognomy and its newer offspring, phrenology, and – though they are sometimes connected to an emerging mood of realism – a Romantic sense of parallel states of being. It was doubtless not merely as a comic, but as an artist alert to human contrasts and dualities, that he took such an abiding interest in the story of Don Quixote. Cervantes's comic hero, the unwordly knight and wise fool, his brain addled by a surfeit of medieval romances, full of dreams and impractical ideas, and his greedy, earthy companion, Sancho Panza, had never been out of fashion. For the Romantics, however, the Don was not so much a deranged aberration as a sad portrait of themselves – the quintessential

212
Honoré Daumier,
Don Quixote and Sancho Panza,
*c.*1870.
Oil on canvas;
100×81 cm,
39³⁄₈×31⁷⁄₈ in.
Courtauld Institute Gallery, London

free spirit, an artist in pursuit of his own truths heedless of scorn and derision. It was also newly appreciated that these two apparent opposites could coexist in the same person, and Daumier depicts them almost as one, Sancho on his ass riding beside his master as if he were his shadow (212).

Here, duality is a source of wistful comedy. For Daumier's colleague and the 'king of caricature', Jean-Jacques Grandville (Jean-Ignace-Isidore Gérard; 1803–47), it was something more sinister. In disturbing prints like his series *Today's Metamorphoses* (1829) and *Un Autre Monde* (1844), animated flowers, animals dressed as humans or, as in *Fish Fishing for People* (213), exchanging roles with them, suggest the uncontrollable transformations that our multiple identities might produce. For other Romantics, the double or *Doppelgänger* had implications for both their life and art. It signified, of course, the unconscious processes beneath the veneer that could split a personality. It was out of admiration for Rousseau that the German writer Johann Paul Richter changed his name to Jean Paul, but his idol's civilized humanism and pastoral ideals occupied only half his mind. His stories, appearing from the early 1790s, veered wildly from rural idylls to dark, disturbing dreams, haunted by nihilism and self-destruction. With deliberately antithetical names like Walt and Wult, their characters represent opposite temperaments and realize contrasted destinies, but are also subtly linked, for the deeply religious Jean Paul intended to reconcile the dualism of spirit and matter in human nature. Like Blake he inserts himself into his narratives, to comment and reflect upon them. But he never attained Blake's redemptive reconciliation: ensconced in the small town of Bayreuth, he lived out personal extremes of sociability and suicidal despair. He would have deserved Gautier's brilliant description, 'Fantasy in a black coat', with all that it implied of a seething inner life concealed in the everyday uniform of the new bourgeoisie. So, too, would his great admirer, and Gautier's own idol, E T A Hoffmann, a frustrated Prussian civil servant and judge by day, dreamer

213
Jean-Jacques
Grandville
*Fish Fishing
for People,*
from *Un
Autre Monde,*
1844

and drinker by night, artist, composer, music critic, author
and high priest of the bizarre. Nowhere do dreams and
reality, the diabolical and the divine merge or clash with
such disorientating effect as in Hoffmann's stories. Distorting
mirrors, opera houses that are also hotels, a stranger in a
Berlin café who believes he is, perhaps *really* is, the composer
Christoph Willibald Gluck years after Gluck's death, malevolent
singing dolls and malign automata, the goldsmith Cardillac
who murders to save his masterpieces from their unworthy
purchasers – Hoffmann had no equal as an inventor. Reading
him, Gautier felt as if his head were spinning like a windmill
and he had drunk ten glasses of champagne.

Hoffmann preferred to mix his own champagne, in still larger quantities, with Rhine wine, and his nocturnal antics in his favourite Berlin bars became legendary. Alcohol aside, music was Hoffmann's drug, an emanation, he believed, of the 'world beyond', capable of opposing effects, from sublime calm to 'fear, awe, horror, suffering and that infinite longing which is the essence of Romanticism'. He was writing then of Beethoven, but his most revealing musical heroes are portraits or caricatures of himself. 'I see myself through a multiplying glass,' he wrote in 1809: 'all the forms which move around me are other Myselfs.' Fascinated by the theme of the split personality and the double, he created his own, the half-crazed musician Kreisler, who flees his restricting life as a court composer to concentrate on sacred music in a monastery, but is driven ever onward by his restless demons. As if his own adventures were not bizarre enough, Hoffmann interpolated them with the memoirs of his pet cat Murr, a feline Sancho Panza to his musical Quixote. In his masterpiece, *Lebens-Ansichten des Katers Murr* ('The Life and Opinions of Murr the Cat', 1820–2), the self-satisfied tom has written a pompous poetic autobiography, using printer's proofs of Kreisler's for the draft. Hoffmann, the 'editor', is left to explain that the publisher has issued the two mixed up together. The two fragmented works play off each other, Murr's once orderly history exposing the Romantic torture of Kreisler's, which his interventions have made more disorderly still. The reader is left to find parallels – a duel and a cat fight, a love duet and rooftop caterwauling. In a final episode, Kreisler is left mad, his disordered universe turned into a hell. Although his protean transformations live on in the shimmering piano realizations of Robert Schumann's *Kreisleriana*, it was typical of his creator and of the wider Romantic quest for the ideal that their final resolution remained unexpressed. Hoffmann died, burnt out, at the age of forty-six.

Among painters, the closest to Hoffmann's spirit was Carl Blechen, whose unstable mind expressed itself both in bright,

sunny landscapes and in cruelly ironic parodies of Friedrich's Gothic – as in a lost picture where a pilgrim enters a church only to find its floor has become a lake, blocking his progress. Such almost Piranesian insights into the irrational were perhaps easier to render pictorially than the childlike innocence evoked by the folk and fairy tales or *Märchen* which had become popular in Germany, such as the anthology collected by Hoffmann's friend Clemens Brentano with Achim von Arnim: *Des Knaben Wunderhorn* ('The Boy's Magic Horn', 1806–8). Their appeal for German readers, as insights into a childlike, wish-fulfilling state and at the same time the repository of a national folk tradition, demanded a pictorial language both innocent and referential. How indeed could the artist hope to visualize stories that the German poet Novalis described as 'dreams of that native world that is everywhere and nowhere'?

The artist whose work had seemed to hold out the best prospect of convincing realizations was Runge (see Chapter 3), whose visionary symbolism and otherworldliness were suffi- cient to decide Brentano that 'the artist must look around within himself to construct Paradise Lost'. While assembling the *Wunderhorn* in 1808, Brentano drew on Runge's *Times of Day* (see 72) to design a frontispiece to the section for children's songs, and later commissioned him to illustrate some romances of his own. Runge's death cancelled the project, but his influence lived on in Brentano's hieratic lithographs for his later fairytale, *Gockel, Hinkel and Gackeleia* (1838). In the concluding plate, the child-poet, who has been inspired to create a paradisiacal world by rummaging among his grandmother's cast-off gowns and mementoes, lies asleep, clasping his completed book, beneath the feet of Runge's *Night* (214). While there is nothing here of the fear and disorder that others had found when they lifted the veil of consciousness to enter a parallel world, the design is still a potent one. The work of art – the child's story and that of his inventor and *alter ego* Brentano – seems at once completed and still in the process of its creation through his dreaming slumber and the suggestive

unreality of the scene. The author-artist has produced a Romantic allegory of creativity that is in the end more profound than the playful nursery fancies of his book.

The task of such tales was to suspend 'adult' belief and allow the imagination to soar. It is ironic that German painters and critics, who understood this better than most, were among the least open to its technical implications, and the most critical of

214
Clemens Brentano, final plate to *Gockel, Hinkel und Gackeleia*, 1838

215
J M W Turner, *Undine Giving the Ring to Massaniello, Fisherman of Naples*, 1846. Oil on canvas; 79×79 cm, 31⅛×31⅛ in. Tate, London

Turner. His late pictures with their gauzy textures, incandescent colour and collages of free association communicate above all a sense of wonder, as if the old man had discovered again the child within himself. It was, admittedly, not for his exhibition public that Turner played with such fantasies as sea monsters emerging from the waves off the Kentish coast, but he presented it with visions hardly less astonishing. It was from a German

story, by Friedrich Heinrich Karl, Baron de la Motte Fouqué, that he took the story of Undine, the sea sprite who, created without a soul, must gain one by marrying a human and bearing his child, but pay the price of assuming all the burdens of humanity. Turner probably knew the story from Hoffmann's opera (1816) or from a ballet recently seen on the London stage. In a picture of 1846 (215), he marries his sprite to Massaniello, who had led a fishermen's revolt in seventeenth-century Naples. As a keen fisherman himself, and angry about recent criticism of his work, he doubtless identified with the rebellious Italian. In this union of fact and fantasy, history and myth, body and soul, and its contrasted protagonists, realized in shimmering colours, he seems to comment on his own union with elemental forces of sea, sky and wave. It is certainly not the product of a rationalist who 'saw nothing', but rather of an artist who penetrated far beyond the cold light of day.

A Romantic Trinity Love, Death and Faith

216
Francisco
Goya,
*Time (Old
Women)*,
*c.*1810–12.
Oil on
canvas;
181×125 cm,
71¼×49¼ in.
Musée des
Beaux-Arts,
Lille

Turner's *Undine* appeared in the Royal Academy in 1846 with
a companion picture, no less dazzling and strange. *The Angel
Standing in the Sun* (217) was none other than the Angel of the
Apocalypse from the biblical Book of Revelation. In the early
edition of his book *Modern Painters* (1843), Ruskin had recently
compared Turner to the Angel, and perhaps the artist was also
thinking of himself as he conceived the apparition materializing
from a blaze of his famous painted sunshine. But the biblical
references, and their potential personal meanings, do not end
here. The art historian John Gage has suggested that Turner's
Angel is compounded with the cherubim and the flaming
sword at the gates of Paradise, presiding over the expulsion
of Adam and Eve. In the foreground are tableaux of the fallen
couple lamenting over the dead body of Abel, and of Judith
before the decapitated Holofernes. A coherent explanation
of all this defeated even Ruskin, whose ability to find meanings
where most critics covered their confusion with laughter was
urged by *The Times* as a caution that 'things like these are too
magnificent for jokes'.

Turner's supposed deathbed cry, 'The sun is God', had not yet
been heard. But perhaps the notion was already on his mind
at a time when he felt intimations of mortality, as well as the
sharp sword of critical judgement. Perhaps it throws light on
his conception of his avenging Angel. In old age it is natural
to ponder on what death means, where it might lead and what
might be left behind. The imagery favoured by Neoclassical
funerary sculptors, led by John Flaxman (1755–1826) in
England or Antonio Canova (1757–1822) in Italy – ageless,
often androgynous figures borne heavenwards in a state of
ecstatic trance – hardly addressed the important issues of faith
and conscience. It was in spite, or perhaps because, of the

many assaults on belief that they inherited or experienced, from the cool scepticism of Enlightenment philosophy to the anti-clericalism of the Revolution, that the Romantics gave such anguished attention to these matters. Some, like the German Nazarenes (see Chapter 4), took refuge in extreme piety; others found an informed agnosticism the only satisfactory position. Some were convinced atheists; others regained their faith or found a home in a different church. Not all were comfortable with their chosen positions. And their spiritual lives had profound effects on their art. While a revival of religious subject matter was perhaps the final Romantic achievement, it was often qualified by distinctly secular or worldly considerations. Those Romantics who, like Blake, experienced faith as a living force, often did so because they had freed themselves from the moral codes of the established Church. Indeed their independence in spiritual matters was part of what made them Romantics.

It was, after all, the punitive concept of original sin (the idea that humans are born sinful) that alienated many Romantics from conventional Christianity. Its moral code of self-denial was incompatible with their aim of self-fulfilment. Others, more boldly, revised religion, celebrating physical love as an approach to the divine. For Blake the morality of the established Church was a perversion of true faith. Looking at Turner's *Undine* and his *Angel*, it seems right to add Turner to this company. Conventional sexual morality had never bothered him. Unmarried, he had taken mistresses and fathered two daughters. Now, at the end of his life, he was comforted by his former landlady, the widowed Mrs Booth. He adapted codes of behaviour with the same freedom that had enabled him to abandon conventional iconography for the complex, multiple imagery which, in the 1846 pictures, contrasts the sacred and profane. What links these is above all their concern with romantic, or rather sexual, love and its consequences: the sprite who finds a soul through union with the human she entices into her elemental realm is matched by Adam and Eve,

217
J M W
Turner,
*The Angel
Standing in
the Sun*,
1846.
Oil on
canvas;
78·5×78·5 cm,
$30^7_8 \times 30^7_8$ in.
Tate,
London

whose coupling ejects them from Paradise and leads to the Fall. These transitions from one world to another are, of course, a kind of death, and like other late pictures, these have struck some observers as proof of Turner's pessimism, the Angel being an avenging spirit and his beloved sun revealed at last as a deluding force. But it is hard to see these sparkling canvases as emanations of despair. Rather Turner's view seems nearer to Blake's liberated, energized faith, which celebrated physical love, and sought to harmonize the material and spiritual worlds. His pictures are hieroglyphs of one of the most tantalizing of all Romantic associations of ideas – the conjunction of love and death. And indeed it was probably in Hoffmann's *Undine* that the *Liebestod* – the love-death – was first articulated as a single experience.

'One Heaven, one Hell, one immortality/And one annihilation' was Percy Bysshe Shelley's description of sexual consummation in his strange poem *Epipsychidion* (1821). Sometimes regarded as an apostle of free love, the poet had actually disapproved of the explosion of sexual promiscuity that had followed the French Revolution. Rather he believed in an ideal of love, more soul than sex, which would unite its devotees in eternity. This apotheosis is described in terms of a rapture both orgasmic and annihilating, and there is the same terminal energy about Turner's painted vortices, spinning round explosive bursts of light. His late pictures might also be compared to passages by Novalis, who revelled in 'sunny glimpses of the other world' and of 'lighter existence after death'. Before his death from tuberculosis in 1801, at the age of twenty-eight, this product of 'Jena mysticism' had combined daytime work as a mining engineer with poetry and story-telling of the most ethereal enchantment, in which themes of love, death, faith and immortality combine as in a fugue. His most famous work was his dream-story, *Heinrich von Ofterdingen* (1800), which begins with the hero's dream of a strange blue flower sprouting by a stream. It is an unworldly vision of perfect love, mirroring the author's own longing to be reunited with his first love, Sophie

218
William Blake, *Los entering the Grave*, frontispiece, *Jerusalem*, 1804–20. Etching with pen, watercolour and gold; 22×16cm, 8⁵₈×6¹₄in. Yale Center for British Art, Paul Mellon Collection, New Haven

von Kühn, who had died while hardly more than a child. This fuelled his hopes of early death by a kind of 'spiritual suicide', and a new life in Heaven. Novalis's parallel habitation of real and supernatural worlds is remarkably similar to Blake's, and like Blake's may owe something to the Swedish philosopher Emanuel Swedenborg, who sought to unite contraries through an intensely personal, mystical and emotional faith. Novalis's masterpiece *Hymnen an die Nacht* ('Hymns to the Night', 1800) combines poetry and prose, moving from an opening vision of light to one of transfiguring night, promising eternal life. Novalis found faith in love, and love in faith; for Blake or Shelley, sexual ecstasy was an earthly approach to the infinite.

Novalis's and Blake's celebration of the passions, so long proscribed by the Church, was for them a powerful force, animating their belief. For Blake the spiritual world was not a realm of rules and conscience but a place of discovery, in which the imagination might rove and return with a redemptive message for mankind. This, for him, brought Christ's sacrifice to life as a paradigm of his own artistic quest, and in the coloured version of the frontispiece to his *Jerusalem*, he placed the thorns of the Passion beneath his own personification, Los, as he steps bravely through a door into a dark, grave-like void (218). This is not an end but the beginning: Los has embarked on an adventure, one hand raised in greeting and the other holding a blazing sun to illuminate the truths to be revealed in the following pages. Novalis's condition, by contrast, seems morbid and self-centred, that of a sick and lovelorn youth dreaming of consummation beyond the grave. But he was not alone in his suffering, and his death wish was actually realized by his fellow writer Kleist in his joint suicide with his lover Henriette Vogel, who was dying of cancer. This true Romantic *Liebestod* – by a lake between Berlin and Potsdam in 1811 – was one of the movement's greatest scandals.

It would be the German composer Richard Wagner, in *Tristan und Isolde* (1865), who provided in Isolde's *Liebestod* the

supreme artistic expression of the Romantic love-death. The Romantics were convinced that true love could hardly be found on earth, and doomed love was another recurrent theme, sought out from eclectic sources in literature, myth or history. Even David expanded his repertoire to explore extremes of erotic passion or despair. For a Russian visitor to Paris, Prince Nicolas Yusupov, he painted the ancient Greek poetess Sappho, setting down her lyre when interrupted by her lover Phaon, while Eros sings the hymn to Aphrodite that she has just composed (219). This apparently saccharine incident took on

219
Jacques-Louis David,
Sappho and Phaon,
1809.
Oil on canvas;
225×262 cm,
88⅝×103⅛ in.
State Hermitage Museum, St Petersburg

a darkly ironic aspect when the tragic conclusion of the lovers' story – Phaon's faithlessness and Sappho's suicide – was known. And it was with this that the young Gros – still to come to the fore with his Napoleonic epics (see Chapter 2) – moved his Salon audience in 1801, with his unearthly *Sappho at Leucate* (220), in which the poetess, in agonies of rejection, casts herself into the sea. Described as a 'romantic' scene by the *Journal de Paris*, this matched overwhelming emotion with a supernatural aura. Touched by the moonlight shimmering

220
Antoine-Jean
Gros,
*Sappho at
Leucate,*
1801.
Oil on
canvas;
122×100 cm,
48×39³⁄₈ in.
Musée
Baron
Gérard,
Bayeux

through her transparent veil, Sappho seems poised between
two worlds; behind her on the cliffs stands a sacrificial altar.

Such episodes have more to do with sexual longing than the
condition of the soul, but it is striking how often martyrdom to
passion became entangled with religion. Faith too was so often
sought but not quite attained, and love-death was a worldly
echo of Christ's sacrifice. Such imaginative leaps from passion
to Passion were perhaps unconscious, but must account for the
echoes of religious painting – of Christ dead or taken down
from the cross – in a picture such as Girodet's *Atala* (see 159).
There the tragedy hinges upon the collision of Christian and
pagan beliefs. Another extraordinary scene of love and death
was exhibited by Pierre-Auguste Vafflard (1777–1837) at the
Salon in 1804 (221). Here it is paternal love that drives the poet
Edward Young to struggle with the body of his dead daughter
by the cold light of the moon. This episode is now known to
be based on a factual clash of faiths – Young's removal of his
eighteen-year-old daughter, who had died on a visit to Lyon, to

221
Pierre-Auguste Vafflard,
Young Holding his Dead Daughter in his Arms,
1804.
Oil on canvas;
238×192·5 cm,
93³⁄₄×75³⁄₄ in.
Musée Municipal, Angoulême

the city's Swiss cemetery, after the girl, as a Protestant, had been denied burial in the Catholic one. At the time, however, the theme, from the poet's *Night Thoughts* (1742–5; published in French 1769–70), was so inscrutable that it seemed touched with eroticism, even necrophilia. A critic spoke of its 'sweet melancholy … which softens us to the idea of extinction'. Similar themes entwine in the wholly pagan realm of Turner's *Parting of Hero and Leander*, painted in 1836 (222). Here the religion of love itself is present, since Leander's bereaved lover, about to fling herself into the surging Hellespont where he had drowned while swimming to meet her, had been a priestess of Venus. In 1809 Byron had courageously swum across these same waters to prove the legend's circumstantial truth.

Turner's picture richly demonstrates the Romantic notion that religion and love were both forms of worship, mysteries that must sometimes be attended by sacrifice. In the early 1850s Delacroix took up similar messages from his author-friend George Sand (pseudonym of Amandine-Aurore Lucille Dupin).

222
J M W
Turner,
The Parting
of Hero and
Leander – from
the Greek of
Musaeus,
1836.
Oil on
canvas;
146·1×236·2 cm,
57½×93 in.
National
Gallery,
London

**223
Eugène
Delacroix,**
*Lélia Mourns
over Stenio's
Body,*
1847.
Oil on
canvas;
22×15·5 cm,
8⅝×6⅛ in.
Karen B
Cohen
Collection

**224
Claudius
Jacquand,**
*The Count of
Comminges
Recognizing
Adélaïde,*
1836.
Oil on
canvas;
163×208 cm,
64¼×82 in.
Musée des
Beaux-Arts,
Rennes

Her novel *Lélia* (1833) is a sort of updating of Sappho's story
to the Christian age, with genders and roles reversed. Lélia,
disillusioned with her poet-lover Stenio after he makes love to
her courtesan sister, enters a convent and rises to be its abbess.
When Stenio rediscovers her there and she rejects him again, he
drowns himself, but Lélia is overcome by remorse and longing.
For the author herself, at once the high priestess of romantic
love and a pioneer of women's liberation, Delacroix painted
the climax of her tale, in which Lélia, 'the dignified fiancée of
a corpse', declares her love for the body, watched by the monk
Magnus (223). The painter was wise to opt for the version in
the later edition, where the abbess is left to die of grief, rather
than the first where Magnus goes mad and strangles her with
his rosary. Even this story, however, is not as steamy as the
'Gothic' tale by F T M d'Arnaud that Claudius Jacquand
(1805–78), a pupil of the Troubadour painter Fleury Richard
(see Chapter 4), produced for the Salon of 1836. Realized in a
gruesome greenish-yellow palette reminiscent of the hospital or

the morgue, Jacquand's *Comminges* (224) depicted the count of that name slumped in despair over the expiring body of a fellow monk – actually his former lover Adélaïde, who had entered his Trappist monastery to be near him after he had taken orders to escape his own torments of love.

That these doomed lovers' monastic order was a silent one only heightened the melodrama of their situation. While providing pious Romantics like the German Nazarenes (see Chapter 4) with a model of the virtuous life, monasteries and nunneries challenged the sceptical to puncture their self-denial and enclosure. The passions seething beneath the habit in Delacroix's or Jacquand's pictures seem absurd today, but belong to the irrational fantasies which were common in the literature of the time, and depend on popular associations of love and religion. Sometimes frivolous, at others taken to

extremes, these could also carry passionate conviction. 'In
Germany', Madame de Staël declared, 'love is a religion, a
romantic religion, which too easily tolerates everything that
sensibility is willing to excuse.' But the heroine of her romantic
novel *Corinne* (1807) speaks of love as 'all poetry, all heroism,
all religion', and Novalis was serious when he compared
the departed Sophie to the Virgin Mary. Such, also, were the
sentiments of the Nazarenes in their quasi-devotional portraits
of each other and their ideal wives or longed-for lovers (see
132, 133) – often, it must be remembered, doomed to early
death from the common diseases of the time – or of Friedrich's
pictures of his wife (see 7). Perhaps their most extreme
expression occurs in a series of religious pictures painted by
Delaroche in the decade after the death of his wife, Louise
Vernet, in 1845. In the finest and strangest of these, the *Young
Christian Martyr* of 1855 (225), her features float on the dark
waters of the Tiber, lit by the halo of sainthood. But if the

225
Paul
Delaroche,
*Young
Christian
Martyr*,
1855.
Oil on canvas;
170·5×148cm,
67¹⁸×58¹⁴in.
Musée du
Louvre, Paris

Romantics often took their conflation of the sacred and secular to the point of idolatry, what of relations between the sexes themselves? How accurately did their ideals and aspirations reflect reality?

It was Friedrich Schlegel's contention – based largely on observation of his wife Dorothea – that women were more inclined than men to poetry and religion. Certainly women play a leading role in Romantic discourses on time, mortality and the life of the soul. Contrary to the Enlightenment rationalists, who had regarded all human beings as fundamentally equal, regardless of gender, the Romantics preferred to explore different and complementary characteristics. Often they believed in a feminine principle, which of course is inimical to modern feminism. The faithful, virtuous women whose destiny was the love of a true partner, who peopled contemporary literature, especially German children's literature and fairy tales, were, needless to say, male creations. In fact, in Jena or Berlin, London or Paris, there were already hosts of emancipated women whose lives were not so much liberal as libertine, whose domestic arrangements were often far from regular, or who were writing and painting, laying claims to the intellectual life.

Such women, alas, were likely to be mocked by men like Byron, who famously declared love was 'woman's whole existence'. But women such as Mary Wollstonecraft – author of a stridently polemical *A Vindication of the Rights of Woman* (1792) – now asked 'What can I allow myself?' and wanted women to be 'rational, useful creatures'. While she, and Madame de Staël, set out to dismiss male stereotyping, their lives were a more ambiguous testimonial. Their own turbulent pursuits of love often left them disappointed victims – Wollstonecraft chasing the painter Fuseli until driven off by his wife, attempting suicide off Putney Bridge after being jilted by her American lover Gilbert Imlay, and eventually dying as a result of giving birth to the future Mary Shelley; de Staël notorious for a string

of 'unsuitable' liaisons. The latter's Corinne is a true portrait of her creator's emotional despair and a fantasy of genius fulfilled: the poetess is crowned by a Roman crowd chanting '*Vive le génie*' – a triumph that the real de Staël never quite attained. This was not at all the spirituality Schlegel had in mind; his novel *Lucinde* (1799) gives a typically Romantic effusion on the eternal unity of complementary souls in marriage, 'the timeless union and conjunction of our spirits'. In reality, however, this was written in the emotional euphoria of his elopement with Dorothea Veit, a married woman. The elevation of a cult of love, and a growing appreciation of female sexuality, could not but undermine marriage, and George Sand was to campaign for more enlightened divorce laws. Herself uncomfortably married to the Baron Dudevant, she put into constant practice her belief that the 'sacred rights of love' should be freely observed.

Meanwhile, the possibility of replacing unwanted lovers or husbands was widely denied to women. Instead, their experience had been of enforced separation and loss, for the toll of young men in the Revolution, and in the ensuing wars, was immense. For the writer Jean Paul in Germany, one consequence was a general return to the Church – the graveyard, as he put it, became the preacher. While loss afflicted both sexes and all ages, families as well as lovers, its consequences for women were more practical. Survival and responsibility created new opportunities. While women artists were not a new phenomenon, it was women artists in Paris – some of them associated with David – who found the means to project the grief of an abandoned generation in terms of poetic allegory. But far from asserting independence, their pictures tended to reinforce male stereotypes of female attachment. Epitomized by *Melancholy* (226) by Constance Charpentier (1767–1849), which appeared in the Salon of 1801 and showed a girl seated alone and despondent in a woody landscape, meditating on her lost loved one, these soulful and sentimental images conveyed a passive devotion. These women

seem to have nothing to do but remember; time and emotion are frozen for them. At the same time, however, they offer the erotic appeal of female vulnerability and dependence, and in this they were surely calculating – for their purchasers were likely to be men. While doubtless designed to draw attention to the predicament of the legions of impoverished women who had lost husbands or future husbands in the wars, they also seem to appeal to the exploitative male attitudes of the day.

Their background was a Paris where women had, exceptionally, taken matters into their own hands, from the lightly garbed beauties who famously prowled the arcades of the Palais Royal – the city's main haunt of prostitution – to the great society figures like the beautiful but icily unavailable Madame Récamier who, with perfectly judged charm, held her husband and countless admirers from Chateaubriand to Napoleon's brother Lucien in her thrall. The Empress Josephine, whose marriage to Napoleon in 1796 two years after her husband Beauharnais was guillotined had invited endless speculation, seemed to her detractors the ultimate in contemporary opportunism. But when that master of tender emotion Pierre-Paul Prud'hon (1758–1823) painted her reclining in her shady woods at Malmaison, he portrayed her instead as a woman of the most delicate sensibility (227), simply gowned and covered by a crimson shawl like a vast open wound. Begun in 1805, still unfinished on the couple's divorce in 1809, and naturally excluded from the Salon on its completion the following year, the picture might have been designed to banish once and for all any idea that its sitter had been an adventuress. Rather she appears as the victim of abandonment by her more calculating husband.

Meanwhile, Napoleon's long wars threw up many examples of women actively taking part in events. Some disguised themselves as men to get into the army, while the famous 'heroine of Saragossa' fought beside her fiancé on the city's ramparts during its siege by the French. When he fell dead

226
Constance
Charpentier,
Melancholy,
1801.
Oil on
canvas;
130×165 cm,
51⅛×65 in.
Musée de
Picardie,
Amiens

227
Pierre-Paul
Prud'hon,
The Empress
Josephine,
1805–10.
Oil on
canvas;
244×179 cm,
96×70½ in.
Musée du
Louvre,
Paris

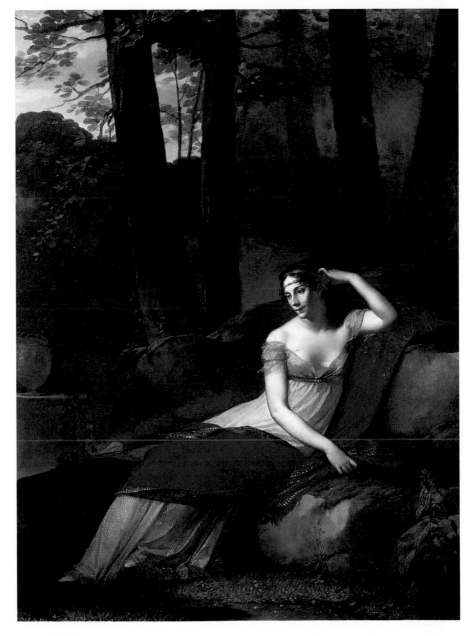

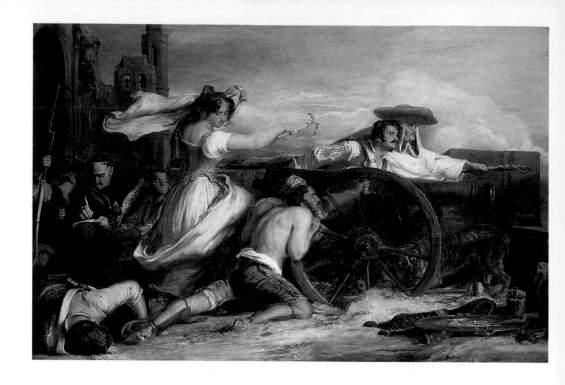

beside her, she seized a burning brand from his hand to fire
his cannon at the advancing enemy. This real event of female
bravery was celebrated by Byron in verse and by Wilkie in a
dramatic picture of 1828 (228). Goya's own version of the
Saragossa heroine, in his *Disasters of War*, is less an individu-
alized portrait than a patriotic symbol, a kind of Hispania
to match the female national personifications of Britannia,
Germania or the French Marianne that were so emotive in these
troubled times. Though she has lost her own lover, she inspires
above all love of country.

For Heinrich Heine, however, there was something less than
admirable about Delacroix's *Liberty* (see 64), the bare-breasted
standard-bearer of Paris's 1830 revolution; he called her an
'alley Venus'. With her grubby, tanned skin but her head turned
to display a classic, sculptural profile, she offered a blend of
the real and the ideal that offended conservative critics. While
reflecting these objections, Heine's remark further implied that
she was in fact a prostitute. There were plenty of stories of such

women on the Parisian barricades, even if it would be the
more specifically working-class revolution of 1848 which did
most to create an enduring myth of the 'red whore', rallying
the proletariat. This bourgeois phobia reflected the increasing
prominence of the prostitute in the contemporary conscious-
ness, and the ambiguous place she represented through her
supposed sexual freedom and subjection to market forces.
Both depending on and mocking male desire, she was already
a threat; as a political force she could only lead her followers
to ruin. But she was also a measure of the moral condition
of society.

The image of the prostitute as vicious, destructive or diseased
represented a misogynist Romantic extreme opposed to the
reductive ideal of the virtuous wife and mother. Its decadent
climax can be found in Baudelaire's volume of poems *Les Fleurs
du mal* ('Flowers of Evil', 1857), whose paradoxical title hints
at its ironic inversions and contrasts. Female artifice and deceit
are constant themes, by which the poet is both enthralled and
repelled. The prostitute, irresistible yet disgusting, becomes
the essence of original sin, her soul-destroying orgies leading to
death. But instead of the Romantic ideal of the love-death, this
is the slow death of disease and decay, the punishment of age
and vice. Never a subtle painter, but renowned for his sensuous
rendering of flesh and a decidedly necrophiliac streak, the
Belgian artist Antoine Wiertz (1806–65) anticipated just this
Baudelairean mood in a picture of 1847, ironically titled *Two
Young Girls or the Beautiful Rosine* (229). Before an easel on
which her own portrait has presumably been, or will soon be
resting, a naked beauty with flowers and pearls in her hair
confronts her future and *alter ego*, a suspended skeleton.
More than just a reworking of the traditional *vanitas* theme
of the brevity of life, the picture presents the erotic as itself
a corrupting force. Goya, often before, had suggested the
same. '*Que tal?*' – 'How goes it?' – asks a mirror of the hideous,
decrepit crone who, in a late picture, preens before it in her
finery, unaware of the truth that the painter makes so grimly

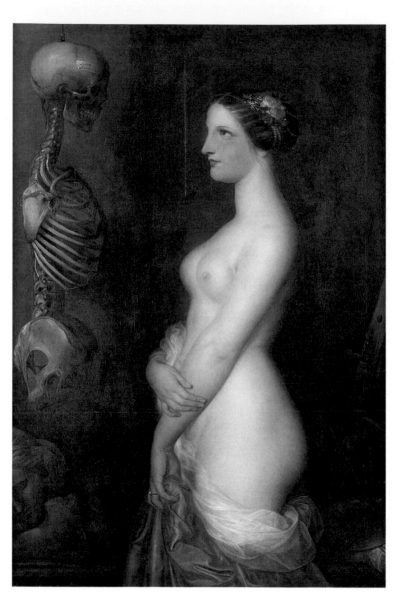

229
Anton
Wiertz,
Two Young
Girls or the
Beautiful
Rosine,
1847.
Oil on
canvas;
140×100 cm,
55¹⁄₈×39³⁄₈ in.
Musée
Wiertz,
Brussels

obvious by including the figure of Time, ready with his broom to sweep her from life (see 216). Attended by an even more repellant friend dressed in black, a parody of a courtesan's procuress, this ancient noblewoman personifies a degenerate world. If, as has been suggested, she is really the nemesis of the sexually rapacious Queen Maria Luisa, grown old and beyond such amusements, her emblematic role becomes clearer still.

Prostitution is a recurrent theme of Goya's *Caprichos*, in which courtesans are seen receiving a sexual education from witch-like elders, duping their male admirers, or as victims of political or social oppression. Their varied roles reflect current debates, since reform and regulation of the trade in the interests of public health was being advocated by liberal thinkers. In any case, Goya often shows high-born women almost as their equals, entrapping gullible and complacent husbands who will guarantee their continued freedom. But in this picture, the rewards of beauty are in the past, replaced by the fear of the death that its subjects deny by clinging to their absurd remnants of girlish vanity. Goya handles their diaphanous silk and lace so tremulously that they seem to shiver into dust. What, Goya asks, will become of them?

These Romantic images of women lead back to the real themes of this chapter – love and death; faith and doubt. 'Time will tell' is the answer Goya gave to questions of guilt and the afterlife raised by one of the prisoners and Inquisition victims that he drew in his so-called 'Album C'. Often these too are women; their crimes – of liberalism or 'marrying as she wished' – make no sense. Like the bitter absurdities of the *Caprichos* to which these drawings seem related, they are emanations of a sick society consuming itself. Often resembling Christian martyrs in their poses and attributes, they are destined for death; but are their absurdly ordinary doings any more de-serving of immortality than punishment? The Church itself is their severest persecutor, and Goya seems to ask whether it is possible to believe in a God who permits such things.

Like Turner, Goya was a master of chiaroscuro – the contrast of light and dark. And it is in this shadow play, as much as in the captions he attached to his prints, that we can divine the questions that meant most to him. The print from the *Disasters of War* in which a corpse clutches a paper on which its skeletal hand has written '*Nada*' – nothing – is often taken as evidence of unbelief (230). Yet the contrasted background, divided between a burst of burnished light and an angelic figure holding scales of judgement, and a sinister gloom peopled by gibbering spirits, suggests rather the artist's uncertainty between claims of heaven and hell. It asks whether the

230
Francisco
Goya,
*Nothing.
The Event
will Tell*,
plate 69,
*The Disasters
of War*,
1810–14.
Etching,
burnished
aquatint,
lavis and
drypoint;
15·5×20·1 cm,
6¹⁸×7⁷⁸in

sufferings depicted in the series have been pointless, but does not answer. The crown that seems to be held in the dead man's other hand might indicate that this is a conventional *vanitas* image – that such baubles count for nothing in eternity does not mean that eternity does not exist. On the other hand, other prints offer a less orthodox Christian narrative than appears at first glance. In the concluding plates of the *Disasters of War* are shown the burial of a beautiful young woman, followed by her exhumation or resurrection (231, 232). Captioned *Murio la verdad* ('Truth has Died'), the first shows her body radiant with

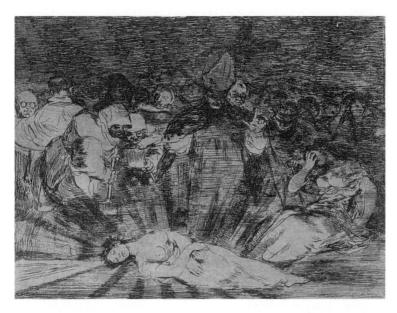

231
Francisco
Goya,
Truth has
Died,
plate 79,
The Disasters
of War,
1810–14.
Etching;
17·5×22 cm,
6⁷₈×8⁵₈ in

232
Francisco
Goya,
Will She Rise
Again?,
plate 80,
The Disasters
of War,
1810–14.
Etching;
17·5×22 cm,
6⁷₈×8⁵₈ in

light as she lies in her grave and a looming priest administers the last rites. In the companion print, *Si reucitaria?* ('Will She Rise Again?'), she is exposed, her radiance and beauty faded, her face aged. Still she emits a glow that seems all the greater for the depth of background shadow – and sufficient to throw the crowd of peering ghouls into a frenzy. Here, the parallel hatching of the first etched plate is replaced by radiant lines, inked more intensely as they spread away from the body.

As in his drawings of doomed prisoners, Goya's martyr is shot through with recollections of the resurrected Christ. It is Reason and Liberty, the ghosts of constitutional Spain, that are offered the hope of resurrection as much as the soul itself. Or rather, these *are* the Spanish soul. Accounts of Goya's agnosticism have surely been exaggerated; his letters reveal a faith remarkably uncomplicated for his time, and he painted many religious works with a sincerity that seems to transcend the circumstances of their commission. Of the saints that he produced for Seville Cathedral in about 1817, a contemporary wrote that he was 'infused with the faith, strength, and love of God' that characterized his subjects. Sceptical rather than unbelieving, his art posed the questions to which he longed for answers.

Turner's motives for his religious subjects remain an enigma. Their own strong contrasts of shade and darkness, light and colour – to paraphrase the titles of two late pictures of the biblical Flood – suggest aesthetic as well as spiritual tension. There is little evidence that he hoped to take advantage of the boom in Church commissions that followed the Napoleonic Wars, and his earlier biblical pictures seem to have been painted from his ambitions as a history painter and in response to his favourite Old Masters or contemporaries.

Among the likely sources of Turner's *Angel Standing in the Sun* was a remarkable picture by the young American history painter Washington Allston, a friend of Coleridge, Wordsworth and Haydon. His *Uriel Standing in the Sun* (233), a chromatically brilliant vision of the archangel guarding heaven against Satanic

revolt, inspired by Milton's *Paradise Lost,* had first been seen in London in 1817, and belonged to the Marquess of Stafford, one of Turner's early patrons. Allston certainly expected a market for his epic religious works, following his teacher Benjamin West whose reputation had been vastly extended by a series of biblical blockbusters. West's *Christ Healing the Sick* caused a sensation in 1811 when – having originally been intended as a gift to the painter's native Philadelphia – it was bought by the British Institution in London for the record price of 3000 guineas. The Institution was keenly promoting historical art and living artists, and took a strongly prescriptive view of what was good for the public, for whom it was hoping to establish a picture gallery. That such a public existed was proved by attendances when West put this and other similar pictures on independent exhibition, for an entrance fee. What is harder to gauge is whether the crowds were more attracted by piety or the sheer sensationalism of such vast canvases. Nor is it clear whether the painter was motivated more by faith or by opportunism. Institutional patrons often regarded religious art as another form of history, and thus a worthy aspect of High Art.

Allston's friend Haydon certainly saw it in that light himself, but he was also impelled by strong personal faith to undertake his own uncommissioned religious canvases. The years of labour he expended on them helped to ruin him. It was his aim to cast out doubt as well as win fame, and in *Christ's Entry into Jerusalem* (234), he addressed the issue of doubt directly, assembling past rationalists and sceptics like Voltaire and his own more devout friends like Wordsworth among the watching crowd. Their varied reactions to Christ's appearance amount to a debate on faith. Like West's, Haydon's pictures drew the crowds when exhibited in special fee-paying shows, but despite

234
Benjamin
Robert
Haydon,
*Christ's
Entry into
Jerusalem*,
1814–20.
Oil on
canvas;
3·96×4·57m,
13×15ft.
Mount St
Mary's
Seminary,
Cincinnati

235
John Martin,
*Great Day of
His Wrath*,
1851–3.
Oil on
canvas;
196·5×303·2cm,
77³⁄₈×119³⁄₈in.
Tate, London

his hopes, they were bought neither by the British Institution nor for any of the new churches being constructed by the Church Commissioners. Financed by money set aside by Parliament in 1818 and 1824, these reflected official aims to establish security and order through moral improvement – and to counter the rise of Nonconformism. In fact, the popular religious revival currently under way was often expressed through Nonconformist and evangelical movements that ran counter to the Established Church. Not funded by the state, these had no impact on 'official' art or architecture but were

felt instead in such fundamentalist extremes as John Martin's vast visions of wrath and judgement – unsuitable for any sort of church – and the immense public response to them. However, by the time Martin began his *Great Day of His Wrath* (235), his own rendering of the Book of Revelation, in 1851 (the year of Turner's death), a Roman Catholic revival had made a real impact on the arts.

While Pugin's equation of Catholicism and the Gothic style (see 142) was based on a belief in their moral superiority, for many

Romantics the nostalgia for Catholic pomp was aesthetic, almost sensual. There was a yearning for beauty and shared ceremony to offset the Protestant's individual act of faith. The poet Joseph von Eichendorff, a Catholic from Silesia, regarded German Romanticism itself as a species of Protestant craving for the lost faith. The Catholic conversions of numerous important Romantic figures, from Friedrich Schlegel to the Nazarenes, tend to support this view; and indeed it might be extended beyond Germany to those who matched creative

innovations with conversion or return to Roman Catholicism. Among the first of a number of artists to take a pictorial interest in Roman ritual, rather than in the traditional Christian iconography, was the young Provençal Granet, who while studying in Rome began painting church interiors with officiating clergy. This new genre anticipated the medievalism of his Troubadour compatriots and found a ready market. His haunting *Crypt of San Martino ai Monti*, a view of the vaults which were once part of the ancient Baths of Trajan, includes a female corpse in its white shroud, while a hooded priest and his acolyte prepare for the committal (236). Granet sold the picture to an influential Roman collector, the Countess of Albany, the estranged wife of the Jacobite 'Young Pretender' to the British throne, Charles Edward Stewart. She in turn bequeathed it to her last lover, the French painter Xavier-Pascal Fabre (1766–1837), thus endowing it with a romantic worldly history strangely appropriate to a work that treats devotion as an affecting spectator sport. While some painters from the Protestant north found humour in the gullibility of the Italian faithful, most followed Granet in finding their reverence touching. Even Wilkie, the son of a Scottish minister, was moved by the events of Holy Week, such as the tradition of the nobility washing the feet of peasant pilgrims.

'What, this is Christianity? But it is delicious!' Such, according to one reader, Madame Hamelin, was the habitual female reaction to Chateaubriand's *Génie du Christianisme* when it appeared in France in 1802. It was at Ulm, years later, in a cathedral stripped bare by the German Reformation, that Chateaubriand let slip the longings that must have driven him to write the book – dreams of 'chants, pictures, ornaments, silk veils, draperies, laces, gold, silver, lamps, flowers and incense of the altars', all swept away from his native France by the Revolution. A cry for Catholic renewal, his book appeared at an apparently opportune moment, within months of Napoleon's Concordat with the Church. But Napoleon's motives were more pragmatic than pious: together with his

236
François-
Marius
Granet,
Crypt of San
Martino ai
Monti, Rome
1806.
Oil on canvas;
125·5×159 cm,
49³⁄₈×62⁵⁄₈ in.
Musée Fabre,
Montpellier

237
Jean-Baptiste
Mallet,
Gothic
Bathroom,
1810.
Oil on
canvas;
40·5×32·5 cm,
16×12³₄ in.
Château-
Musée de
Dieppe

strong government, the Church provided a bolster against any return to revolutionary disorder. His qualified reconciliation – which did not prevent him locking up the pope several years later – left it subordinate to the state, and while abandoned ecclesiastical buildings were brought back into use, he promoted neither a revival of faith nor of patronage of Christian art. Granet, for example, found himself blocked from the 1804 Salon by Denon, and while the new Troubadour painters flirted with religion – or at least religiosity – it was mainly to enhance their stylistic archaism. They favoured approachable characters and episodes of sentimental or romantic interest that hardly involved spiritual issues at all. But it was also permissible to cast a vaguely churchy air over such a blatantly erotic scene as the *Gothic Bathroom* (237) by Jean-Baptiste Mallet (1759–1835), shown at the Salon of 1810, whose curvaceous occupant disrobes before a font-like washstand by the light of a stained-glass window set with scenes of love.

The blasphemous comedy of this picture is sufficient warning to take Napoleonic religion with a pinch of salt. Similarly, the more enthusiastic revival of Christian art after the Restoration was not always as sincere as it seemed. New altarpieces and devotional pictures were commissioned by the monarchy and many civic authorities, both to erase the memory of revolutionary iconoclasm and to revive the tradition of official patronage. Moreover, these pictures were seen as opportunities for the history painter, to be appreciated as much as examples of the highest academic genre as sacred objects. The Church, indeed, became an extension of the museum or vice versa, as when the Louvre, struck by the exceptional qualities of Prud'hon's *Crucifixion* (238), commissioned for Metz Cathedral, claimed it for itself. Said at the time to have been painted to console the artist in his grief at the suicide of his mistress and pupil Constance Mayer (1775–1821), the sincerity of this work, with its lights and shadows playing over Christ's twisted body and averted face, is beyond doubt.

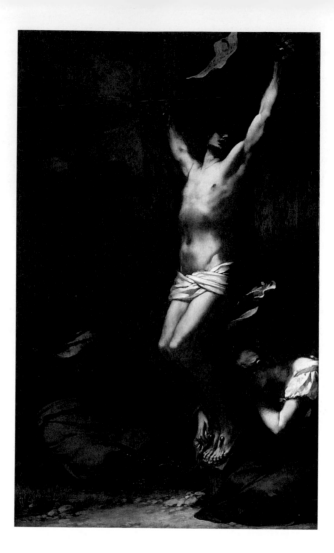

238
Pierre-Paul
Prud'hon,
Crucifixion,
1822.
Oil on
canvas;
278×165·5 cm,
109¹₂×65¹₈ in.
Musée du
Louvre, Paris

239
Jean-
Auguste-
Dominique
Ingres,
*The Vow of
Louis XIII*,
1824.
Oil on
canvas;
421×262 cm,
165³₄×103¹₈ in.
Montauban
Cathedral

By contrast, in the monumental altarpiece that Ingres painted –
somewhat under duress at first – for the cathedral of his home
city of Montauban, Christian faith is occluded by the worship
of art (239). The Ministry of the Interior set the painter his
subject – the early seventeenth-century king Louis XIII placing
himself and his kingdom under the protection of the Virgin
in his endeavour to defeat a Protestant rebellion. Ingres
composed the Virgin and other aspects of the painting from
works by Raphael; the cathedral clerics were appalled by the
naked sexuality of the child angels and lost no time in applying
vine leaves to their offending parts. Ingres's picture – which he

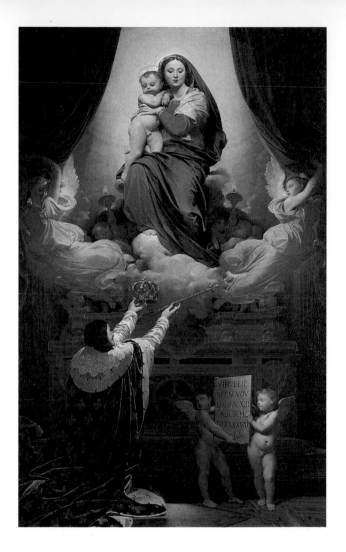

described to a friend in 1822 as '*painting itself*' – is as much a manifesto for classic art, and for its appropriate patronage, as for faith.

Ingres took four years over the picture, before its triumphant appearance in the 1824 Salon, and went to immense trouble to bring together the earthly plane, with the king prostrate before the altar, with the visionary apparition of the Virgin. While the monarch's robes are painted with minute realism, she is more softly and sensuously treated. Ingres had not gone as far as Friedrich, in his *Tetschen Altar* (see 67), in secularizing the altarpiece, but his substitution of a pictorially sourced Virgin

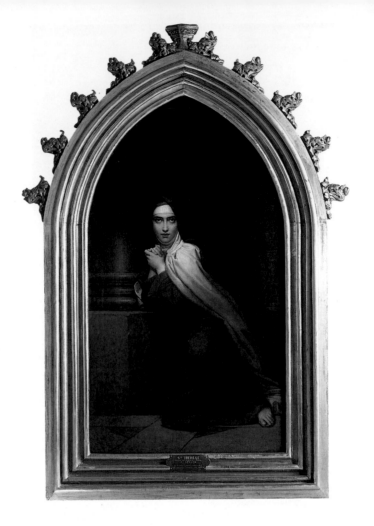

for a truly divine revelation, and characterization of Louis as
an adoring saint, seem yet another idolatry. Moreover, the
picture was immediately co-opted into the service of royalist
propaganda, being shown, in at least one picture of Charles X
giving prizes in the 1824 Salon, directly behind the King. As to
the sensuality of the Virgin herself – the final potent ingredient
in the picture's appeal – Ingres knew that Raphael's model
for his Madonnas had been his mistress, 'La Fornarina'. In a
Troubadour phase, in 1814, he had painted the two of them
together, with one of these pictures in the background. Proof
of the paradox that profane love could inspire sacred art, the
theme exercised him all his life. It was popular with many other

painters for its coded eroticism, but Ingres's were by far its most resonant treatments.

In 1819 Chateaubriand's wife conceived the idea of a charitable asylum for distressed noblewomen and priests fallen on hard times. In what is now the boulevard Raspail in Paris, it was christened the Infirmerie Marie-Thérèse, after the wife of the future Charles X. It was none other than Madame Récamier, on whom Chateaubriand had long had his eye, who took the lead in commissioning David's pupil Gérard to paint the princess's patron saint, Theresa of Avila – most famous for her concept of 'mystic marriage' with God – and presented the picture to the new chapel (240). In 1819 Récamier received as a gift from Prince Augustus of Prussia another picture by Gérard, an affecting realization of Madame de Staël as Corinne, set like Sappho on the wild shore of Cape Miseno and pausing in her recitation of an ode when interrupted by her infatuated admirer, Lord Nelvil. Corinne looks up heavenwards in her confusion, the saint towards us in the rapture of her prayer (241). That such a sensual creation should have served as the complement to Madame Chateaubriand's altarpiece is of

240
François
Gérard,
St Theresa,
1827.
Oil on
canvas;
172×93 cm,
67³⁄₄×36⁵⁄₈ in.
Infirmerie
Marie-
Thérèse,
Paris

241
François
Gérard,
*Corinne at
Cape Miseno*,
1819.
Oil on
canvas;
256·5×277 cm,
101×109 in.
Musée des
Beaux-Arts,
Lyon

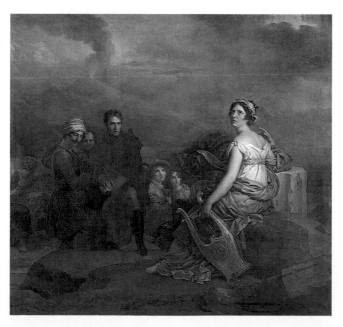

course highly revealing, as is the contemporary suggestion that the painter drew his inspiration from Chateaubriand's chapter on 'religion considered as a passion'. Its origins in the fashionable society of Restoration Paris, and the painter's insistence on keeping his work and interpretation secret, would have been sufficient to ensure his *St Theresa* a sensational response. The decision not to exhibit it publicly when completed in 1827 only heightened expectations. By popular demand it was shown in the Salon after all, before being installed in the chapel in the presence of the Archbishop of Paris. With its beautiful saint kneeling in rapt devotion, the

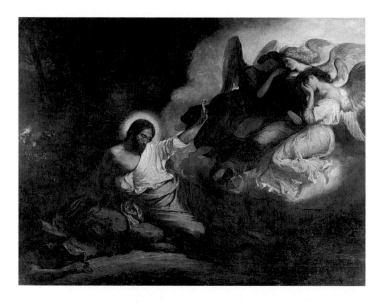

242
Eugène
Delacroix,
*Christ in the
Garden of
Gethsemane*,
1827.
Oil on canvas;
294·6×363·2cm,
116×143in.
Church of
Saint-Paul-
Saint-Louis,
Paris

work soon became as defining a work of Romanticism as Delacroix's *Sardanapalus*, seen in the same exhibition. Both achieved emotional extremes, and their very differences from each other, and failure to conform to any recognizable prototypes, showed the new movement in full flow.

What might his picture reveal of Gérard's own religious attitudes? The answer, probably, lies in the saint's gaze – directed at the spectator, rather than an unseen altar or divine presence. She seems lit from within, but her radiance could just as well be reflected, as if the painter had heard the same cry from God

with which Blake had rallied his readers at the beginning of his *Jerusalem* – 'I am in you and you in me, mutual in love divine'. By the end of his life, Delacroix too had decided that God is in us all – to which he added the typically Romantic assertion that men of genius, like men of virtue, were singularly blessed by his inner presence. His own numerous religious works, along with the questions and speculations he confided to his journal, bear witness to this belief's gradual dawning. It was fitting that his first significant religious theme should have been the moment when Christ himself was tested, praying for deliverance in the Garden of Gethsemane. Completed in the same year as *Sardanapalus*, the picture was made for the Paris church of Saint-Paul-Saint-Louis (242). Rich in pictorial sources yet highly original in its bold diagonals, and the triple grouping of the central figure, the sleeping Apostles and the Angels of Death, the picture was a masterpiece. It gave Delacroix the opportunity to step back from the extremism of his *Sardanapalus* and woo the critics and public whose own shock had rather shocked him. But there can be little doubt that he also used the picture to address questions of his own; for most of his life, it was those religious scenes that confronted issues of doubt, solitude or suffering that had the most meaning for him. The incredulity of St Thomas, the fears of the disciples as they are tossed on the stormy waters of the Sea of Galilee before Christ quells the tempest, and the agonies of Christ himself, resigned to his earthly fate, were stages of a personal spiritual journey that led, if not to convinced belief, to acceptance of his destiny.

Delacroix was the most prolific and sensitive religious painter among the Romantics. But while he received important Church commissions, for example for Saint-Sulpice, other admirers such as his friend George Sand treated his religious pictures as collectibles, much like Old Master works – an attitude that the painter was quite content to accept, even encourage. In this secularization of Christian imagery, he was not alone. Its most famous example in early nineteenth-century Paris – a work which

**243
Antonio
Canova**,
*The Penitent
Magdalene*,
1796.
Marble;
h.94 cm,
37 in.
Palazzo
Bianco,
Genoa

**244
Henri
Lehmann**,
*St Catherine
of Alexandria*,
1839.
Oil on
canvas;
152×262 cm,
59⅞×103⅛ in.
Musée
Fabre,
Montpellier

Stendhal and many others considered the greatest of modern times – had been the marble *Penitent Magdalene* by Canova (243). First exhibited at the Salon in 1808, it was later acquired by the Milanese Bonapartist the Baron Sommariva, who installed it in his house – near Madame Récamier's – in a special room, half chapel, half boudoir, which was painted violet and lit by an alabaster lamp. The kneeling penitent, of a thoroughly worldly perfection of figure, transfixed by her contemplation of cross and skull, created a 'miraculous' effect on all who came to her shrine – and one which was surely not entirely pious. In London, even the devout Haydon tried to foist his own *Agony in the Garden* (1821) on a patron for his ballroom, and was surprised at his reluctance to hang it 'where quadrilles were danced'. And it was for his own collection, rather than for one of his city's churches, that a young collector from Montpellier, François Sabatier, bought from the German-born Henri Lehmann (1814–82) a large

picture of the martyred St Catherine of Alexandria carried to her tomb by flying angels, painted in Rome in 1839 (244). He was apparently as intrigued by the picture's combination of extreme sentiment and aesthetic primitivism, based on early Italian painting, as by its imagery of Christian martyrdom. In any case, the freely floating forms of the saint and her celestial escort suggest – not for the first time in a scene of death and transfiguration – an almost sensual ecstasy.

The readiness of Delacroix and other Romantics to impart a quasi-religious air to profane or even frivolous subjects was, of course, the opposite side of the same coin. Lehmann, who had

studied with Ingres, first exhibited at the Salon in 1835, the year that Ary Scheffer, himself of German origin, showed one of his most sensational pictures. Like Delacroix, though in a more seductively sentimental manner, Scheffer – that 'transposed poet' as Gautier called him – could turn with equal ease from saints and martyrs to scenes of romantic love. From Dante's *Inferno* he took what was for the Romantics perhaps the ultimate story of love and death, the tragic tale of Paolo and Francesca, whose doomed romance culminated in their martyrdom, not in heaven but in hell. In a picture (245) already

245
Ary Scheffer,
Paolo and Francesca,
1835.
Oil on canvas;
166·5×234cm,
65½×92⅛in.
Wallace Collection, London

owned by the Duke of Orléans when he exhibited it in the Salon, Scheffer showed the dead lovers hovering in darkness, fixed in eternal embrace, while Dante and Virgil look on, much as the angels look on Christ in Delacroix's *Garden of Gethsemane*. The theme is full of echoes, not least of the origins of Romanticism itself, for it had been while reading the Arthurian romance of Lancelot and Guinevere that Francesca was interrupted by the kiss from her lover Paolo that was witnessed by her jealous husband, and his brother, Giovanni, who then slew them. In the swooning position of saints transported to heaven, their bodies bear wounds like Christ's stigmata, and their punishment seems more bliss than torment. Just as religion lived on in Romantic art in new, translated forms, so romance lives on after death. To vanquish time and mortality was, perhaps, the final Romantic pretension. Scheffer dedicated one version of the subject to his friend, the opera singer Pauline Viardot, whom he was trying to restrain from an adulterous affair with the Russian poet Ivan Turgenev, but his picture is far from a condemnation. Rather it seems to open a prospect of infinite rapture. It was another poet, and another of Scheffer's friends, the Pole Sigismund Krasinski, who most completely sensed its appeal to the Romantic mind. When his own version of the picture arrived in 1851, his sister-in-law, the Princess Odescalchi, wrote to the painter, 'you can't imagine how many ideas you create in him at each moment with this magnificent image of eternal death conquered by eternal love.'

Epilogue

Epilogue

'Romantic art', Friedrich Schlegel had declared, 'is … a perpetual becoming without ever attaining perfection … It alone is infinite, alone free; its first law is the will of the creator … that knows no law.' That such an art should be abruptly abandoned, just because some of its practitioners preferred to reject the Romantic label, and critical opinion in Paris turned against some of the more outlandish manifestations associated with it, was hardly to be expected. Baudelaire might have sounded its death knell in 1846, but an ongoing revolution had been set in train, a virus to whose constant mutations, it sometimes seems, the entire subsequent history of Western art can be attributed. Modernism, as it appeared early in the twentieth century, is often said to have roots in the restless energy and inventiveness of Romanticism. Yet tracing Romanticism's lineage through the complex movements of modern art is a difficult and elusive task. This chapter offers just a few examples to suggest the richness of the Romantic heritage and its continued relevance today.

In music, Romanticism remained a living force, for while this had so often been considered the most quintessentially Romantic of the arts, it would also be the least affected by anti-Romantic reaction. Romantic expression and spirituality permeate the operas of Richard Wagner, whose *Ring* cycle, first performed between 1869 and 1876, is the supreme expression of the Romantic *Gesamtkunstwerk* or 'total work of art'. His *Meistersinger* (1868) proclaims the freedom and independence of Romantic art in its story of a singing competition in which a new song, formed from emotion and instinct, triumphs over the traditional rules applied by the judges in medieval Nuremberg. And nothing could be more Romantic than the ambitions of the Russian Alexander Scriabin: as late as 1915 he

246
Max
Beckmann,
Carnival,
1920.
Oil on
canvas;
186·4×
91·8cm,
73³⁄₈×36¹⁄₈in.
Tate,
London

was planning an epic, *Mysterium* (which remained unwritten), to be performed over a week by vast orchestras and choirs on top of an Indian mountain, at the end of which all mankind would be overwhelmed by a sense of harmony with the universe.

Occasionally, Romanticism lived on in the form of outright pastiche. The Polish painter Piotr Michalovski (1800–55), in Paris in the early 1830s, fell so thoroughly under the spell of Géricault that he painted pictures that could almost pass as his, and the lost Napoleonic epic exerted a similar appeal for his febrile temperament. In Spain Leonardo Alenza y Nieto (1807–45) pursued Goya's spirit to the point of parody in scenes of superstition, horror or suicide. These artists were Romantics at second hand; more often the Romantic artist lived on – if not literally like Turner until 1851 or Delacroix until 1863 – as an idea and an ideal rather than one whose work or style was any longer to be recommended.

The most pervasive Romantic legacy is the popular image of the artist – free spirit, rebel, outsider, leader, part of an *avant garde*, to be judged on originality, integrity, personal response, and probably suffering for all these things. The Hollywood view of the artistic life, as typically expressed in the 1965 film based on Irving Stone's novel about Michelangelo, *The Agony and the Ecstasy*, has clear Romantic roots – if reduced to something of a cliché. So too does the belief that artists are the true voices of their time.

If a Romantic sense of artistic vocation outlived Romantic art, it was because Romantic ideas had empowered artists with the confidence to look for new directions. No painter better exemplifies this apparent paradox than Gustave Courbet (1819–77), who emerged in the 1840s as the leader of the artistic movement that, in France at least, appeared to supersede Romanticism. Realism opposed the Romantics' subjectivity and sentiment and sought instead to look un-flinchingly at objective truth. But Courbet's own creative self-image was a Romantic one, constructed around a cult

247
Gustave Courbet, *The Meeting* or *Bonjour, Monsieur Courbet,* 1854. Oil on canvas; 129×149 cm, 50³⁄₄×58⁵⁄₈ in. Musée Fabre, Montpellier

of personality and fraught with tensions between insecurity and pride. To resolve these he painted many self-portraits, and included himself – as both impoverished wanderer and wise man – in his picture *The Meeting* (also known as *Bonjour, Monsieur Courbet*), painted for his Montpellier patron Alfred Bruyas in 1854 (247). In this encounter between painter and patron in open country, it is unclear whether Courbet, who with his backpack and walking stick literally appears to have struck out on a new path, is to be understood as dependent on or superior to the patron. Courbet's role as a 'Realist' recorder of his own truth was inevitably conditioned by Romantic concepts of reality itself – as the perception of the individual rather than the collective consciousness. For Courbet, a highly developed sense of self was necessary to his radical agenda.

Later in the nineteenth century, the Romantics' self-absorption took a decadent turn in the concept of 'art for art's sake' or '*l'art pour l'art*'. For its adherents, art constituted a parallel universe, a retreat from the world rather than the bringer of any message for it. This essentially negative escapism was one of the more sickly offspring of Romanticism. In the twentieth century, blatant self-promotion, propaganda or egotism appeared as its supercharged opposite. The self-defining claims of some contemporary artists, critics and curators – 'it's art if I say it is, or if it's in my gallery' – would similarly have been inconceivable without the Romantics' seizure of the initiative from the traditional élite consumers and arbiters of art. Artistic arrogance has sometimes come to seem an end in itself. Between these extremes, however, artists have followed those Romantics who brought their own sensibilities to bear on issues of general concern.

The history of the twentieth century has been marked by seismic changes, dislocations and horrors that equal or exceed those of the Napoleonic period. For the German Max Beckmann (1884–1950), traumatized by memories of his service as a stretcher-bearer in World War I and the shattered

condition of his country in 1919, self-aggrandising confidence was entirely out of place. In his poignant and sinister *Carnival* (see 246) he identified with the chaos around him by casting himself as a sad clown, with his *commedia dell'arte* companions Columbine and Harlequin. The disorientation of his defeated nation is manifest in his unhinged state, and in the contained confusion of the picture space – a tiny room with an overturned table, sagging shelf and blind window. Beckmann had formerly been called the 'German Delacroix', and like the earlier painter's *Sardanapalus* (see 2), painted in post-Napoleonic Paris, his hollow comedy addresses the alienation of a society in shock. Tragically, that very shock would give birth to Hitler and National Socialism. In 1930s Germany the Nazis unleashed the dark, demonic forces always latent in the Romantic assault on moral and social constraints. They twisted the ethnic and nationalist ideas of Fichte, Kleist and other thinkers to justify their own notions of Teutonic 'Aryan' purity. In a speech in Munich in 1937, Hitler described Romantic artists as 'noble Germans in search of the true intrinsic virtues of our people' in order to denounce by contrast many contemporary painters as 'degenerate'. Terrible as the outcome of Nazi ideology would be, its artistic consequence was a banal pastiche of the artists they professed to admire and the exclusion of their true successors.

For Joseph Beuys (1921–86), a German artist of a later postwar generation, the challenge was to repair a world even more damaged by the nuclear bomb, the Holocaust and the growing threat of environmental pollution. He took on a shamanistic role as the maker of 'social sculpture' and advocated the transformation of the world itself into a 'total work of art' through the liberation and empowerment of people (he set out to show that everyone was an artist), as well as through active politics as a founder of the German Green Party. Beuys constructed elaborate symbolic rituals for his art, and a personal mythology that claimed insights into the universal energies contained in the natural materials with which he worked. He can seem a

Blakean figure, but it is Turner's drama of being lashed to a mast in a storm (see Chapter 1) that comes to mind in connection with Beuys's claim to have been saved from freezing to death, after his Luftwaffe plane had been shot down over the Crimea, by Tartars who wrapped his naked body in fat and felt – a personal salvation that directed his fallen civilization, just as the Romantics had directed theirs, to the redemptive power of nature. Like Turner's, Beuys's autobiographical account has been questioned, but was embodied in such assertive works as *Der Chef* (*The Chief*), a performance piece of 1964 in which he rolled himself in fat and felt and proclaimed his oneness with nature by uttering stag-like noises. Beuys acknowledged an affinity with the Romantics, stating, 'I can connect only by going back as far as possible, radically,' and that 'a good starting point would be the age of German idealism'; specifically he named Novalis, Friedrich, Carus and Hegel.

For some critics, Beuys's assumption of iconic status was inappropriate in the light of modern German experience, in which Nazism should have destroyed all faith in charismatic leadership. While their cults of Hitler and the master race had degraded the heroic, the Nazis' appropriation of German history and myth discredited it even more. In the large compositions of Anselm Kiefer (b.1945), who was briefly Beuys's student, the claims of the German Romantics to raise an intellectual republic against the material reality of Napoleonic occupation are both acknowledged and undermined. In his *Ways of Worldly Wisdom* (248), Romantic writers and thinkers are arrayed with military and political figures in an ironic pantheon around the battleground of the *Hermannsschlacht* – the scene of the Cheruscan Hermann's victory over the Romans in the Teutoburg Forest in 9 AD that laid the historical foundation of German freedom. The field appears as the smouldering embers of battle, suggesting Nazi book-burnings. Having been invoked by the Nazis when unleashing their supposedly cleansing fire, these ghostly national heroes are to be viewed with extreme caution. Kiefer's disenchantment with history and the heroic is shared by his slightly older contemporary Georg Baselitz (b.1938), who in a series of pictures from the mid-1960s painted 'heroes' as anti-heroic, lost souls. Though he sometimes identified them with Romantic painters – Franz Pforr or Ludwig Richter – Baselitz also characterized these as 'new men' or 'new types', deprived by subsequent history of their legitimacy and purpose. In every sense, these pictures exaggerate still further the transformations of classic history painting introduced by the Romantics. Of all the great paintings of the twentieth century, *Guernica*, painted in 1937 by Pablo Picasso (1881–1973), is arguably the closest in its formal qualities to academic prototypes of history. Yet, painted in protest at the bombing by German planes of the Basque village of Guernica in the Spanish Civil War, it raised the sufferings of ordinary people to an epic scale, thus continuing the process begun by Gros and Delacroix in their pictures of

248
Anselm Kiefer, *Ways of Worldly Wisdom*, 1978. Acrylic and shellack on wooodcut paper mounted on canvas; 360·5× 339cm, 144¹₂× 135³₄in. Froehlich Collection, Stuttgart

the horrors of Eylau, Chios or Missolonghi (see 46, 170 and 173). In the United States, Andy Warhol (1928–87) was more radical still, asserting celebrity rather than exemplary behaviour as the basis of iconic status. In Warhol's art, fame is not heroic but becomes part of the everyday landscape of modern life. He famously declared that everyone would be famous for fifteen minutes, and treated anonymous accident victims or soup cans with the same techniques and multiple repetition as the world-famous faces of Marilyn Monroe or China's Chairman Mao.

The process begun by the Romantics of exploring landscape's potential for meaning was bypassed in the late nineteenth century by the French Impressionist painters, whose emphasis was on the immediate and outwardly observable. It was a recognition of Impressionism's limitations, together with disgust at the materialism of the modern world, that prompted other painters to take up metaphysical or spiritual themes in landscape. For Vincent van Gogh (1853–90), the impact of the

Impressionists was qualified by his own appreciation of 'soul' in nature. It was, he wrote to his brother in 1888, from 'a terrible need of – shall I say the word? – religion' that he went out to paint the stars. His *Starry Night*, painted at St Rémy in Provence the next year, has an ecstatically swirling sky pierced by a church spire and the dark silhouette of cypress trees – traditional images of the death wish – that suggest associations of death and resurrection, and a mystical approach to the natural world worthy of Friedrich.

While Van Gogh probably did not know Friedrich's work, it was certainly familiar to Symbolist artists working in Germany in the 1890s. Theirs was an art of metaphor, whose images evoke aspects of the human condition, and Friedrich's rehabilitation around the turn of the century went hand in hand with their own investigations of symbolic landscape. There is an unmistakably Friedrichian atmosphere in *The Island of the Dead* (249), painted in 1880 by the Swiss-born Arnold Böcklin (1827–1901) for his patron, Marie Berna, who was in mourning for her husband. Böcklin said it was intended to help 'dream yourself into a world of dark shadows'. While the title was not the painter's own and there is nothing of the specifically Christian promise that the pious Friedrich would certainly have allowed, this mysterious image of an island resting place, shadowed by the dark spires of trees, to which a white-cloaked mourner and coffin are rowed across water, endows landscape with extraordinary powers of suggestion. The development of landscape as the territory of the subconscious, of memory and of dream, was taken further by the Paris-based Surrealist movement. In his *Autumnal Cannibalism* of 1936, in which a couple embrace and consume each other in a parched Catalan landscape, the Spanish Surrealist Salvador Dalí (1904–89) painted 'the pathos of civil war seen as a phenomenon of natural history'. For another Surrealist, Max Ernst (1891–1976), the loneliest and most suggestive of all Friedrich's pictures in its confrontation of man and nature, *The Monk by the Sea* (see 73), came to have a particular meaning. In 1972 he translated Kleist's 1810 essay on

249
Arnold
Böcklin,
*The Island
of the Dead*,
1880.
Oil on
canvas;
111×155 cm,
43³⁄₄×61 in.
Kunst-
museum,
Basel

the picture into French, and made six collages based on the work to accompany its publication. Already, in a work of 1960, Ernst had acknowledged the movement to which his idol belonged in its very title, *The Almost Late Romanticism*. The painter-seer evokes a primordial forest, perhaps even on another planet, lit by a strange disk lying on its side, apparently neither moon nor sun. Whether this represents regression into some purer, ancient state of nature, or entering a future one, is left unclear. But Ernst's image of organic growth and cosmic energy has the feeling of a dream.

Like the Surrealists before them, the American Abstract Expressionists of the postwar period attempted to paint from the subconscious by adopting automatist methods and cultivating a trance-like working state. The technique of 'action painting' used by Jackson Pollock (1912–56) involved pouring paint spontaneously on to the canvas, conveying an explosive energy. His abstract works often evoke metaphors of nature or landscape in such titles as *Full Fathom Five* (1947) and *Autumn Rhythm* (1950), and indeed when asked about the relationship, he apparently replied 'I am nature'.

For the American art historian Robert Rosenblum, an apprehension of the spiritual in the world around us has been among the main legacies of Romanticism. In his controversial 1972 Slade lectures, he took an apparent likeness between the horizontal planes of earth and heaven in Friedrich's *Monk* and of pure colour in a painting of 1956, *Green on Blue*, by the American Mark Rothko (1903–70) as the cue to tracing a 'northern Romantic tradition' in which artists had consistently addressed in landscape and other secular subjects issues once confined to religious painting. This was a challenging analysis, for it interpreted Modernist art in conceptual and philosophical, rather than formal, terms and thus did not place Paris at the centre. While the stark economy of Friedrich's picture was acknowledged, it was seen as more than a formal premonition of later abstract art. Turner's case was different; after having

like Friedrich fallen out of fashion, he was increasingly rediscovered in the wake of the Impressionists – although they themselves discounted the larger part of his work. From the 1890s, late oil sketches and studies that Turner had never intended the public to see were exhumed and exhibited for their apparent similarity to Impressionist spontaneity. The exhibition *Imagination and Reality*, at the Museum of Modern Art in New York in 1966, presented him as a proto-Modernist, with some of his works even framed accordingly. In 2000 an exhibition at Tate Liverpool hung his work unframed, like pieces of contemporary art fresh from the easel. Among contemporary artists themselves, it is perhaps the American painter Cy Twombly (b.1929), with his devotion to Italy and the past, his sense of myth and the passing of time, who has come closest to Turner's fusion of memory and visual experience.

Twombly's echoes of Turner are entirely conscious, evidence of a rediscovery and reassessment of the Romantics that still continues. Today it is part of a wider reconsideration of the past associated with post-modernism. More broadly, these processes derive from the revivalism and historicism pioneered by the Romantics themselves – for they too had looked back for ways forward in their art. In Italy, the influence of the Nazarenes and of Wackenroder and the Schlegels combined with early Italian painters to inspire the *Purismo* movement, led by Tommaso Minardi (1787–1871) from the early 1830s, in its quest for a suitably Catholic art and for 'subjects dear to the human heart'. Romantic historicism took on a patriotic flavour in the fervent atmosphere of the Italian unification movement, the *Risorgimento*. For the Pre-Raphaelite Brotherhood, formed in London in 1848, stylistic archaism was affected primarily as a means of attaining their main aim of truth to nature and largely lacked a spiritual or nationalist dimension. Although the dreamy evocations of medieval or Arthurian legend by Dante Gabriel Rossetti (1828–82) won him an accolade from Ruskin, as late as 1888, as the leader 'of the Romantic School in England' because he looked at the world 'as a singer of

Romaunts would have regarded it in the Middle Ages', his fellow Brothers often professed an earnest topicality in modern moral subjects that would have struck the Nazarenes as meretricious. More recently, as we have seen, the Nazis' adoption of the Romantics gave revivalism a bad name. But at the same time in Britain, artists including the young Graham Sutherland (1903–80) and John Piper (1903–92) adopted their own benign form of Neo-Romanticism. They turned to the example of Blake, Palmer and the 'Ancients' to create an English Arcadia, remote from war-torn Europe, much as the Romantics themselves had looked to the Gothic and medieval.

Like their vision of landscape, the Romantics' yearning for the primitive has been compelling. The exotic, the Oriental and the 'great elsewhere' sustained their appeal throughout the nineteenth century and beyond. In 1891, Paul Gauguin (1848–1903) left France and went to the island of Tahiti where he painted the local inhabitants. In 1895 he wrote to the Swedish playwright August Strindberg of 'Civilization that makes you suffer' and 'Barbarism which is to me rejuvenation'. For the subsequent development of the modern movement, the quest for lost innocence and (often sexual) freedom, and the desire to reconnect with primeval instincts, have been immensely important, drawing artists to return to nature, or to try as the Romantics had done to access natural instincts and feelings in the subconscious, in the child or the animal. To this 'primitivist' mentality has been added conscious stylistic primitivism, based on borrowings from tribal and non-European art. Henri Matisse (1869–1954) and his colleagues the Fauves began collecting African and Oceanic masks in 1906, the year of Gauguin's posthumous retrospective in Paris. For the German painters of the short-lived group Die Brücke (The Bridge), bathing naked with their lovers and models in the lake at Moritzburg near their homes in Dresden was a personal purification best expressed, as by Ernst Ludwig Kirchner (1880–1938), through deliberate awkwardness and vivid colour (250) based on painted carvings in the city's

**250
Ernst
Ludwig
Kirchner**,
*Bathers at
Moritzburg*,
1909–26.
Oil on
canvas;
151·1×
199·7cm,
59½×78⅝in.
Tate,
London

ethnographic museums. Kirchner and his friends decorated
their homes and studios in a similarly primitive style. Among
their contemporaries of the Blaue Reiter (Blue Rider) group,
based in Munich, Franz Marc (1880–1916) found liberation
through empathy with the consciousness of the animal world.
His apprehensions embraced both a pastoral Eden and the
violence of apocalyptic rebirth. Marc's associate Wassily
Kandinsky (1866–1944) expressed the modern artist's 'spiritual
relationship' with the primitive. Its formal consequences would
be immense. Kandinsky's search for purification and devotion
to the 'inner necessity' (rather than external stimulus) of
creativity was a driving force in his development of abstraction,
while Picasso's experimentation and engagement with tribal art
was one source of the fragmentary structures of Cubism.

For these artists, the lure of the primitive was also the lure
of the unknown, and it pointed forwards to the discovery of
a new artistic future as much as it looked back to the past.
Subconscious experience has offered a similar promise of
escape from the material world, and a return to a forgotten
natural state from which new insights and visions might spring.
Today, the relationship between these concerns, established
first by the Romantics, is well understood by the American
artist Susan Hiller (b.1940), a trained anthropologist, writer on
artistic primitivism, and, as artist and curator, a dispassionate
witness of the unconscious mind – in dreams, hallucination,
hypnosis, or altered by alcohol or drugs. Critical of the
Surrealists for their Freudian translation of dreams into
patterns of word and image, she prefers to confront and
record things beyond explanation, as in her installation in
2000 consisting of a suspended forest of speakers emitting
a multitude of individual reports of encounters with alien
visitors. One is reminded of the collecting of folkloric stories
by Brentano, von Arnim or the brothers Grimm, of Hoffmann's
fantasies, and of the early, literal definition of the Romantic –
as in a story – and its releasing effect on the imagination.

251
Mariele
Neudecker,
*I Don't
Know How
I Resisted the
Urge to Run*,
1998.
Glass, water,
food dye,
acrylic
medium,
salt, fibre
glass, plastic;
75×70×
180 cm,
29$\frac{1}{2}$×27$\frac{1}{2}$×
70$\frac{7}{8}$in.
Collection
Bernarda
and
Johannes
Becker,
Cologne

Hiller and her younger contemporaries have often used glass cases to present found or made objects in a new and challeng- ing light. As Novalis said of his own 'Romanticizing', they make the familiar strange and the strange familiar. For Damien Hirst (b.1965), the glass vitrine and the *real* – if dead or preserved – rather than the picture frame and the traditional media of art, have provided the means for assaults on the great themes. His dead animals in formaldehyde confront us with the ultimate truth of death and beg their own questions of what lies beyond. In the early twenty-first century Hirst has the status of a star, and among his latest works is a glass case containing a simulacrum of his studio, set up for the production of his self-portrait, from which both he and the painted face are absent – an absence that serves only to focus the imagination even more on the artist and the nature of art. Vitrines, again, are used by Jake (b.1966) and Dinos (b.1962) Chapman for their installation *Hell* (2000), an epic conflict between hundreds of model figures of Nazi soldiers and Auschwitz inmates, re- calling the horror and hysteria of Goya's *Disasters of War*, which the brothers have also realized in sculptural and graphic form.

Finally, the landscape constructions of Mariele Neudecker (b.1965) are similarly contained in glass cases, placed just below eyelevel (251). These knowingly recreate landscapes by Friedrich – a cross on a peak; a Gothic window against light; a dense, misty forest of dead trees; mountainscapes stretching, it seems, for ever. Does containment to a vitrine relegate these latest echoes of Romantic art to the museum? Surely not. Rather like the picture frame, the glass vitrine suspends our disbelief and sets our imagination free. And the works themselves are more than referential, for the great concerns of Romantic artists are still ours today – the artist's vocation, stories and dreams, the past and its art, nature and life, its sufferings and its end.

Glossary

Antique Term applied retrospectively to the surviving works and styles of ancient Greece and Rome, especially sculpture.

Enlightenment A philosophical movement which began in the late seventeenth century and became dominant in Europe by the mid-eighteenth, led by British, French and German thinkers. It was a major influence on the French Revolution. Based on rationalism and empiricism, it aimed to advance human progress. Its period is sometimes known as the Age of Reason. Romanticism was in some respects a reaction against it, but was also empowered by its belief in human freedom and equality and its challenge to traditional dogma.

Etching A form of printmaking in which prints are pulled from copper plates bitten with acid.

Gothic A style in European architecture prevalent from the twelfth to sixteenth centuries, characterized by the pointed arch. Its finest expression was in church architecture. From the second half of the eighteenth century the style was revived for its associations with Christian faith, feudalism and chivalry, first in England where it gave rise to the Gothic Revival, and then in Germany, France and elsewhere. At the same time, its origins within Europe were disputed. The term also became applied to novels of exaggerated horror or mystery, often set against a 'medieval' background.

History Painting The depiction of scenes from the Bible, literature, classical myth or history itself, as well as contemporary reportage. When suitably inspiring or educational, this was regarded by academic theory as the highest form of art.

Lithography A form of printmaking in which a stone is treated so that the areas to be printed can be inked but the surrounding surface repels it.

Neoclassicism The dominant architectural, artistic, decorative and literary style during the Romantic period, prevalent in Europe and as far afield as America and Australia. At its peak from the mid-eighteenth century to *c.*1830, it emulated the civilization of ancient Greece and Rome from which it drew canonical standards of form and taste. It was against these that the Romantics reacted.

Philhellenism Term used for the sympathy and support, practical and moral, given by other Europeans to the Greeks in their War of Independence (1821–8) against the Ottoman Empire.

Primitive During the nineteenth century this took on various meanings, generally associated with nostalgia for an earlier or purer state. The '*Primitifs*' in **David**'s studio hankered for the art and lifestyle of archaic Greece. In the early decades of the century the term was applied to pre-Renaissance art in Italy or the Low Countries. Later it was transferred to the experience and art of peoples in Oceania, Africa and the Americas, and later still to that of children or the insane. Continuing into the twentieth century, 'Primitivism' emerged as the conscious imitation of their art in search of rejuvenation and self-expression.

Sturm und Drang (Storm and Stress) Title given to a group of young male German writers including **Goethe** and Schiller, who in the 1770s and 1780s rebelled against classical literary forms and **Enlightenment** rationalism. They explored the subjective and irrational in diverse, highly expressive styles and were fundamental to the development of Romanticism.

Sublime In the Romantic period this was understood both as an aesthetic and as an experience, which could be had from nature or art that aspired to the most exalted kind. Defined as the antithesis of the Beautiful, it engendered fear and awe by a sense of scale or infinity.

Troubadour Troubadours were lyric poets of the twelfth and thirteenth centuries whose verses, written in Provençal on themes of courtly love and chivalry, became famous in continental Europe. In the first decades of the nineteenth century, the term was applied to French painters who took up similar subjects from the Middle Ages and a correspondingly archaic style. Troubadour pictures are small in scale and depict intimate, emotional moments in the lives of their historical characters.

Brief Biographies

Achim von Arnim (1781–1831) German writer and patriot. Co-author with **Brentano** of the folk-song collection *Des Knaben Wunderhorn* (1806–8). His afterword to the first volume, *On Folk Songs*, took up the idea of the poetic creativity of the German people (the 'Volk') first propounded by **Herder**.

Charles Baudelaire (1821–67) French poet and critic whose Salon reviews, published from 1845, defined the taste of his age. Though too young to have experienced Romanticism at full flow, his Salon review of 1846 gave it a valedictory but enduring definition that embraced its variety, aspiration to the 'Infinite' and essential modernity. He proclaimed **Delacroix** the supreme Romantic artist.

William Blake (1757–1827) British artist, poet and illustrator. Frustrated in his ambition to be a history painter, he turned to publishing his own illustrated 'Prophetic Books' which expressed his personal mythology and radical political, social and religious ideas. They typify the Romantic rejection of **Enlightenment** Reason and the constraints of conventional Christian faith. In his last years he attracted a devoted group of younger admirers including **Samuel Palmer**.

Clemens Brentano (1778–1842) German writer and patriot. He collaborated with **Achim von Arnim** on the folk-song collection *Des Knaben Wunderhorn* (1806–8). He was increasingly dominated by his Catholic faith. His children's tale *Gockel, Hinkel and Gackeleia* (1838) was a masterly return to his early folk inspiration.

George Gordon, Lord Byron (1788–1824) The most famous British poet of his generation, his unconventional personal life, debts and disdain for his literary rivals and critics combined to ensure that he spent most of his life abroad. His first travels in Europe and the Near East were described in his poem *Childe Harold's Pilgrimage* (1812–18), whose autobiographical 'Byronic hero', aloof and disaffected, helped define a Romantic type. His works were an inspiration to painters, notably **Delacroix**. His death at Missolonghi, having gone to fight for Greek independence, made him a martyr of the movement.

François-René, Vicomte de Chateaubriand (1768–1848) French writer and diplomat. In 1791 he fled to America to escape the Revolution and after returning briefly to France to fight with the Royalists, lived in exile in Britain, 1793–1800, where he wrote his semi-autobiographical novel *René* – a self-portrait of Romantic alienation – and *Essai sur les révolutions* (1797). *Atala* (1801) evoked a distant and exotic culture, *Génie du Christianisme* (1802) the beauties of Roman Catholic ritual. Under the Restoration he was ambassador to London from 1822.

Thomas Cole (1801–48) British-born American landscape painter who founded the Hudson River School of landscapists. His paintings of the American wilderness were imbued with the moral and religious overtones of **history painting** and the influence of the Old Masters and European contemporaries – especially **J M W Turner** – he studied on trips back to Europe in 1829–32 and 1841–2.

Samuel Taylor Coleridge (1772–1834) British poet, critic and philosopher. With his friend **Wordsworth** he wrote *Lyrical Ballads* (1798), which revolutionized literary taste through use of familiar language and a celebration of everyday experience. While these arguably began the Romantic movement in Britain, his own main contribution to it lay in his investigations of the supernatural, the subconscious and the exotic, as in *The Ancient Mariner* and *Kubla Khan* (1797–8). His *Biographia Literaria* (1817) documented the growth of his poetic imagination and reflected his debt to German philosophy, which he helped to introduce to Britain.

John Constable (1776–1837) British landscape painter. From 1802 he created his pictures from real experience of familiar scenery and rural activities – especially in his native Stour Valley – and through sketches and painted studies made outdoors before the motif. This naturalistic impulse was increasingly modified in the 'six footer' canvases he exhibited in his later years, and by an increasingly experimental handling of paint. His *Hay Wain* made an immense impression on **Delacroix** and other French painters when shown in the Paris Salon of 1824.

Jacques-Louis David (1748–1825)
French history painter whose central
position in the development of
Neoclassicism was established by
The Oath of the Horatii (1784).
However David also embodied
Romantic characteristics such as anti-
academicism which, while influenced
by revolutionary politics, was also
aesthetically principled. His polemical
zeal and appeal to emotion in works
of political propaganda also broke
Neoclassical conventions of restraint.
While Napoleon's official painter, he
trained many artists of the Romantic
generation. With the fall of the empire
he went into exile in Brussels.

Eugène Delacroix (1798–1863) French
painter who, after studying with
Guérin, took the lead among the
Romantic generation with a succession
of pictures from *The Barque of Dante*
(1822) to *The 28th July 1830: Liberty
Leading the People* (1830). A dynamic
innovator, he was also strongly affected
by the Old Masters and was equivocal
in his own attitude to Romanticism.
For **Baudelaire**, he epitomized it. A
champion of **philhellenism**, his visit
to Morocco in 1832 further developed
his interest in exotic subject matter.
His range extended from literary,
historical and religious themes to
animal and landscape subjects and
large-scale decorations for the Senate
and the Palais Bourbon.

Paul Delaroche (1797–1856) French
painter. A student of **Gros**, he
emerged as a more restrained
counterpart to **Delacroix** in the
field of **history painting**. His pictures,
often taken from British history,
were marked by a sense of theatre,
exactness of detail and costume and
a more finished technique. They
often took a revisionist view of
history through their focus on
individual experience and emotion.

Dominique-Vivant Denon (1747–1825)
French painter, printmaker, illustrator
and author. A diplomat under the
ancien régime, he served Napoleon as
supervisor of the scholars sent with
his Egyptian campaign, and afterwards
as director of the Musée Napoléon
(Louvre). As organizer of the Salon
exhibitions under the empire he
had great powers of patronage and
largely dictated the programmes of the
pictures of the Napoleonic campaigns
painted by **Gros** and others. His taste
was eclectic and he also encouraged
young artists including those
associated with the **Troubadour** style.

Johann Gottlieb Fichte (1762–1814)
German philosopher and patriot. A
pupil of Immanuel Kant, he argued
that the ego is the sovereign reality,
defining itself by what it is not in the
surrounding world or 'non-ego'. Later
however, he sought reality in an idea
of the divine. His *Addresses to the
German Nation* delivered in French-
occupied Berlin in 1807–8 gave his
ideas a patriotic and nationalist slant,
rallying his countrymen against
Napoleon with a plea to rediscover
their distinctive Germanness.

Caspar David Friedrich (1774–1840)
German painter who was, with **J M W
Turner** and **Constable**, the greatest of
the Romantic landscapists. For most
of his life he was based in Dresden,
where his *Cross in the Mountains* (1808)
introduced the symbolic approach to
landscape that reflected his Lutheran
faith and – during the Napoleonic
occupation – his patriotic nationalism.
His later works move towards a greater
naturalism.

Henry Fuseli (1741–1825) Swiss painter
and writer. He was closely associated
with writers of the **Sturm und Drang**
group before moving to London in
1765. He worked prolifically as a
painter of historical, literary and
fantastic subjects, and as a book
illustrator. His work showed a
preoccupation with psychological
and sexual drama. In 1799 he
became professor of painting at the
Royal Academy.

Théophile Gautier (1811–72) French
poet, novelist and critic. He
championed Romantic artists and
ideas, proclaiming total creative
freedom. An admirer of **E T A
Hoffmann**, his own writings embraced
fantastic, historical and exotic themes.

Theodore Géricault (1791–1824)
French painter and printmaker whose
inscrutable character, dandified habits,
love of horsemanship and tragically
early death have often cast him as the
quintessential Romantic. After studies
with Carle Vernet and **Guérin**, he
spent a year in Italy, 1816–17. His
ambitions as a history painter were
frustrated by a lack of grand national
themes after the fall of Napoleon, and
he turned to a more subversive analysis
of contemporary events, as in *The
Raft of the Medusa* (1819). He was a
formative influence on **Delacroix**.

Anne-Louis Girodet de Roucy-Trioson
(1767–1824) French painter. A pupil
of **David**, he soon aroused his criticism
with pictures such as *Ossian Receiving
the Ghosts of French Heroes* (1802).
While his most famous picture
was *The Entombment of Atala* (1808),
illustrating **Chateaubriand**'s story,
he painted important scenes of
Napoleon's campaigns.

Johann Wolfgang von Goethe
(1749–1832) German writer, scientist
and amateur artist. One of the literary
giants of his period, he was often
associated with 'Weimar classicism' –

supposedly the dominant aesthetic of the small court where he served as a privy councillor and a magnet to cultural pilgrims from all over Europe. However, in his novel *The Sorrows of Young Werther* (1774) or his drama *Faust* (1808, 1832), in his interest in the feudal society and architecture, if not the Catholic religion, of the Middle Ages, and in his insights into the emotional values of colour, he anticipated many Romantic ideas.

Francisco de Goya y Lucientes (1746–1828) Spanish painter and printmaker. After studying in Rome, 1767–71, he made his name in Madrid as a court painter of portraits and history, and a tapestry designer. He served Charles III and Charles IV and became president of the Madrid Academy. He was closely involved in the brief flowering of the Spanish Enlightenment but disillusioned by its failure and the nation's capitulation to Napoleon. Bouts of ill-health leading to deafness and mental stress isolated him further. His series of etchings, *Los Caprichos, Disasters of War* and *Disparates* and his paintings *Second of May 1808* and *Third of May 1808* castigated contemporary ills. A further illness confined him to his house where he painted his hallucinatory 'black paintings' on the walls. In 1823 he left Spain, finally settling in Bordeaux.

Antoine-Jean Gros (1771–1835) French painter. The most brilliant of **David**'s pupils, his enormous pictures of Napoleonic battles formed a bridge between his master and the Romantics. His pictures of the Egyptian campaign showed his empathy with the sufferings of his subjects, and introduced the emotive Orientalism taken up by **Delacroix** and others. When David went into exile, he took over his studio – a privilege that proved a burden as he struggled to reconcile his duties to his master's classical heritage with his own sensibilities. He drowned himself.

Pierre-Narcisse Guérin (1774–1833) French painter. As a history painter he belonged mainly to **Neoclassicism**, but his propensity for themes of intense violence and drama, or of sensual or erotic power, led him away from its essential restraint. **Baudelaire** noted his instinct for melodrama, which he passed on to his pupils who included **Géricault** and **Delacroix**.

Benjamin Robert Haydon (1786–1846) British painter, teacher and writer. His intransigent personality, quarrels with patrons and the Royal Academy, and dedication to large-scale **history painting** against the current of national taste left him marginalized and penurious. He was imprisoned for debt, and committed suicide. His

diaries and autobiography are quintessentially Romantic accounts of the inspiration and sufferings of the artist.

Georg Wilhelm Friedrich Hegel (1770–1831) German philosopher. He attempted to reconcile the dualities introduced by Immanuel Kant, arguing that separate things gain value as parts of the greater whole. His *Philosophy of History* saw history as the realization of ideas, essentially of freedom, and that the individual is their instrument. His ideas both reflected and influenced German nationalism in the Romantic period, and were later an early influence on Marx and Engels.

Heinrich Heine (1797–1856) German poet and critic. He opposed the repressive conservatism of the 1830s, when his works were banned in Prussia, and spent thirteen years in exile in Paris where he was a sometimes critical observer of Romanticism. His *The Romantic School* (1836) surveyed the movement at its height but, as a cosmopolitan Jew, he was disconcerted by the nationalist historicism and nostalgia for the Gothic cathedral that he encountered back in Germany.

Johann Gottfried Herder (1744–1803) German writer and philosopher. A humanist, he was impressed by French Revolutionary ideals but rejected violence. Instead he proposed national regeneration through intellectual effort and the revival of German language and folk literature.

Ernst Theodor Amadeus Hoffmann (1776–1822) German writer, critic, lawyer and artist. A polymath, he served as Kapellmeister (master of the court choir) at Bamberg before becoming a liberal judge in Berlin. His books ranged from fashionable novellas to works of bizarre fantasy and psychological penetration, exploring the complexities of the Romantic self. The unconscious, the double and the creative autobiography are recurrent themes. He was a masterly music critic.

Victor Hugo (1802–85) French poet, novelist, dramatist and artist. He was a passionate exponent of Romanticism, whose literary freedoms he defended in the preface to his play *Cromwell* (1827) and exemplified in his later *Hernani*, the performance of the latter in 1830 bringing riotous confrontations between 'classicists' and Romantics in which Hugo's supporters were judged the victors. His drawings show his fantastic imagination.

Jean-Auguste-Dominique Ingres (1780–1867) French painter of history and portraits. A student of **David** he was widely upheld as a Neoclassical counterpart to **Delacroix** and the

Romantics, but he absorbed strong Romantic influences, including Orientalism and medieval historicism, and reacted against classical ideals of beauty. His career prospered under Charles X. He directed the French Academy in Rome. In 1829 became a professor at the École des Beaux-Arts in Paris and its president in 1833.

Heinrich von Kleist (1777–1811) German poet and writer. From an old Prussian military family and bred to a soldier's code of duty, he took up the poetic vocation with equal commitment. Having settled in Dresden he was also closely associated with **Brentano** and **Von Arnim** in Berlin. He collaborated in their 1810 review of **Friedrich**'s *Monk by the Sea*. His attitude to emergent Romanticism was ambivalent though he rejected **Enlightenment** rationalism. He died in a joint suicide with his platonic lover Henriette Vogel.

Alfred de Musset (1810–57) French poet, dramatist and journalist. His *Confession d'un enfant du siècle* (1836) crystallized the Romantic *mal du siècle* and his *Lettres de Dupuy et Cotonet* (same year) dissected the movement through satirical debate between two puzzled observers.

Novalis (pseudonym of Friedrich von Hardenberg) (1772–1801) German poet and philosopher. He adopted his friend **Friedrich Schlegel**'s view of the sovereignty of the poetic inspiration and creative life. His novel *Heinrich von Ofterdingen* (1800) cast the artistic quest as a search for a vision of perfect love. In other writings he foresaw a post-Revolution revival of faith and of Roman Catholicism and introduced the Romantic death wish. He died of tuberculosis.

Johann Friedrich Overbeck (1789–1869) German painter. While studying at the Vienna Academy he joined Franz Pforr and others in forming the Lukasbund in opposition to its teaching and in pursuit of an alternative ideal of spirituality and stylistic archaism. He subsequently moved to Rome with Pforr, converting to Catholicism in 1813. With Peter von Cornelius he joined the Nazarenes.

Samuel Palmer (1805–81) British painter and printmaker. Influenced by **Blake** and a nostalgia for the past, he joined a self-styled group of 'Ancients'and withdrew to Shoreham in Kent, where he cultivated a visionary and archaic view of landscape. His 'Shoreham period' lasted *c.*1824–35. Following two years in Italy, 1837–9, he developed a more commercially accessible style.

Jean Paul (pseudonym of Johann Paul Richter) (1763–1825) German writer.

He changed his name in 1793, out of admiration for **Rousseau**. A very popular novelist, his stories both express and attempt to reconcile divisions between the spiritual and material, and contradictory aspects of character, which mirror those between Romantic and classical ideas. His themes are death and immortality, dualism and the complexities of the self, and under his pseudonym he often appears as a reflective participant in his own narratives.

Auguste Préault (1809–79) French sculptor who was widely held to have 'Romanticized' a medium generally considered the preserve of classicism by exchanging formal restraint for a freer, more plastic modelling, and by adopting subjects of mysterious or frightening psychological implications, as in his relief *Tuerie* (1834). He trained with the republican sculptor David d'Angers (1788–1856).

Fleury (Fleur-François) Richard (1777–1852) French painter. A pupil of **David**, he rejected his style and subjects to initiate the **Troubadour** style with small pictures of chivalric or sentimental medieval scenes. The Empress Josephine collected his work for Malmaison and named him Painter to Her Majesty in 1808.

Jean-Jacques Rousseau (1712–78) French-Swiss philosopher and novelist whose ideas contributed to the French Revolution, the American Declaration of Independence and the development of Romanticism. His beliefs in the original purity of human nature, as expressed in the 'noble savage', in the interdependence of people and leaders as set out in his *Social Contract* (1762), and in the inspiration of nature were hugely influential. During the Revolution he was reburied in the Panthéon.

Philipp Otto Runge (1777–1810) German painter, writer and theorist. He studied at the Academy in Copenhagen, where he first met **Friedrich**, and then at Dresden, where he encountered progressive thinkers and writers including **Tieck**. From 1802 he was in contact with **Friedrich Schlegel**. He attempted to combine hs interests in symbolic landscape, nature mysticism and colour theory in his designs for a series of compositions of the *Times of Day*, but he also painted portraits and wrote fairy tales reflecting the current revival of German folk literature. He died of tuberculosis.

Karl Friedrich Schinkel (1781–1841) German architect and painter. Trained and based in Berlin, where he was a member and later a professor of the Academy, he visited Italy, 1803–5, and

travelled widely on the continent. His architectural career was cut off by the French occupation, and he took up painting. His landscapes and architectural subjects reflected the influence of **Friedrich** and medieval revivalism as well as the fundamentally classical taste that reasserted itself when he resumed his architectural practice after the expulsion of the French. His major buildings, mainly in Berlin, date from after 1815.

Friedrich Schlegel (1772–1829) German poet, critic and aesthetic theorist who, with his brother August Wilhelm (1776–1845), pioneered German Romanticism. In Jena, he published the journal *Athenaeum* in which, in 1798, he defined Romantic poetry – understood as a composite genre also embracing drama and the novel – as 'progressive' and 'universal', marked by sensibility rather than form. He saw artistic creation as a utopian aim to reclaim a lost perfection, but recognized that this was unattainable; his additional concept of irony acknowledged the critical distance felt by the creator from his inevitably imperfect productions. He later moved to Berlin. August Wilhelm gave lectures there, 1801–4, and in Vienna, 1808, that expressed the Romantic view of creative autonomy and set it in a historical context.

Germaine de Staël (1766–1817) French-Swiss novelist and critic. The daughter of the banker Jacques Necker, financial adviser to Louis XVI, she moved with him to Paris where she began a literary and social career. In 1803 she travelled to Germany, where she met A W Schlegel. Her book *De l'Allemagne* ,a sympathetic account of Romantic trends there, was finished in 1810 but banned by the Napoleonic authorities – who had already excluded the author herself from Paris – and was published in London in 1813. With her earlier essay *De la littérature* (1800), it consecrated the 'religion' of poetry and captured the lyrical, nostalgic and spiritual aspects of Romanticism as well as its claim to modernity. Also a romantic novelist, her *Corinne* (1807) served as an inspiration to painters. Her salon at Coppet, on Lake Geneva, was visited by many Romantics.

Stendhal (pseudonym of Henri Beyle) (1783–1842) French writer. He served with Napoleon's army in Italy in 1800, and later in Germany and Russia, before taking up consular posts in Italy. His essay *Racine et Shakespeare* (1823, 1825) adopted the Romantic position in current critical controversies, while other works explored romantic love. He wrote widely on art, artists and music.

Ludwig Tieck (1773–1853) German writer. Introduced to Romantic circles in Berlin by **Friedrich Schlegel**, he became a close friend of **Wackenroder**, collaborating with him, and editing *Heartfelt Outpourings of an Art loving Friar* (1797) and *Frans Sternbald's Excursion* (1798) – tales of artistic education and medieval nostalgia. He edited the posthumous works of his friend **Novalis** (1802). His writings were an inspiration to artists, and **Runge** hoped to accompany his *Times of Day* with passages written by him.

Joseph Mallord William Turner (1775–1851) British painter and printmaker. At the heart of his immensely varied output – ranging from topographical watercolour to **history painting**, marines and scenes of modern industrial achievements – lay a commitment to a landscape art regenerated by awareness of the flux and energy of the natural world and of phenomena of atmosphere and light. Together with his restless search for new subjects, which led him on extensive travels in Britain and, after the Napoleonic Wars, in Europe, this made him essentially a Romantic. But he also incorporated many Neoclassical and other established tendencies into his work, which began in conscious imitation of the Old Masters before finding its own individual voice.

Horace Vernet (1789–1863) French painter from a family of artists who included Carle (1758–1836), the sometime teacher of **Géricault**. His commitment to Napoleon at first isolated him under the Restoration and his Paris studio became a focus of Napoleonic nostalgia. However, he managed to ingratiate himself with Charles X while also becoming close to the circle of the future Louis-Philippe for whom he painted battle scenes for his galleries of French history at Versailles, and ended his career as official painter to Napoleon III.

Wilhelm Heinrich Wackenroder (1773–98) German writer and poet based in Berlin. He was the principal contributor, with his friend **Tieck**, to *Heartfelt Outpourings of an Art-loving Friar* and *Frans Sternbald's Excursion*.

William Wordsworth (1770–1850) British poet who, with **Coleridge**, inaugurated the British Romantic movement in literature by his celebration of nature and of familiar language and experience. Born in the Lake District, he drew constant inspiration from its scenery, settling at Grasmere in 1799, a year after publishing *Lyrial Ballads* with Coleridge. His *Prelude* (1805) was a Romantic creative autobiography.

Romanticism	A Context of Events
1770 Chatterton commits suicide. West paints *Death of General Wolfe* [39]	**1770** Cook lands at Botany Bay and claims east coast of Australia for Britain
1774 Goethe, *Sorrows of Young Werther* and *Götz von Berlichingen*	**1774** Louis XVI crowned King of France
1776 Reynolds paints *Omai* [155]. Hodges paints *Tahiti Revisited* [156]	**1776** American Declaration of Independence
	1779 Death of Cook in Hawaii
1781 Fuseli paints *The Nightmare* [189]. Kant, *Critique of Pure Reason*	**1781** Cornwallis surrenders to George Washington at Yorktown
1784 David paints *Oath of the Horatii* [37]. Kant, *What is Enlightenment?*	**1784** Beaumarchais's play *The Marriage of Figaro*
1785 Wright of Derby paints *Widow of an Indian Chief* [158]	**1785** Marie-Antoinette under attack. First Channel crossing by balloon
1786 Beckford, *Vathek*	**1786** Mozart, *The Marriage of Figaro*
1787 Heinse, *Ardinghello*. Boydell opens Shakespeare Gallery in London	**1787** American constitution signed. Mozart, *Don Giovanni*. Sierra Leone settled by freed slaves
1788 Bernardin de Saint-Pierre, *Paul et Virginie*	**1788** La Pérouse wrecked in the Pacific
1789 Goethe's play *Torquato Tasso*. Blake, *Songs of Innocence*. West completes paintings for the Audience Chamber at Windsor Castle	**1789** French Revolution begins with storming of the Bastille. Washington elected first president of the United States
	1790 Burke, *Reflections on the Revolution in France*
1791 Koch flees Stuttgart Academy. Chateaubriand in America	**1791** Paine, *Rights of Man* (part 1). Louis XVI accepts new constitution
1792 Death of Reynolds	**1792** France declared a republic. Terror begins (to 1794). Wollstonecraft, *Vindication of the Rights of Woman*
1793 David paints *Death of Marat* [40]. Tieck and Wackenroder tour Franconia and Main valley. Goya begins *Los Caprichos* (to 1799)	**1793** Louis XVI and Marie-Antoinette executed. Marat murdered. France declares war on Britain
1794 David paints *Death of Bara* [41]. Blake, *Songs of Experience* and *Book of Urizen*	**1794** Robespierre executed. Whitney invents cotton-gin
1795 Blake produces *Isaac Newton* [191] and *Nebuchadnezzar* [190]. Musée de Monuments Français founded in Paris	**1795** Directory established in France (to 1799). Austrian Netherlands annexed by France
1796 Gros, in Italy, sketches *Napoleon at Arcola* [42]	**1796** French victory over Austrians at Arcola in north Italy.

	Romanticism		A Context of Events
			Napoleon marries Josephine de Beauharnais
1797	Wackenroder, *Heartfelt Outpourings of an Art-loving Friar*	1797	Napoleon occupies Rome
1798	Friedrich Schlegel publishes *Athenaeum* at Jena, and defines 'Romantic' poetry. Wordsworth and Coleridge, *Lyrical Ballads*	1798	Battle of the Pyramids; Napoleon secures Egypt. Battle of the Nile; Nelson defeats French fleet
1799	Novalis, *Christendom or Europe.* Goya issues *Los Caprichos*	1799	Directory ended by Napoleon in a *coup d'état*; he becomes First Consul
1800	Goya begins *The Family of Charles IV* [198]. Novalis, *Heinrich von Ofterdingen* and *Hymns to the Night*	1800	Napoleon crosses Saint Bernard Pass and defeats Austrians at Marengo. Assassination of Kléber in Cairo
1801	David paints *Napoleon Crossing the Great Saint Bernard Pass* [36]. Gros paints *Sappho at Leucate* [220]. Chateaubriand, *Atala*	1801	French surrender in Egypt. Toussaint L'Ouverture conquers Spanish Santo Domingo from neighbouring Haiti and frees black slaves
1802	Girodet paints *Ossian Receiving the Ghosts of French Heroes* [44]. Fleury Richard exhibits *Valentine of Milan* [128] at the Salon. Chateaubriand, *Spirit of Christianity.* Denon appointed curator of Musée Napoléon (Louvre)	1802	Peace of Amiens (to 1803) brings truce between Britain and France and allows cross-Channel travel; many Britons go to Paris to see artistic plunder in the Louvre. Napoleon elected Consul for life
1804	Blake begins *Jerusalem* (to 1820). Gros paints *Napoleon Visiting the Plague-Stricken at Jaffa on 11 March 1799* [165]	1804	Napoleon proclaimed Emperor (First Empire lasts to 1814). Spain declares war on Britain
1805	Wordsworth finishes *The Prelude.* Runge paints *Nightingale's Lesson* [70] and *Hülsenbeck Children* [71]. Beethoven's opera *Fidelio*	1805	Battle of Trafalgar; British navy defeats French and Spanish. Battle of Austerlitz; Napoleon defeats Russia and Austria
1806	Chateaubriand in Palestine. Ingres to Italy (to 1824)	1806	Battle of Jena; Napoleon defeats Prussia and French enter Berlin
1807	De Staël, *Corinne*	1807	Inconclusive Battle of Eylau between France and Russia
1808	Friedrich paints *The Cross in the Mountains* [67]. Guérin paints *Napoleon Pardoning the Rebels at Cairo* [166]. Gros paints *Napoleon on the Battlefield of Eylau* [46].	1808	French invade Spain and install Joseph Bonaparte as king. Madrid revolt against French occupation begins Peninsular War. French occupy Rome. Papal States annexed
1809	Girodet paints *François-René de Chateaubriand* [23]. Lukasbund formed in Vienna. Publication of *Description de l'Égypte* begins (to 1828)	1809	Napoleon captures Vienna, divorces Josephine and is excommunicated by the pope, whom he arrests and imprisons
1810	Turner paints *Fall of an Avalanche in the Grisons* [95]. Pforr completes *Entry of Rudolph von Habsburg into Basle in 1273* [131]. Overbeck paints *Franz Pforr* [132]. Friedrich completes *Abbey in the Oakwood* [135]. Girodet paints *Revolt at Cairo* [167]. Goya begins *Disasters of War* (to 1814)	1810	Napoleon marries Marie-Louise, daughter of Emperor Francis I of Austria. George III, suffering from porphyria, is declared insane
1811	Kleist commits suicide	1811	Prince of Wales made Regent

Romanticism	A Context of Events
1812 Byron, *Childe Harold's Pilgrimage* (to 1818). Géricault paints *Charging Chasseur of the Imperial Guard* [49]. Turner paints *Snow Storm: Hannibal and his Army Crossing the Alps* [51]	**1812** Wellington enters Madrid. United Sates declares war on Britain. Napoleon invades Russia; Russians burn Moscow; French retreat with terrible losses
1813 Ingres paints *Dream of Ossian* [45]. Ward paints *Gordale Scar* [86]. De Staël, *De l'Allemagne* published in London	**1813** Wellington defeats French at Vitoria and crosses into France. War of Liberation in Prussia. Napoleon defeated by allies at Battle of Leipzig
1814 Géricault paints *Wounded Cuirassier Leaving the Field* [50]. Goya paints *Second of May 1808* [56] and *Third of May 1808* [57]. Friedrich paints *Chasseur in the Forest* [76]	**1814** Allied armies enter Paris. Napoleon abdicates and exiled to Elba. British capture Washington, DC. Stephenson builds first steam locomotive
1815 Schinkel paints *Medieval City on a River* [137]. Kersting paints *Wreath-Maker* [53]. Brighton Pavilion reconstruction [164]	**1815** The Hundred Days. Napoleon escapes from Elba and returns to Paris. Battle of Waterloo: Napoleon defeated by the Allies and exiled to St Helena
1816 Cornelius and Nazarenes begin frescos in Rome for Prussian consul [134]	**1816** Postwar economic depression in Britain; riots in London
1817 Turner exhibits *Decline of the Carthaginian Empire* [145]	**1817** Allies withdraw from French territory
1818 Turner paints *Field of Waterloo* [52]. Mary Shelley, *Frankenstein*	**1818** San Martin leads rebellion against Spanish rule in Chile
1819 Géricault paints *Raft of the Medusa* [61]. Hugo, *Odes*	**1819** Peterloo massacre in Manchester: handloom weavers attacked by militia
1820 Turner paints *Rome, from the Vatican* [97]	**1820** George IV succeeds George III
1821 Constable paints *The Hay Wain* [101]. Ingres paints *Entry of the Future Charles V into Paris* [130]	**1821** War of Independence begins in Greece (to 1828). Death of Napoleon on St Helena
1822 Delacroix paints *The Barque of Dante* [32]. Wilkie completes *Chelsea Pensioners Reading the Waterloo Dispatch* [38]	**1822** Turks massacre Greek population on island of Chios
1823 Seroux d'Agincourt, *Histoire de l'art par les Monuments* [118]	
1824 Constable exhibits *The Hay Wain* in Paris. Delacroix paints *Scenes from the Massacres at Chios* [170]. Byron dies at Missolonghi	**1824** Charles X succeeds Louis XVIII as King of France
1825 David dies in Brussels. Hazlitt, *Spirit of the Age*	**1825** Stockton to Darlington Railway, the first steam railway, opens
1826 Delacroix's *Greece on the Ruins of Missolonghi* [173] exhibited in Paris. Cole paints *Falls of the Kaaterskill* [114]	
1827 Ingres paints *Apotheosis of Homer* [33]. Delacroix paints *Death of Sardanapalus* [2] and *Christ in the Garden of Gethsemane* [242]. Deaths of Beethoven and Blake	**1827** Battle of Navarino: French, British and Russian fleets defeat Ottoman Turkish navy, heralding Greek independence
1828 Turner, in Rome, exhibits *Regulus* [92]	
1829 Grandville, *Today's Metamorphoses* F R de Toreinx, *Histoire du Romantisme en France*	**1829** Catholic emancipation granted in Britain

Romanticism	A Context of Events
1830 Delacroix paints *The 28th July 1830: Liberty Leading the People* [64]. Uproar in Paris over Hugo's play *Hernani*	**1830** July Revolution in Paris; Charles X abdicates in favour of Louis-Philippe. William IV succeeds George IV
1831 Delaroche paints *Princes in the Tower* [148]. Barye sculpts *Tiger Devouring a Gavial Crocodile of the Ganges* [209]	**1831** Darwin's first voyage in the *Beagle* (to 1836). Brunel designs Clifton suspension bridge
1832 Delacroix visits Morocco	**1832** Reform Act extends franchise
1833 Bryullov paints *Last Day of Pompeii* [146]. Catlin paints *The Last Race, Mandan O-Kee-Pa Ceremony* [182]	**1833** Slavery abolished in British colonies
1834 Marilhat exhibits Egyptian views in Paris. Delacroix paints *Women of Algiers in their Apartment* [175]. Préault sculpts *Tuerie* [210]	**1834** Houses of Parliament destroyed by fire. Tolpuddle Martyrs deported for trade union activities (pardoned 1836)
1835 Scheffer paints *Paolo and Francesca* [245]. Vigny's play *Chatterton*. Gros commits suicide	**1835** Press censorship tightened in France
1836 Cole finishes *Course of Empire* [147]. Pugin, *Contrasts* [142]	**1836** Siege of the Alamo; Republic of Texas established
	1837 Victoria succeeds William IV
1839 Delacroix paints *Tasso in the Madhouse* [20]	**1839** Chartist riots in Britain. Opium War begins in China (to 1842)
1840 Delacroix paints *The Taking of Constantinople by the Crusaders* [177]. Death of Friedrich	**1840** Queen Victoria marries Albert of Saxe-Coburg-Gotha. Napoleon's ashes are returned to Paris
1842 Turner paints *Snow Storm – Steam-Boat off a Harbour's Mouth* [5], *Peace – Burial at Sea* [34] and *War, the Exile and the Rock Limpet* [35]. Haydon paints *Wordsworth on Helvellyn* [10]	
1843 Ruskin, first volume of *Modern Painters*	**1843** Paris to Rouen railway opened
1844 Turner paints *Rain, Steam and Speed* [100]. Grandville, *Un Autre Monde* [213]	**1844** War between France and Morocco
1845 Delacroix paints *The Sultan of Morocco and his Entourage* [174]. Baudelaire's first Salon review	
1846 Death of Haydon. Turner exhibits *Undine* [215] and *Angel Standing in the Sun* [217]	**1846** Potato famine in Ireland
1847 Rude's sculpture, *Napoleon Waking to Immortality*	
1848 Delaroche paints *Bonaparte Crossing the Alps* [66]. The Pre-Raphaelite Brotherhood founded in London. Death of Chateaubriand	**1848** Marx and Engels, *Communist Manifesto*. Louis-Philippe abdicates; Louis-Napoleon elected president of France. Revolutionary outbreaks across Europe
1849 Durand paints *Kindred Spirits* [113]	**1849** Thoreau, *Civil Disobedience*
1850 Delacroix paints *Michelangelo in his Studio* [28]. Death of Wordsworth	

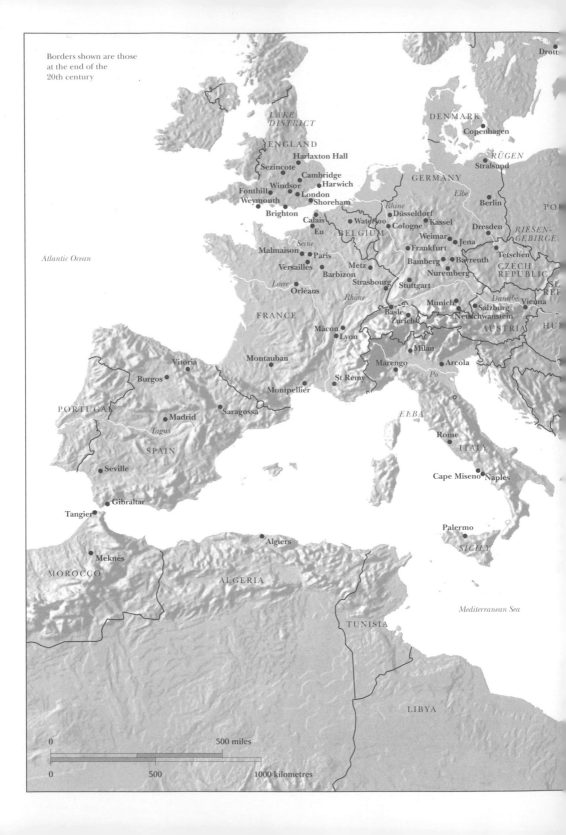

Borders shown are those
at the end of the
20th century

LAKE
DISTRICT

ENGLAND

Harlaxton Hall

Sezincote

Cambridge
Windsor Harwich
Fonthill
Weymouth London
 Shoreham
Brighton

Calais
Eu Waterloo
BELGIUM
Seine
Malmaison Paris
Versailles
Barbizon Metz
Orléans

Atlantic Ocean

Mâcon
Lyon

Vitoria
Montauban
Burgos

St Rémy

Montpellier

PORTUGAL
Madrid
Saragossa

Tagus

SPAIN

Seville

Gibraltar

Tangier

Meknès

MOROCCO

ALGERIA

Algiers

DENMARK
Copenhagen

RÜGEN
Stralsund

GERMANY

Elbe

Rhine Düsseldorf Berlin
Cologne Kassel
Weimar Dresden *RIESEN-*
Jena *GEBIRGE*
Frankfurt Tetschen
Bamberg Bayreuth CZECH
Nuremberg REPUBLIC
Strasbourg Stuttgart

Danube
Munich Salzburg Vienna
Basle Neuschwanstein
Zurich AUSTRIA HU

Milan
Marengo Arcola

Po

ELBA

Rome
ITALY

Cape Miseno Naples

Palermo

SICILY

Mediterranean Sea

TUNISIA

LIBYA

0 500 miles

0 500 1000 kilometres

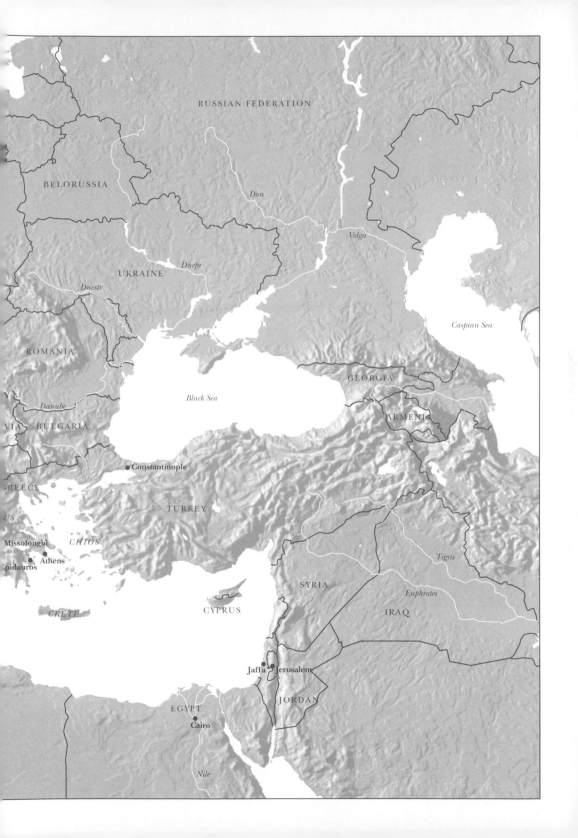

Further Reading

General Works

Listed under this heading are general cultural histories as well as more specifically art historical studies. Most general histories of Romanticism have focused mainly on its literature. The only wide-ranging accounts of the movement in the visual arts – both excellent – are Honour and Vaughan.

Keith Andrews, *The Nazarenes* (Oxford, 1964)

Nina M Athanassoglou-Kallmyer, *French Images from the Greek War of Independence 1821–1830* (New Haven and London, 1989)

Hans Belting, *The Germans and their Art. A Troublesome Relationship* (New Haven and London, 1998)

Isaiah Berlin, *The Roots of Romanticism* (London, 1999)

Albert Boime, *Art in an Age of Revolution 1750–1800, A Social History of Modern Art, 1* (Chicago and London, 1987)

—, *Art in an Age of Bonapartism 1800–1815, A Social History of Modern Art, 2* (Chicago and London, 1990)

Anita Brookner, *The Genius of the Future* (London, 1971)

—, *Soundings* (London, 1997)

—, *Romanticism and its Discontents* (London, 2000)

Chris Brooks, *The Gothic Revival* (London, 1999)

Council of Europe, *The Romantic Movement* (exh. cat., Tate Gallery and Arts Council Gallery, London, 1959)

—, *La Révolution française et l'Europe 1789–1799* (exh. cat., Grand Palais, Paris, 1989)

Kenneth Clark, *The Gothic Revival* (London, 1928, repr. Harmondsworth, 1964 and Atlantic Heights, NJ, 1970)

—, *The Romantic Rebellion. Romantic versus Classic Art* (London, 1973)

Kenneth Clark et al., *La Peinture romantique anglaise et les PréRaphaelites* (exh. cat., Petit Palais, Paris, 1972)

Frances S Connelly, *The Sleep of Reason. Primitivism in Modern European Art and Aesthetics 1725–1907* (University Park, PA, 1995)

Thomas Crow, *Emulation. Making Art for Revolutionary France* (New Haven and London, 1995)

Malcolm Easton, *Artists and Writers in Paris: the Bohemian Idea 1803–1867* (London, 1964)

Stephen F Eisenman et al., *Nineteenth Century Art. A Critical History* (London, 1994)

Walter Friedlander, *David to Delacroix* (Cambridge, MA, 1952)

Northrop Frye et al., *Romanticism Reconsidered* (New York, 1963)

Lilian R Furst, *Romanticism in Perspective* (London, 1969)

Keith Hartley et al., *The Romantic Spirit in German Art 1790–1990* (exh. cat., Royal Scottish Academy and Fruitmarket Gallery, Edinburgh; Hayward Gallery, London; Haus der Kunst, Munich, 1994–5)

Francis Haskell, *Past and Present in Art and Taste* (New Haven and London, 1987)

—, *History and its Images. Art and the Interpretation of the Past* (New Haven and London, 1993)

Erich Heller, *The Artist's Journey into the Interior* (London, 1965)

Werner Hofmann, *The Earthly Paradise* (New York, 1961, and as *Art in the Nineteenth Century*, London, 1961)

—, et al., *Ossian* (exh. cat., Grand Palais, Paris, 1974)

Hugh Honour, *Romanticism* (London, 1979)

Jean-Marcel Humbert et al., *Egyptomania. L'Egypte dans l'Art occidental 1730–1930* (exh. cat., Louvre, Paris; Musée des Beaux-Arts, Ottawa; Kunsthistorisches Museum, Vienna, 1994–5)

David Irwin, *Neoclassicism* (London, 1997)

Isabelle Julia et al., *Les Années romantiques 1815–1850* (exh. cat., Musée des Beaux-Arts, Nantes; Grand Palais, Paris; Palazzo Gotico, Plaisance, 1995–6)

Andrew McClellan, *Inventing the Louvre* (Cambridge, 1994)

Mario Praz, *The Romantic Agony* (2nd edn, London, 1950, New York, 1970)

Charles Rosen and Henri Zerner, *Romanticism and Realism. The Mythologies of Nineteenth Century Art* (London and Boston, 1984)

Pierre Rosenberg *et al.*, *French Painting, 1774–1830: The Age of Revolution* (exh. cat., Grand Palais, Paris; Detroit Institute of Arts; Metropolitan Museum of Art, New York, 1974–5)

Robert Rosenblum, *Transformations in Late Eighteenth-Century Art* (Princeton, 1967)

—, *Modern Painting and the Northern Romantic Tradition* (New York and London, 1975)

Edward W Said, *Orientalism. Western Conceptions of the Orient* (London, 1995)

H G Schenk, *The Mind of the European Romantics* (London, 1966)

Nadia Tscherny *et al.*, *Romance and Chivalry. History and Literature reflected in Early Nineteenth Century French Painting* (exh. cat., New Orleans Museum of Art; Stair Sainty Matthiesen Inc., New York; Taft Museum, Cincinnati, 1996–7)

William Vaughan, *German Romanticism and English Art* (New Haven and London, 1979)

—, *Romantic Art* (London, 1978)

—, *German Romantic Painting* (New Haven and London, 1980)

René Wellek, *A History of Modern Criticism, The Romantic Age* (London, 1955)

—, *Concepts of Criticism* (New Haven, 1963)

Theodore Ziolkowski, *German Romanticism and its Institutions* (Princeton, 1990)

Monographs and Contemporary Writings

The literature on Romantic artists is so vast that any selection can only be personal. Moreover, much of it is in languages other than English. It has been impossible to avoid some non-English publications here, though they have been kept to a minimum. Items marked with an asterisk are either original texts, complete anthologies of contemporary writings or at least contain substantial passages. The best anthology of contemporary criticism and aesthetics is Eitner. The journals of Delacroix and Haydon, and Constable's and Palmer's letters, provide some of the best insights into the artist's life.

Maurice Arama, *'Le Voyage'; Delacroix, le Voyage au Maroc*, (exh. cat., Institut du Monde arabe, Paris, 1994–5)

Stephen Bann, *Paul Delaroche. History Painted* (London, 1997)

Charles Baudelaire, *Salon de 1846*, ed. David Kelley (Oxford, 1987)*

—, *Intimate Journals*, trans. by Christopher Isherwood, with introduction by T S Eliot (London, 1930)*

—, *Curiosités ésthétiques. L'art romantique*, ed. H Lemaître (Paris, 1962)*

R B Beckett (ed.), *John Constable's Correspondence*, 6 vols (London and Ipswich, 1962–8)*

David Bindman, *Blake as an Artist* (London, 1987)

—, *William Blake. His Art and Times* (exh. cat., Yale Center for British Art, New Haven; Art Gallery of Ontario, 1982–3)

Anita Brookner, *Jacques-Louis David* (London, 1980)

David Blayney Brown, Robert Woof and Stephen Hebron, *Benjamin Robert Haydon 1786–1846. Painter and Writer, Friend of Wordsworth and Keats* (exh. cat., Dove Cottage, Grasmere, 1996)

Lorenz Eitner, *Neoclassicism and Romanticism 1750–1850*, 2 vols (Englewood Cliffs, NJ, 1970)*

—, *Géricault's Raft of the Medusa* (London and New York, 1972)

John Gage, *Colour in Turner: Poetry and Truth* (London, 1969)

—, *J M W. Turner. 'A Wonderful Range of Mind'* (New Haven and London, 1987)

Théophile Gautier, *Histoire du Romantisme 1830–1868* (Paris, 1929)*

Nigel Glendinning, *Goya and his Critics* (New Haven and London, 1977)

Geoffrey Grigson, *Samuel Palmer: The Visionary Years* (London, 1947)

Robin Hamlyn, Michael Phillips *et al.*, *William Blake* (exh. cat., Tate Britain, London; Metropolitan Museum of Art, New York, 2000–2001)

Tomás Harris, *Goya: Engravings and Lithographs*, 2 vols (Oxford, 1964)

James A W Heffernan, *The Recreation of Landscape: a Study of Wordsworth, Coleridge, Constable and Turner* (Hanover, New Hampshire and London, 1984)

Robert L Herbert, *David, Voltaire, Brutus and the French Revolution* (London, 1972)

Werner Hofmann, *Runge in seiner Zeit* (exh. cat., Kunsthalle, Hamburg, 1977)

—, *Caspar David Friedrich* (London, 2000)

Elizabeth Gilmore Holt, *From the Classicists to the Impressionists. A Documentary History of Art, 3* (Garden City, NY, 1966)*

Gerard Hubert *et al.*, *Napoléon* (exh. cat., Grand Palais, Paris, 1969)

A Joubin, *Journal d'Eugène Delacroix*, 3 vols (Paris, 1932, repr. 1981; trans. by W Pach, London, 1938)*

Lee Johnson, *Delacroix* (London, 1963)

Philippe Jullian, *The Orientalists: European Painters of Oriental Scenes* (Oxford, 1977)

Joseph Leo Koerner, *Caspar David Friedrich and the Subject of Landscape* (London, 1990)

Simon Lee, *David* (London, 1999)

Raymond Lister (ed.), *The Letters of Samuel Palmer*, 2 vols (Oxford, 1974)*

—, *Samuel Palmer: A Biography* (London, 1974)

Régis Michel *et al.*, *Géricault* (exh. cat., Grand Palais, Paris, 1991–2)

Hamish Miles, David Blayney Brown *et al.*, *Sir David Wilkie of Scotland* (exh. cat., North Carolina Museum of Art, Raleigh; Yale Center for British Art, New Haven, 1987)

H B Nisbet (ed.), *German Aesthetic and Literary Criticism* (Cambridge, 1985)

Leslie Parris and Ian Fleming-Williams, *Constable* (exh. cat., Tate Gallery, London, 1991)

Alfonso E Perez Sanchez and Eleanor A Sayre, *Goya and the Spirit of Enlightenment* (exh. cat., Prado, Madrid; Museum of Fine Arts, Boston; Metropolitan Museum of Art, New York, 1989)

Claude Pétry *et al.*, *Delacroix. La naissance d'un nouveau romantisme* (exh. cat., Musée des Beaux-Arts, Rouen, 1998)

Willard Bissell Pope (ed.), *The Diary of Benjamin Robert Haydon*, 5 vols (Cambridge, MA, 1960–63)

Christopher Prendergast, *Napoleon and History Painting: Antoine-Jean Gros's La Bataille d'Eylau* (Oxford, 1997)

François Pupil, *Le Style Troubadour ou la nostalgie du bon vieux temps* (Nancy, 1985)

Pierre Rosenberg *et al.*, *Dominique-Vivant Denon. L'oeil de Napoléon* (exh. cat., Louvre, Paris, 1999–2000)

Robert Rosenblum, *Jean-Auguste-Dominique Ingres* (London and New York, 1967)

Michael Rosenthal, *Constable: The Painter and his Landscape* (New Haven and London, 1983)

Nicole Savy, *'Charles Baudelaire ou l'espace d'autre chose', Regards d'écrivains au Musée d'Orsay* (Paris, 1992)

Gert Schiff, *Images of Horror and Fantasy* (New York, 1978)

Antoine Schnapper *et al.*, *Jacques-Louis David* (exh. cat., Grand Palais, Paris, 1989)

Arlette Serullaz *et al.*, *Delacroix. Les dernières années* (exh. cat., Grand Palais, Paris; Philadelphia Museum of Art, 1998–9)

Michael Snodin *et al.*, *Karl Friedrich Schinkel: A Universal Man* (exh. cat., Victoria and Albert Museum, London, 1991)

Germaine de Staël, *De l'Allemagne*, ed. S Balayé (Paris, 1968)*

Sarah Symmons, *Goya* (London, 1998)

Tom Taylor (ed.), *The Life of Benjamin Robert Haydon, Historical Painter, from his Autobiography and Journals*, 3 vols (London, 1853; repr. 1926)*

Peter Tomory, *The Life and Art of Henry Fuseli* (London, 1972)

F R de Toreinx, *Histoire du Romantisme en France* (Paris, 1829)*

William H Treuttner and Alan Wallach (eds), *Thomas Cole: Landscape into History* (exh. cat., National Museum of American Art; Smithsonian Institution, Washington, DC, 1994)

William Vaughan *et al.*, *Caspar David Friedrich 1774–1840. Romantic Landscape Painting in Dresden* (exh. cat., Tate Gallery, London, 1972)

Timothy Webb (ed.), *English Romantic Hellenism 1700–1824* (Manchester, 1982)

Juliet Wilson-Bareau and Manuela B Mena-Marques, *Goya, Truth and Fantasy. The Small Paintings* (exh. cat., Prado, Madrid; Royal Academy of Arts, London; Art Institute of Chicago, 1994)

Andrew Wilton, *Turner in his Time* (London, 1987)

Jonathan Wordsworth, Michael C Jaye and Robert Woof, *William Wordsworth and the Age of English Romanticism* (exh. cat., New York Public Library; Indiana University Art Museum; Chicago Historical Society, 1987)

Index

Numbers in **bold** refer to illustrations

Acknowledgements

Many people have helped to make this book. Marc Jordan persuaded me to attempt it. Years ago, Michael Greenhalgh and Philip Conisbee struck sparks of interest which I hardly recognized at the time. Among friends and colleagues who kept them alive later, at different times and places, I would mention above all Colin Bailey, David Bindman, Giuliano Briganti, John Gage, Luke Herrmann, Hamish Miles, Patrick Noon, Felicity Owen, Eleanor Sayre, Gert Schiff, Robert Woof and Jonathan Wordsworth. Dr Alexander Babin, Curator of French Nineteenth-Century Painting at the State Hermitage Museum, St Petersburg, has expedited the conservation and photography of Fleury Richard's *Valentine of Milan*, which he rediscovered in 1999, in time for illustration here. Caroline Elam and Duncan Bull have prodded me with book and exhibition reviews. My former colleagues at the Ashmolean Museum, especially Christopher Lloyd and Jon Whiteley, were a constant inspiration, as are my present ones at Tate Britain, especially Andrew Wilton, Robin Hamlyn, Anne Lyles and Ian Warrell. Gerhard Kruger, Gerhard Obenaus and Klaus-Heinrich Nordhoff have been hosts and guides in Germany, and helped with translations. Selwyn Hardy has been a constant host in Paris. Without Anton Pozniak, this book would certainly not have been written at all, and my editors at Phaidon, Pat Barylski and Julia MacKenzie, have shown extraordinary forebearance and patience during its slow progress. Steven Spurgeon has shared many Romantic journeys, and more of the Romantic agony than anyone should be asked to bear.

D B B

Photographic Credits

AKG, London: photo Erich Lessing 198; Allen Memorial Art Museum, Oberlin College, Ohio: R T Miller Jr Fund (1982) 31; Architect of the Capitol, Rotunda of the US Capitol, Washington, DC: 184; Artothek, Peissenberg: 54, 67, 75–6, 90, 176; Art Resource, New York: National Museum of American Art, Smithsonian Institution, Washington, DC 182; Ashmolean Museum, Oxford: 69, 89, 180; Bayerische Staatsbibliothek, Munich: 214; Bibliothèque National de France, Paris: 59, 60, 151; Boston University, Special Collections, on deposit from Washington Allston Trust: 233; Bridgeman Art Library, London: 13, 149, 179, 192, 218, Agnew & Sons, London 48, Château de Malmaison, Paris, photo Lauros-Giraudon 44, Derby Museum & Art Gallery 158, Detroit Institute of Arts, Founders Society purchase with Mr & Mrs Bert L Smokler and Mr & Mrs Lawrence A Fleischman funds 189, Hermitage, St Petersburg 219, Lincolnshire County Council, Usher Gallery 153, Louvre, Paris, photo Peter Willi 209, Musée des Augustins, Toulouse, photo Giraudon 174, Musée des Beaux-Arts, Chartres 210, New York Historical Society 147, Stapleton Collection 164; British Library, London: 87; British Museum, London: 91, 120, 195; Syndics of Cambridge University Library: 123; Castle Howard Collection, Yorkshire: 155; Courtauld Institute Gallery, London: 212, executors of Sir Brinsley Ford, photo John Webb 68; École Nationale Supérieure des Beaux-Arts, Paris: 27; Froehlich Collection, Stuttgart: 248; Giraudon, Paris: 47, 62, 129, 170, 226, 242, photo Alinari 26, photo Lauros 45, 216, 239, photo Telarci 30; Robert Harding Picture Library, London: photo Adam Woolfitt 140; Hirschsprung Collection, Copenhagen: 15; Ikon Gallery, Birmingham: photo Lotta Hammer 251; A F Kersting, London: 139, 141, 143, 163; Kunsthalle, Hamburg: photo Elke Walford 9, 11, 70–2; Kunsthaus, Zurich: 188; Kunstmuseum, Basel: photo Martin Bühler 249; Metropolitan Museum of Art, New York: purchase, gifts of George N & Helen M Richard and Mr & Mrs Charles S McVeigh and bequest of Emma S Sheafer, by exchange (1989) 183, Karen B Cohen Collection 223; Mountain High Maps © 1995 Digital Wisdom Inc: pp.436–7; Musée Baron Gérard, Bayeux: 220; Musée des Beaux-Arts, Angoulême: 221; Musée des Beaux-Arts, Bordeaux: photo Lysiane Gauthier 173; Musée des Beaux-Arts, Lyon: 241; Musée Fabre, Montpellier: 28, 236, 244, 247; Musées Royaux des Beaux-Arts de Belgique/Musée Wiertz, Brussels: 229; Museo del Prado, Madrid: 206; Museum Boijmans van Beuningen, Rotterdam: 152; National Gallery of Australia, Canberra: purchased by admission charges (1982–3) 157; National Gallery, London: 94, 100, 101, 178, 222; National Gallery of Canada, Ottawa: 39; National Maritime Museum, London: 150, 156; National Portrait Gallery, London: 10, 169; New York Public Library: Astor, Lenox and Tilden Foundations 113; Oskar Reinhart Collection, Winterthur: 20, 207; Österreichische Galerie, Vienna: 194; Palazzo Bianco, Genoa: 243; Petrushka, Moscow: Pushkin Museum 29, Russian Museum, St Petersburg 146; Photothèque des Musées de la Ville de Paris: 172; Powerhouse Museum, Sydney: 124; RMN, Paris: 2, 18–19, 22–3, 32–3, 37, 41–3, 46, 49, 50, 61, 64–6, 110–11, 122, 125–7, 148, 159, 165–8, 171, 175, 177, 181, 208, 211, 224–5, 227, 237–8, 240; Royal Academy of Arts, London: 107; Royal Collection, Windsor, © Her Majesty Queen Elizabeth II: 115, 121, 228; Sächsische Landesbibliothek-Staats-und Universitätsbibliothek, Dresden: photo A Rous 80; Sammlung Georg Schäfer, Schweinfurt: 133; Scala, Florence: 57; Sir John Soane's Museum, London: 162; Spencer House, London: photo Mark Fiennes 161; Staatsgalerie, Stuttgart: 25; Staatliche Museen zu Berlin: Bildarchiv Preussischer Kulturbesitz: 6, 7, 53, 73–4, 77–9, 81–4, 112, 132, 134–5, 137–8, Preussischer Kulturbesitz Kupferstichkabinett: 55, 136, 203–4, 230–2; Städelsches Kunstinstitut und Stadtische Galerie, Frankfurt am Main: 131; © State Hermitage Museum, St Petersburg, 2001, acquired 2000: 128; Statens Museum for Kunst, Copenhagen: 14; Strawberry Hill Enterprises, Twickenham: 117; Tate, London: 4–5, 12, 21, 34–5, 51–2, 86, 92–3, 95–9, 102, 109, 119, 145, 154, 160, 185, 187, 190–1, 196, 215, 217, 235, 246, 250; Thorvaldsens Museum, Copenhagen: 24; V&A Picture Library, London: 85, 88, 103–6, 108, 116, Wellington Museum, Apsley House: 38; Verwaltung der Staatlichen Schlösser und Gärten Hessen, Bad Homburg: 144; Wadsworth Atheneum, Hartford, Connecticut: gift of Paul Rosenberg and Company 130; Wallace Collection, London: 63, 245; Warner Collection of Gulf States Paper Corporation, Tuscaloosa, Alabama: 114; Wordsworth Trust, Cumbria/St Mary's Seminary, Ohio: photo Tony Walsh 234

Phaidon Press Limited
Regent's Wharf
All Saints Street
London N1 9PA

Phaidon Press Inc.
180 Varick Street
New York, NY 10014

www.phaidon.com

First published 2001
© 2001 Phaidon Press Limited

ISBN 0 7148 3443 2

A CIP catalogue record for this book is
available from the British Library.

Typeset in ITC New Baskerville

Printed in Singapore

Cover illustration Caspar David
Friedrich, *The Wanderer above the Mists*,
*c.*1817–18 (see pp.26–7)